HAPPY CANYON

A HISTORY OF THE WORLD'S MOST UNIQUE
INDIAN PAGEANT & WILD WEST SHOW

REBECA FLETCHER WAGGONER

THE
History
PRESS

Published by The History Press
Charleston, SC
www.historypress.net

Front cover, top, left to right: Princesses in convertible. *Hall of Fame Collection*; Chief Raymond "Popcorn" Burke. *Howdyshell Collection*; Curtis Sampson on Win-Sauki. *Howdyshell Collection*; *bottom, left to right*: Happy Canyon princess bag. *Eye of Rie*; tents and cowboys in Old Canyon. *Photo by W.S. Bowman, Howdyshell Collection*; bank robber Greg Dennis. *Harper Jones II*.
Back cover, top: The 2014 quadrille team. *Eye of Rie*; *bottom*: The 1934 quadrille team in Indian village. *Hall of Fame Collection*.

First published 2016

Manufactured in the United States

ISBN 978.1.46713.677.8

Library of Congress Control Number: 2016936006

Notice: The information in this book is true and complete to the best of our knowledge. It is offered without guarantee on the part of the author or The History Press. The author and The History Press disclaim all liability in connection with the use of this book.

For my dad, Robin A. Fletcher Jr.,
and to each person who has volunteered at Happy Canyon since 1914.

CONTENTS

Contents

FOREWORD

No place in the world celebrates the rich history of the American West like Pendleton, Oregon, where for a century, the spirit of the West has been presented live on a grand stage in the form of Oregon's Official State Outdoor Pageant & Wild West Show: Happy Canyon!

At its core, Happy Canyon is a story about the West and the town of Pendleton. This story begins by showcasing the life of the Cayuse, Umatilla and Walla Walla tribes through traditional events like hunting and gathering, a wedding ceremony and a young boy's successful first hunt—all acted by tribal members adorned in remarkable one-of-a-kind native attire. Lewis and Clark and Sacagawea arrive as the story unfolds, and Oregon Trail pioneers in full-sized prairie wagons pulled by teams of oxen follow in the next scene. The show wraps up with a reenactment of life in a western frontier town whose main street is never free from mischief!

Even after one hundred years, this production continues to thrive thanks to the generational commitment of the hundreds of community volunteers. These dedicated men, women, children and even animals carry on the vision of Happy Canyon's founder, Roy Raley. His vision was to provide first-class evening entertainment for rodeo attendees inspired by the stories his father told him about his experiences along the Oregon Trail.

These volunteers possess a boundless passion and love for the production. Starting at the end of the last show until the beginning of the next season, countless hours of preparation, planning and coordination take place behind the scenes each year. This dedication has been passed down from family member to family member and friend to friend.

And now, just like it has been for one hundred years on opening night, the excitement grows, spectators are in their seats, the livestock are harnessed and saddled, the live orchestra

begins to play and finally the hard work is a distant memory as the announcer shouts, "On with the show!"

Congratulations to the generations of Happy Canyon volunteers past and present for reaching this incredible milestone, and thank you for providing the world a century of living history and quite a bit of fun to boot!

—Greg Walden

U.S. congressman Greg Walden and his wife, Mylene, at the Happy Canyon West Gate. *Greg Walden.*

ACKNOWLEDGEMENTS

One of my first memories as a three-year-old is being dressed in a pioneer costume and red wig and being pulled out of a trunk on "my turn." This is called "being volunteered" in Happy Canyon: having no say whatsoever in our new role in the community. I am so thankful I was volunteered that way!

Happy Canyon has been a huge part of my family's history since 1914. My great-grandfather R.W. (Robin Wesley) Fletcher played the first sheriff, a role that has been passed down within our family for four generations.

My hope is that you, the reader, will see this incredible one-of-a-kind show through a new lens or maybe with the eyes of the first crowd who jammed the little town scene in September 1914, never imagining it would last for over one hundred years.

Few pictures of the show or its location exist for the first several years. Early on, Roy Raley established that the pageant would be an "unpublished literary production, and that no detailed programs or moving pictures or photographs of the production shall be made."[1]

While this was an effort to protect the originality of the show, it left scanty evidence for those of us who long to see the record of history. In some ways, it adds to the romance of what has made this show great and well loved.

Where do you begin a project of this kind? Over several years, I "spread the net wide," and through researching records, letters, memorabilia and interviews—including true tales, some too special to print—I have attempted to give you an overall history of Happy Canyon's first century. I was amazed at the depth and complexity of what had happened over Happy Canyon's one-hundred-year history.

To each person I had the honor of talking to and hearing Happy Canyon stories from, whether it was in a store or a formal interview, I honor and thank you.

Sally Raley Brady: it has been a delight and an honor to call you my friend. Your stories of

your wonderful grandfather Roy Raley for this project have no price. What a wonderful legacy we share!

Mitzi Rodriguez: thank you for your time and special stories of your grandmother Anna Minthorn Wannassay.

Thank you, Ann Terry Hill, for the gift of encouragement and for writing a piece of this project.

Very heartfelt thank-yous go to:

Joe Temple and Pat Johnson, and the Howdyshell family, for seeing my heart and vision for this project. Joe Temple packed the camera for his father, Bus Howdyshell, and also played the part of a Chinaman in the show.

Jennifer Boise, Joe Temple's daughter, you were key to this project. I felt our grandfathers Bus and R.W. smile on the two of us for perpetuating their love for the show, especially when I found the article describing them promoting Happy Canyon and Round-Up together.

Wayne Low and the wonderful photography collection you so willingly share.

Don Cresswell and Harper Jones II, for your excellent photos of the show.

Rie Grace, no words describe the time and gift of photography you gave to capture Happy Canyon through an artist's eyes.

Virginia Roberts and Round-Up and Happy Canyon Hall of Fame.

Carolyn Gerberding and Umatilla County Historical Society.

Marv Anderson and Master Printers Northwest.

Cheryl Sherman and Sofi Smith, who were invaluable to this project.

Kathryn Brown and the *East Oregonian*.

Heather Karle, for catching my vision and your exceptional editing gift!

Natalie Hanemann, for your editing expertise and good questions.

Happy Canyon board and Happy Canyon Foundation, each past director I had the honor of interviewing and especially my friend Jason Hill.

Tamástslikt Cultural Institute and especially Marjorie Waheneka and Dallas Dick for your time, insight and knowledge—you are assets to this special place of your people.

Fritz Hill, for your stories and excitement for this huge project.

Scott and Bonnie Sager, for your insight and a special day at Tamarack Temple.

Allen Arnold and Christen Thompson, who saw the vision of this book.

To my wonderful husband, Allen, thank you for loving all things Happy Canyon and believing in me and this book. I am so proud of you and all you put into Happy Canyon both as a director and an actor. I still miss you and Dad, sitting in the directors' booth, having a blast and seeing the show come together.

Kyle, Kaleigh and Riley, fifth-generation Happy Canyon volunteers and my greatest blessings.

Mom: right out of OSU, you volunteered and embraced Happy Canyon. My love and thanks for cheering me on!

To my majestic God for every insight, blessing and idea for this book: I give you my deepest thanks!

Lastly, Dad: this is for you. What words are there to describe how our family loves the

Robin Fletcher Jr. (left) and Allen Waggoner (right) in the show director's booth, 2008. *Photo by author.*

holiday we call Happy Canyon? Every day that I wrote, I felt you with me, yet I wished I could ask you many Happy Canyon questions. Thank you for keeping your files and for believing in this project the moment I told you I was going to do it. I love and miss you every day, especially at the show!

1

THE HAPPY SHOW IS BORN

Now turn into that Pendleton institution of human ingenuity, Happy Canyon, which means a spot right in the Heart of Pendleton, where everyone can complete a day of Frontier Fun....Out in the arena you see the rip-roaring life of the range in its fullness, and at its best, but in Happy Canyon you see, drawn more vividly than any pen or brush can depict, the life of the frontier town.[2]
—*Charles Wellington Furlong,* Let 'Er Buck, *1921*

Happy Canyon became a Pendleton tradition the day it began.

On September 23, 1914, the capacity crowd seated at the corner of Southeast Frazer and Main Streets in Pendleton, Oregon, watched the first Happy Canyon night show. They never could have imagined that one hundred years later, it would still be going strong. War spread around the world, but in this quiet eastern Oregon town, a pageant was born.

Happy Canyon's story is close to that of Pendleton's; both hold the same frontier spirit. The Happy Canyon pageant is not a commercial show. It is one of the greatest community enterprises of its kind in the world.

The community first raised the question: How could Pendleton entertain families in the evenings once the afternoon Round-Up (a local rodeo that began in 1910) ended? Besides attending the local fair, visiting one of the twelve saloons (mostly banned to women) or heading to a movie showing, women and children had few activities to choose from in the evening. Even the few street dances had their problems, such as local cowboys riding horseback through the dancers. Round-Up nightlife became a problem for Pendleton law enforcement.[3]

INFLATION OPENS THE DOOR FOR HAPPY CANYON

Just one year earlier, in 1913, the Umatilla-Morrow District Fair offered the largest evening entertainment following Round-Up. This weeklong affair already existed when Round-Up began in 1910, and Round-Up overlapped its last three days. At first, crowds supported both, but Pendleton eventually—and enthusiastically—supported only Round-Up, leaving the district fair more vacant every year.

Nevertheless, for the 1913 fair, the large pavilion, lavishly decorated with "fluttering color from floor to ceilings and incandescent lights,"[4] sat on the east side of Main Street. The livestock arrived, the jams and jellies became displays and local businesses, including the Sunnybrook Distillery, set up their exhibits for all to enjoy. A baby contest was planned, as was a special flute solo.

In the afternoon, the Round-Up Band featured several numbers, including the *William Tell Overture* and Bert Jerard's "Let 'Er Buck" song. And no one wanted to miss the daredevil performance of "Marvelous De Olney," the human fly.[5]

The rabbit displays, especially those of Mrs. Chilson, attracted keen interest but not enthusiasm. It is not hard to imagine Roy Raley, George Hartman and Lee Drake standing in front of Mrs. Chilson's rabbit hutches, thinking, "There has to be more we can offer the night crowd than this."

If the Umatilla-Morrow District Fair had offered just a little better value for its fifty-cent admission, doubled from the year before, Happy Canyon might not have found the open door it needed.

The 1913 district fair proved a catalyst, launching the idea of a night show. Leaving the fair on Main, those three men of vision and

Umatilla-Morrow District Fair postcard. *Wayne Low collection.*

16

ingenuity began discussing ways to offer the Round-Up crowd something better.

"We thought something must be done," Lee recalled, quoting Roy's suggestion, "Let's start our own night show." The men brought their thoughts to the Pendleton Commercial Association, and the idea of Happy Canyon, being met with hearty approval, sprang forth. Roy, Lee and George drafted a program for the 1914 Round-Up.[6]

Raley's job was to write the first script, plan the scenery and direct the first shows. After the first Round-Up in 1910, Roy—later known as the father of Round-Up and Happy Canyon—started creating an evening entertainment to complement Round-Up. Roy had served as director of activities at Round-Up and envisioned Happy Canyon acts not suited for rodeo.

In 1915, the *East Oregonian* summed up the show, stating, "Happy Canyon came into being to fill a real need." The theaters, the lagging fair and the street dances did not provide enough entertainment for the Round-Up crowds, especially for families. Happy Canyon became a possible solution to this problem.[7]

Top: Roy Raley. *Raley family. Bottom, left to right*: George Hartman and Lee Drake. *Hall of Fame Collection.*

WHAT'S IN A NAME?

The name is the magic drawing card.

Roy and the Pendleton Commercial Association created it, labeling the show Happy Canyon—an actual location in the Nolin district near Pendleton. How could a title better describe the personality of Pendleton's early inhabitants? By popular consent, the name stuck. As the *East Oregonian* reported, "'Happy Canyon' Will Be Name of Town in Fair Pavilion: It has been thus christened and the name, while suggesting days of a romantic past, is also indicative of the gaiety which will prevail there."[8]

Through Charles Wellington Furlong's eyes in 1921, a lovely visual of the Happy Canyon community (which no longer exists) in Eastern Oregon is given:

If you follow the Umatilla [River] down from Pendleton, it will take you to where nature has sculptured out a wide defile before it broadens into the prairie. Today a store and three or four houses called Nolin nestle here. This little hidden-away spot, in the days of the stage coach and pony express, was the most fertile spot of the surrounding country, a veritable little Garden of Eden with its vegetable lands and orchards. Here in this tucked-away paradise, many a dance was pulled off, not to mention other episodes, when the crowd rode in to the ranch house of one of the other of the settlers. No wonder they called it Happy Canyon.[9]

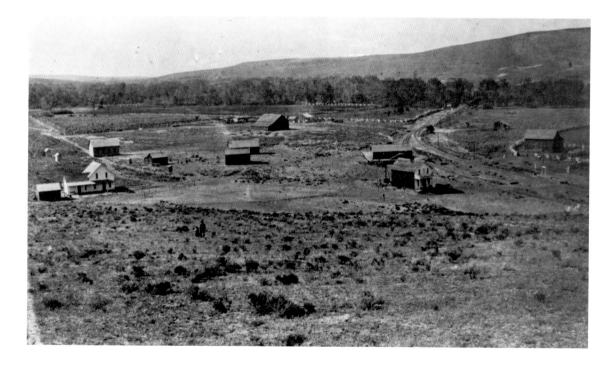

"The legend rides on...."

[Ha]ppy Canyon was an actual location along [the U]matilla River on old Highway 30 between [Eco]kum and Nolin. According to Ad Nye, early [ran]ching pioneer and sheriff, the name came [to] be around the winter of 1868. He described [the] location as the part of the Umatilla from [B]arnhart Station to the Jack Morton farm, one mile below Nolin.

Nolin was the halfway point between Umatilla Landing and Pendleton or Pilot Rock that freighters used. Many freighters going either way camped in a two-acre tract called Grayback Flat. People even addressed letters to "Happy Canyon by way of Pendleton."

Several stories contribute to the naming of this famous canyon, but two stand out.

The long winter months afforded time for families, many from Missouri, to gather and tune their fiddles for regular hoedowns. This dancing club met each week at one of the members' homes. One night, at the conclusion of a particularly enjoyable dance, Ad Nye's brother-in-law, Mr. Angell, declared that the valley be christened "Happy Canyon," and the motion passed with a "Whoop!"

Thus, the small settlement soon became named Happy Canyon for the many dances, socials, parties and community events it held. Children bedded down in a loft or in a corner while parents danced the night away, enjoying a huge supper during a break. Nye reported that it was easy to grab the wrong baby by the end of the evening after all the dancing finished.[10]

Opposite: Happy Canyon of Nolin, Oregon. It's possible to see the famous horse racetrack seen in the background. *Umatilla County Historical Society*.

The second naming story proves a delight. The horse racetrack was a popular entertainment at Happy Canyon, with high stakes of forty to sixty dollars. The race day always included a community lunch and a keg or two of liquor.

On one occasion, after the races were over and the liquor consumed, an argument broke out and guns were pulled. The crowd broke for cover, and from the top of the cliff, a young man yelled, "Hurrah for Happy Canyon!" And the name thereafter stuck.[11]

Both accounts add to and support the naming of Raley's show, as Nye stated in 1914, "Now I want to congratulate the Pendleton boys in choosing this name for the place of amusement during Round-Up."[12]

First Shows: 1914-15

The first Happy Canyon committee,[13] made up of Pendleton Commercial Association men, set out to design, build and put on the 1914 show with great excitement and enthusiasm. Just for good measure, the committeemen decided Happy Canyon would cost a spectator twenty-five cents—half the cost of the 1913 Umatilla-Morrow Fair.

For the first script, Roy wrote what is now known as the Wild West portion of Happy Canyon. He had heard firsthand stories from his own father, Colonel J. H. Raley, who came west in a wagon train on the Oregon Trail in 1862.

Because of the poor fair attendance in 1913, the Umatilla-Morrow Fair pavilion

was secured by the newly formed Happy Canyon committee. Using the vacated fair's board fence and location, the committee went to work on the first show venue and the accompanying entertainment. This wooden clapboard setting sat at the corner of Southeast Frazer and Main Streets, about where the Eagles' new lodge now stands (one block from the railroad depot, opposite the Bowman Hotel).

With plans in hand, the carpenters and painters transformed the old fair pavilion into a "fit setting for entertainment." The bleacher seats faced south so that they were positioned opposite the frontier setting. False fronts with slab wood facing composed the set for the little frontier town on which the show was based. The *East Oregonian* described the new western burg in colorful detail: "Facing the bleachers will be the buildings of the street, the bank, saloons, Chinese laundry, millinery store, grocery store, blacksmith shop, hotel, post office, gambling houses and other institutions such as flourished in the days of '49."[14]

As the Happy Canyon men's vision began to unfold, the community began to grasp the significance of this new enterprise. The *East Oregonian* wrote:

> *Happy nights in Happy Canyon are promised to visitors to the Round-Up this year. Not only will they be entertained each afternoon with the thrilling pastimes of the cowboy and Indian but in the evening too they will have an opportunity to revel in the picturesque and romantic life of frontier days.*[15]

Colonel J.H. Raley. *Raphael Hoffman.*

As part of the overall plan, the audience would be invited into the false-front town to dance, gamble and frolic at the end of the pageant. The goal for Roy and his team was to help "people to enjoy themselves to the utmost."[16]

The article describes how you could purchase a Happy Canyon buck for one cent and use the fake money for gambling. While carpenters continued to build the Old West town, a huge tent was stretched out on Southeast Frazer Street for dancing. The jitney dance cost a gentleman ten Happy Canyon bucks per dance (or ten cents a dance), but ladies entered free.[17]

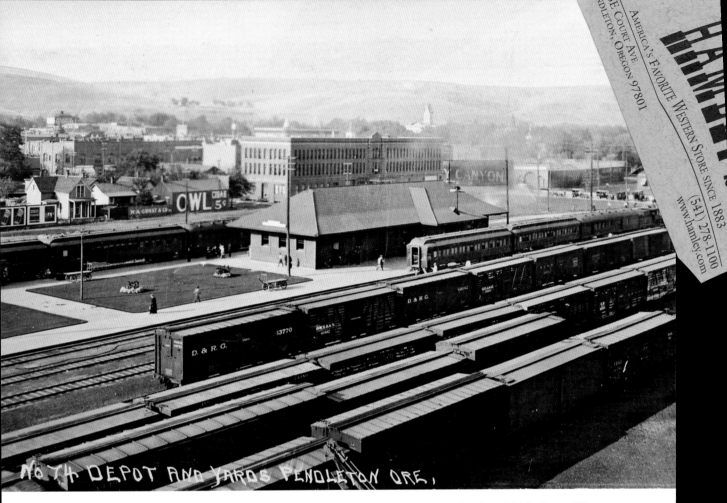

NO.4 DEPOT AND YARDS PENDLETON ORE.

Anticipation in Pendleton grew for this new show. The *East Oregonian* reported:

Looking northeast on Pendleton's Main Street, "Happy Canyon" (partially obscured) is painted on the side of the building in the background, 1914. *Wayne Low collection.*

> *There will be a 23 piece band to render selections and there will be a few dramatic scenes significant of frontier life. Some cowboy stunts will be sandwiched in and one event will follow another in rapid order. The tamest of modern citizens sometimes longs for a taste of the reckless pleasures of the pioneer, miner or cowboy. Both the glimpse and the taste will be in Happy canyon [sic] and that too, without offense to the finer sensibilities. There will be a chance to eat, drink and be merry in a real old western way and the sin will be extracted from it all.*[18]

The first performance was already being entitled "Home People's Night" at Happy Canyon, offering locals the first look at the show and leaving more room for out-of-towners at the successive nights.

The day before the first show opened, constant excitement and buzz circulated through Pendleton and Round-Up visitors. The Happy Canyon men dedicated themselves to the final touches to the scenery, the dance hall and, most of all, the first show rehearsal.

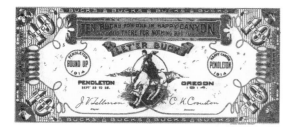

The 1914 Happy Canyon buck. *Jason Hill.*

"Tomorrow evening will see the opening of a new institution in Pendleton which will henceforth be known in connection with the Round-up," the *East Oregonian* reported. "Happy Canyon, the town of other days, will throw open its gates."[19]

THE FIRST HAPPY CANYON PERFORMANCE

"Tonight Sees Happy Canyon Open," the *East Oregonian* headline announced. The article expressed the crowd's excitement: "All Pendleton and her visitors are anticipating the opening of the town with an eagerness that is all but impatience."[20]

The happy throng literally "jammed" in to see the inaugural show, which found such success that the seating capacity and the entrance had to be enlarged. Some spectators were even allowed to watch from the Happy Canyon buildings on the set, due to the lack of seating. As Lee Drake recalled in later years, "The darned audience got in the way so bad we couldn't tell them from the actors." [21]

As the concert band played, the town militia went through a hilarious drill, the fire department made a heroic rescue at "Stagger Inn," bad men shot up the town, Jinks Taylor drove the stagecoach, the quadrille of professional cowboys and cowgirls "danced" their horses expertly and Chinamen were "made victims of the cowboy's sportive nature."[22]

In one of the features, Doris Reber sang from horseback. She had just returned from a singing engagement in Portland, where she "secured several appropriate songs for a frontier evening show." Doris was known for her beautiful voice and cut quite a figure singing from the back of her horse.

The highlight for many, though, was the release of Round-Up's "most vicious, long-horned steer." After the cowboys riled him up with the red blankets, enraging him to crash through the scenery, the steer turned his sights on Buffalo Vernon, Otto Kline and Dell Blancett—to name a few.

Most surprisingly, Charles Wellington Furlong, the author of *Let 'Er Buck*, took on the steer. Lastly, after falling in front of the large, horned animal, Vernon was forced to bulldog it to save himself from injury. What ensued was a thrilling five-minute tussle, ending when Buffalo finally wrestled down the steer to the wild applause of the crowd.

At the end of the night, the first Happy Canyon committeemen breathed a sigh of relief. The local newspaper provided a glowing

Opposite, top: The supposed location on Railroad Street (Southeast Frazer) of the first canvas-covered dance. *Wayne Low collection.*

Opposite, bottom: Doris Reber, first Happy Canyon soloist, sang from horseback. *Author file.*

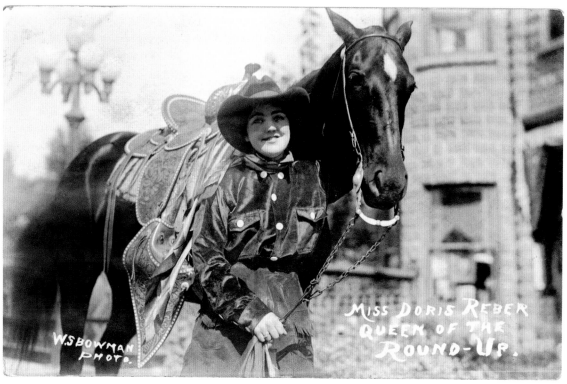

W.S. BOWMAN
PHOTO.

MISS DORIS REBER
QUEEN OF THE
ROUND-UP.

description of the first performance. "Happy Canyon proves novel entertainment and 3,000 people flock there opening night," the *East Oregonian* reported.[23]

The next morning, carpenters went to work enlarging the seating capacity. The second performance the next day saw four thousand in the audience and hundreds more trying to find a way in. The dance hall was filled to the brim, the gaming tables became "a merry-mad throng" and "everybody went away happy."[24]

"Happy Canyon proved itself last night a fit supplement to the Round-Up," the article concluded. "It filled the gap which has heretofore been caused by the lack of a

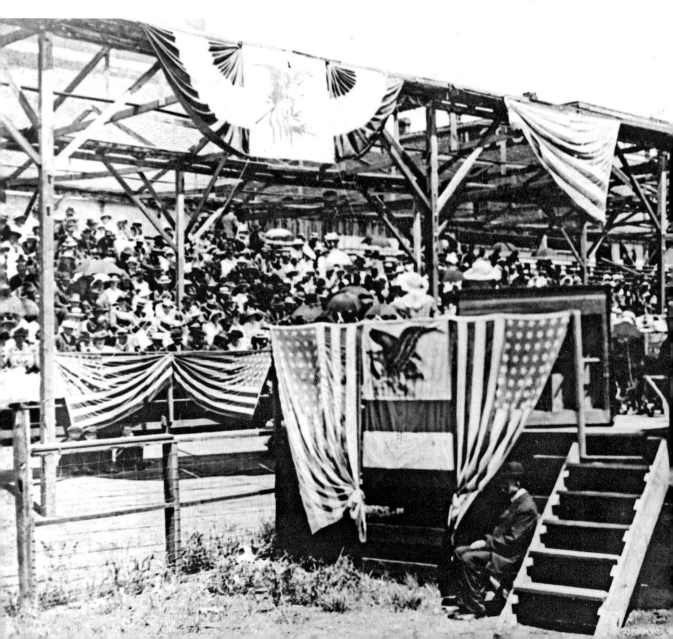

suitable entertainment for the crowd. It is in harmony with the big wild west show and it will add to the fame of Pendleton as the 'Let 'Er Buck' town."[25]

When the Saturday performance ended, the Happy Canyon men, led by President Tallman, congratulated themselves as they considered how to improve the 1915 show.

From the beginning, Happy Canyon was a successful staged and acted drama, gaining traction from its first year.

NO HAPPY CANYON

—BUT—

Pastime Theatre

STILL SHOWS

FEATURE PICTURES

TUESDAY---WEDNESDAY

BROADWAY STAR FEATURE

MR. BARNES of NEW YORK

Vitagraph—6 Parts 6—Vitagraph

Maurice Costello and Mary Charleson

A Picture that All Should See

15c Admission 10c

Above: This September 28, 1914 *East Oregonian* ad for a local movie house was already capitalizing on Happy Canyon's name and success. *From the* East Oregonian.

Left: The first Happy Canyon on Main Street. Note the bandstand and hastily constructed grandstands, which later drew remarks. *Hall of Fame Collection*.

25

1915 HAPPY CANYON PAGEANT

The Wednesday opening show in 1915 had a larger attendance than the previous year's.

"Those who saw Happy Canyon last year were crazy about the original idea for entertaining," the *East Oregonian*'s report said. "Those who see it this year will be plumb delirious, according to those few who are on the inside of the arrangements."[26]

Happy Canyon had "thrown off the lid" after the first night's performance, according to the newspaper. "More than 3,000 people crowded into the pavilion wherein has been built a reproduction of the towns which flourished in this country when civilization was young out here," it stated. "The committeemen had lived the Old West and knew exactly how the entertainment should look."[27]

"Bank Robbed but Guns Bring Down Two Bandits" the *East Oregonian* announced on September 24, 1915, describing the second performance of the show in its second year. The show's next night saw more than four thousand people, who even "overflowed into the 'street.'" The newspaper went on to say, "There were hundreds of others who vainly tried to force their way into the jammed pavilion. Happy Canyon is proving a close runner-up to the Round-Up itself in its appeal to the pleasure appetites of the populace."

After a spectacular bank holdup, the show bandits were pursued at full gallop while Benny Corbett and his horse executed a planned fall under the rain of bullets. Next in the program, three bucking horses and their riders proved a delight, followed by Bonnie McCarroll, champion bronc rider, who made

```
1   Stage Coach
2   Quadrille
3   Drag
4   Bucking horses.
5  Band
    Crutchfield
6   McCarroll
7   Reber
8   Sharkey
9   Big, Indians
      militia & Goat
10  Bucking Steer
11  Quartette
12  Bank Robbery
      falling horse
13  Burros
14  Shorty
15  Steer Fight
16  Fire
```

The oldest known cue card, 1915. *Raley family.*

a "pretty ride" on a bucking steer, and her "much muscled husband," Frank, withstood the attempts of two horses to pull his folded arms apart, a marvelous act of strength.

For the second year, Doris Reber mounted her lovely black horse and sang a number easily heard throughout the small set. She had also been chosen as Round-Up Queen in 1915. Doris would go on to become a professional

vocalist, but she was first heard in humble Happy Canyon.[28]

The famous Round-Up bucking Belgrade bull, "Sharkey," was paraded around for the crowd to see before he "piled" a rider and "nearly tore part of the town down." The newspaper then described how the bucking burros "kept the crowed in an uproar with their antics."[29]

Once again, the highlight in the second year involved a large steer turned loose on the street—this time for the purpose of relieving him of the strap tied about his horns. The cowboy who accomplished this received ten dollars—a good reward, considering the show cost only twenty-five cents.[30]

The surprising discovery for those who know and love the show today is that several acts are now a century in the running, having begun in the first two years of the show: the quadrille, the use of a stagecoach, the singing quartet (although they originally were mounted cowboys), the Indian attack and pursuit of a man full of arrows, the bank robbery, the doctor amputation and the hotel fire.

The *East Oregonian* describes how whole families were rescued from the burning Stagger Inn and goes on to give a picture of the doctor amputation.

One of the comedy stunts which caught the fancy of the crowd was the surgical operation performed by the village doctor. One of the bad men having been shot, he was dragged on to a table, and, with saw and ax, the doctor amputated his legs at the knees. To the surprise and hysterical delight of the crowd, the patient jumped off the table and walked away on his stumps.[31]

The first man to play the part of the amputee was in reality a cattle buyer from Helix, Oregon, who had lost his legs at the knees in an accident.[32]

Next, the use of the stagecoach is described: "The street program will begin with the dashing up of the stage coach with the mail and the money for Spender's Bank where interest is charged on deposits."[33]

To add to the dance and gambling after the show, the Happy Canyon men put together a contraption called "shute the shutes" to simulate a bucking bronco experience. This proved to be extremely popular and was akin to the mechanical bulls we see during Round-Up week today.

To cap off the second year of Happy Canyon, a frontier wedding took place at the Saturday performance. But this would be no act—it was a real wedding on horseback.

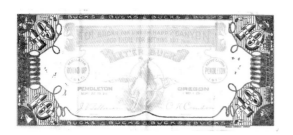

The 1915 Happy Canyon buck. *Author file.*

FRONTIER WEDDING AT HAPPY CANYON

Visitors at "Happy Canyon" Saturday night will see a frontier wedding on horseback and it will be no sham affair. On the other hand

it will be very real. The bride will be Miss Leota Dunnick and the groom Fred Dupuis. Both are from Weston and they are to be married "sure enough." All participants in the wedding will be on horseback and there will be a full list of attendants, including best men, bridesmaid and ushers. Music will be supplied by the band. The young people are popular at Weston and in honor of the occasion it is said the entire town will be here headed by Mayor P.T. Harbour and Col. Lucas. The wedding is set for 10 o'clock Saturday night and will be in addition to the regular "Happy Canyon" program.[34]

The wedding was the highlight of the last show in 1915. As the entire wedding party entered the gates on horseback and dressed in cowboy finery, the band struck up the wedding march. Even the reverend, J.E. Snyder, was on horseback, touting a large sombrero.

As the spotlight rested on the group, the wedding party rode the length of the "street" before turning to meet the minister in the middle. The ceremony was described by the *East Oregonian* as "striking and impressive." As the bride and groom rode out, five thousand show-goers pelted them with rice. In fact, the little Happy Canyon arena was so jammed with people, it was hard for all the acts to take place.[35]

The articles goes on to say, "Featured by the largest crowd of the four nights, by a cowboy wedding and by a grand climax of the "Let 'Er Buck" spirit, Happy Canyon ended the second year of its existence Saturday night in a burst of cowboy noise and a blaze of cowboy glory."[36]

As the Happy Canyon committeemen toasted themselves on two successful shows, they began to look ahead. What would this show involve in the future? What did they want it to look like?

The *East Oregonian* summed up the first two years by saying:

And the Happy Canyon! Well the Happy Canyon was all that it was intended to be, a sort of burlesque, the reproduction in miniature of an old frontier town with the lid off....The Happy Canyon has a place in the Round-Up. It takes care of the crowd during the evening and furnishes them amusement at little cost. Had it not been for Happy Canyon these four or five thousand people would have been turned loose on the streets.[37]

The big gamble had paid off. The show was deemed a growing success by both Pendleton and the businessmen who had taken a chance on a new community event. Even so, as the set was taken down, the tent over the dance floor rolled up and the props put away, the men of the Happy Canyon committee had no idea their pageant would be going strong an entire century later.

2

THE CREATIVE TEAM

When Roy Raley was admitted to the Oregon Bar…it is quite probable that the world of entertainment was deprived of a genius.[38]

Roy Raley was a showman at heart with a flair for the theatric. And he might have missed his calling. He only practiced law when he wasn't traveling, promoting Happy Canyon and Round-Up and producing shows around the Northwest.

It is hard to imagine Pendleton without its two great shows: Happy Canyon and Round-Up. These gifts from Roy's vision and innovation are something we all benefit from today. But what is the story behind "the father of Happy Canyon"?

James Roy Raley was born on July 10, 1880, to early Umatilla County pioneers Colonel James Henry Raley and Minerva "Minnie" Pruett Raley. Roy first attended school at the Pendleton Academy. He always went by "Roy" because his father had the same first name.

As a young man, he felt at ease with the theatric, performing a recitation of "The Polish Boy" at the Frazer Opera House and giving the salutatory when he graduated from Pendleton High School in 1895.

Roy chose to attend the University of Portland and later graduated from the School of Law at George Washington University in Washington, D.C., in 1904. At law school, he was known as a valued member of the winning debate team.

Upon returning to his beloved Pendleton, he entered into the law practice in his father's office and was named city attorney in 1910. Later, in 1926, Roy was elected as the Umatilla County Bar Association president.

Eventually, romance came to Roy when he met Eva Froome, a lovely Pendleton

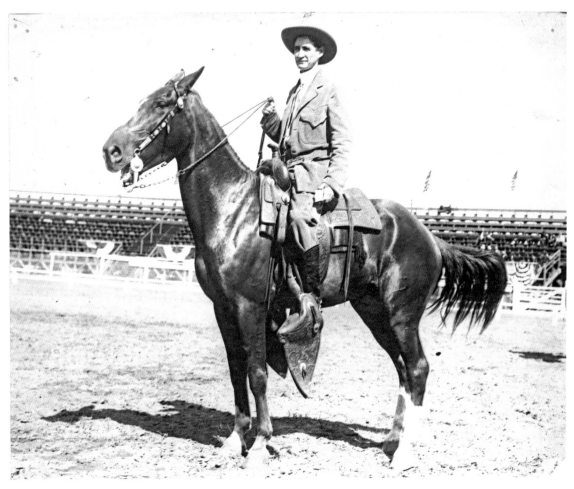

Above: Roy Raley in his famous saddle in the Round-Up Arena. *Raley family.*

Opposite: With a flair for the dramatic, Roy Raley stands on a friend's shoulders. *Raley family.*

schoolteacher. After a courtship period, the couple married in 1908 and had one son, James H. Raley, who served with distinction in World War II. Eva was known in Pendleton for her service to the community and received Pendleton's First Citizen Award in 1957. Sally Raley Grady, Roy and Eva's granddaughter, remembered how often her grandparents held hands and what a loving couple they were. Over the years, Roy and Eva enjoyed much travel together.

As an attorney, Roy became president of the Oregon Bar Association. In July 1954, he received a plaque from Oregon's Sixth Judicial District (Umatilla and Morrow Counties) on his fiftieth anniversary in law practice. The plaque

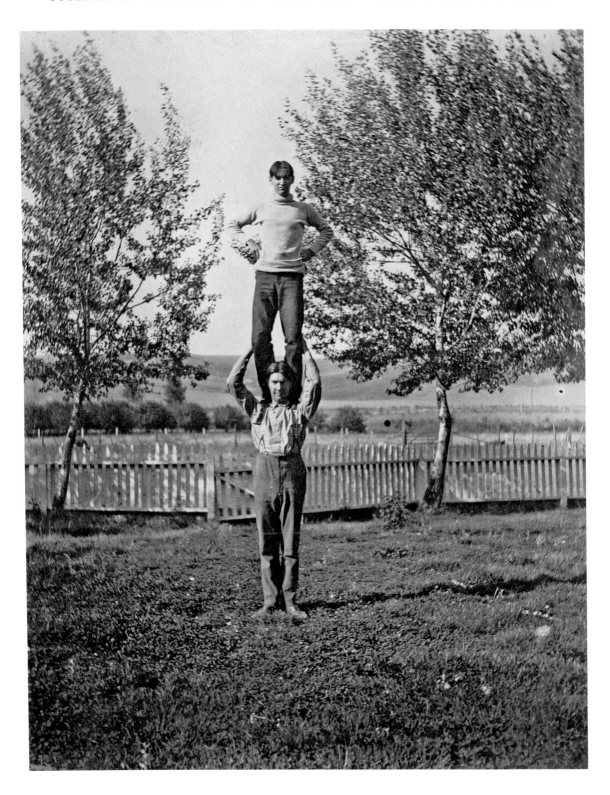

was inscribed in part: "Congratulations to Roy Raley…in recognition of his leadership as citizen and lawyer."

Later, Roy practiced law with John Kilkenny and with his own son, James H. Raley. They became the law firm of Raley & Raley, which is currently the offices of Mautz & O'Hanlon, LLC.

Aside from law, Roy contributed to Pendleton in a variety of ways. He was a founder and charter member of the Pendleton Rotary Club, which he helped begin in 1920, serving as its president in 1927. He was also one of the planners of the Pendleton Vert building, an original member of the Pendleton Foundation Trust and part of the Pendleton School Board for many years.

Yet the thing he loved best outside his family was creating great celebrations. He "made things happen" and enjoyed every minute of it. Because he did everything in a grand manner, Roy had earned the nickname "Prince" from the young men he knew. In fact, Roy could easily be called a showman by avocation.[39]

It began when Roy and a group of five Pendletonians met in a Portland restaurant in 1910 and conceived the idea for the world-famous Pendleton Round-Up. The Fourth of July bucking contest of 1909 had been the catalyst for their ideas. One of these five men was Lee Drake, who also helped conceive and support the Happy Canyon pageant and show idea. But Roy did not stop there.

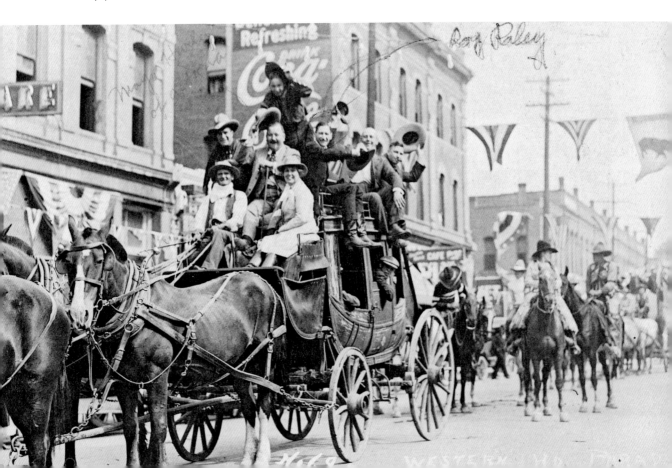

Above: Roy (bottom, with an unidentified friend above) entertained many times on his banjo. *Raley family*.

Opposite: Roy is the first hatless man on this stagecoach (possible Happy Canyon committee) in a Pendleton parade. *Raley family*.

THE FATHER OF HAPPY CANYON

Since Round-Up began, Roy had been thinking of a show with acts not conducive to rodeo. His chance to try it out came after the disappointing visit to the 1913 Umatilla-Morrow Fair. It's not difficult to imagine him at the fair with his friends George Hartman and Lee Drake, watching "Marvelous De Olney" (the human fly) perform, walking past the display of jams and jellies and seeing his chance.

Considered the main creative mind behind Happy Canyon, Roy receives the credit for developing the original plot, scenery and other details—all designed, as Roy was wont to say, "to complement the Round-Up by giving night entertainment to supplement the day." The men's original idea included the crowd participation in the "saloon"—the dancing, drinking and gambling that still have great appeal today.

Animals became a key component of the Happy Canyon pageant. Roy's love for animals was evident, as displayed in his decision to visit a zoo instead of a ballgame while in New York.

After the Happy Canyon men pronounced the 1914 and 1915 shows successes, Roy set out to take the show to the next level. It is not hard to imagine Roy working on the show script from the Tamarack Temple, the Raleys' Blue Mountain retreat.

This beautiful little cabin was the family escape to solitude and peace, where Roy's father, Colonel Raley, spent much time in his final years. In fact, it is purported that the colonel, with a big heart for returning World War I soldiers, picked up large numbers of them in Pendleton, transporting them to the

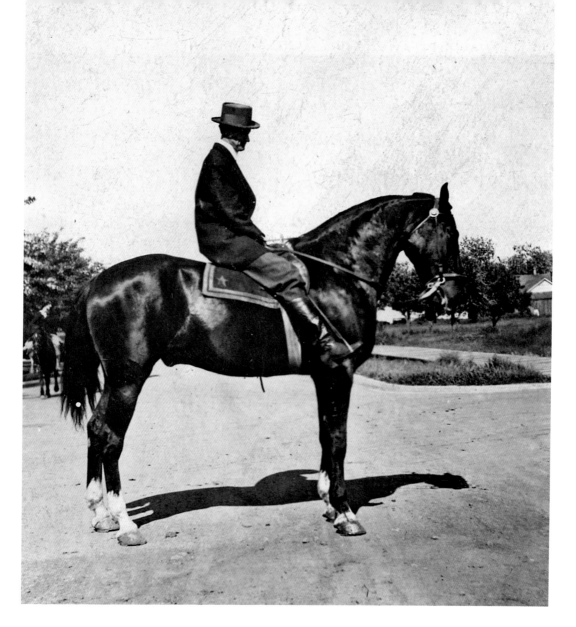

Tamarack Temple with libations and women to not only honor the men but also ease their hard transition home.[40]

It is safe to say that the Happy Canyon script and scenery ideas materialized over many discussions in the picturesque old cabin in front of a roaring fire in the stone fireplace. The colonel provided to Roy the true tales from firsthand knowledge of the Oregon Trail.

Colonel Raley had traveled along the Oregon Trail to Pendleton in 1862, settling in a log cabin where the Oregon State Correctional facility is now located, west of Pendleton. In fact, most of Umatilla County's history comes from the colonel's records of early days when the Raleys arrived in Pendleton.

During the Indian uprisings of 1878, the colonel was with the men killed at Willow

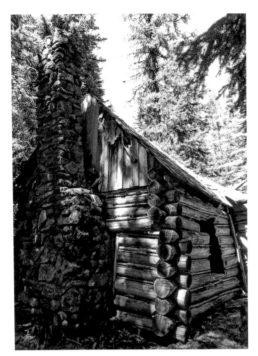

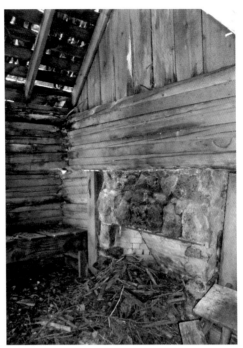

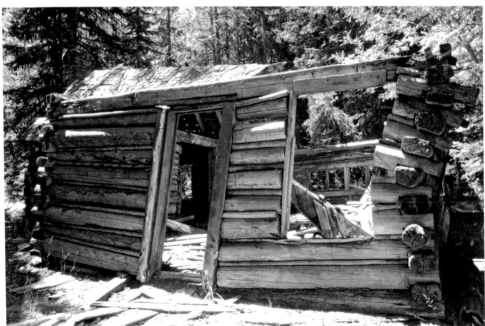

This page: Tamarack Temple in the Blue Mountain solitude, where some say Roy worked on the original script. *Photo by author*.

Opposite: Roy Raley and his prize horse. *Raley family*.

Springs and survived other hazardous adventures as a scout. He told Roy the stories of heading to the Byers' Mill, used as a fortification.

The colonel's lifelong belief was that the Indians were "more wronged than wrong."[41]

Roy's own mother, Minerva, had been in the group barricaded behind sacks of wheat and flour at Byers' Mill in Pendleton during the threat of Indian attack. A year later, she married the colonel in Portland, and they returned from Portland to Pendleton by riverboat and stagecoach.

From his rich family history, Roy easily envisioned and wrote the 1916 through 1923 scripts. Happy Canyon honors real-life stories from the true West.

The colonel had witnessed ox-team travel give way to stagecoaches, horses and buggies, railroads and, finally, automobiles and airplanes. But before his death in 1936, he watched in amazement as his son planned and directed this tribute to the Old West called Happy Canyon.

In fact, Hollywood studios approached Roy several times to buy Happy Canyon, but Roy loved this unique show based on his hometown and made sure it was protected, which led the board to copywriting the show.[42]

Between 1916 and 1917, Roy's honor and love for the Indian people brought him alongside Anna Minthorn Wannassay as he began adding the Indian portion to the script. He had many friendships among the local tribes, and Anna's insight, wisdom and vision helped him formulate the Indian sequences we now enjoy today. He directed the first several years of the show and served on the board until the early 1920s.

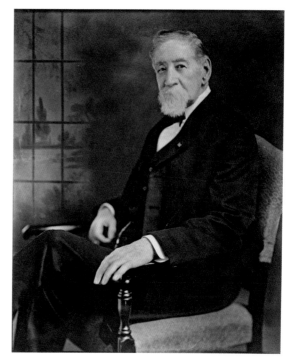

Colonel Raley, joint senator for Umatilla and Morrow Counties, judge and cattleman. Died in 1936 at the age of eighty-one. *Raphael Hoffman.*

One of his largest contributions to the show is the "transformation scene," as he called it, which is known today as the "change of scenery." This was designed and built at the second location in 1917 and was a crowd pleaser all on its own. As audiences watch the scenery change a century later, they continue to enjoy Roy's creativity.

When Roy wrote the Happy Canyon script, planned the scenery and directed the pageant, he did not consider such an undertaking a large task. He saw it as a labor of love for Pendleton and its history. It is safe to say not many would have taken on such an all-consuming mission.

Roy was ever full of creative show ideas and had the opportunity to enact them. He was selected in 1915 to help stage a summer Wild West show in Los Angeles, which included cowboy contests, bucking horses and parades. Roy had helped the two previous years and expected the 1915 rodeo to be a huge affair.

The Portland Rose Festival noticed Roy's talents and chose him as their first general manager in 1925. He was also entrusted with the June pageant, entitled "Rosaria," as the first professional producer ever hired for the celebration. This production was three times the size of any he had produced in the past. This spread his reputation as a show director throughout the Northwest.

Next, he staged the "Trail-to-Rail" Celebration pageant at Eugene in August 1926, which commemorated completion of the Southern Pacific's new Cascade line between Portland via Klamath Falls and Eugene. This pageant depicted the evolution of travel from the days of the Indians to 1926. It was considered a brilliant show by many and described as "the most elaborate ever produced in Oregon," featuring three thousand performers.[43]

Roy Raley and Pendleton Parks

We can also thank Roy for the number of Pendleton's city parks, though most people do not know how Happy Canyon fits into this story.

One of Roy's goals was to set aside a fund each year to benefit Pendleton's park system. Roy had persuaded the Happy Canyon board (formed in 1916 upon incorporation) to designate a certain amount of Happy Canyon's revenue for "the acquisition, development and improvements of parks and playground property."[44]

When Happy Canyon voted in 1927 to contribute $2,700 from the profits of the 1927 Happy Canyon pageant for park and playground improvements, the park commission of Pendleton received the start it needed. These funds, generously given by Happy Canyon, enabled Pendleton to construct and maintain its many parks.

By 1940, an ongoing agreement stated, "One half of the net profits from the Happy Canyon Show, as produced in Happy Canyon Arena is to be paid to the Pendleton Public Parks Commission."[45]

In 1928, a controversy arose regarding the ownership and rights to Happy Canyon. Roy claimed ownership of the show and "leased" it to the Happy Canyon Company for $100 a year.

Jim Sturgis, a former Happy Canyon board member and Roy's good friend, was interviewed in 1975, and he claimed Roy gave the royalties to the Pendleton park system. The board continued to give Roy a royalty until his death.

Because of Roy's foresight, for many years, Pendleton was the premier city in Oregon for the number of its parks and their sizes. It is not hard to imagine the need for trees and grass in Pendleton's hot, dry and dusty summers. Thus, Roy is considered the father of Pendleton's park system and served for many years as the city parks commission chairman.[46]

Many times, Roy could be found planting flowers or shrubs in those parks he helped to

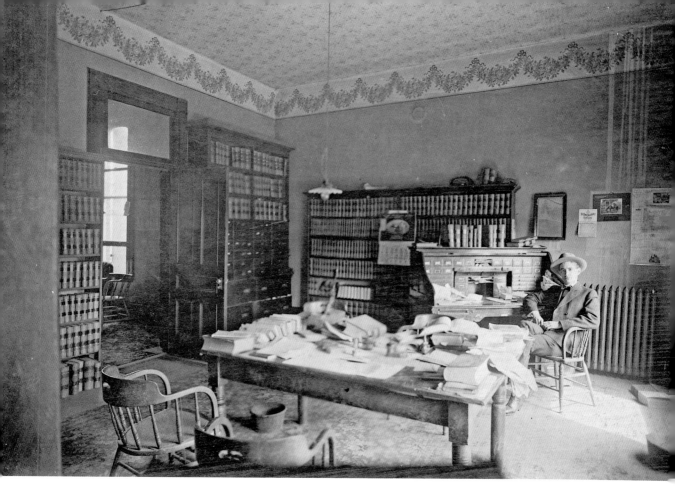

Roy Raley in his office at home. *Raley family.*

establish, such as Til Taylor Park, Minnie Stillman Park and Round-Up Park, including the natural amphitheater (what became the Roy Raley Park after Roy's death).

Apparently, Roy had a thing for green grass. Alongside E.B. Aldrich, he worked hard to get the turf on the big arena at Round-Up. Later, the Happy Canyon board considered adding turf to the current location of the Happy Canyon Arena. The cast who fall to the ground in various acts are thankful to land on sawdust instead!

Roy's vision and hard work have left us with a beautified city. But we can also thank Happy Canyon for setting aside funds to develop the Pendleton Park System we enjoy today.

The Idea Man

Roy remained involved with Happy Canyon for the rest of his life. In fact, as the Happy Canyon board made plans to move the arena and scenery to a new location in the early 1950s, Roy felt he had a logical solution. Ever a visionary, Roy had found a "perfect location" on Pendleton's North Hill, which formed a natural amphitheater.

Roy repeatedly asked the board to consider his vision of a grandstand and arena, as well as a museum for Indian and pioneer artifacts to

preserve the history he so loved. The motives for passing over this location are unclear. Regardless, the current location of the event's arena, built with funds from the city, state and federal levels, is next to Round-Up and the Indian village.

Due to a long illness, Roy passed away in February 1956 at the age of seventy-five—unfortunately, without seeing the Happy Canyon pageant in its new location. Because of his history of beginning and growing Pendleton's park system, the city renamed Round-Up Park—a site that had been considered for the show's permanent home—in memory of Roy.

Upon the dedication of Roy Raley Memorial Park, John F. Kilkenny, former Happy Canyon president, said:

> *It has been said that a community's greatness is measured by the public service of its citizens. Pendleton's place is in no small measure due to the tireless efforts and uncompromising loyalty of the man whom we honor. His spectacular and outstanding record of public service, his ready smile and friendly approach are now safe in the keeping of the public which he honored and who loved and honored him so much.*[47]

Roy's achievements as a lawyer in Pendleton are many, but his heart's devotion was at Round-Up and Happy Canyon. Fittingly, Roy was one of the first recipients of the Pendleton Round-Up and Happy Canyon Hall of Fame award. He was a man of rare vision with the ability to execute creative plans in detail.

His son, James Raley—also a Pendleton attorney—passed away in 1967, and James's

Roy Raley in his later years. *Hall of Fame Collection.*

wife, Beverly Raley Gantz, followed in 2010. James and Beverly had three daughters: Tiah Raley Lawrence, Sally Raley Brady and Mary Raley Shelton. Tiah passed away in The Dalles in 2007. Roy is also survived by numerous great-grandchildren.

Sally fondly remembers her grandfather as a gentleman. "He always tipped his hat to every lady he saw and he was always willing to help others," she said.

Roy loved his hometown deeply, and we can thank him for all the gifts he left to each one of

us, including Happy Canyon. On the occasion of his fiftieth anniversary as a lawyer, the *East Oregonian* honored him by saying: "Pendleton owes him so very much."[48]

This man with a true pioneer spirit, foresight and ingenuity left us with a great tradition.

Anna Minthorn Wannassay

Born in 1886, Anna Minthorn Wannassay was a woman ahead of her time. She grew up on a farm in the northern part of the Umatilla Indian Reservation.

She was born Anna Kash Kash, but when the reservation was allotted, her parents became registered as the Phillip Minthorns. Phillip Minthorn was a brother to Sarah Minthorn, the fifteen-year-old pupil of Marcus and Narcissa Whitman at Waiilatpu. Sarah and Phillip's father was Chief Yellow Hawk (Petamyo-mox-mox), chief of the Cayuse and a treaty signer. Anna's name thus became Anna Minthorn.

Encouraged by her parents to seek higher education, Anna was educated in Pennsylvania at the Carlisle Institute. Adapting to the cold, harsh winters was difficult for Anna. She described those winters to her granddaughter Mitzi Rodriguez as "bitter cold." In the beginning of her time in Pennsylvania, Anna went through bouts of loneliness, infrequent mail and holidays without her family.

Soon Anna adapted to the cold and found companionship with new friends. During her years at the Carlisle Institute, she was a classmate of fellow Cayuse William O. Jones, who became a Round-Up cochief, and athlete

Jim Thorpe. She enjoyed telling stories of watching Jim play football.

After graduating from the Carlisle Institute in 1906, she became ill with a high fever on her way home. Anna ended up in Oklahoma under the care of the famed Quanah Parker. While Quanah was tending her in his home, Anna went deaf in one ear as a result of the illness. Anna was forever grateful for Quanah's hospitality and care in a time when she was far from home and needing help.

Back home in Pendleton, Anna began using her education and gift of leadership for the tribes. As the granddaughter of Chief Yellow Hawk, who was a leader in tribal affairs, Anna also learned the wisdom of governing and leadership. When the constitution governing the tribes was formed in 1949, Anna was one of the first members on the board of trustees, lending her insight to the construction of the constitution and bylaws of the confederation.

Anna also served on the Tutuilla Presbyterian Church trustee board for several years. She became a charter member of the Oregon Trail Women's Club, the only federated club in the United States with all Indian women members. This group even met at her home.

Many of Anna's people sought her advice and wisdom, often at her home, especially in regard to reservation matters.

Being tiny in stature yet big in heart, she raised not only her own family but also some of her grandchildren and her one great-

Anna with her granddaughter Mitzi Rodriguez. *Mitzi Rodriguez.*

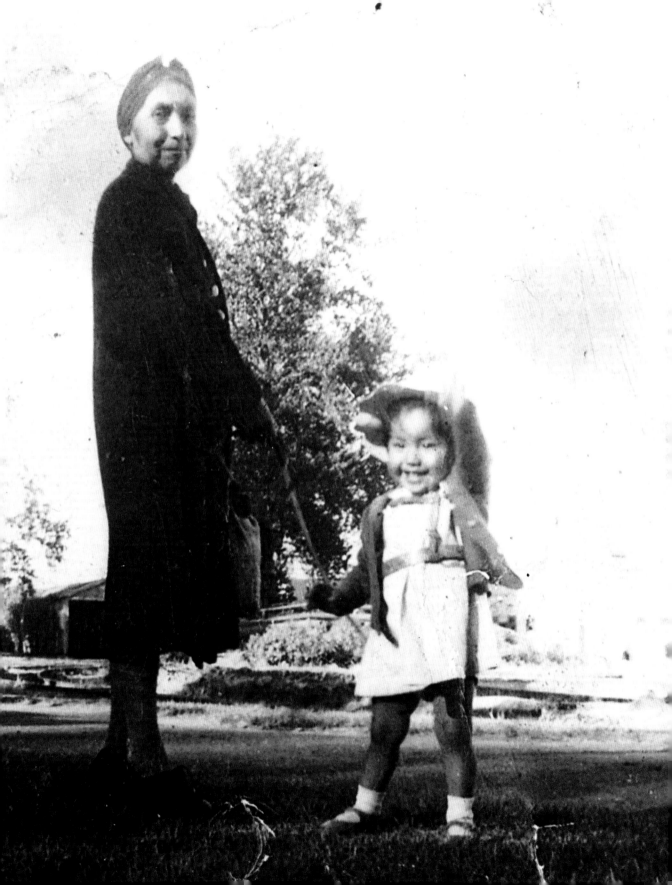

grandchild. She is remembered by tribal members for driving a little red pickup, though she was barely tall enough to peek through the steering wheel to see the road.

Anna's granddaughter Mitzi was one of the grandchildren Anna raised in the old, two-story green house at the Mission Market intersection. Mitzi remembers the stacks of magazines and the constant hunt for books at secondhand stores. Not only did Anna have an extensive library, but she also taught Mitzi the love of learning through reading, especially history.

Anna taught Mitzi and her family the importance of family and tradition. Mitzi can remember her grandmother putting her on the Round-Up and Happy Canyon floats at an early age.

Her grandmother also believed in civic involvement. "We were always going and always involved," Mitzi said. "We had people to see and places to go. Life was meant to be lived." Anna never stopped giving to her community and being active.

After moving the show location in 1916, Roy envisioned adding an Indian portion to the script. Roy saw in his mind's eye the significance of reenacting Indian life before non-Indian explorers came west and wagon trains passed into eastern Oregon.

The key figure he turned to was Anna, of course, and together they wrote the tribal life scenes from the Columbia River Plateau Indians, who inhabited the area hundreds of years before non-Indians appeared. The show's preservation of the unique heritage and the life of the local tribes before pioneers arrived is unequaled anywhere in the United States.

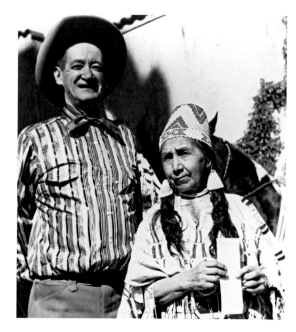

Above: Roy and Anna, who were friends their entire lives. *Opposite, left*: Anna as a young woman; *opposite, right*: Anna with an Indian Beauty Contest winner. *Howdyshell Collection*.

Anna's love and understanding of history, combined with her need to see Indian life preserved, gives us the beauty of our script today. While at Carlisle, Anna had also participated in dramatic arts. This skill came to fruition as she worked with Roy. The 1917 script was a result of their collaboration and became Anna's gift for tribal history, legend and lore. Anna felt the Indians did not need to be stereotyped.

The added tribal scenes delighted the audience after the first performance in 1917, as summed up by the *East Oregonian*:

All that was promised for the Happy Canyon entertainment of 1917 was justified by the performance of last evening. It was truly a

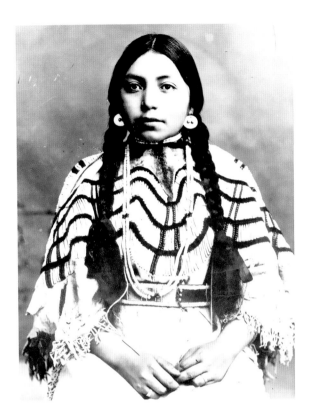

big show and some of the effects fell little short of wonderful. Nothing has ever been done in the making of previous Happy Canyons on the scale of the show this year. Both in scenery and in action.[49]

Even though the 1917 scripted parts for the local tribes began more simply, Anna and Roy continued developing the pageant portion of the script. They added the traditional way of life, such as deer hunts, women working hides, berry harvests, root digging, fishing, grinding foods and the beauty of a wedding gathering with its tradition of trade between the groom's and bride's families. By 1923, the Indian part was developed, elaborately displaying true

Indian life here in eastern Oregon before the non-Indians arrived.

Together, Roy and Anna helped preserve history.

Roy and Anna remained good friends for the rest of their lives. Roy's granddaughter Sally Raley Brady remembers visiting Anna at her teepee with her grandfather every Round-Up before he passed away. Sally can vividly remember sitting in the canvas shade listening to Roy and Anna catch up and reminisce about days of old.

Conversely, Mitzi fondly remembers the trips with her grandmother to the Raley house in Pendleton, where Anna visited Roy for advice and legal help. Mitzi remembers Roy as a kind

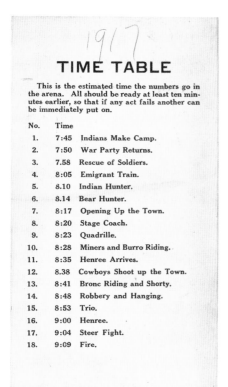

1917

TIME TABLE

This is the estimated time the numbers go in the arena. All should be ready at least ten minutes earlier, so that if any act fails another can be immediately put on.

No.	Time	
1.	7:45	Indians Make Camp.
2.	7:50	War Party Returns.
3.	7.58	Rescue of Soldiers.
4.	8:05	Emigrant Train.
5.	8.10	Indian Hunter.
6.	8.14	Bear Hunter.
7.	8:17	Opening Up the Town.
8.	8:20	Stage Coach.
9.	8:23	Quadrille.
10.	8:28	Miners and Burro Riding.
11.	8:35	Henree Arrives.
12.	8.38	Cowboys Shoot up the Town.
13.	8:41	Bronc Riding and Shorty.
14.	8:48	Robbery and Hanging.
15.	8:53	Trio.
16.	9:00	Henree.
17.	9:04	Steer Fight.
18.	9:09	Fire.

PROGRAM. 1923

7.20-7.30	Overture.
7.30-7.35	Dance of Fairies.
7.35-7.38	Indian Maid in Canoe
	a. Miss Leach soloist
7.38- 7.45	Indians make Camp.
	a. Vanishing race
	b. Motanic-Blakely dance.
7.45-7.57	Return of War Party.
	a. Captive
	b. Indian burial (omitted)
7.45-7.57	Rescue
	a. Scout & Frontiersmen
	b. Cowboy Funeral.
8.03-8.18	Emmigrants.
	a. Oxen & horse teams.
	b. Ordeman male soloist
	c. Indian Hunter
	d. Doctor.
	** CAVALRY*
8.18-8.23	CHANGE OF SCENERY.
	a. Tumblers
	b. Characters...chinks -sheriff -etc
8.23-8.26	Stage Coach arrives.
	a. Swimming kids
	b. Shorty Stunt
	(1)Doctor
8.26-8.32	Male quartet.
	a. Sheriff
	b. Burley guard
8.32-8.37	Quadrille
8.37-8.40	1. ROPER
	2. MINER & BURROES
	3. MINER'S CHORUS
8.40-8.42	Bank robbery.
	a. Twitchell
	b. 3 Frontiersmen.
	c Sheriff
8.42-8.47	Lady Soloist.
8.47-8.57	1.Cab with souse
	2. Sucker
	3. Chinks
	4. Hick band
8.57-9.00	FINALE

NOTE... when show runs smooth this can be run in from 15 to 20 minutes less than scheduled.

Left: A 1917 Happy Canyon cue card. *Raley family.*

Right: The 1923 Happy Canyon script. *Happy Canyon Collection.*

Opposite, top: Mitzi Rodriguez, before the 2015 show, with her grandchildren— Anna Minthorn Wannassay's great-great-grandchildren. *Eye of Rie.*

Opposite, bottom: Mitzi leads the welcome dance in the show for Lewis and Clark. *Eye of Rie.*

and soft-spoken gentleman. Sitting on the porch of the Raley house, Mitzi and Sally, Roy's granddaughter, had no idea of the legacy and history Roy and Anna were making together.

In 1923, when Roy thought up the Indian Beauty Contest, which is still held annually before the Westward Ho! Parade, he turned again to Anna for contest parameters and for her participation in the event. For years afterward, she signed up the girls and assisted with the competition as part of her job.

In later years, her granddaughter Mitzi continued in her place. Anna was known for wearing the basket hat. The basket hat, unique to the area and worn upside down, is especially made for Indian maidens as they

enter adulthood, and it stays in the family. Today, Mitzi wears this piece of heirloom regalia in Happy Canyon, proudly leading the welcome dance for the Lewis and Clark scene, remembering Anna and the legacy she left.

In 1966, at the age of seventy-nine, Anna received the Outstanding Indian award (one of several awards), which is given to a participant in the Westward Ho! Parade each year. The word "outstanding" barely begins to describe this unique woman.

Anna died in 1972 at the age of eighty-six, leaving the history of a kind-hearted woman of wisdom who contributed to the success of Happy Canyon. Her work is forever felt by thousands who have witnessed the authentic

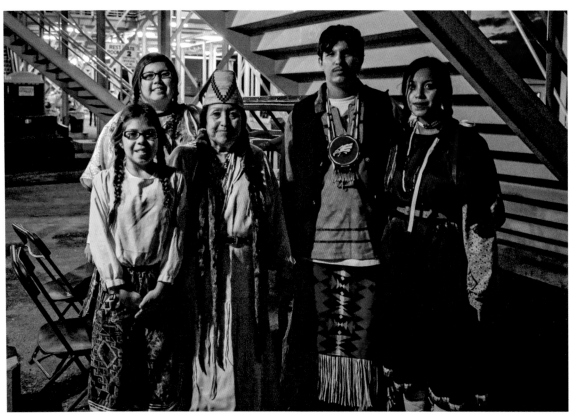

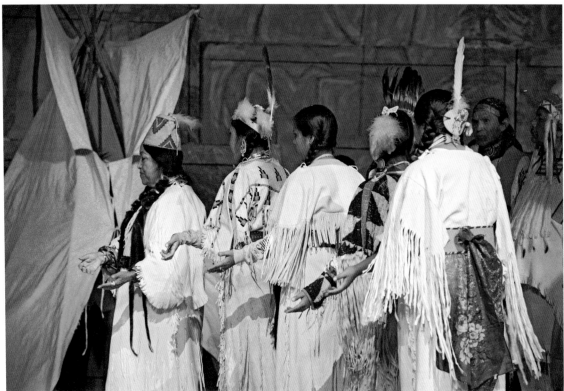

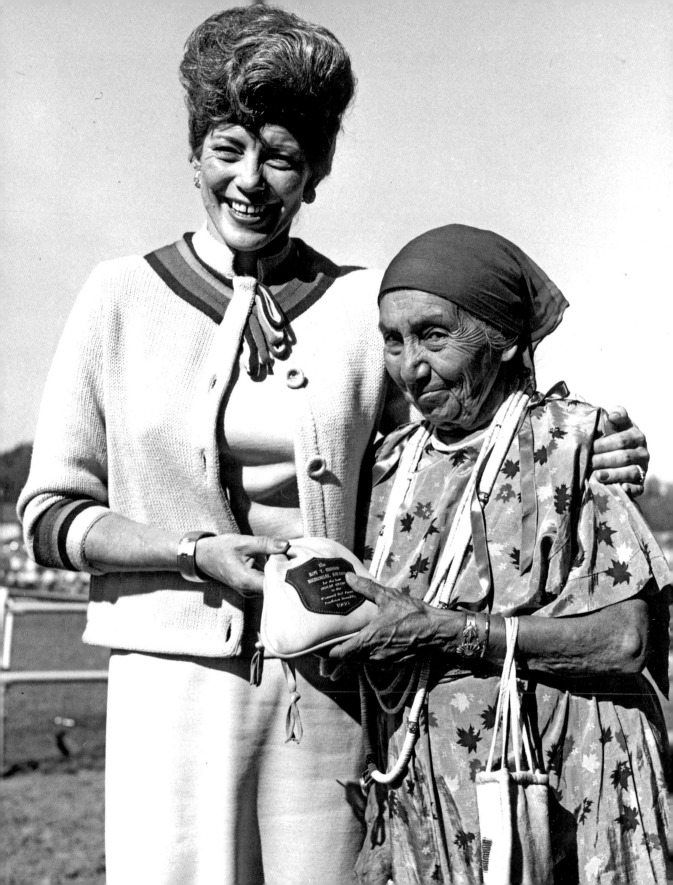

Columbia plateau Indian village life not seen anywhere else in the world. Today, three of Anna's grandnieces have been Happy Canyon royalty (Anna Minthorn, Michelle Spencer and Talia Minthorn).

Raised by this extraordinary woman, Mitzi still speaks of her with warmth, humor and awe. To her, walking in her grandmother's shoes is an honor.

Currently, several of Anna's great-great-grandchildren, the fifth generation of Anna's family, act in the Happy Canyon pageant. Anna's legacy continues through her family, the script she helped write and the beloved history she helped preserve through a one-hundred-year old pageant called Happy Canyon.

Together, Roy and Anna formed the unique creative team of Happy Canyon—or, as the Indians called it, *Sapatq'ayn* (sha-pot-kain) in Nez Perce and *ša-pát-ḱi* in Umatilla, which both translate as "the Show."

Above: A 1916 full-page *East Oregonian* ad for the "new" Happy Canyon location. *From the* East Oregonian.

Opposite: Anna (right) and Doris Bounds. *Photo by Howdyshell; courtesy of Hall of Fame Collection.*

THE EARLY YEARS
AT THE "OLD CANYON"

1916-1954

The show started as a way of entertaining visitors who were in Pendleton for the Round-Up. It has evolved into a pageant highlighting Indian life and culture along with some of the fun and hi-jinks of the frontier West.[50]

What was next for the hit show? Its growing success left the Happy Canyon organizers with several critical questions: Do they continue and, if so, where should the show go on? The *East Oregonian* reported in 1916:

Yes, there will be a Happy Canyon!

In answer to the many queries made both locally and from a distance, the Commercial Association last evening formally decided that the institution, which for the past two years has provided evening entertainment for Round-Up crowds, will be retained as one of the big features of the Round-Up week of 1916.[51]

As the *East Oregonian* noted, Happy Canyon would continue, but the location was still uncertain. After the first two years, the show's organizers saw the need for a permanent structure. The show had outgrown the first location, and rebuilding parts of the venue, including a canvas-covered dance/gambling area, was not cost effective for the Happy Canyon board.

In the search for a new venue, they agreed to purchase a building known as the Oregon Feed Yard from J.A. Potter and to lease the grounds of the Northern Pacific Railroad. Currently, this location is used by the Baxter Auto Parts/ Western Auto on Southwest Emigrant and Southwest Third Streets.

At this site, C.A. Lansdowne of Spokane, Washington, built a new structure utilizing

some of the older buildings and funds from bank loans and public subscription.

The last nail was driven in when the 1916 show opened to a sellout crowd, according to the *East Oregonian*. The tickets were fifty cents for adults and twenty-five cents for children.

After the 1914 and 1915 shows, which mainly featured the Wild West scenes, Roy Raley began expanding the already popular act sequence. In 1916, the improved location and scenery allowed Roy to practice more creativity as he and his fellow directors built on the old show script. What resulted was the backbone of the pageant we know and love today.

Roy and Anna Minthorn Wannassay scripted the Indian village acts for the 1917 show. These included the addition of the Indian camp, the war party, the rescue of soldiers and the emigrant train. It was over the next five years that Roy and Anna added the sequence we watch today. By 1923, the script was fully developed and included much of the current pageant.

"Raley called on many of his friends among the Umatilla Indians for plotting the Indian portion of the show," the *East Oregonian* reported. "Such persons as Johnson Chapman, Willie Wocatsie, Fred Dickson, Marcas McKay, Dick Johnson, Jim White, and Gilbert Minthorn brought their families, their horses and living equipment to the stage to enact the first scenes before a painted backdrop that was set up on the roof of the old feed yard building."[52]

On the first night of the 1916 show, the *East Oregonian* reported:

Happy Canyon, wildest of all wild and wooly towns, opened the third year of its exciting history last evening in the new pavilion to which it had been transplanted. Between 2500 and 4000 were present. At the conclusion of the program at 9:30, the crowed swarmed into the Red Dog Saloon and Gambling Palace and the Happy Canyon dance hall in numbers that taxed the capacity of those fun resorts. The wildest and most exciting feature of the preliminary street program was the fighting steer turned loose as the last act before the opening of the indoor sports. The steer was wild and fighting mad.[53]

This crazy steer was the highpoint of the 1916 show. The steers in those early years were much larger than the roping steers you see in the Round-Up arena today, standing at least a foot taller with horns much thicker and wider. The *East Oregonian* article described how six cowboys with red serapes drove the steer even wilder.

In fact, the 1914 and 1915 Happy Canyon steers were tame compared to "the long horned brute that chased cowboys in all directions." He was let loose as the closing act, with a leather strap around his neck. Cowboys tried to catch and wrestle him. Some, such as Frank McCarroll of Boise, Idaho, managed the job, which was worth "a real greenback."[54]

For several years, gutsy cowboys on foot tried to bulldog this steer after he was turned loose. Even Charles Furlong, author of *Let 'Er Buck*, volunteered also right out of the crowd one September night of the show, though without success. Show participants would dive into the nearest bar or false-front door in dead earnest while the cowboys taunted the long horn. Because too many were injured, the act was eventually dropped.

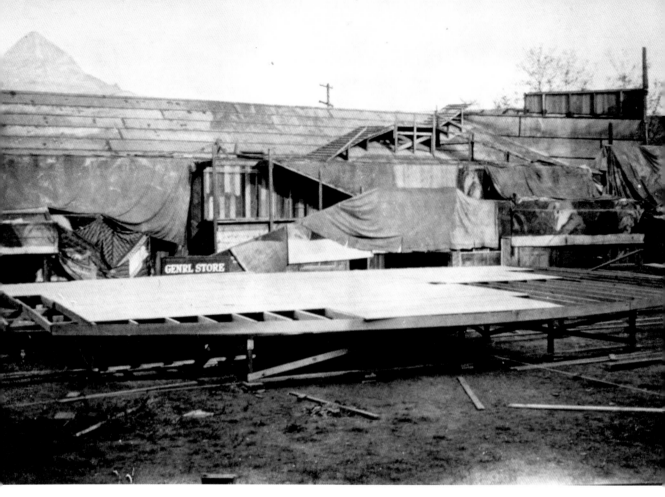

GENRL STORE

A rare photo of the second Happy Canyon construction, 1916. *Wayne Low collection.*

The 1916 show also featured a dance of wood nymphs on the "forest roof," led by Mrs. James Sturgis, a director of folk dancing. This consisted of high school dancers dressed in red gowns. As the spotlight illuminated the upper scenery near the beginning of the show, each girl rose from behind a rock, "dancing airily about as if they were wood sprites in very truth." One girl dressed in white even performed a solo. It was definitely 1916—a different time.[55]

The 1916 cue card also lists "Diving Girls"— or, as they were promoted in the newspaper, the diving "mermaids and mermen." The painted cliff, rising straight from the edge of the "pond" dug into the ground, became the platform for the divers, who had come from Portland.

The *East Oregonian* lists this Multnomah Aquatic Diving Team: Mrs. Constance Meyers, twice national champion; Helen Hicks; Thelma Payne; Billie Royal; and Brownie Webster. Miss Royal happened to be a Portland police detective, and the article states she would be "sleuthing" while in Pendleton. Duty and fun all in one.[56]

These old acts receive more color through Roy Raley's reminisces in his undated diary:

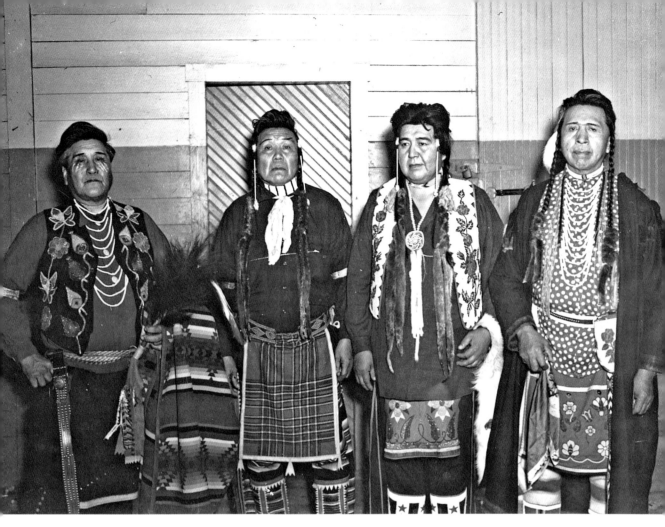

Tribal headmen and key figures in the early show (left to right): Gilbert Minthorn, Willie Wocatsie, Clarence Burke and Allen Patawa. *Howdyshell Collection.*

When I was quite a kid I was deeply interested in the accounts of the New York Hippodrome Water Ballet. This was written up in the magazines as a remarkable production in which the girls marched down into the water and never came up. I never got to see it but worked out a solution in my own mind by comparing it to a teapot.

Then in working on Happy Canyon it was simple to have the Indian shot on the cliff fall into the pool and dove back out of the spout of the teapot. By building the scenery between the pool and the spout, it was easy to mask the "sneak" getaway.

The first pool was built of wood with a heavy canvas lining. This is the way temporary pools are built at fairs and expositions. I found however to dive in the water pressure became too great and it would not hold the water. It was necessary to keep the fire hose running in it in order to keep it full.

I had arranged for a troupe of divers to come to help in the first Happy Canyon [at the new location] *and while they did their*

HAPPY CANYON
1916
Program

No.	Starts	Time	Act
1	7.50	10	Bucking Burros
1	8.	3	Stage Coach
2	8.03	5	Quadrille
3	8.08	3	Entrance Characters
4	8.11	5	Bucking Horse
5	8.16	4	Indian Fight
6	8.20	9	Song and Trained Horse
7	8.29	1	Drag the Chinaman
8	8.30	5	Pulmotor stunt
9	8.35	10	Diving Girls
10	8.45	3	Bucking Bulls
11	8.48	8	Trio
12	8.56	10	Ballet
13	9.06	4	Coon Dance
14	9.10	6	Steer Fight.

Above, left: A 1916 Happy Canyon cue card. *Raley family.*

Above, right: Pool in the Old Canyon. Notice the women's dresses. *Umatilla County Historical Society.*

Left: Roy Raley's original pool design drawing for the Old Canyon. *Raley family.*

stuff they were not too happy to perform in the very cold water which was coming directly in a strong stream from the fire hose.[57]

The newspaper summed up the 1916 show by stating, "The third annual Happy Canyon was a big success, both as an entertainment for the Round-Up crowds during the evening and a self-supporting institution.…[V]isitors and many hundreds were turned away during the last two nights."[58]

THIRTY-EIGHT YEARS AT THE OLD CANYON

We can imagine the early years and listen intently to the stories, but the desire to see it for ourselves is ever present—to see the Indians, wagons, cowboys and cowgirls parading down from the Round-Up grounds through Pendleton streets every night, to feel the intimacy of the old arena and the actors themselves, many of whom had lived the very scenes they were enacting. These were the glory years of Happy Canyon at the "Old Canyon" (the term used by locals and those who volunteered in this second location from 1916 to 1954).

The next year, in 1917, Roy turned to his next project for the show: making the new scenery embody the local area. This project was named the "transformation scene." In the original production, the show starts with a setting of the high basalt cliffs of the region with teepees in the foreground. For the transformation scene, Roy created a late 1800s town backdrop to show the coming of the white frontiersmen and pioneers.

The set "transformation" was so popular that several hundred spectators attended rehearsals to watch as the "rocky cliffs gave way to store fronts. The transformation was so complete that even the splash of a mountain stream gave way to the churning of a mill wheel."[59]

Aurelia Shippentower remembered 1917, the year she started in the show, like yesterday. She recalled riding horses from the encampment to the Baxter Auto Parts location and later traveling in the trucks used for non-rider transportation. "It was fun going down Main Street and waving to all the people," she said. "I've always enjoyed Happy Canyon."[60]

In 1918, the *East Oregonian* announced: "Happy Canyon Lid Off and There Is No Limit but the Sky."[61] The show began with the Indians carrying Emerald Greenwald, a young boy who was dressed as a maiden. This led into the crowd-favorite rescue scene, where the scout releases the "maiden" and the two flee along the mountain trail, leaping into the pool below.

An Indian "fire burial" was included beginning in 1918 and continued through 1923, evolving into what we watch as the medicine man scene. Unfortunately, little is known about the "fire burial" sequence.

Afterward, the pioneer scene included tent pitching and campfires. A chorus of nineteen sang, "When You and I Were Young, Maggie," and a talented baritone, Tom Ordemann, sang, "A Long, Long Trail a-Winding."

Opposite: Roy Raley's 1917 "transformation scene," showing the church before and after. *Raley family.*

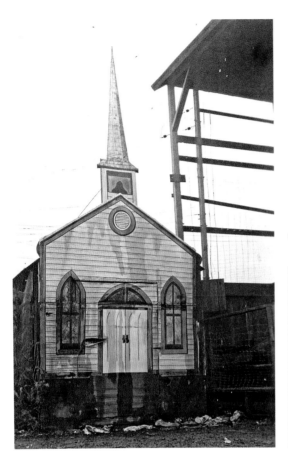

Later, Miss Irmalee Campbell sang "Belgian Rose" on horseback, accompanied by the Milton-Freewater Band. The script also included bucking burros, ponies and horses, as well as the famous steer dogging.

The show grew in popularity and success—so much so that in 1917 and 1918, the Happy Canyon board encouraged the hometown crowd to stay home and allow the out-of-town guests seating. This led the 1919 board of directors to sell the seats to permanent ticket holders. The day the tickets went on sale, a crowd formed a long line at the Alta Street ticket booth to claim seats. By 2:00 p.m., the middle sections reserved for presale had sold out.

As Roy and Anna were first working through the village sequences, they were devoted to authenticity. For example, the 1919 show included smoke pots brought in from San Francisco to create realistic smoke floating out of the teepees.

The 1919 Happy Canyon also featured the "Dance of Victory" by young men from the Cayuse, Umatilla and Walla Walla tribes. The older men taught this dance to the younger tribal members since it had not been danced

OPENS TONIHGT

Wonderful Transformation Scene Patriotic Finale

Indians, Cowboys, Real Bears, Bucking Horses,
everything savoring of Frontier Town

Let 'er Buck Dance and Red Dog Saloon

CAMP LEWIS MILITARY BAND WILL BE THERE

Opens 7:00
Program at 8:00
Dance 9:00 **HAPPY CANYON**

Left: A 1918 *East Oregonian* "transformation scene" ad. Notice the typo. *From the* East Oregonian.

Below: Pioneers setting up camp in the Old Canyon. *Photo by W.S. Bowman; courtesy of Howdyshell Collection.*

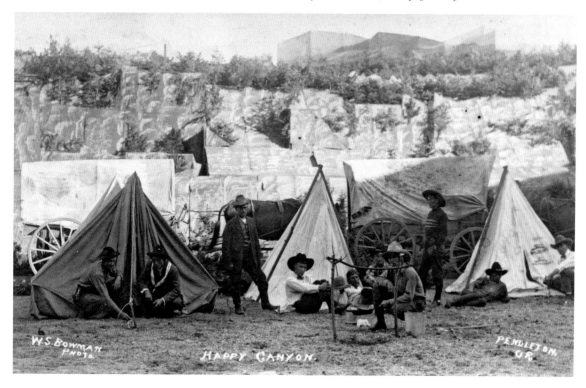

for an entire generation. This was a highly anticipated event for the 1919 show, since it celebrated the return of the Indian boys from Umatilla County who had fought bravely for freedom overseas in World War I.[62]

Chief Tall Pine, a non-Indian, performed in the show for years, using a real rattlesnake in one of his most famous acts, the "Wild Snake Dance." In 1921, the rattlesnake struck the "chief," but the thickness of his leather gloves saved him from serious injury. Needless to say, this dance is no longer performed.[63]

Bucking horses and bulldogged steers still performed in Happy Canyon in the 1920s, but it

1918 Time Table

This is the estimated time the numbers go in the arena. All should be ready at least ten minutes earlier, so that if any act fails another can be immediately put on.

No.	Time	
1.	8:00	Indians Make Camp.
2.	8:05	War Party Returns.
3.	8:13	Fire Burial.
4.	8:15	Rescue by Soldiers.
5.	8:22	Emigrant Train.
6.	8:25	Songs.
7.	8:30	Indians and Shorty.
8.	8.34	Bears.
9.	8:37	Change of Scenery.
10.	8:38	Stage Coach.
11.	8:42	Quadrille.
12.	8:46	Miners Arrive Also Cowboys.
13.	8:48	Miss Campbell.
14.	8:53	Henry Arrives.
15.	8:56	Shooting up the Town.
16.	8:58	Chinese.
17.	9:01	Bucking Horses and Burros.
18.	9:08	Robbery.
19.	9:12	Rescusitation of Henry.
20.	9:16	Steer Fight.
21	9:20	Finale.

Happy Canyon Directors

President...................................James Johns, Jr.
Secretary...................................Claude I. Barr

Music— Bert Jerard	Scenery Thos. F. Murphy
Bar— J. A. Murray	Grounds and Equipment James B. Welch
Games— Harvey Hanavan	Indians— Glen Storie
Bank— James R. Bowler	Characters and Costumes—
Dance— Sprague Carter	Elmer Storie
Tickets— Rudy M. Mollner	Arena Director— Philo H. Rounds

LET 'ER BUCK

Presented by the
Pendleton Commercial Association

Happy Canyon

HAPPY CANYON is an institution whose purpose is to help you live again the days gone by.

We ask you to view it not as a complete connected story but rather as an historical pageant—a series of scenes constructed to recall the different steps necessary to the "Winning of the West."

1923

SYNOPSIS

I. Long, Long ago in the mountains the fairies played and danced.

II. Then came the Red Man. These mountains, rivers and plains were his playground. Around his campfire he recited the deeds of his forefathers, performed ceremonials to his Gods and danced his dances of sadness and gladness.

III. The White Man came—first the frontiersman, who clashed with the Indians. Eventually his coming meant the passing of the Red Man. There was no further west; he had come to "The end of the trail."

IV. Westward the Course of Empire takes its way.

The long emigrant train appears — the covered wagon brought civilization.

SYNOPSIS

V. The trading post and frontier town— the day of the pony express, the stage-coach, saloon and dancehall, where the cowboy mixed business with pleasure—a rustic civilization, red blooded and exciting but out of which came the West we now know.

VI. Finale.

> Follow the crowd to the dance hall. Dance, gamble and be merry.

The Happy Canyon show is owned and staged by the Pendleton Commercial Association. This event is staged each year by the business men of Pendleton who devote their time and effort, without pecuniary reward, toward making this show what it is.

Above: The 1923 Happy Canyon program, one of the oldest still existing. *Hall of Fame Collection.*

Left, top: A 1918 Happy Canyon cue card. *Raley family.*

Left, bottom: A rare 1918 Happy Canyon participant's pass. *Raley family.*

soon became apparent that these types of acts were better during the day at Round-Up. The Happy Canyon town scene often interfered with the bucking broncos or wild steers, leading to injury for those brave enough to ride. When one bucking horse ran into the "Slipshod Blacksmith Shop" scenery, his rider saved himself only by grabbing hold of the roof above him. In 1921, the wild steer managed to charge into the dance hall and "shake a leg" on the newly polished floor—much to the board's chagrin.

The 1920s saw vaudeville soar to popularity, and the Happy Canyon pageant soared with it.

The show started out with the "Dance of the Fairies," which included fourteen performers. Happy Canyon provided the ladies with fairy costumes and, as part of their compensation, paid for a taxi to take the fairies to their rooms each evening.

Several significant changes occurred in the 1920s. Art Motanic initiated the "Indian Love Call," in 1923. Also, the Lewis and Clark and

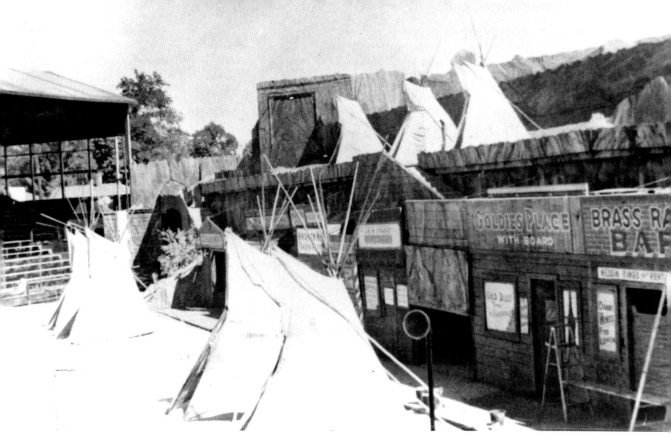

Above: Teepees set up in old Happy Canyon arena. *Happy Canyon Collection.*

Opposite: Front page of 1923 *East Oregonian Round-Up Souvenir* edition with artist rendering of the Old Canyon. *From the* East Oregonian.

Sacagawea sequence was added the next year and remains as a fixed act today.

In 1928, the famous "husband/wife act" was added, where a big wife and henpecked husband arrive in an "old" cab. As soon as the husband gets in thick with a dance hall girl, the wife notices and chases him into the pool. After he is hauled out of the water and taken to the laundry, his twin comes out—a new, clean "pressed husband." This act is still a crowd pleaser.

The 1929 show featured a "Spanish Dance" and a special number with a saxophone trio dressed as Chinamen. The show also added a bucking mule and a barrel with an African American inside.

The emigrant train included a female vocalist solo, a square dance, an Indian attack and a cavalry charge. The "Indian Figure on Roof in Silhouette" and the "Passing of the Race" were also new features, and the stagecoach holdup enacted that year continues to be an act today.

During the Depression, both Round-Up and Happy Canyon struggled, especially in 1932. The next year saw Happy Canyon report a net profit of $1,500, however, and the 1934 show did even better with a $2,500 profit. Happy Canyon had somehow weathered the Depression.

Cayuse Confederated tribal member Blackhawk (Jay Minthorn, Tutauts) remembered fondly that in the early days before each show,

24 Pages
SECOND SECTION
Pages 9 to 16

East Oregonian

24 Pages
SECOND SECTION
Pages 9 to 16

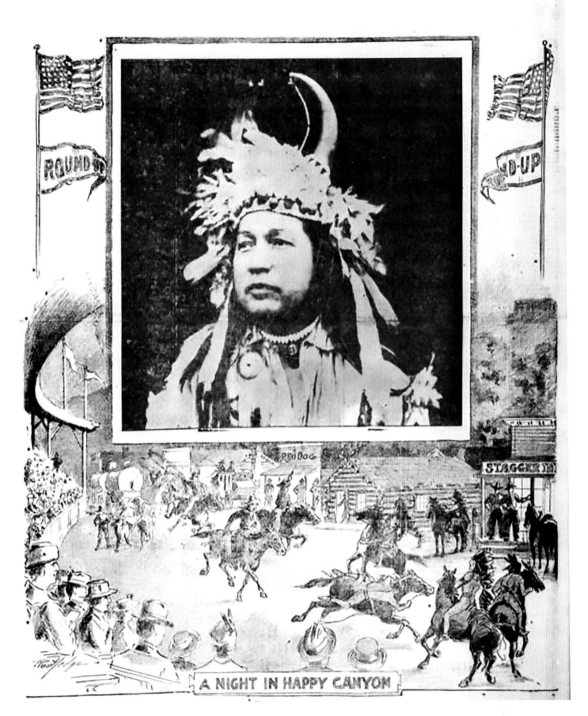

A NIGHT IN HAPPY CANYON

59

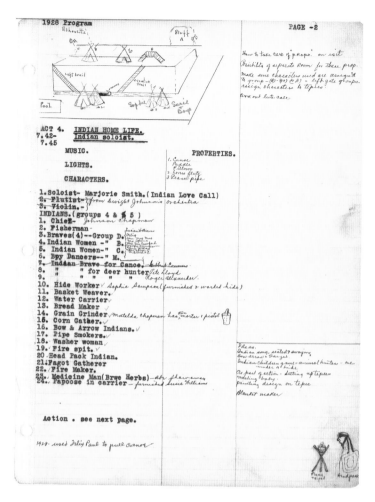

Left: The 1928 Happy Canyon script. *Happy Canyon Collection.*

Above: Husband and wife act in the Old Canyon began as early as 1928. *Hall of Fame Collection.*

all the Indian cast members paraded from the Indian Village to the Old Happy Canyon. As a small child, he began acting in the show, playing the part of a dancer, raider, drummer and chief smoking the peace pipe. Happy Canyon was an important part of Jay's family.[64]

During these years in the old arena, the Indians came dressed in full regalia. Many of them rode horses decorated in finely beaded and designed horse trappings. These riders dismounted and often displayed authentic dances in the Happy Canyon arena. In fact, the Tribal Ceremonial Dancing contest was held at the Old Happy Canyon after the Saturday night show and sometimes did not end until 3:00 a.m.[65]

Chief Raymond "Popcorn" Burke explained how he helped translate in the early shows since many of the elder Indians could not speak English in the 1930s. In an interview for the Happy Canyon Appreciation Awards, he stated, "The Indian scenes enacted by my people are the last of the past traditions, and Happy Canyon is preserving them for future generations."[66]

Other tribal members remember the unexpected moments of the Old Canyon. Louie Dick grew up learning to ride his

father's quality racehorses, which were also used in the Happy Canyon pageant. But using racehorses in Happy Canyon presented its challenges. One night, down at the Old Canyon, someone shot off a gun while young Louie was waiting to ride one of these racehorses into the raiders scene. The horse took off, running back to the Round-Up grounds and not stopping until it was back in front of his stall. Louie held on for dear life but never forgot that wild ride.

By the 1940s, Happy Canyon's directors knew their show was unique after observing the Cheyenne, Wyoming nighttime show:

> *Informed, fair-minded Cheyenne citizens make no attempt to compare their night show with Happy Canyon. After observing "Frontier Nights" twice, I am convinced that Happy Canyon has no competition anywhere…this experience adds strength to the feeling that Happy Canyon can go much further as a renowned spectacle of historical significance and beauty, that it should not take second position to any enterprise of showmanship.*[67]

On September 12, 1941, as the *East Oregonian* featured a Happy Canyon story on its front page, the headline above it read: "FDR Orders U.S. Navy to Strike First." As Happy Canyon and Round-Up took place that year, World War II weighed heavily on Pendleton hearts. In 1940, 3,088 young men in Umatilla County registered for the draft, and 100 of these young men never came home.

The show continued its success, though, and experienced sold-out attendance, turning away one thousand would-be spectators for the Thursday night performance in 1941.

As noted in the *East Oregonian*, "In three nights, approximately 12,000 persons have seen Happy Canyon, the copyrighted pageant that takes the viewer from the aboriginal west of the Indians into the pioneer and trading post days, with 200 Indians and 300 whites in the cast of characters—not to mention the horses, oxen, deer, pheasants and others."[68]

The next year brought the reality of the war home. The atmosphere at the Pendleton Commercial Club on July 14, 1942, was weighty, as a special meeting of the Happy Canyon Board of Directors took place. Should they have the show at all?

The effects of the world war were felt in Pendleton. The fuel rations made travel impossible for those in the Northwest and beyond prohibitive. Happy Canyon saw the need to conserve with the shortage of fuel and tires, especially since many key men were away in military service. The Round-Up organizers had already decided to forego its events that year

Page 62: Jay Minthorn (Tutauts) began in the Old Canyon at an early age and played several parts throughout his life. *Photo by Don Erickson; courtesy of Hall of Fame Collection.*

Page 63, top: The beauty of the local tribes is captured in this Old Canyon photo. *Photo by W. S. Bowman; courtesy of Howdyshell Collection.*

Page 63, bottom: Oxen with covered wagon and H.O. Powell in the Old Canyon. *Howdyshell Collection.*

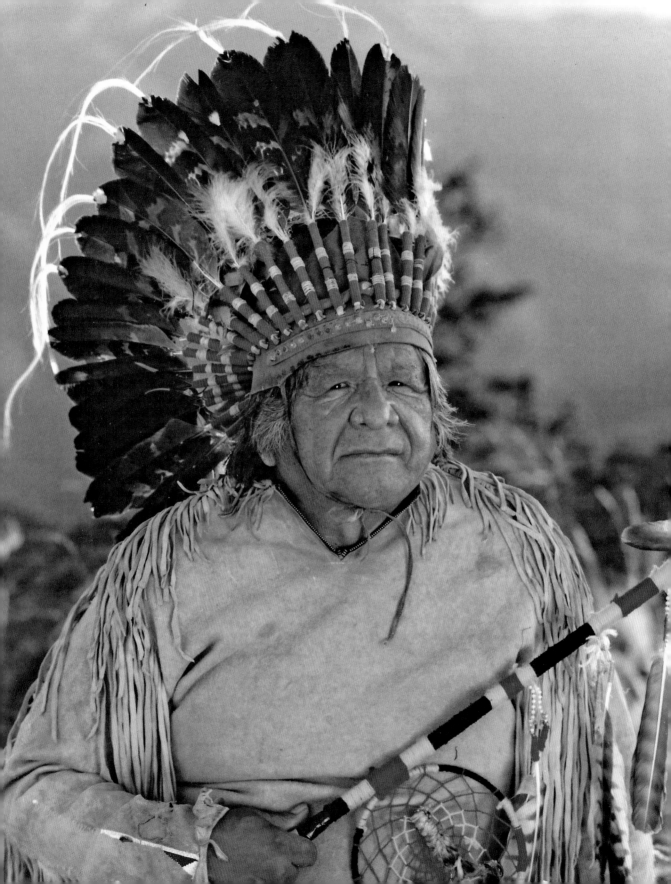

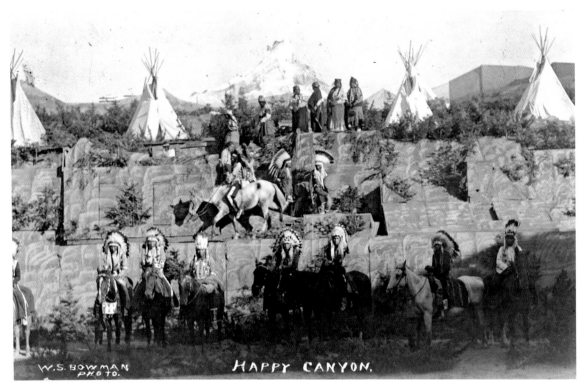

HAPPY CANYON.

W.S. BOWMAN
PHOTO.

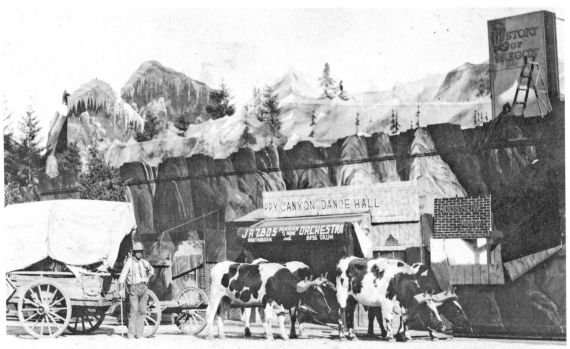

63

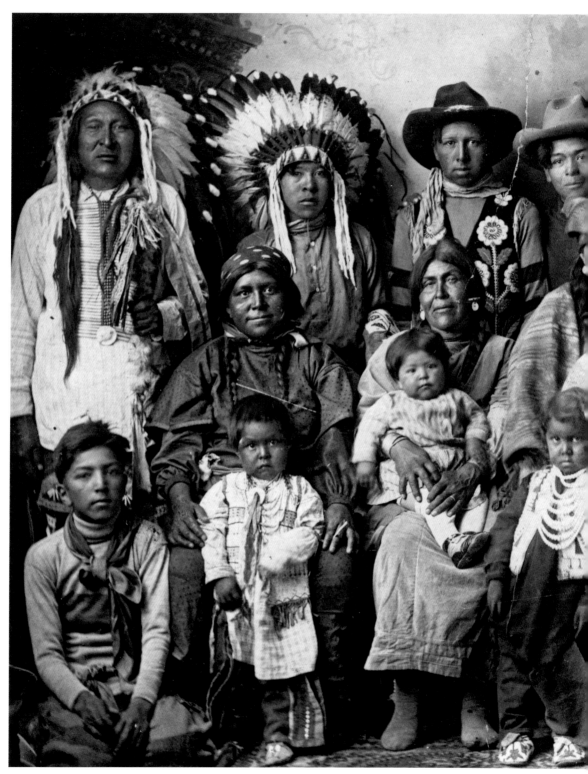

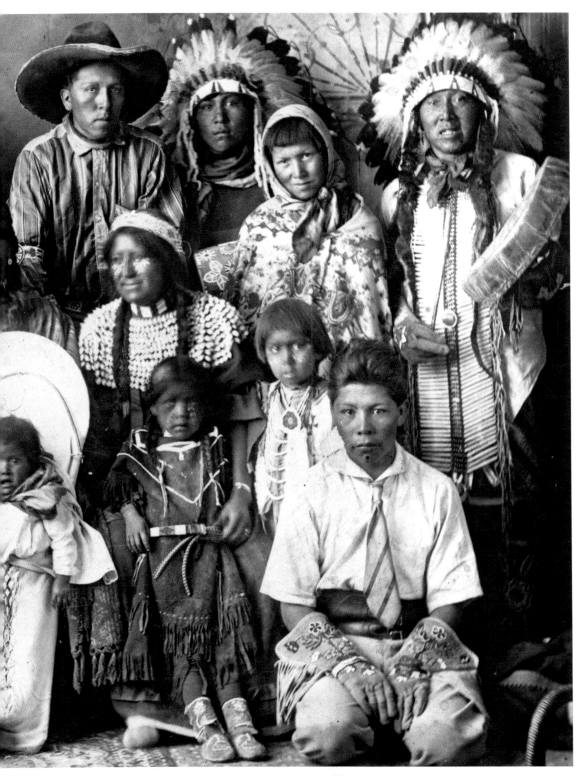

Happy Canyon

1940 PERFORMER'S PROGRAM

1.	7:45-7:51	Band Overture
2.	7:51-7:52	Show of Scenery
3.	7:52-7:53	Silhouette (Welcome)
4.	7:53-7:56	Indian Quartette
5.	7:56-7:59	Indian Home Life
6.	7:59-8:02	Indian Wedding
7.	8:02-8:03	Silhouette (Peace)
8.	8:03-8:11	Indian Hunters (Scalpers) Gathering of Indians Vanishing Race
9.	8:11-8:12	Silhouette Lewis-Clark-Sacajawea
10.	8:12-8:13	Sacajawea, and Lewis-Clark Party
11.	8:13-8:14	Silhouette (Signaler)
12.	8:14-8:21	War Party Indian Runner, Phillip Bill Dead Indian, Young Captive, Mary Beaton Medicine Man Boy Dancers
13.	8:21-8:23	Rescue Cowboy Funeral Scouts, King, Fletcher Young Falling Horse Cowboys
14.	8:23-8:24	Silhouette (War)
15.	8:24-8:30	Immigrants Leader, Kirby Quartette Quadrille Indian Announcer, Fletcher Cavalry Lieuallen Cecil Conners
16.	8:30-8:31	Silhouette (Fade-Out)
17.	8:31-8:35	Pipe of Peace
18.	8:35-8:36	Passing of the Race Johnson in the Lead

(OVER)

Above: A 1940 Happy Canyon cue card. *Author file.*

Right: An undated Happy Canyon program. Notice it is presented by the Pendleton Commercial Association. *Author file.*

Opposite: The 1944 Happy Canyon program. *Author file.*

Previous pages: Phillip Bill, shown here in the beaded vest (back row, third from left), with visiting tribes. *Howdyshell Collection.*

Immediately following the arena program the doors to the Happy Canyon Dance Hall are opened for your enjoyment. There is no additional admission for those who have purchased tickets to witness the arena program.

Inside "Happy Canyon Hall" you will have an opportunity to participate in the numerous activities of an old frontier town. The dance music is furnished by Dwight Johnson and his celebrated artists. An evening of pleasure and enjoyment awaits you.

The Happy Canyon Show is owned by the Pendleton Commercial Association. This event is staged each year by the business men of Pendleton who devote their time and effort without pecuniary reward.

DIRECTORS OF HAPPY CANYON

Philo H. Rounds	Ed. C. Olsen
Rudy Mollner	Fay Hodges
Elmer Storie	Fred Donert
Bert Jerard	Dan Hobart
Glen Storie	Finis Kirkpatrick

Happy Canyon

PRESENTED by the PENDLETON COMMERCIAL ASSOCIATION

WHILE we do not attempt to present a complete story, yet there is a sequence of events that will help you to a better appreciation of the action.

The INDIAN—in outlined form is our interpreter.

The INDIAN—welcomes you. To the North—to the South—to the East—to the West—his arms extend. Including all. Welcoming all.

A glimpse into Indian home life. There was grain to be ground—baskets to be woven—hides to be dressed—game to be caught. The tepee was the home and center of their life.

The INDIAN—with pipe, bow and arrows —all is peace. There is time for play and hunting.

Four Indian boys return home. They have scouted a rival tribe—they have won scalps— they are entitled to be known as braves. They signal the chief to call the tribe together. They tell of their brave deeds—and the tribe approves and the chief rewards.

Sacajawea appears—pointing Lewis & Clark to the West. Always to the West. Footsore and tired, she falters—but carries on. Into the camp of her people she leads them—a strange people in a strange land. 'Pale faces' never seen before—objects of awe, of fear, of curiosity.

The first white man has appeared, others shall follow.

The INDIAN—with signal fires signals danger. His people have clashed with the white man.

The War Party comes. Already blood has been shed. The chief's son has been killed. A white girl held captive. The chief asks guidance from the "Medicine Man." The answer is WAR— The Tom Toms sound— The War Dance begun.

And while they plan—scouts and plainsmen rescue the captive.

The INDIAN—with war bonnet and tomahawk! WAR!

Westward bound, the emigrant wagons appear. It is night and they make merry with song and dance. Until—

The INDIAN. The War Bonnet is laid away.. Knowing resistance is futile—he bows to the Fates. He has reached the end.

Their old hunting ground is gone—usurped by the Whites. The Chief, majestic, even in retreat, leads his people to new fields—standing guard until the last one has passed over the trail.

The trading post and frontier town. The day of the pony express, the stage coach, the saloon and the dance hall. Where cowboy mixed business with pleasure. A rustic civilization, red blooded and exciting— but out of which came the West we now know.

NOTE:—Excepting soloist—all Indian parts are played by full-blooded Indians.

because of the war and the limited service facilities for the visitors.

The *East Oregonian* stated, "Cancellation of the show may not help much but it will help some. None of us can do much but we can all do some and we had better do it."[69]

The men of Happy Canyon felt they had no choice but to join with Round-Up and cancel the 1942 show. It must have been hard for a September to pass without Round-Up and Happy Canyon.

The year of 1943 did not decrease any of the war problems, and the boards agreed to cancel again. During these two years, Pendleton was home to a troop training center along with its own USO building, which was on the east side of Emigrant Street, across the street from the Happy Canyon grounds, and later converted to a youth center.

By 1944, things had begun to look up. The war was going well, and the Happy Canyon directors, along with the Round-Up board, decided to resume both shows. They felt both would offer a worthwhile break in routine since life

Cole McElroy; his famous brass section and Margaret Carroll, entertainer.

This Program Compliments of
HAMLEY & COMPANY AND WM. ROESCH BREWING CO.
Pendleton, Oregon

Happy Canyon

The World's Most Unique Show

★

Evenings, September 13, 14, 15, 16, 1944
PENDLETON, OREGON

THE Happy Canyon Show is owned by the Pendleton Chamber of Commerce. This event is staged each year by the business men of Pendleton who devote their time and effort without pecuniary reward.

DIRECTORS OF HAPPY CANYON
G. F. Hodges, Bert Jerard, Ralph Hassell, Ben Cresswell, Will F. Glass, J. Sydney Laing, Homer Beale, Dave Jackson, Raley Peterson, Walter Holt.

We do not attempt to present a complete story, yet, there is a sequence of events that will help you to a better appreciation of the action.

THE INDIAN—
In silhouette is our interpreter.

THE INDIAN WELCOMES YOU—
To the North—to the South—to the East—to the West—his arms extend. Including all. Welcoming all.

A GLIMPSE INTO INDIAN HOME LIFE—
There was grain to be ground—baskets to be woven—hides to be dressed—game to be caught. Indian Maidens and Braves to be wed. The tepee was the home and center of their life.

THE INDIAN—
With pipe, bow and arrows—all is peace. There is time for play and hunting.

FOUR INDIAN BOYS RETURN HOME—
They have scouted a rival tribe—they have won scalps. They are entitled to be known as braves. They signal the chief to call the tribe together. They tell of their brave deeds—and the tribe approves and the chief rewards.

SACAJAWEA APPEARS—
Directing Lewis and Clark to the West, always to the West. Footsore and tired, she falters—but carries on. Into the camp of her people she leads them—strangers in a strange land. 'Pale faces' never seen before—objects of awe, of fear, of curiosity.

Immediately following the arena program the doors to Happy Canyon Dance Hall are opened for your enjoyment. There is no additional admission for those who have purchased tickets to witness the arena program.

The first white man has appeared, others shall follow.

THE INDIAN—
With signal fires warns of danger. His people have clashed with the white man.

THE WAR PARTY COMES—
Already blood has been shed. The chief's son has been killed. A white girl is held captive. The chief asks guidance from the "Medicine Man."

THE ANSWER IS WAR—
The Tom Toms sound. The War Dance begins. And while the Indians plan—scouts and plainsmen rescue the captive.

THE INDIAN—
With war bonnet and tomahawk. WAR!

WESTWARD BOUND, THE EMIGRANT WAGONS APPEAR—
It is night and the Emigrants make merry with song and dance. Until—

THE INDIAN—
The War Bonnet is laid away. Knowing resistance is futile—he bows to the Fates. He has reached the end. The pipe of peace is smoked.

Their old hunting ground is gone—usurped by the whites.

The Chief, majestic even in retreat, leads his people to new fields—standing guard until the last one has passed over the trail.

A PEACEFUL WESTERN TOWN—
Then war sweeps over the world.

Volunteers, white men and red men, rush to defend their home land over which they had previously fought each other.

A rustic civilization, red-blooded and exciting—but out of which came the West we now know.

Inside "Happy Canyon Hall" you will have an opportunity to participate in the numerous activities of an old frontier town. The dance music is furnished by Cole McElroy and his Orchestra.

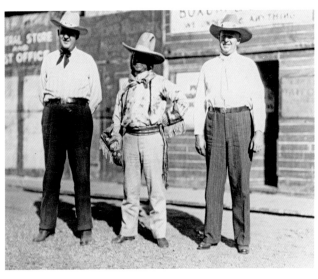

Right: *From left to right*: Elmer Storie, Johnson Chapman and an unidentified man in the Old Canyon. *Umatilla County Historical Society.*

Below: The inside of the 1953 Happy Canyon program, detailing the show. *Raley family.*

Opposite: One of the original Hick Bands from Happy Canyon. *Wayne Low collection.*

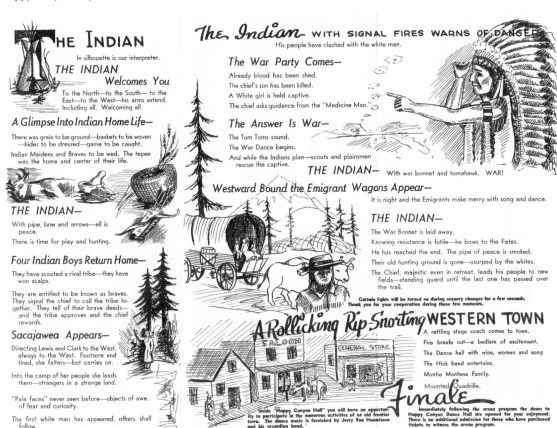

THE INDIAN

In silhouette is our interpreter.

THE INDIAN Welcomes You

To the North—to the South— to the East—to the West—his arms extend. Including all. Welcoming all.

A Glimpse Into Indian Home Life—

There was grain to be ground—baskets to be woven —hides to be dressed—game to be caught.

Indian Maidens and Braves to be wed. The tepee was the home and center of their life.

THE INDIAN—

With pipe, bow and arrows—all is peace.

There is time for play and hunting.

Four Indian Boys Return Home—

They have scouted a rival tribe—they have won scalps.

They are entitled to be known as braves. They signal the chief to call the tribe together. They tell of their brave deeds— and the tribe approves and the chief rewards.

Sacajawea Appears—

Directing Lewis and Clark to the West, always to the West. Footsore and tired, she falters—but carries on.

Into the camp of her people she leads them—strangers in a strange land.

"Pale faces" never seen before—objects of awe, of fear and curiosity.

The first white man has appeared, others shall follow.

The Indian WITH SIGNAL FIRES WARNS OF DANGER

His people have clashed with the white man.

The War Party Comes—

Already blood has been shed.

The chief's son has been killed.

A White girl is held captive.

The chief asks guidance from the "Medicine Man."

The Answer Is War—

The Tom Toms sound.

The War Dance begins.

And while the Indians plan—scouts and plainsmen rescue the captive.

THE INDIAN— With war bonnet and tomahawk. WAR!

Westward Bound the Emigrant Wagons Appear—

It is night and the Emigrants make merry with song and dance.

THE INDIAN—

The War Bonnet is laid away.

Knowing resistance is futile—he bows to the Fates.

He has reached the end. The pipe of peace is smoked.

Their old hunting ground is gone—usurped by the whites.

The Chief, majestic even in retreat, leads his people to new fields—standing guard until the last one has passed over the trail.

Curtain lights will be turned on during scenery changes for a few seconds. Thank you for your cooperation during these few moments.

A Rollicking Rip-Snorting WESTERN TOWN

A rattling stage coach comes to town.

Fire breaks out—a bedlam of excitement.

The Dance hall with wine, women and song

The Hick band entertains.

Montie Montana Family.

Mounted Quadrille.

Finale

Inside "Happy Canyon Hall" you will have an opportunity to participate in the numerous activities of an old frontier town. The dance music is furnished by Jerry Van Hoomissen and his recording band.

Immediately following the arena program the doors to Happy Canyon Dance Hall are opened for your enjoyment. There is no additional admission for those who have purchased tickets to witness the arena program.

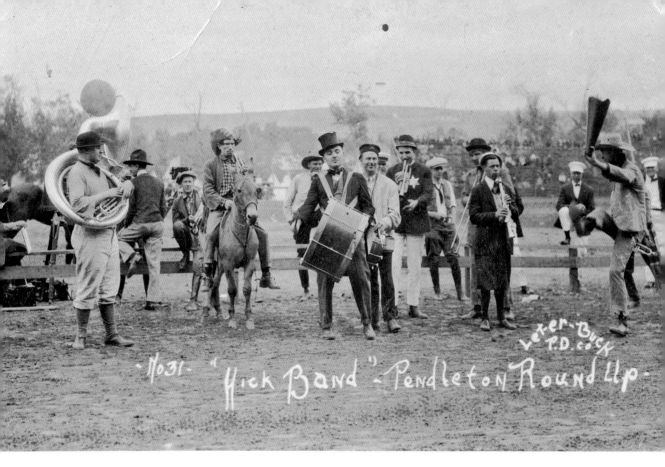

"Hick Band" - Pendleton Round Up -

had been serious for far too long. When the *East Oregonian* announced that Round-Up and Happy Canyon would resume, it was truly happy news for the local population.

During the war years, the Happy Canyon buildings and scenery underwent little to no maintenance, creating a large expense for arena and grandstand improvements. Show attendance in 1944 was large, though, and the shows proved a success in the revenue stream.

After thirty-one years in one location, Happy Canyon did not have a vacant seat or place to stand at its 1948 opening performance. Wednesday night, known as "hometown night," did not disappoint the Pendleton crowd. In August 1950, the *East Oregonian* reported that some spectators hadn't missed a show in over thirty years.[70]

Around this time, the Happy Canyon board knew it needed to either upgrade the facility or change the location and improve the arena and grandstand. All who attended the Old Canyon referred to it as a "firetrap." After much deliberation, the board agreed it was time to find the Happy Canyon a new home.

The Old Canyon property sold to Safeway stores for $100,000. Patrons in 1954 saw the last show at the old facility before it was torn down, signaling the close of a long period of eventful Happy Canyon history downtown.

Many local people regretted the show's move to its present location. "We loved watching the Indians bring their horses up Frazer, and it was so much fun to go to the jitney dances [dances you paid for] after the pageant," Marie Martin Chorazy said."[71]

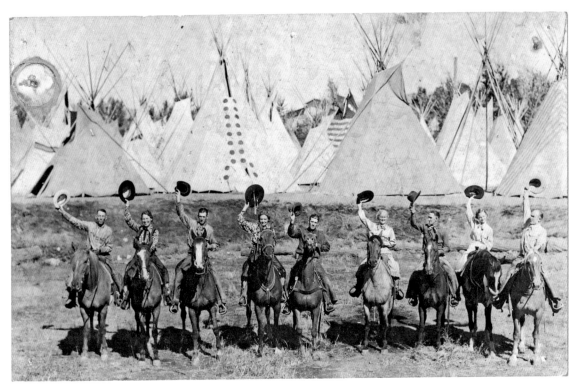

Above: Happy Canyon's 1934 quadrille team. *Hall of Fame Collection.*

Opposite: Chief William Burke. *Photo by Don Erickson; courtesy of Hall of Fame Collection.*

In the final year of the show at the old location, observers noticed Philip Bill, the show's Indian chief on the famed "Trail Horse," was more majestic than ever before as he rode up the wooden trail through the artificial mountains: "Bill astride his majestic horse was personification of the sturdy redman of the old West."[72]

Meanwhile, Duane Conner, the silhouetted Indian, played the part as an experienced showman.

When tribal leaders Bill Burke, Chief Clarence Burke, George Spino, Joe Hayes, Sol Webb and Tom Joe smoked the peace pipe for the last time in the Old Canyon, it was said their presence alone filled the arena. These moments were forever etched in the minds of those watching.[73]

The 1954 Happy Canyon pageant concluded with the whole crowd singing "Auld Lang Syne," "Show Me the Way to Go Home" and "This Old House."

As a finale, the words of "This Old House" were changed to: "Ain't gonna need this house no longer, ain't gonna need this house no more, it's gonna be a Safeway store."[74]

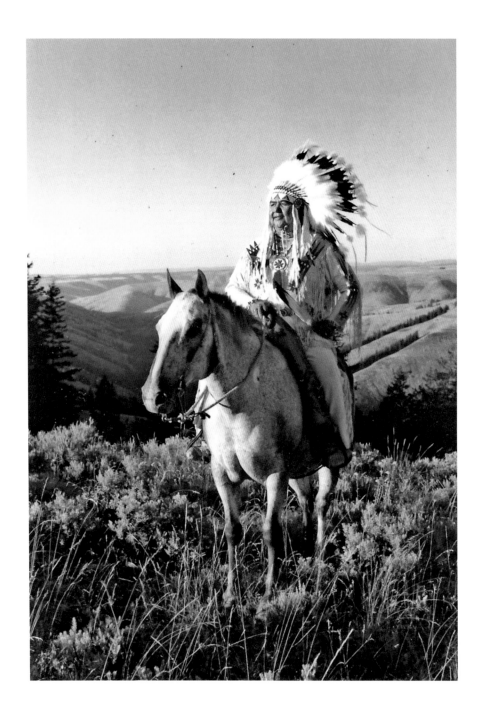

With the change in location, Happy Canyon saw the loss of many memories as well as a strategic downtown location. Even now, many actors or volunteers speak of this venue with a wistfulness and longing to see the old location and remember the great performances.

But Happy Canyon would soon begin a new chapter of its history.

4

VILLAGE OF PAST AND PRESENT

The out-of-town Round-Up attendant, viewing the 1,500 to 2,000 Indians who annually participate in the parade and the other Round-Up events, often remembers the Indians more vividly than he does other parts of the Round-Up, especially if he comes from a section of the country where there are few Indians….He leaves with the colorful performances of the Indians indelibly impressed in his memory…the inescapable beauty of the Indians' part in the Happy Canyon pageant.[75]

What convinced the First Peoples to be so willing to join this community event? As several key tribal leaders brought family and horses to Happy Canyon, they gave from their very hearts and received in return a way to preserve their heritage.

Nowhere else in the United States does such a display of Indian pageantry exist as in the Pendleton Round-Up and Happy Canyon. From regalia, which is Native American art at its finest, to the culture displayed during the four nights at the Happy Canyon pageant, the Cayuse, Umatilla and Walla Walla people reveal the beauty of Native American life that has been passed down for generations.

Roy Raley knew Indian heritage must be part of the show. To this day, around 375 tribal members, most of them descendants of the first families who participated, portray their history. They briefly rehearse their parts, learning them from their elders, which adds to the importance of their display.

As Roy and Anna Minthorn Wannassay completed the Happy Canyon script, they explained their vision to the local Indians. Key to this vision were: Poker Jim, Gilbert Minthorn, Jim White, Dick Johnson, Philip Bill,

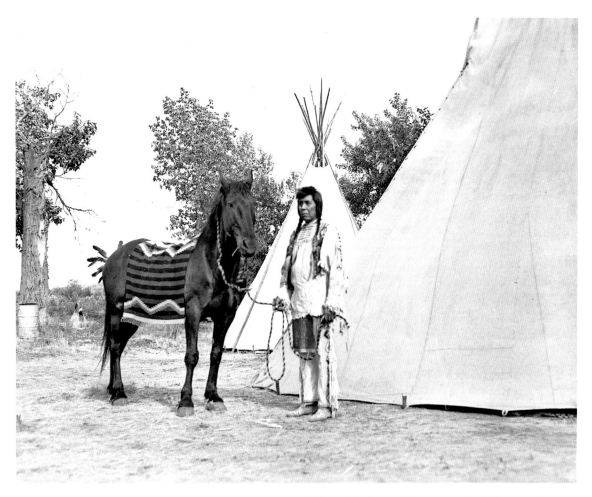

Gilbert Minthorn, a Cayuse and key Indian organizer, participated until his death. *Howdyshell Collection.*

Narces McKay, Fred Dickson, Willie Wocatsie and Johnson Chapman.

Participating with their families and horses, these great men put up teepees and worked alongside the creative team to portray Indian life on the roof of the old feed yard, using the painted backdrop as their setting.

The willingness of the Indian leaders to lend their time, resources and lives to a non-Indian vision cannot receive too much applause. They brought centuries of living history with them. A 1928 Happy Canyon record shows around four hundred full-blooded tribal members in the show, forming the nucleus of the entire pageant.[76]

"We're landowners here, members of the community," Leah Connor, longtime show actor, said. "We've always felt very much a

part of the whole community involvement." She said the chiefs did not have the authority to decide tribal involvement in Round-Up and Happy Canyon. Instead, each family chose to participate.[77]

The brochure *Nun-Mip-Ni-Sheek (We Remember) The People Who Have Gone Before*, written for the 1959 National Indian Encampment in Pendleton, states:

> *We honor the memory of the people who lived in this land that is now northeastern Oregon. They are remembered for their leadership, their outstanding personalities and all that they did for others. May they know that we remember them in a special way during this great gathering…There are many, many more we remember in our hearts, but whose stories were difficult to trace and whose photographs could not be found. But to all the great and good of the past we give honor.*[78]

Visitors Always Welcome

Looking at the Round-Up and Happy Canyon grounds, you cannot miss the place of intersection: the Indian encampment. This village is assembled once a year for the week of Round-Up and Happy Canyon, forming a place for tribal families to dress in regalia and participate. Neither show would be as unique without this involvement.

"It's amazing," former Indian director Ron Pahl stated. "We get used to seeing 300 tee-pees [*sic*] next to the rodeo grounds. In Cheyenne they have maybe 20 tents, Calgary 30 or 40. I just think it wouldn't be the same without them. Having the dancing in the arena during the show is very unique. Others may not agree that it is part of the rodeo, but it definitely is part of the Round-Up."[79]

In the early years, tribal families could look up the draw of Cayuse or McKay Creek in early September and see dust clouds swirling above the horses.[80] With travois, men, women and children brought all they needed, dragging teepee poles behind their Cayuse ponies for a week of camping. Louie Dick remembers the anticipation of seeing friends and the trek down the Umatilla to the village grounds.

Some rode over twenty-five miles to participate. In fact, in *Let 'Er Buck*, Furlong mentions the local tribes "with teepee-poles and outfit, stored in every kind of wheeled rig, and drawn by every variety of cayuse."[81]

Chief Poker Jim and his wife, Wa-Win-Lay-Echt, led the group with Gilbert and Molly Minthorn, who became key to the Happy Canyon pageant and are listed in the 1923 script in vital roles.

"They were the real thing," Antone Minthorn, grandson of Gilbert and Molly, said. "A cowboy was a cowboy. And an Indian was an Indian. Indians, I think, realized the value of that kind of event where they could show people they were still here."[82]

The Pendleton Round-Up Indian village is unparalleled in America and the world. It is one of the largest annual encampments of Indians at a rodeo.

For more than a century, this village has appeared, overnight, to begin Round-Up week. No other rodeo can claim such a strong presence

The 2014 Indian Village. *Eye of Rie.*

of Indians in their glory, and the village plays a large role in this. In fact, the Round-Up and Happy Canyon grounds are part of the original Umatilla Indian Reservation.

Overnight, 250 to 300 teepees spring up in the grassy field behind the North Grandstand, near the Umatilla River. No longer do the Indians arrive by horseback with travois and wagon. Now the line of pickups and other vehicles arrive early Sunday morning, before Round-Up begins, carrying poles and teepee essentials. Some families line up as early as 4:00 a.m.

Usually, families camp in the same spot year after year and generation after generation. Using poles from either a communal pile on the corner of the village or their own supplies, the families quickly mark their traditional spots. They pad the ground with layers of cardboard, tarps and carpet before putting down air mattresses and cots.

Today, the area has lush grass for camping, but in the earlier years, the Indians spread straw over the hard dirt to cushion their beds. As a young girl, Marie Dick stayed with her grandparents in the village; she can still remember the sweet scent of straw. The straw was a fire hazard, though, and was eventually discontinued.

The word *tipi*—or, regionally, *teepee*—is from the Dakota or Sioux tongue, meaning "lodge" or "home." It was the original "mobile home." The tribes did not always live in canvas teepees, however. In eastern Oregon, the lodge was traditionally made of tule mats.

One hundred years ago, the teepee structure was a collection of poles, configured like a modern teepee. In the winter, a lodge made of tule reeds became the primary dwelling. Depending on the weather, these lodges were dug more than a foot into the ground.

When the non-Indians brought in trade goods and later when the pioneers of the 1800s brought the canvas, the structure was redefined. The new canvas material was used for its water

resistance. When the first villages were built at Round-Up, lodges were twenty or more feet wide for a multiple-family unit—not small, one-family teepees.

These first villages were set up in quadrants, according to Marjorie Waheneka (*Et-twaii-lish*—old lady like). The quadrants consisted of family or tribal groupings, and visiting tribes camped in different sections. Early photographs show teepees in what is now the Roy Raley Park area, where the upriver and Thornhollow Cayuse would camp.

Marjorie Waheneka began acting in Happy Canyon in 1953 as a three-month-old in a cradleboard on her mother's back. She has played various parts throughout the years, including a rider pulling a travois, a berry picker in the mountains and one of the key narrators explaining the culture and life of the local tribes.

Marjorie serves as the living history coordinator for Tamástslikt Cultural Institute. Dr. Ron Pond called her a repository for tradition and culture. "She's a voice for the people," he said. "She was taught so well at this point in her life people rely on her for knowledge and that's admirable."

"It is about the pride of representing our families," Marjorie said. "It's tradition and that's a word that always comes out when you talk about Round-Up and Happy Canyon."[83]

Most of the representing families are from the Confederated Tribes of the Umatilla Indian Reservation, located only six miles east of Pendleton, but tribal families also come from Oregon, Washington and Idaho. The groups gathering with the hosting Cayuse, Umatilla and Walla Walla tribes are mainly from the Nez Perce, Yakima and Warm Springs people.

Just as parts in the Happy Canyon pageant are passed down, so are the camping spots today. Descendants of tribal leaders still camping where their grandparents or great-grandparents did.

You can see the present blended with the past: tribal elders display regalia while children play football; music from an iPod plays while a circle of drummers sing century-old pieces.

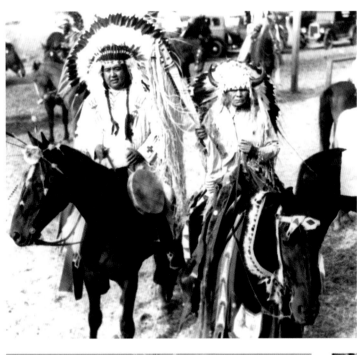

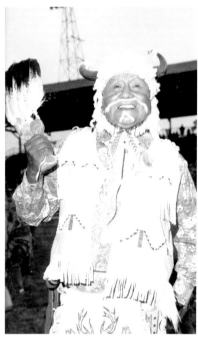

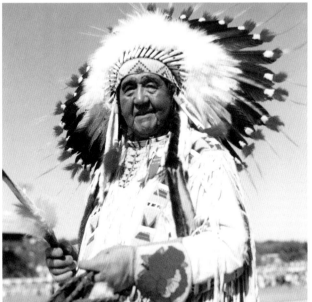

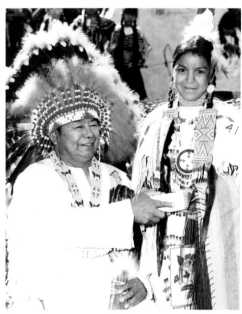

Above: *Top, left*: Chief Clarence Burke (left) and Chief Poker Jim; *top, right*: Richard Burke; *bottom, left*: Chief Clarence Burke; *bottom, right*: Chief Raymond Burke with an unidentified girl. *Howdyshell Collection.*

Opposite: The village in a September sunset. *Eye of Rie.*

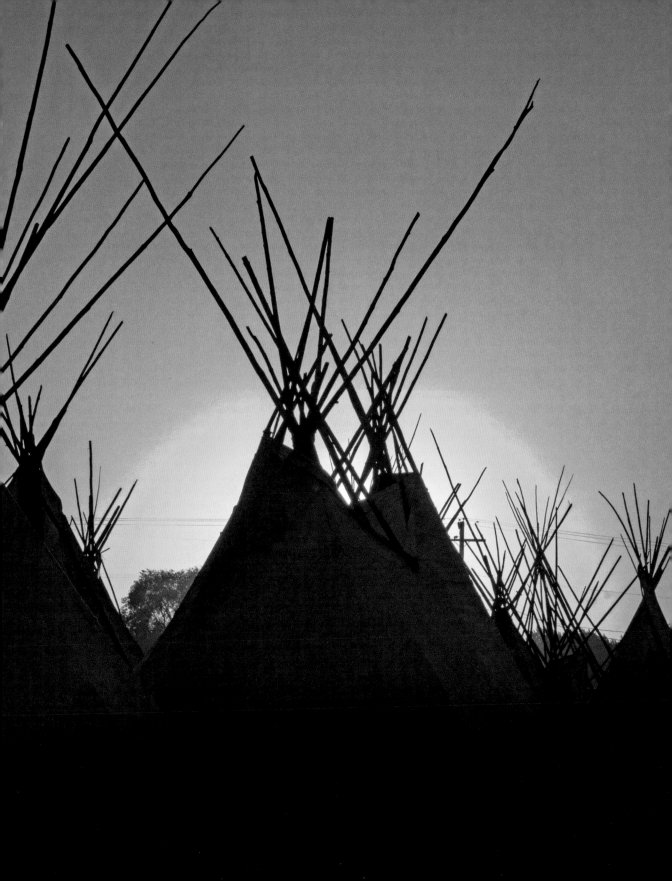

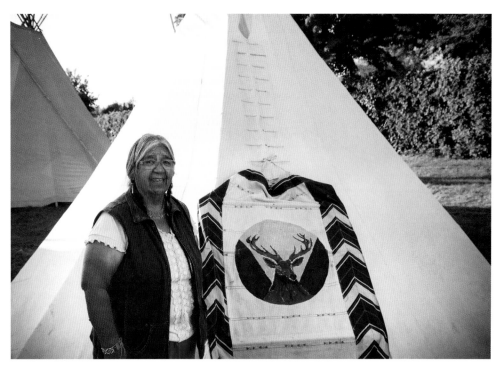

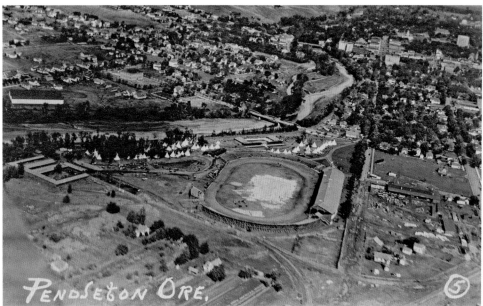

This page, top: Marie Dick in front of her family's "Red Elk" teepee. *Eye of Rie.*

This page, bottom: An aerial view of the Round-Up grounds, showing old divided encampment and natatorium. *Wayne Low collection.*

Opposite: Teepees flying the flags of families' favorite sports teams. *Eye of Rie.*

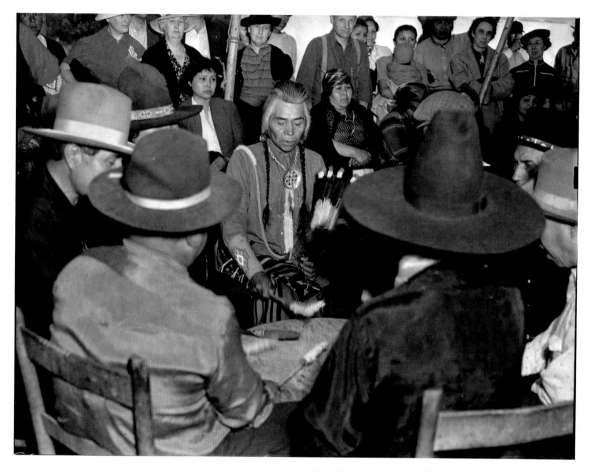

In 1948, Elwood Patawa, known as "Woody," around the age of five first walked into the Old Canyon location with his sister Rose. Woody's grandmother Teresa Minthorn and mother, Mary Patawa, performed in the show for years.

Woody can still remember the early days when tribal members rode the Happy Canyon flatbed truck, with scenery painted on its sides, to the Old Canyon. In those days, Chief Clarence Burke played his drum as they traveled to town from the village.

Woody began as a teepee boy and has since played several roles in the show. In 2006, Woody

Above: Drummers in the village with spectators, 1938. *Howdyshell Collection.*

Opposite: Inside the Patawa family teepee, which displays a wood stove traditionally hauled into camp. *Eye of Rie.*

received the Happy Canyon Appreciation Award for his excellent contributions. He served as tribal chairman from 1981 to 1993 and as national director of Indian Affairs for the U.S. Department of Agriculture in Washington, D.C.

In the village, the tradition of dressing for Happy Canyon takes place. The regalia

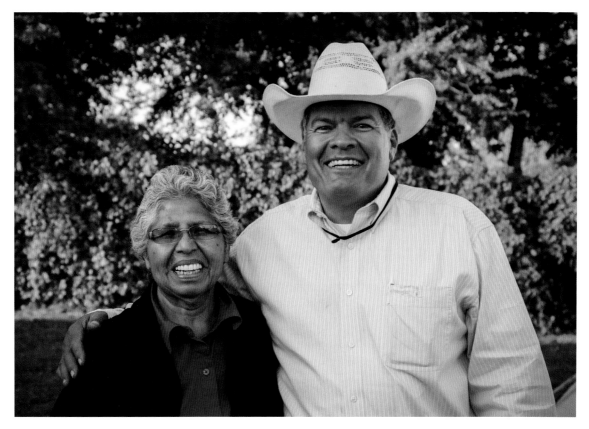

comes out of careful storage in large suitcases and old trunks—ready to be worn and displayed.

Great-granddaughters proudly wear the moccasins of their great-grandmothers as they enter the same arena that their ancestors once had. In several cases, the entire outfit involves pieces passed down to great-grandchildren, including regalia worn in the 1916 show.

In the early days, contests evaluated whose teepee had the best decoration of regalia, buckskins and beadwork. "In those days, no one worried about theft," Marjorie Waheneka said. "People honored your home."[84]

Some of the earlier teepees were more elaborate in the early years. The 1941 *East*

Above: Rose Patawa, a Happy Canyon actor at an early age, with her nephew Rob Burnside, a past Happy Canyon director. *Eye of Rie.*

Opposite: Yakima tribal member Terry Heemsah shows his regalia. Terry is an example of a tribal member newer to the show. *Eye of Rie.*

Oregonian Round-Up Edition reported on a rare teepee made of buffalo hide and owned by John Abraham in the village. That year, Willie Wocatsie had a teepee made of flour sacks as his cooking teepee—complete with colored advertising.

The late Mrs. Minthorn had an even more amazing buffalo hide teepee to set up.

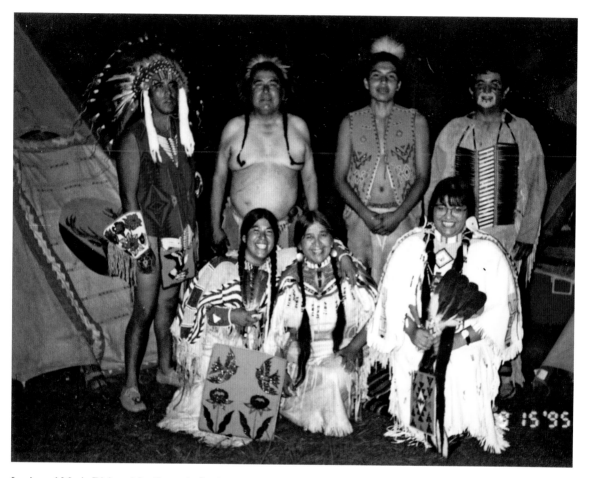

Louie and Marie Dick and family, ready for the pageant, 1995. *Marie Dick.*

Living to age 108, she remembered meeting Lewis and Clark. After her death, the famous teepee was given to Amos Pond, who allowed Dr. J.M. Cornelison, Tutuilla Indian Mission minister, to take it to Boston for the Missionary Fair. The 1919 *East Oregonian* encouraged everyone to see the special buffalo hide lodge that year.[85]

In the early days, the women gathered along the bank of the Umatilla to rinse clothes, wash up and visit. Joan Patawa Burnside, sister of Woody Patawa, remembers the clothes hanging on the branches to dry. She also recalls the enjoyable dinners held regularly behind the North Grandstands, where the entire village ate together.

Tessie Williams and her family are an example of the village hospitality. Beginning in 1975, they hosted a feast for guests from Round-Up and Happy Canyon, as well as other

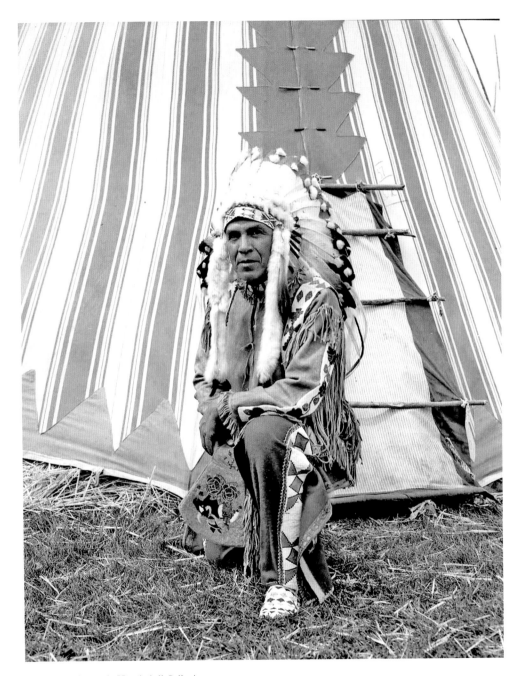

Jesse Jones Sr., n.d. *Howdyshell Collection.*

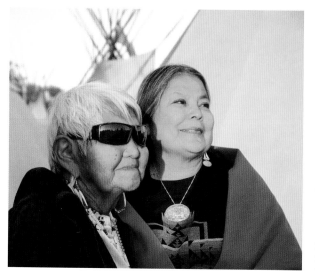

Left: The sunset shines on Tessie Williams, who was born on the Umatilla River in a lodge, and her daughter Nancy Minthorn. *Eye of Rie.*

Below: *From left to right*: Raymond Burke, Gary Burke, Dr. Richard Koch, Jesse Jones and David Wolfe at Roy Raley Park. *Mary Koch.*

visiting royalty and dignitaries. This traditional native feast included fry bread and salmon after Thursday's performance of Round-Up and before Happy Canyon. Tessie generously gave handmade items to each guest, commemorating the exchange of friendship and cultures.

In 2006, Louie Dick, Happy Canyon Appreciation Award recipient and Hall of Fame inductee, reminisced about changes in the village over the years. For instance, the "village crier" is absent. The crier rode through the village, making announcements about event times and locations. "They went through the village," Louie said. "They would stop at a location and announce news in Nez Perce and Walla Walla."[86]

At one time, the village contained a horse area, a feed lot and a sunken area of land where the Indians shared meals as a community, usually supplied by Indian leaders.

In the beginning, hundreds of horses were brought into Round-Up, usually the job of the Indian children. They started early in the morning, traveled most of the day, and reached the village by evening. It was hard work but fun for those making the journey. The number of horses in the village varied from seventy-five to one hundred, but currently, it is at thirty to forty head. Cecelia Bearchum remembered, "We didn't have horse trailers. We rode our horses from Adams."[87]

Another change from years past is that a fence now surrounds the Indian village, which makes several tribal members feel caged in. However, they acknowledge that there have been safety issues over the years, such as when the Brahma bull got loose and ran through the village and when a tractor accidently ran into several teepees.

STICK GAMES

The village nightlife included "stick games" or "bone games"—a form of gambling. These games were played late into the evening.[88]

Stick games were played hundreds of years before the arrival of the Lewis and Clark Expedition. They also took place between the Round-Up arena dances and Happy Canyon and after the show. Teams of up to ten on each side sit behind a long pole, using a short stick to drum on the pole while the game is played. One team has one set each of white and dark bones, which the team members hide in their hands. The object of the game is to find the white bones. The other side selects a player from its team to choose the hand of an opposing player holding a white bone.

The score is kept by eleven sticks stuck into the ground between the players. As a correct guess is made, one stick is passed over to the other side and stuck upright in the ground.

Even though parts of the village have changed since 1910, the Confederated Tribes of the Umatilla Indian Reservation continue to share their culture, lives and history year to year. Cecelia Bearchum remembered the teepees stretching to the concrete dike along the Umatilla River. She shared, "Visitors come by and want to see inside a teepee. They look in and see a table and chair and stove. I don't mind; I'm a people person and I like to visit."[89]

Visitors, including grade school field trips, continue to be welcome in the picturesque village and have the rare privilege of enjoying the atmosphere of a bygone era. It continues to be a special opportunity for Happy Canyon

and Round-Up guests to enjoy the hospitality, stories and culture of the Cayuse, Umatilla and Walla Walla people.

Marie Dick says, a bright smile on her face, "We still get asked: Do you still live in teepees? Do you live here all year?"

Louie Dick said the Happy Canyon and Round-Up week is an opportunity for Indians to share their heritage with one another and with non-Indians. But the unobservant may miss many things. "You can walk by and be completely unaware of a quiet memorial

Above: Stick games played in the village sometimes lasted all night. The gambling was an important part of the village culture. *Howdyshell Collection.*

Opposite: Top, left: Chief Blackhawk (William Minthorn); *right:* Carl Sampson. *Photos by Don Erickson; courtesy of Hall of Fame Collection. Bottom, left, from left to right:* Calvin Jones and Chief Jesse Jones Jr. *Photos by Don Erickson; courtesy of Hall of Fame Collection. Bottom, right:* Johnson Chapman. *Umatilla County Historical Society.*

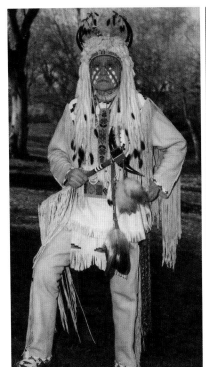

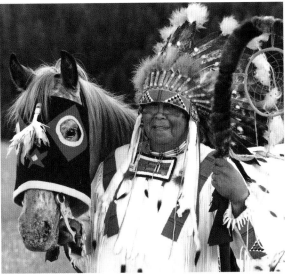

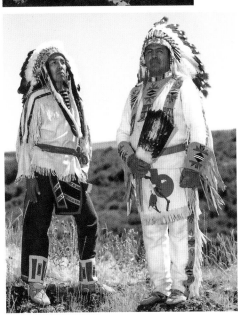

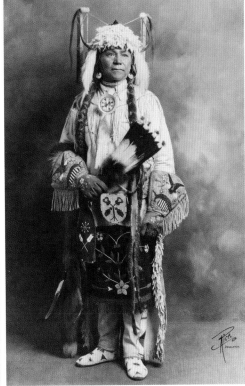

going on in the village," Louie said. "It's also a chance to display our Indianship. Otherwise, we're drawn into the non-Indian culture."[90]

Wes Grilley, former Happy Canyon show director, said, "There's a worldwide fascination with Indian culture and Indian history. Indian participation is essential; people come here to see the Indians."[91]

For many of the families camped within, the village is a family reunion that, in itself, helps bring the next generation back.

The teepee village is a contrast of old ways and the modern world. Chief Poker Jim and Gilbert Minthorn led their families to

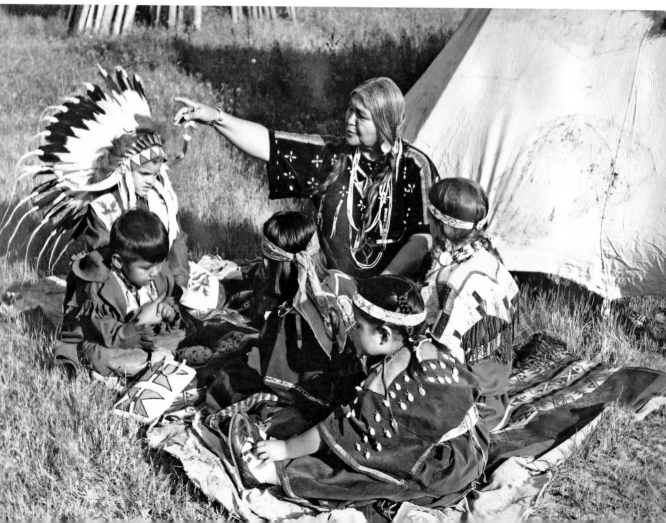

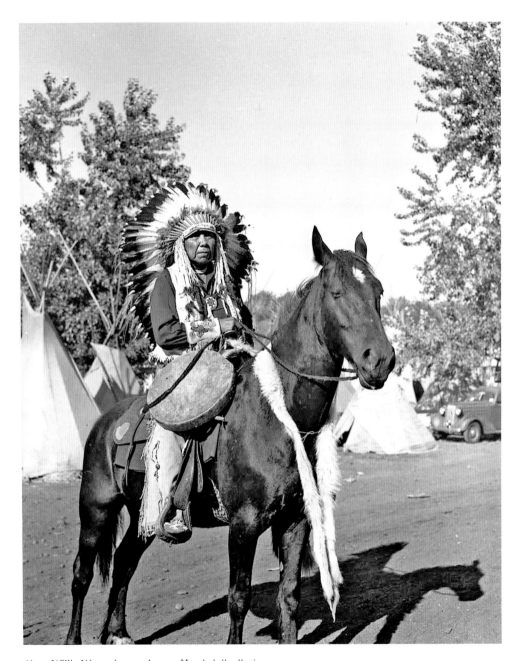

Above: Willie Wocatsie on a horse. *Howdyshell collection.*

Opposite, top: A sign designating Chief Gary Burke's family area in the Round-Up village. *Eye of Rie.*

Opposite, bottom: Louise Red Elk teaching her grandchildren. *Author file.*

camp on the banks of the Umatilla River, approximately where the families still camp today. Due to this tribal involvement, Happy Canyon is an ongoing success today.

For over one hundred years, the Indians have willingly come to share their homes, culture and hospitality with the Happy Canyon guests. A week later, the grounds are empty, as if they had never been there.

5

THE SCRIPT PART ONE

The Pageant

The story and enactment of Happy Canyon is filled with the magic of pageantry, of beauty and music; under the open sky there unfolds, first of all, the story of the life of the Indian, who, untrammeled, roamed the hills and valleys of his own great domain.[92]

The magic of Happy Canyon is not easy to describe. In fact, no written history expresses the true feelings of those who lived it. For those who have participated as actors, volunteered behind the scenes or watched the show in the last one hundred years, Happy Canyon is a true link to the past.

The 1914 and 1915 show scripts focused on entertainment, employing key ingredients that remain today. Compared to the 2015 show script, the 1915 cue card tells the tale of a simple show.

After Happy Canyon moved to its new location in 1916, Roy Raley expanded the 1915 script, sketching the history of Umatilla County throughout the pageant. He consulted with Anna Minthorn Wannassay, adding

what would become the most unique and unequaled sequence of tribal life anywhere in the United States.

As the years have passed, older generations of the First Peoples have taught the younger through acting. As the music unfolds, moccasin-clad children follow the elders to enact scenes written a century ago. Several Indian families can boast of six generations of Happy Canyon actors.

When the set for the Silhouette scene was built in the Old Canyon,[93] the scene featured Chief Clarence Burke, who served in the Silhouette role for decades, welcoming audiences "from the North, the South, the East, and the West" until his death in 1987. Bill Burke, his son, stepped into the role after

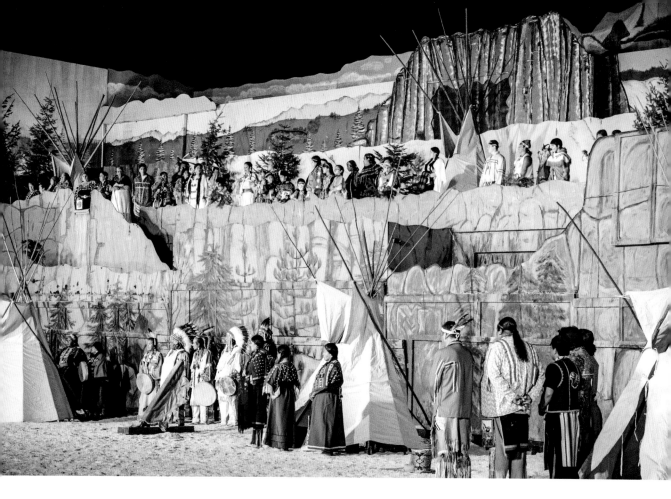

Clarence's death, followed by Raymond "Popcorn" Burke. Currently, Chief Raymond's son, Chief Gary Burke, is the official greeter in the opening Silhouette scene.

As the pageant begins, the lights dim and a gong reverberates out as Chief Gary Burke speaks a greeting in the Cayuse language,[94] translated into English by Calvin Ashbeck, wearing a Lewis and Clark costume. *Leloinin*, the Cayuse word for "welcome," is followed with:

> *Chief Gary Burke has just welcomed all from the North, the South, the East and the West to the Happy Canyon Show! Tonight we have gathered together to enjoy what has become the common heritage of ourselves and our Indian Friends. And now on with the show!*[95]

The pageant welcome is spoken in Cayuse and preserves a small portion of that language, which was nearly entirely lost in the 1940s. Before this part was passed to him, Chief Gary Burke learned the greeting in Cayuse from his grandmother Ada Patrick Jones, who wrote it down for him to learn. His grandmother and his father, Chief Raymond, even recorded themselves saying it in native Cayuse so Gary could learn to pronounce the words correctly. Gary feels honored to wear his father's regalia and declare this greeting.[96]

The show's narration begins by reminding the audience of the local tribal heritage:

Welcome to our home. Cayuse, Umatilla, and Walla Walla peoples have lived here for thousands of years on this land. We live according to lessons from the animals, from nature, from our Creator. We live peaceably with our relatives and neighbors abiding by the natural laws. We live a good life with only a few enemies.[97]

In all its pageantry and color, the portrayal of Indian life before the coming of the explorers and the pioneers is a feast for the eyes. With the added element of narration, written in its

present form in 2002, the depiction of Indian life unfolds at sunrise as the orchestra plays the notes from "Indian Love Call" and "Eleanor."

Gilbert Connor began the Silhouette part when it was added in the Old Canyon, continuing in it for over two decades. He was spotlighted behind the screen as he posed with a bow and arrow.

Opposite: For a century, tribal members have willingly participated in the pageant. *Eye of Rie.*

Below: Silhouette scene with Chief Gary Burke and Calvin Ashbeck welcoming the audience. *Eye of Rie.*

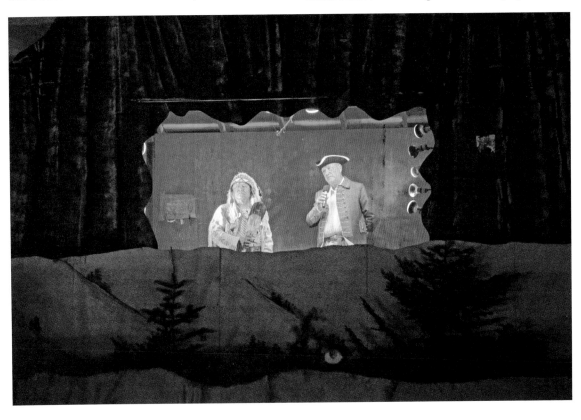

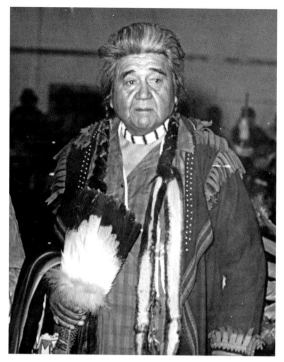

Parsons and Sarah Motanic both acted in the pageant's early years and are listed in the first cast lists. Their children all took part in the show, but it was their son Arthur Motanic (Pahushallatommo meaning Five Mountain Owls) who began singing the "Indian Love Call" in the show in 1923. A friend heard him sing in church and told a Happy Canyon official, "If you want someone to sing the 'Indian Love Call,' you'd better get Art." Art considered his singing voice one of his greatest gifts. Art explained how singing in Happy Canyon was a "pleasure," even though he did not have a microphone.[98]

Later, Art was quoted as saying, "When I would sing, the women in the audience would cry and as the tears fell on the seats, it created maintenance problems."[99] Art sang and acted in the show for most of his seventy-eight years, singing his final "Indian Love Call" in Happy Canyon to his wife, Myrtle.

Art and Myrtle's many descendants, through their daughter, Caroline Motanic Davis, have all continued to be active in the show.

The narrator speaks these words during the show: "Our people—Natitaytma—greet the new day thankful for what the Creator has given us. He gave us this place to live, abundant game and berries in the mountains,

This page, top: Chief Clarence Burke, first tribal chief to welcome the audience in the silhouette, 1948. *Howdyshell Collection.*

This page, left: Chief Raymond "Popcorn" Burke. *Don Cresswell.*

Opposite: Show narrators, *top*: Armand Minthorn; *middle, from right to left*: Andrea Neisdadt and Steve Corey; *bottom*: Steve Corey. The narration, added in 2002, has enriched the show. *Eye of Rie.*

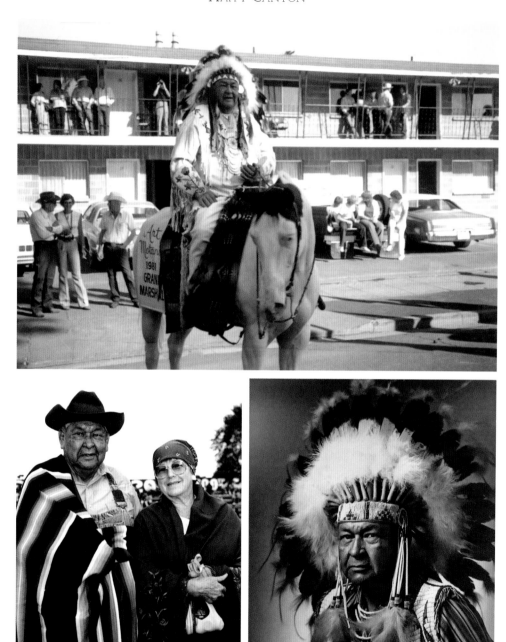

Top: Art Motanic, grand marshal of Westward Ho! Parade. *Bottom, left*: Art Motanic and his wife, Myrtle; *bottom, right*: Art is ready to sing the "Indian Love Call." *Howdyshell Collection.*

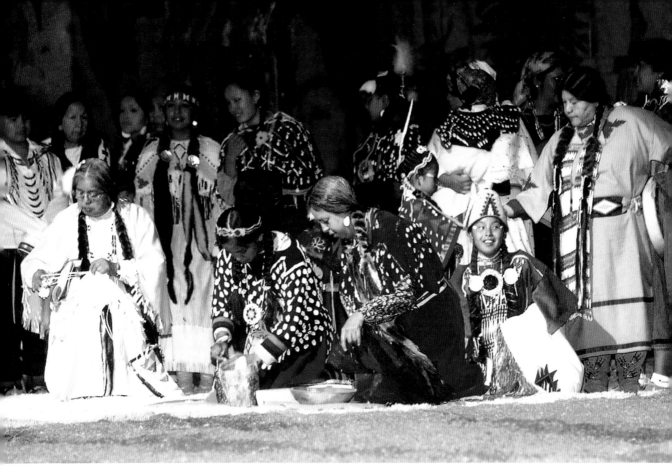

Women have performed in the show since 1917, displaying village home life. *Don Cresswell.*

roots in the foothills, and plentiful fish and lamprey in the rivers."[100]

As morning dawns on the Indian village, home life plays out as it would have for thousands of years. Most years, a group of pheasants will fly across the set as the sunrise arrives and the house lights come up.

Armand Minthorn, whose family has been in the show for decades, recalls being completely caught off guard one night when the pheasants were released. Much to his surprise, one of the feathered fowls decided his war bonnet was the perfect place to land. *Plop!*

For generations, the Alexander family has carried the deer in Happy Canyon, showing the importance of the hunt. Roger Alexander carried the deer as early as 1928 in the Old Canyon. Now, three generations of the Alexander family have proudly carried the deer: "Water, which gives life to all, is clean, cold, and pure from the mountains. Our people are healthy and happy. Daily life is industrious and resourceful. It's important to store food for the winter. Old and young are busy harvesting and preserving foods, making clothing, preparing shelter, getting ready for ceremonies."[101]

The women perform traditional daily tasks: scraping hides, working with beads, weaving baskets, cooking over the fire, hauling water, gathering wood and digging roots.

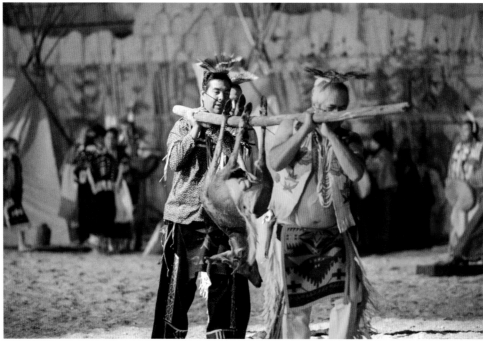

Alongside this activity, you will see men fishing in the pond and children playing.

For many years, both in the Old Canyon and in the current location, an Indian maiden would appear in a canoe, gently "floating" down the stream as she paddled, though the canoe was actually pulled by a rope along a canal in front of the scenery. The maiden would also take part in the Indian wedding scene: "Families have been preparing for a wedding. Many people will gather. A marriage might be arranged between allies or between prominent families to ensure leadership. Ancient laws prohibit marrying relatives. Elders make sure the rules are observed. After the family consents, a wedding dance formally symbolizes the arrangement."[102]

As the deer hunters cross the village, the wedding dance begins. The extended arms symbolize the significance of the groom's choice, and the bride's extended arm reflects her agreement.

The wedding dance song was taught and passed down from the Johnson brothers Bill and Alex, who descended from the Chief Joseph Band. The Johnson brothers were known throughout the Northwest for their singing and knew the traditional songs. At that time, they were the only ones who knew the wedding dance song. Thus, Happy Canyon has helped preserve the tradition of this ceremony.

The show's narration describes the significant ending of the Indian wedding scene:

The ceremony is finalized through the wedding trade. The man's side will give the bride's family men's things—meat, fish, horses, and canoes. The woman's side will give roots, berries, hides, storage bags, baskets, clothing, and tule mats to

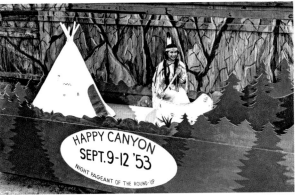

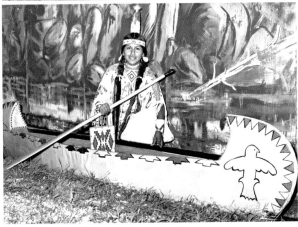

Opposite: Third-generation deer hunters in a part still played by the Alexander family since the 1920s. *Eye of Rie.*

This page: The canoe scene, which was used for years, has been discontinued. *Howdyshell Collection.*

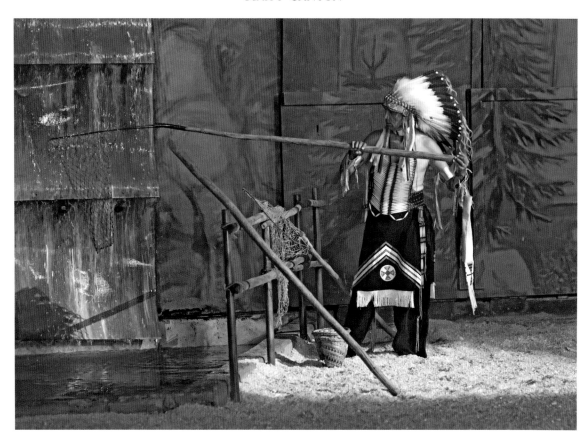

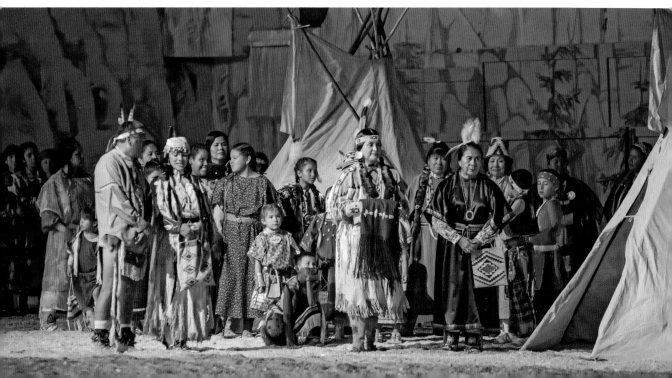

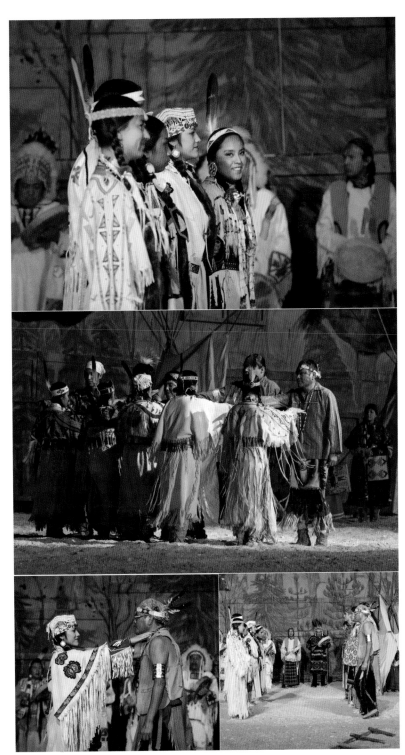

Opposite, top: Curtis Bearchum fishing with a traditional net. *Harper Jones II.*

Opposite, bottom: Families preparing for the wedding dance. *Harper Jones II.*

Right: A wedding scene, showing the beauty of a traditional ceremony. *Eye of Rie.*

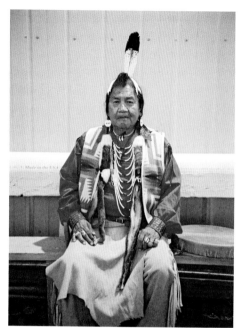

Left: Fermore Joseph Craig Sr. waits for his scene on the cast benches. *Eye of Rie.*

Below: A traditional wedding trade led by third-generation actor Marjorie Waheneka, following in the footsteps of her mother and grandmother Susie Williams. *Eye of Rie.*

Opposite: Tribal drummers perform several places in the show. *Eye of Rie.*

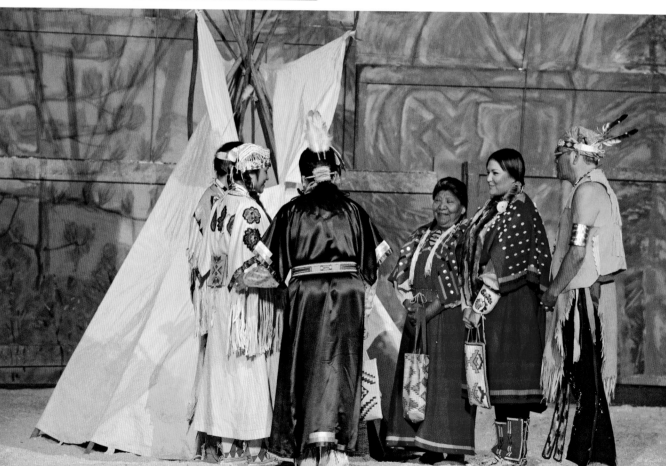

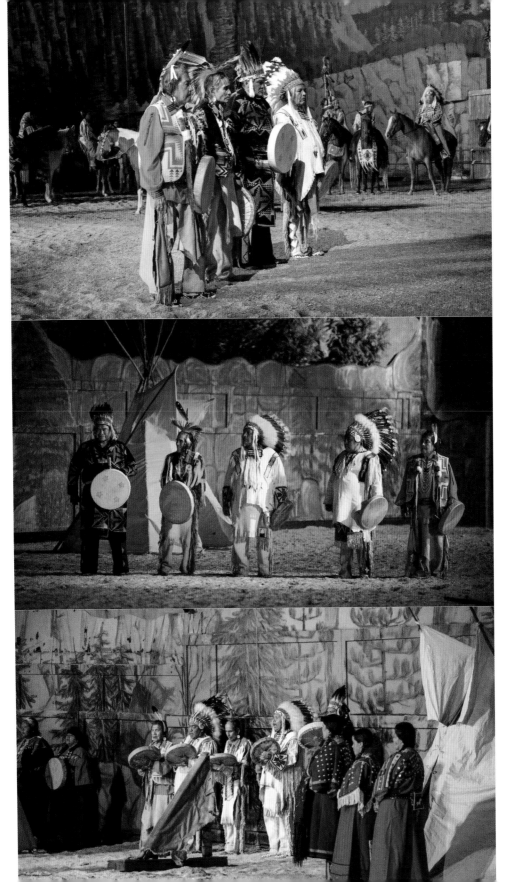

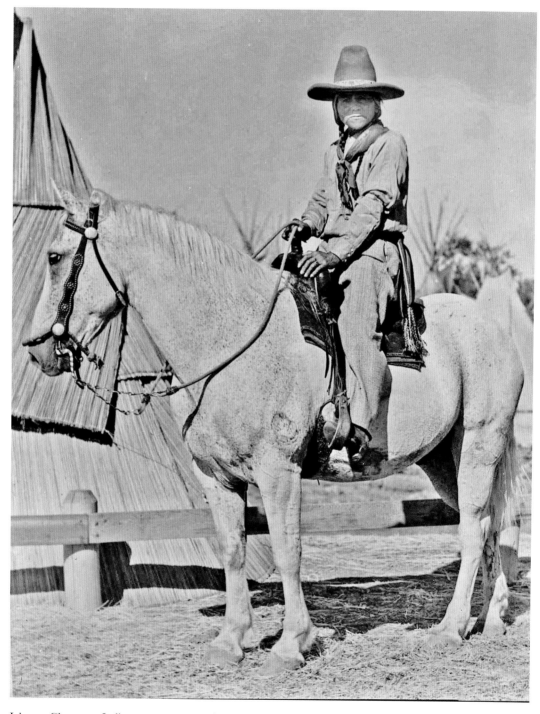

Johnson Chapman, Indian announcer, on a favorite horse. *Howdyshell Collection.*

the groom's family. A feast would usually follow the wedding to celebrate the union. The newlyweds are given a robe to signify that the marriage ceremony is complete.[103]

Leah Conner, who played the part of the bride for many years, joined the Happy Canyon cast at age eight in the role of "making" traditional breads. Upon receiving the Happy Canyon Appreciation Award in 1994, she said, "My greatest reward was to have seen 'my people' play a role that must have been near and dear to their hearts, that of a quiet village scene."[104] Conner family members continue to portray the bride in the Indian wedding scene.

Today, Tamástslikt director Roberta Conner carries the tradition from her mother, Leah Conner, participating in the traditional daily tasks. She can remember being in the show at an early age. "I welcome the chance to remind our neighbors and visitors that we are still here in our homeland, protecting the gifts from the Creator, and taking care of one another," she said.[105]

Enrolled in the Nez Perce tribe, Fermore Craig (*Ko-ya-Mah-Sum-Kin*, meaning "cougar shirt") began acting as a dancer at age four. He was among the "little" tribal dancers who followed the late Susie Williams out of the teepee in the Old Canyon performance. His parents, Daniel Craig Sr. and Louise Sampson Craig, were active in the Old Canyon scenes. Fermore believes Happy Canyon helps demonstrate true Indian culture.[106]

In 1957, Fermore joined the U.S. Army, returning to the cast in 1979. To date, he has had many parts in the show, acting as a raider and an older dancer and participating in the wedding, war ceremony and peace pipe scenes.

The Craig family is a huge part of Happy Canyon. Two of Fermore's daughters, Mary and Sandra, have been Happy Canyon princesses.

Philip Bill followed Johnson Chapman as the first warriors to gallop the picturesque Trail Horse up the steep incline to bring news to the chief—a striking part of the pageant that still remains. These two men were the forerunners for many who have followed in the role.

The one-hundred-year-old part is symbolic for both horse and rider. Roy Raley and the early show directors wanted the audience to

Phillip Bill also played the Indian announcer part. *Howdyshell Collection.*

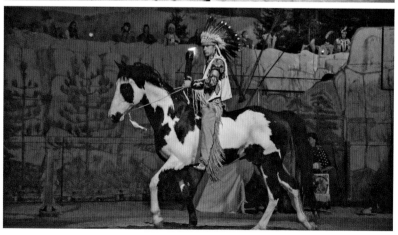

This page: Several shots of Bryson Bronson, current Indian announcer, on Chinook, forming the show's iconic duo. *Eye of Rie.*

Opposite, top: Toni Minthorn pulls travois on a favorite mount. *Harper Jones II.*

Opposite, bottom: Sharon Weathers, longtime travois actor, in regalia in two images. *Left: photo by Don Erickson; courtesy of Hall of Fame Collection. Right: Don Cresswell.*

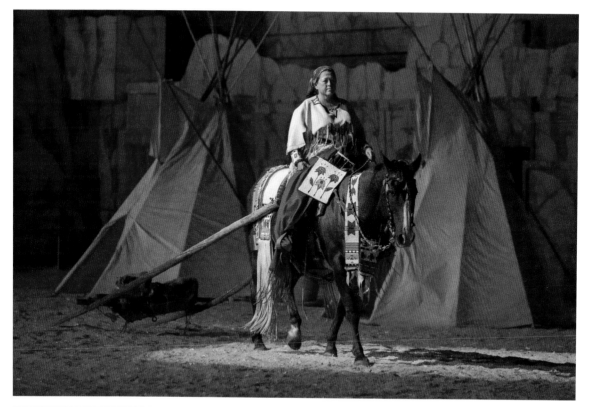

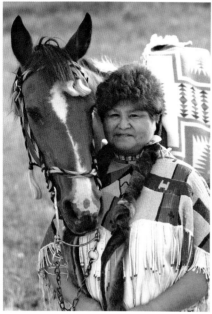

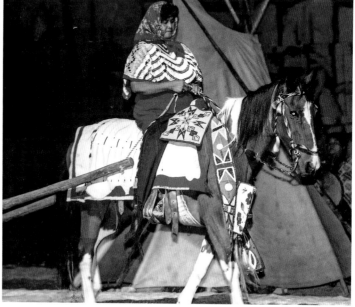

relate by following this horse and rider through the first half of the show.

In the 1920s, the Old Canyon show began to use and display travois. The travois enters the show and passes, quickly showing the nomadic nature of Indians moving from hunting areas to root-gathering grounds.

Several tribal members have pulled travois. When Dr. Richard Koch needed someone to pull a travois behind a horse, ten-year-old Toni Minthorn convinced him she was the girl for the part, gaining her first role in the show.

Sharon Red Elk Weathers, the daughter of the late Robert and Louise Red Elk, invested over forty years in the pageant, participating in the Old Canyon as small child. For years, her father, Robert, played the part of the medicine man. Sharon has acted on horseback pulling a travois in two scenes for several years. This is not an easy task, as a travois takes away a horse's ability to "reverse," making training difficult.

Around 1923, the show added the Lewis, Clark and Sacagawea sequence. The audience watches actual history as Lewis and Clark are led into the mountain scenery with Sacagawea.

The Cayuse, Umatilla and Walla Walla tribes have been hospitable and generous for generations, displaying kindness as Lewis and Clark traveled through their homeland. Descendants of the Indians who met and helped Lewis and Clark now reenact the journey, helping the actors playing Lewis and Clark. As the Welcome Dance is performed, the peaceful ways of the tribes are displayed.

By 1800, more than 30 ships have reached the coast of the Pacific Northwest.

Known as a "matriarch," Annie Johnson was almost one hundred years old when she was honored in 1968 for her years of service to Happy Canyon since 1916. For the first time, she enjoyed the show in its entirety, having only seen pieces throughout the years when she had been a key actor. At age ninety-eight, in 1967, she rode her horse into the arena for the last time. As Russ McKennon said, "Annie rode a horse last year in the pageant but she decided she's getting too old and had better retire." The Happy Canyon board honored her before the Wednesday evening performance.[107]

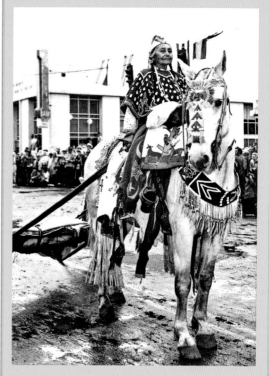

Annie Johnson on her horse in the Westward Ho! Parade. *Howdyshell Collection.*

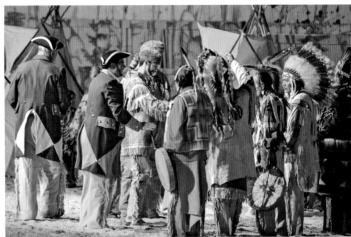

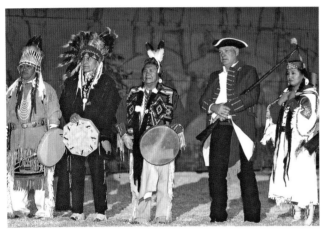

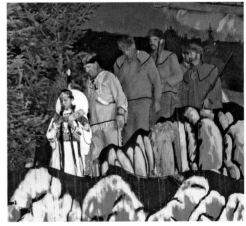

Trade goods and, unfortunately, diseases come up the Columbia River. Beads, trade cloth, and metal goods in the trade network foretold of change even before the arrival of Lewis and Clark.

The Plateau is forever altered after the explorers map our homeland. A few years later, American and British fur companies scramble to stake their claims. Our world continues to change with the arrival of the American missionaries

This page: *Top, right*: Lewis (played by Calvin Ashbeck for thirty-seven years); *left*: Lewis and Clark exchange gifts with tribal leaders. *Eye of Rie. Bottom*: Images of Lewis and Clark over the years. *Don Cresswell.*

Next pages: The welcome dance for Lewis and Clark, led by Mitzi Rodriguez, granddaughter of Anna Minthorn Wannassay. *Eye of Rie.*

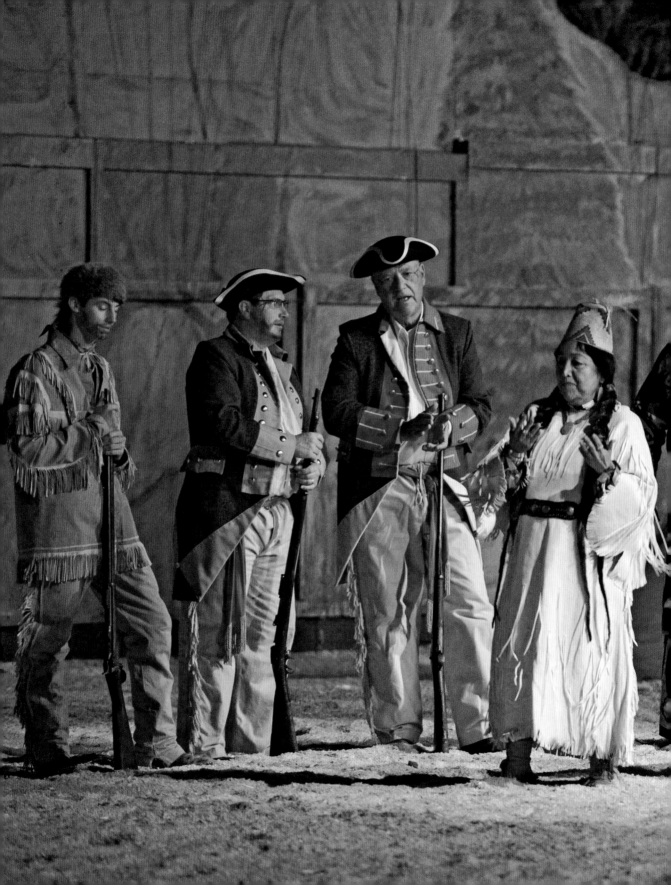

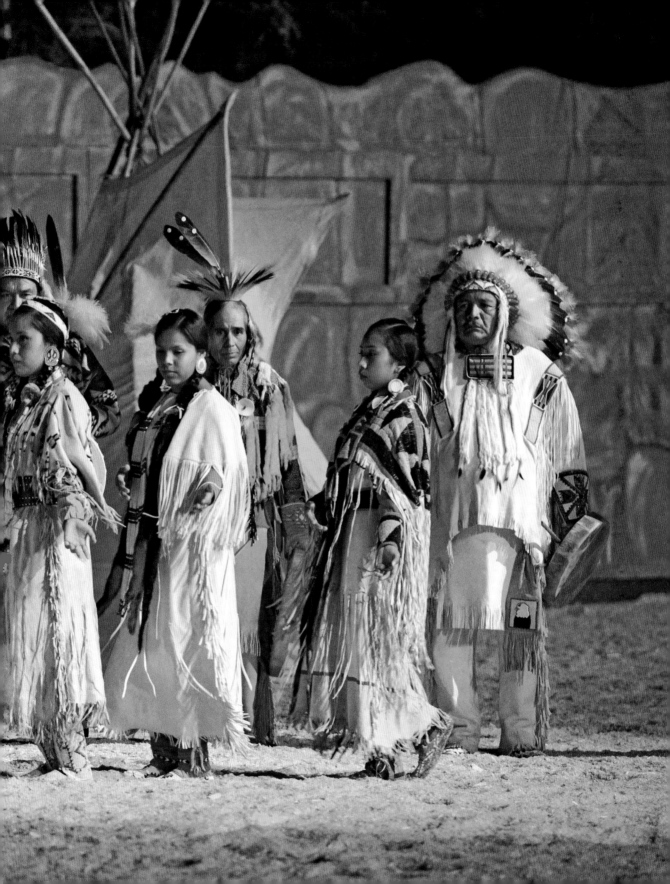

in the 1830's [sic]. The traders and missionaries become competitors as they help their countrymen migrate through our homeland. With the Oregon Trail come many new trade goods, and, unfortunately, more disease.[108]

In the next scene, a warrior enters, brandishing a tomahawk, and relays information to the chief. The war party brings in a captive girl followed by the chief's dead son, draped over a horse.

Dallas Dick has played the medicine man for many years and loves to tell of the time both charges went off in the Indian Sacred Drum, surprising him and singeing his eyebrows. Those in the show directors' booth learned new words that year!

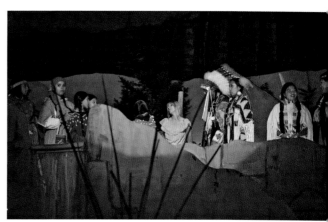

> *The Creator gave our people the ability to heal ourselves. Medicine people have very strong spiritual power. When one of our people is ill or wounded, the Medicine Man sings, prays, and uses his knowledge and the ability bestowed by the Creator to provide care and heal. But nearly half our people die from diseases we cannot cure. The White Man's medicine does not help us. Suspicions about the settlers results in more trouble.*[109]

This page: The captive girl part was added in 1917. Tribal women's role in taking the captive "up top" has passed down through the Pond family. *Eye of Rie.*

Opposite: Dallas Dick plays the medicine man part in these images. *Eye of Rie.*

T.C. Conner remembers well the night they needed the chief's dead son for the medicine man part. As T.C. tells the story: "One night during the war party, the dead Indian hadn't come out in time and somebody said to me 'lie down and play the part,' so I lay down and everybody started laughing. Then the

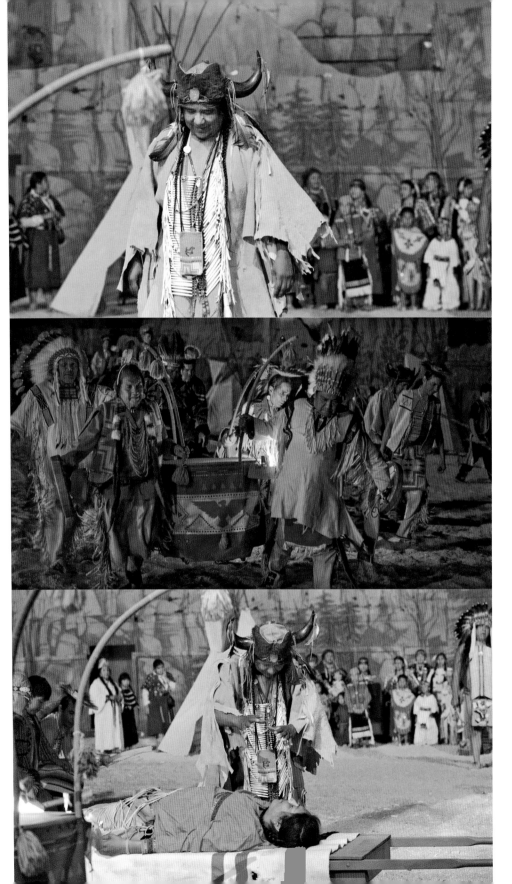

horse with the dead guy showed up. I could hear snickers all about, even though we were supposed to be serious."[110]

THE RESCUE

The 1917 show script included a captive and rescue scene for the first time. A rescue party enters in after the littlest boy dancer leaves the arena, seeking to release the captive girl.

After a gunfight, a young man sneaks up to release the girl, and they both escape by diving into the pool and racing out on horseback. This scene is not without its dangers, and several minor injuries have occurred over the years.

Dorys Grover played the captive girl for only one year, due to the "danger" when she was thrown by Ron Hudson Sr. onto the back of the horse. In the Old Canyon, the main gate to the arena had a slick surface of pavement on one other side, which fresh manure made more of a hazard, according to Bruce Boylen. "That made it exciting!" Dorys said.[111]

Susan Olsen Corey, who also played the captive girl, related how, as she climbed out of the pond one night, Robin Fletcher Jr. flung her so high in the air that she completely missed the horse and landed on the other side. After the horse took off, running out of the arena without a rider, Susan had to "sneak" away. Not many captive girls can say they had to sneak out after being rescued.[112]

Halfway through each show, the music of "The Coronation March" from *Le Prophète* by Meribier can be heard as the wagon master enters from the West Gate. After scouting out the territory, he beckons the wagon train to follow.

The pioneers follow in covered wagon—one pulled by oxen, a rare treat for the audience, and the other by a horse team. Most of the pioneers walk behind, showing the reality of pioneer travel.

In reality, the Oregon Trail is about two hundred yards away from the Happy Canyon stadium—a fact not often known by audiences. The old emigrant road followed the original channel of the Umatilla River from the east edge of present-day Pendleton to Reith Ridge. The wagons entering the show are in proximity to where the actual western migration took place. In fact, thousands of pioneers passed just behind the current Happy Canyon arena—close to where the audience witnesses this reenactment.

The main Oregon Trail entered Pendleton approximately where Mission Highway does now and dropped to Court Place. From there, it curved around the foot of the bluff and followed Emigrant Avenue. Near Southwest Seventh Street, it angled north and crossed the Umatilla River at Tenth Street, following Carden Street before going up Westgate.[113]

In 1841, emigrant trains began to come down the steep descent from the Blue Mountains' summit. The travelers, on their way to the lush, green Willamette Valley, did not stay long in

Opposite: The captive girl, played by several girls over the years. Jodi Sager Bettineski is shown here. *Top and bottom, left*: *Don Cresswell. Bottom, right: Howdyshell Collection*

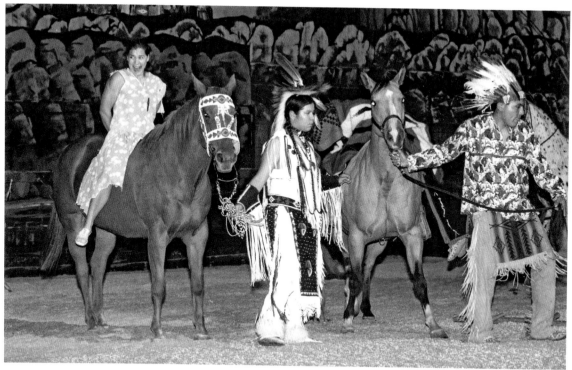

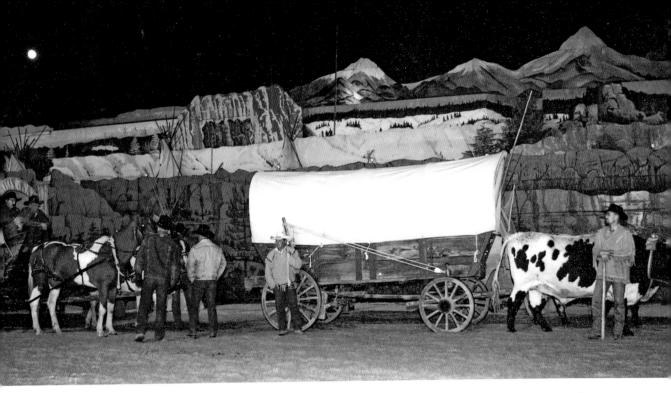

Above: A September moon graces the pioneer act. *Don Cresswell.*

Opposite: *Top, left:* H.J. Kirby was the first wagon master in 1916. *Howdyshell Collection. Bottom, left:* Robin Fletcher Jr. as wagon master. *Don Cresswell. Top, right:* Colby Marshall currently plays the role. *Eye of Rie. Bottom, right:* Colby and Kyle Waggoner. *Eye of Rie.*

eastern Oregon, but some eventually returned to claim homesteads.

As Roy Raley and Lee Drake worked with the actors for the 1917 show in its new location, they met H.J. Kirby, who told Drake he had just moved to Pendleton from Utah to work for Hamley and Co. Drake asked him if he would help them in the show, and Kirby agreed. Kirby became the wagon master, leading in the emigrant train for over forty years until his final show around 1957.[114]

Kirby's son followed him in the part for several years before Bud Wishart took his place, playing the part for twenty years. As Robin Fletcher Jr. took up the reins as wagon master, he remembered fleeting pictures of riding a horse into the Old Canyon at three years old when he began the show. Now, leading wagons into another arena, he did not take the experience for granted.

One year, as Robin rode a new horse that found the crowd and lights disagreeable, the horse bucked instead of cantering. Every night of the show that year, Robin's horse decided it was not a Happy Canyon performer and put on a Round-Up display. At Saturday's show, as Robin rode his bucking equine, show director Steve Corey held up a ninety-two-point bucking bronco score from the directors' booth for another great ride into the pioneer scene. The horse was retired after that year.[115]

Known as the "Granny Cowgirl," Pendleton Round-Up and Happy Canyon Hall of Fame honoree Beryl Grilley has spent over fifty years

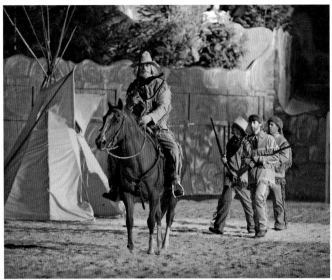

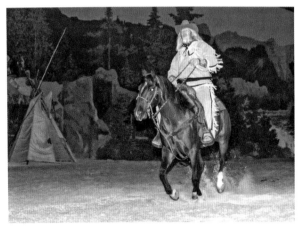

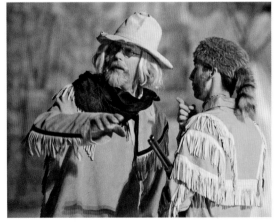

riding into the town scene dressed in a fine 1880s gown and hat. Her granddaughters (Ginnie Grilley, Lynne Grilley, Mary Grilley and S. Kea Grilley) all followed her as sidesaddlers.

She is also known for riding one of her horses with the wagon train. "I think I've ridden enough distance in Happy Canyon[s] over the years to make the actual trip from Missouri," Beryl said in 1970.[116]

From the narration of the show: "Changes continue to come…4,000 emigrants pass through the Umatilla Valley. For many emigrants, the western landscape is harsh and uncertain."

Music has been an essential piece of the pioneer scene since it began in 1917. In fact, the small wooden pump organ used today could tell its own history. It came across on

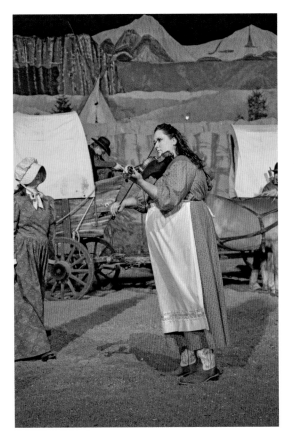

the Oregon Trail, entertaining and lightening the hearts of those on the wagon train.

The quartet piece has been a part of the show for one hundred years, beginning in 1915 with a cowboy quartet on horseback. Many quartets have graced the show in the pioneer scene for the last eighty years, including the Mac Hi Quartette, consisting of Clark Wheeler, Buford Howard, Norman Bline and Ray Hansen in 1930. The young men not only were the State Champion Boys' Quartette but also sang "Clementine" from the top of the scenery.

A quartet in 1939—made up of Rollin McBroom, Marvin Roy, Balfe Ulrich and Will Penland—was accompanied by Mrs. Ted Roy on the same old organ. Featured local talent included Bryan Branstetter, who played the violin, and Bill Smith, playing the harmonica.

The quartet songs around the fire have included "When You and I Were Young, Maggie," and Tom Ordemann, a talented baritone, once sang, "A Long, Long Trail a-Winding" with all the pioneers joining in the chorus. Some years, the audience was even asked to join the quartet's songs. Currently, the quartet sings the old tunes of "Rolling" and "Home on the Range," and a soloist croons "Skip to My Lou."

"All join hands and circle to the left" was a phrase often heard in evenings on the Oregon Trail. Interestingly, it is also a phrase heard at the Happy Canyon dances held at Nolin, Oregon.

As Roy and Anna wrote the Indian attack into the early shows, they were writing from the history of the massive pioneer migration and resulting effects on the local tribes, which led to some conflict.

This page: The quartet was part of the show as early as 1915 and has remained a key scene. *Howdyshell Collection*.

Opposite, top: Megan Corey Furstenberg and Greta Hassler ride in with the wagon train. *Howdyshell Collection*.

Opposite, bottom: Musician Emily Callender lends her fiddle skill to the square dance. *Eye of Rie*.

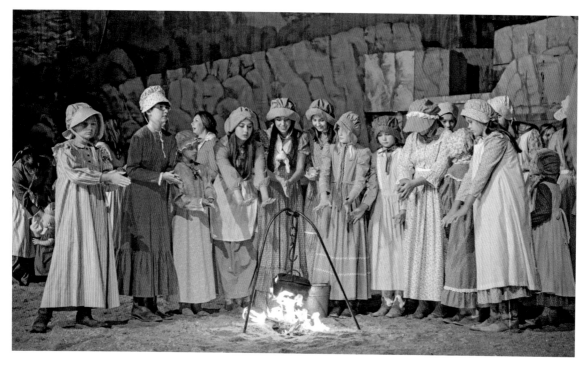

Above: Pioneer children gathered around the fire in the 2015 show. *Eye of Rie.*

Opposite: Images of the 2014 quartet in the pioneer scene. *Eye of Rie.*

While the Indians did not attack the pioneers as often as people seem to think, conflicts did occur in eastern Oregon between the Indians and the settlers. In fact, the 1878 *East Oregonian* reported that seven hundred families crowded into the pioneer settlement of Pendleton "from the Meadows, HAPPY CANYON, Butter Creek and Willow Creek as the threat of Indian attacks grew."[117]

General George Crook told an *Omaha Herald* reporter in a reprint in the 1878 *East Oregonian*, "I do not wonder, and you will not either, that when these Indians see their wives and children starving, and their last sources of supplies cut off, that they go to war. And then we are sent out there to kill them. It is an outrage."[118]

Because of this history, Roy Raley included attacks in the script. Much of the historical fighting, including the last decisive battle, was in Umatilla County. As Roy wrote this part of the script, it had only been thirty-eight years since this battle. What the crowd witnesses in a total of around four minutes is just a taste of local history.

The crowd never sees the good-natured ribbing that occurs every year before the scene is enacted. Indians and cavalry joke, and tribal warriors use their favorite line: "We are going to win this year!"

The Indian raiders' common goal is seeing who can win the "race" around the stationary

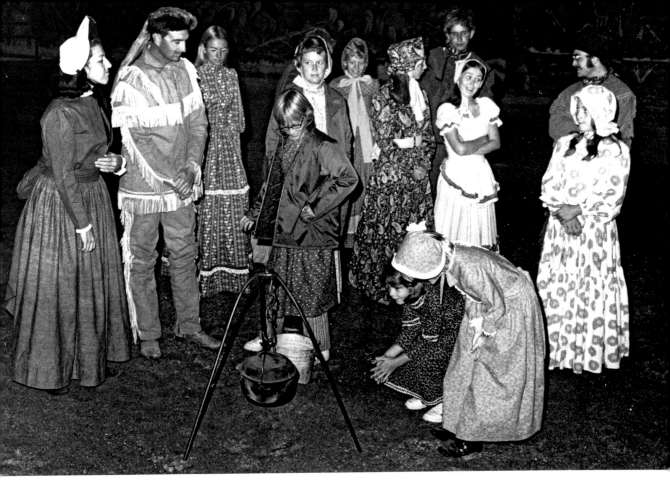

This page: Pioneers reenacting their history. *Howdyshell Collection.*

wagon and team. The goal, according to Chief Gary Burke, is to make three laps around the wagon, and it has caused some interesting outcomes in horsemanship.

One night of the show, as Chief Jesse Jones Jr. rode in as a raider, his cinch broke, sending him and his saddle flying into the arena. With all of the commotion of the raiders' horses, the cavalry's entrance and the gunfire, he could not catch his horse. But Jesse did not miss a beat. He tossed his saddle into the back of the wagon, climbed in after it and rode out with the pioneers, waving to the crowd.[119]

Roy Raley loved to tell the story of when the Indian war party entered the arena as a few raindrops began falling. One of the warriors

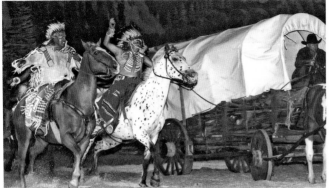
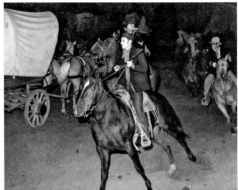
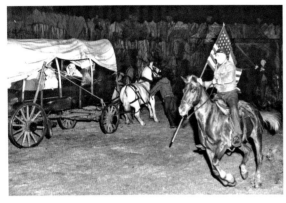
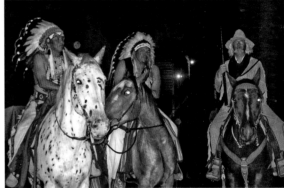

This page: Images of the raider scene over the years. *Top, left: Don Cresswell; top, right, and bottom, left: Howdyshell Collection. Bottom, right:* Raiders chat with the wagon master before the "conflict" they enact. *Author file.*

opened his umbrella as he and his horse came into view, holding it over his head with one hand and shooting at the wagon with the other. Needless to say, it brought the house down.

In the old location, one of the crowd's favorite scenes featured spectacular leaps from the cliff in the Indian warrior attack and the "fall over" Indian.

Roy Raley wrote about this scene, entitling it "The Hobble." He said, "The Indian who gets shot and hangs over the cliff by one foot 'caught on the rock' has been a good 'gasp' for the customers since the first time I used an Indian part in the Canyon."[120]

Many men in the Conner family have played the dramatic part of the "fall over" Indian,

falling over the cliff with only a chain holding them in place over the second-level rocks in the scenery. Cecil and Norman Conner performed this scene for years, followed by John, James and T.C. (Tom) Conner, a third-generation actor.

The part has now been passed to fourth-generation Cyrus Conner, who takes this role seriously. This is another example of the beauty of generational parts, especially as this is one of the harder stunts performed during the show.

Each night before the show begins, T.C. and Cyrus check the chain that holds Cyrus's foot

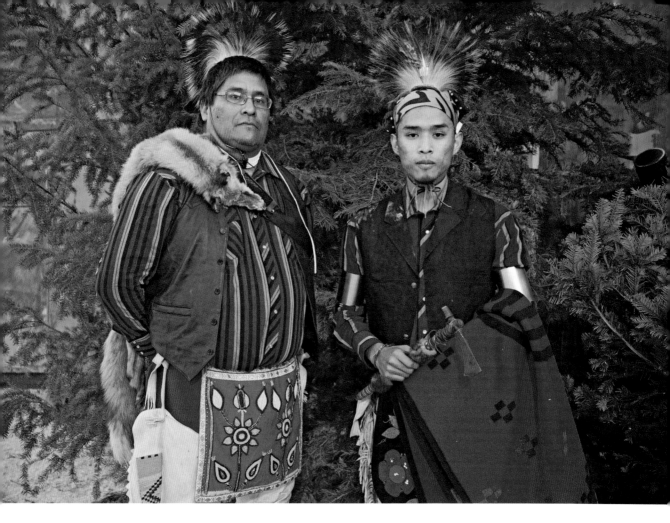

when he is "shot" and falls over the scenery backward in this dramatic, spotlighted stunt. T.C. learned the hard way that after the show is over and opened up to the gambling and dancing crowd, people sometimes mess with the chain.

T.C. will never forget his debut performance in the act when his brother John, who had done the part for years, instructed him as he made the fall: "Whatever you do, don't look back!" If he did, he would hit his head on the scenery.

T.C. described his nerves kicking in as the part approached and he watched the battle scene below, waiting for his cue. He remembered:

I pop up, throw off the blanket, gave my war hoop and started shooting, pretending to take some hits, spun and fell back....I looked back...."BANG"...is that the lights going off or am I blacking out?...Get up...get up,...(I say to myself) so I swung back up and released the chain....My brother was waiting at the bottom of the stairs and said, "You looked back, didn't you?" and started laughing.[121]

Before the scenery changes, the audience witnesses the Passing of the Race and the

Pipe of Peace scenes. These scenes are not easy to watch, nor are they intended to be. Creative team Roy and Anna intended the audience to feel the poignancy of the 1855 treaty and the establishment of the Umatilla Indian Reservation:

> *The establishment of the Umatilla Indian Reservation ushers in an era of radical change. The marked land now governs our lives. We must live on the reservation. Indian agents and missionaries want us to become farmers, to stay in one place and to give up our old ways. Traditional life ways are suppressed. We are forced to give up precious land, horses, and expeditions.*[122]

"This spectator felt somewhat guilty for being a member of the society that was responsible for changing such an idyllic scene into the so-called civilized era that followed," the *East Oregonian* noted.[123]

The current show narration says it best: "We struggle to ensure that our sacred foods, customs, traditions, and songs continue. Our Tribal history and culture are inseparable from this land. We are still Natitaytma. But, our lives have changed forever."[124]

The show does more than entertain. It educates both Indians and non-Indians as a timeless reminder seen by volunteers and audience members each year.

In 1994, Inez Reeves rode horseback in the show in a role her late mother had passed to

Opposite: T.C. Conner, third-generation actor, passing the "fall over" Indian part to his nephew Cyrus Conner, a fourth-generation actor. *Eye of Rie.*

Below: The 1855 treaty scene, added in 2002. *Eye of Rie.*

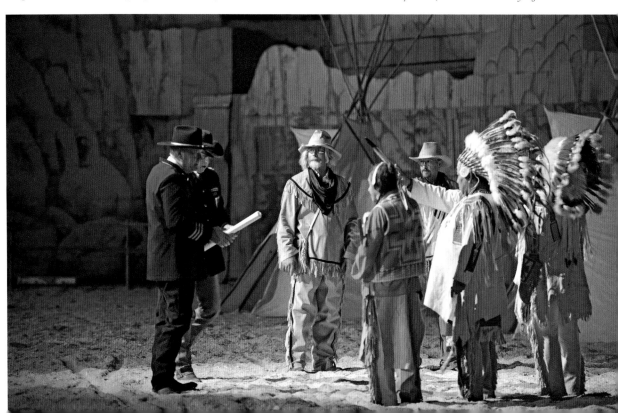

her, though she first began in the pageant as an infant on her mother's back. "What I look forward to is meeting more people," she said. "I was hoping they would understand the Indian ways and how they lived before the settlers came." She stressed how it is important that young people, such as her granddaughter, also learn from the pageant and its traditions.[125]

Louie Dick believed the show was more than good entertainment. "The show helps younger Indians understand more about their culture," he said. "It's another outlet for passing on tradition. Behind the scenes, there's a lot of tradition passed on."[126]

Happy Canyon is a part of the Cayuse, Umatilla and Walla Walla heritage, depicting the legacy they have created over thousands of years.

One spectator said it well: "Certainly enjoyed the beauty and history of the pageant. I hope that this always remains as an integral part of the Round-Up and that you don't spoil it by television or any of the other commercializing processes."[127]

6

THE SCRIPT PART TWO

Wild West Show

Happy Canyon opens tonight. That simple statement may not be of prime significance to the outside world but to the thousands of residents and visitors in Pendleton it is a message brimful of joy.[128]

The music tempo suddenly changes up to *vivace* as the harness jingles and the arriving stagecoach loudly rolls into Happy Canyon. Watching the bandits attack the stage, the audience can see history played out, as an actual Wells Fargo stage robbery occurred in Pendleton's early years, according to the *East Oregonian*.[129]

In 1900, stage fare, round trip from Pendleton to Ukiah, Oregon, was only four dollars. Happy Canyon began only fourteen years later and used a stagecoach in the first show.

Taking the stagecoach in Umatilla County could be hazardous, as evidenced in the story of Elsie Conklin, who later became Mrs. E.B. Aldrich. Elsie remembered taking a stagecoach pulled by a four-horse team—exactly like the one Happy Canyon uses today—from Pendleton to Albee. Elsie also recalled the driver drinking whiskey with a salesman on top, giving him frequent nips. Soon the driver whipped the horses into a dead run, causing the stage to bang across rough roads while dust swirled inside. "I thought I'd never get there alive," Elsie said.[130]

When the stagecoach comes rolling into the Happy Canyon arena, it offers a taste of a bygone mode of travel common to eastern Oregon. In 1914, Happy Canyon featured the stagecoach bringing mail to the "town" and money to the "Spender's Bank." A century later, the stagecoach is still a show highlight.

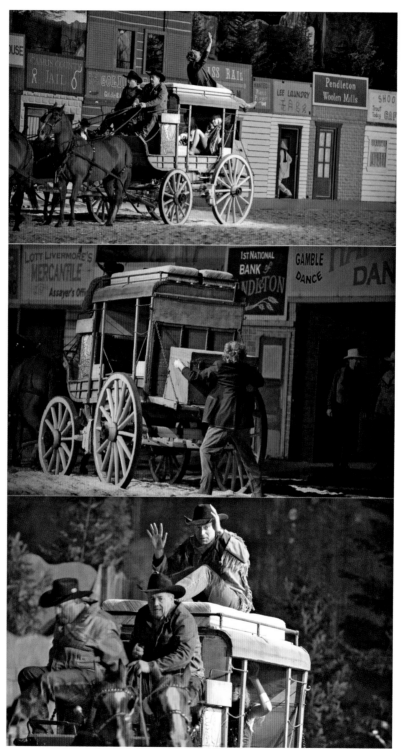

All Stand by for Scenery Change!

The 1917 *East Oregonian* report glowed. Roy Raley had been working all summer to improve the hastily built 1916 show set, and his key "scenery changers" worked to perfect the scenery shift that has become a famous part of Happy Canyon. In a twinkling of an eye, they transform the arena to an 1880s Wild West town that could easily be Pendleton in 1889.

In the middle of the show, lights shine into the audience's eyes. Within thirty seconds (at least that is the goal), the scenery changes from a picturesque eastern Oregon mountain scene to a late 1800s Wild West town, complete with a saloon, blacksmith shop and Chinese laundry.

Each piece of the scenery has to be lifted or moved by hand, though most pieces are counterbalanced with rope, pulleys and window weights. At least twenty or more people make this change happen, and several have done their special part for years. As in most parts of Happy Canyon, some volunteers have been hurt when a piece goes haywire.

The scenery change brings the audience to the gaiety of the original place that became Happy Canyon's namesake.

This page, top: Tim Hawkins (left) and Dick Houston in the tent scene. Tim began acting at age ten. *Howdyshell Collection.*

This page, middle: The town drunk and sheriff begin a new day on the streets of Happy Canyon. *Harper Jones II.*

This page, bottom: The wooden Indian on the street gets a shower from the bedpan. *Howdyshell Collection.*

Opposite: A stagecoach has been part of the show since 1914. *Eye of Rie.*

At the turn of the century, Pendleton was one of the wildest towns in the West. It was a rough cow town where six-guns, sport and cozy rooms were found. Situated on the Oregon Trail, Pendleton boasted of thirty-two saloons on Main Street alone, where cowboys, sheepherders and gold miners came for entertainment after bathing at the Chinese establishments.

Roy Raley did not have to reach far into history to write the first several scripts using only Pendleton's past history. The year 1880 was only thirty-four years in the past.[131]

As the house lights come up and the spotlight focuses, the sheriff exits the saloon to light his cigar and survey the town. Another day has dawned in Happy Canyon.

In years past, this scene included a wooden Indian—one year enacted by Tygh Campbell. A small piece of sandpaper was glued to his cheek so the sheriff could light his match on the side of his face. One night, the sheriff that year, Robin Fletcher Jr., was a wee bit happy and kept trying to light the match, causing the sandpaper to ignite. Tygh, as the wooden Indian, had a hard time maintaining his part as he tried to communicate to Robin that his face was on fire.

SWIM KIDS

Beginning in the Old Canyon, the swim kids used to jump in a wooden barrel after exiting the water and run into the scenery. For the last sixty years, they have had an ongoing war with the sheriff, whose goal is to try to catch

Top, left, from left to right: Fifth-generation swim kids Wyatt Marshall, Riley Waggoner and Easton Corey are just a few of the many boys who have braved the cold water. *Eye of Rie. Bottom, left and right: Eye of Rie. Top, right: Don Cresswell.*

one of the small boys as they run across the arena in sawdust.

Swim kids and fifth-generation actors Easton Corey, Riley Waggoner and Wyatt Marshall, as their grandfathers before them, love playing this part. They love being in the show and plotting each night how to surprise the sheriff as he comes to pull them out of the pool. "Happy Canyon is like one big special family," Riley said. "It is fun to make new friends with kids your age."

TRUNK ACT

The trunk act was added in 1950. It began with an infant or a small child coming out of an old trunk. Later, a trapdoor in the scenery allowed several kids to climb out through the trunk. Bridget Boylen Van Cleave recalls being a part of the original trunk act with her sisters and the Simonton boys. Bridget even remembers a baby burro coming out with them one year and, later, a dog with puppies.

After several directors in the 1960s traveled to Hollywood to visit Yakima Canutt, they decided to expand the trunk act. The revision is still used today. Many cast members have debuted in the trunk act when they were "volunteered" at a young age by their parents, who were usually already in the show. This has included several small babies, who were sometimes just weeks or months old, as the last of the children to leave the trunk. The act is always a crowd favorite.

Delores Swearingen acted as the "mother" for many years and will never forget the night she distracted the children from seeing the bats hanging above their heads. Among the cast, the trunk boys are famous for pulling off the trunk girls' red wigs.

Many fingers and unsuspecting foreheads have fallen victim to the heavy trunk lid when it closed too quickly. Also, out in the arena, several actors have fallen through the trapdoor when it was not properly latched.

THE MINER

In the 1920s, the miner, with his pack outfit, came down out of the "mountains" and made a temporary camp—complete with a fire—before he made his way into town. The current miners tussle with a bear (costumed actor) before they come to town.

Opposite, top: Simonton family in various roles. *Top:* Tom (right) as blacksmith; *right:* Tom and Vera Simonton, shown here with their sons, were the first trunk dad and mom; *bottom:* trunk act. *Howdyshell Collection.*

Opposite, bottom: Miners in the upper set with a watchful bear. Trained bears appeared in the 1917 and 1918 shows. *Eye of Rie.*

Page 138: Trunk act mother Shelley Marshall is happy to see her "kids" have arrived safely. *Eye of Rie.*

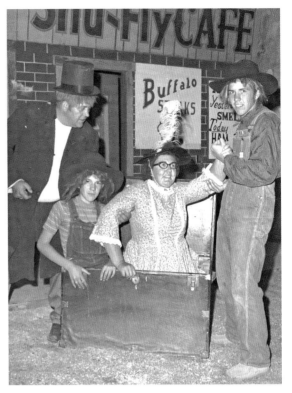

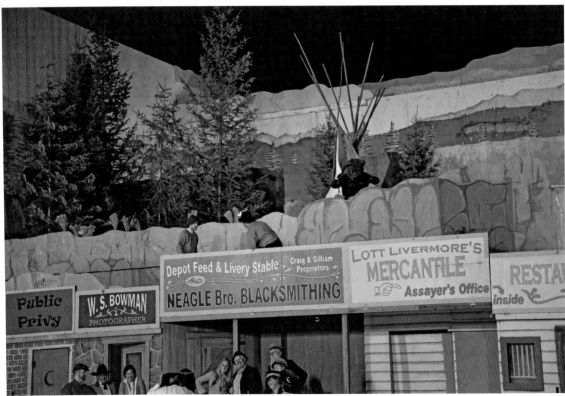

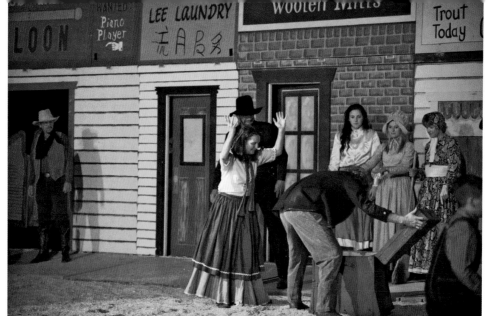

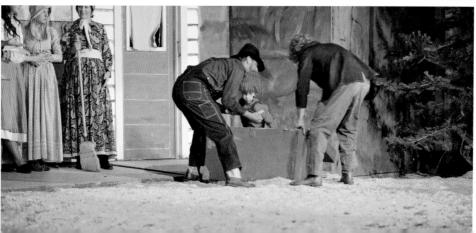

CHINAMEN

The Chinamen were used for character parts in the early shows and quickly worked into various acts remaining today. When Bob Critchlow played a Chinaman one night, he was caught off guard as he prepared to dive into the pool. Instead of the zippers now used in costumes, a safety pin held his pants together. As he jumped to clear the fence, a post caught his pants and ripped them completely off, leaving him exiting the pool in his skivvies. "I made a long, embarrassing dash across the arena for cover," Bob said. You never know what might happen at Happy Canyon!

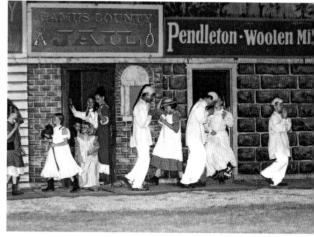

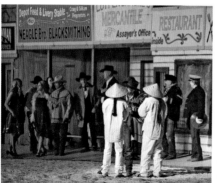

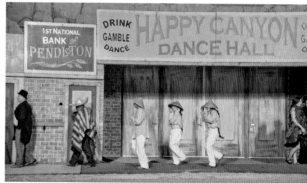

Chinamen, a reality in Pendleton and its underground, have been in the show for decades. *Top image: Don Cresswell; middle images: Eye of Rie; bottom: Harper Jones II.*

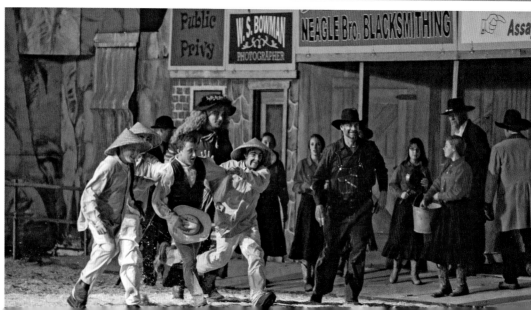

HUSBAND AND WIFE ACT

The husband and wife act began in 1928 and has been in the show ever since. This act consists of a small buggy driven by the large wife accompanied by her browbeaten husband. As she makes her purchase, he flirts with a dance hall girl and quickly finds himself thrown in the pool by his wife. Three generations of Hudson men have played the wife part, beginning with Ron Hudson and followed by his sons, Kevin and Marty. Young Ron Hudson and his cousin Will Hudson played the wife as the third Hudson generation—both "good strong women."

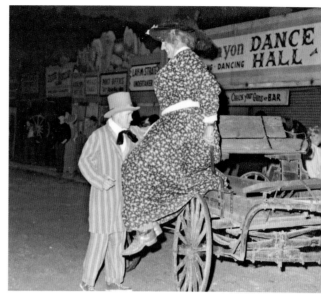

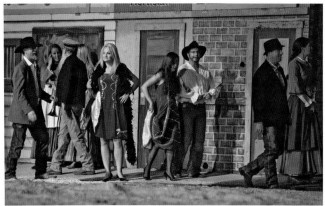

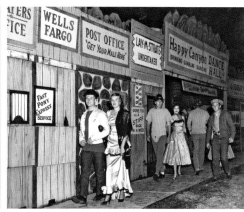

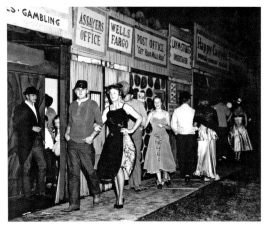

This page: On the streets of Happy Canyon, many dates and priceless conversations have occurred. *Top, left: Harper Jones II; top, right, and bottom, left: Howdyshell Collection; bottom, right: Eye of Rie.*

Opposite, top: Ron Hudson Sr., acting as the wife, and Dean Fouquette, acting as the wet husband. *Howdyshell Collection.*

Opposite, bottom: The husband and wife act is still a crowd favorite. *Left to right*: Zach Szumski and wet husband, Chris Zimmerman. *Harper Jones II.*

Bruce Campbell played the part of the husband in the Old Canyon. He remembers well how cold the water was and how the old pool resembled a true "pond" compared to the current one.

DR. HAL

In the 1980s, Fritz Hill envisioned an Old West "elixir" salesman coming to town, and the Dr. Hal act was born. Fritz said he was always

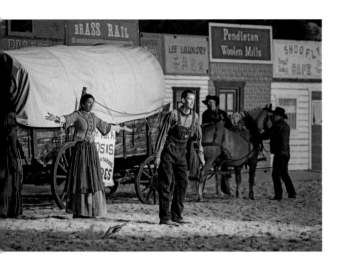

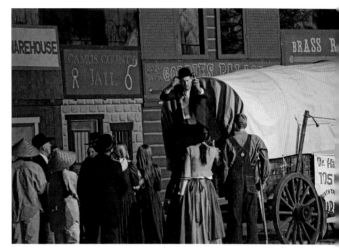

Above, left: After drinking the "tonic," Johnny Stuvland sees its lack of effectiveness. *Eye of Rie.*

Above, right: Dr. Hal, played by Robert Pahl, sells his bottles of elixir. *Eye of Rie.*

thinking about ways to improve the show and add acts. One evening in particular, Fritz remembers discussing the Dr. Hal act with his youngest son, Winston, when Winston thought up the "young kid" who drinks the actual tonic, experiences rigor mortis and has to be carried out. It has remained a major act since that time.

Ray Bowman first played the part of Dr. Hal and Pat Maney followed him for several years. Currently, Robert Pahl acts the part.

Over the years, the tumbler (having just drunk the curing elixir) has been enacted by several excellent gymnasts. It is no small feat to tumble in a dress with two obstacles and sawdust. Yet, night after night, skilled local gymnasts do just that.

CANCAN

The cancan dancers first performed in the 1950 show, and they have danced in Happy Canyon ever since. Proceeding their act, the Spanish Dance occurred right after the stagecoach came to town, performing on and off beginning in the late 1920s through the 1930s.

Since 1950, many girls have dressed in the Happy Canyon cancan dresses, fishnet tights and ballet flats to perform the dance on the famous boardwalk. Children in the cast have their eyes covered, and the preacher or circuit rider riding by pretends to not notice. The cancan girls spend extra time preparing for their part in addition to participating in parades and visiting several retirement homes with the Happy Canyon princesses.

After beginning practice during the summer months, the girls are ready to perform the four nights of Happy Canyon. Shelby McQuinn remembers her first performance well. She was chosen to be the "lead" dancer and became really nervous at the time of the performance.

The cancan began in the show in the 1950s. *Howdyshell Collection.*

Above three images: Images of the current cancan team, coached by Shelby McQuinn. *Eye of Rie.*

Center three images: Cancan in parades over the years. *Howdyshell Collection (top, left and right), Eye of Rie (bottom).*

Far right, top: The 1970s cancan squad. *Becca Hawkins-Zollman.*

Far right, bottom: Laura Herbes and Diane Court-Wagner sidesaddling. *Harper Jones II.*

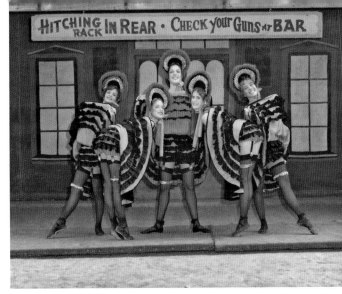

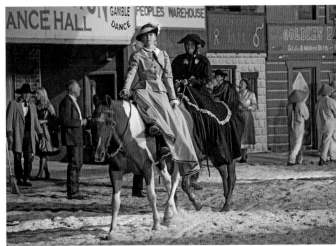

SIDESADDLERS

Riding in huge, sweeping dresses on a sidesaddle is no easy feat for the actors. Over the years, the women have collected stories of the wind catching the dresses or of horses spooking as they enter the arena.

"Being the first cancaner out of the door means you have to yell 'clear the boardwalk' and watch for sidesaddlers and listen for your cue," she said. "The orchestra would play those first notes and out you go screaming the entire time. It is a huge adrenaline rush."[132]

HICK BAND

To spice up the ending, R.W. (Robin Wesley) Fletcher, who played the sheriff, added the Hick Band in the 1930s. The Hick Band has been a favorite promotional Happy Canyon group in the show and parades.

Over the years, various musicians were featured as a part of the Hick Band, such as Edwin "Buddy" Baker, who played with Woody Herman and Stan Kenton and was known throughout the nation for appearances in big-name bands. He also joined with Si Zenter to play for the dance after the show.

The 1964 show concluded with NBC-TV's Doc Severinsen on the trumpet as part of the Hick Band.

Below: The Hick Band in the Westward Ho! Parade. *Howdyshell Collection.*

Right: The current Hick Band group adds spice to every show. *Eye of Rie.*

In 2009, the Zimmerman brothers, Gary, Dennis, Jeff and Wally, received the Happy Canyon Appreciation Award for their service to the show in both the Hick Band and the Mounted Cowboy Band, as well as other parts. Gary related how the Hick Band was originally overlooked in the 1980s, when several parts of the show were invited to the Westward Ho! Parade. In true Hick Band form, they entered themselves into the parade, where they stayed

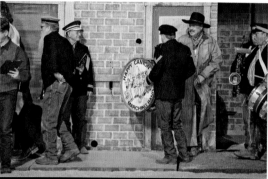

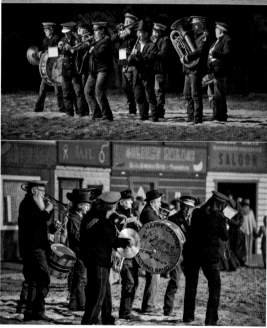

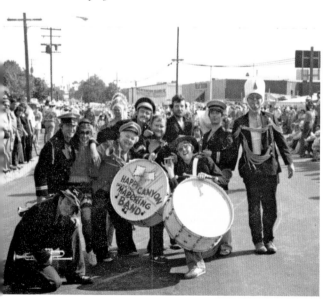

for years until they transferred to the newly formed Mounted Band. Who can forget Tommy Ruth Gardner leading the Hick Band down the street, bringing a smile to everyone who saw them?

PETUNIA

In 1928, Elmer "Peanuts" Pozegar created the "Peanuts and Petunia" dance routine featured until 1930. His dance partner, "Petunia," was a lovely stuffed dummy, but the dance steps improvised by Peanuts so entertained the crowd that for years, he received fan mail addressed to: Peanuts, Pendleton, Oregon.

When Fritz Hill was given the part as Petunia's hot date after Bill Morrison retired from the part, he looked up Peanuts Pozegar for advice on dancing with petulant Petunia. Peanuts demonstrated the important footwork and passed on his tricks of the trade.

When Fritz Hill inherited the act, he began "talking" to Petunia as he danced with her, treating her as if she were real. He once had someone ask him what he was saying to her as he danced, since the audience could see the conversation. One night, she took him down. When Fritz wasn't looking, she crossed her legs, causing Fritz to misstep, and into the sawdust they went.

"I wasn't sure if I taught her to dance or if she taught me," Fritz said.

Jim Whitney found out Petunia could be vindictive with guys who gave her rough treatment. One night as Jim went to "yank" her back up out of the sawdust he felt something give way in his shoulder, as his rotator cuff gave out. He said, "That old girl was a lot heavier than you think."

Top, left: Fritz Hill "talking" to Petunia. This act has come and gone over the years. *Howdyshell Collection. Bottom, left, and right*: Dancing with Petunia. *Eye of Rie.*

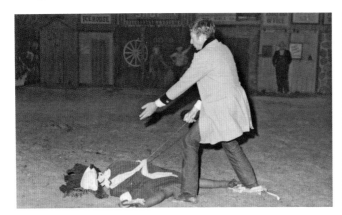

ACTS OF ONE HUNDRED YEARS

Quadrille

Beginning as a key act, the quadrille—or square dancing on horseback—has been a show mainstay besides a couple years' absence. Since the show has moved to its current location, the quadrille usually takes place as part of the finale.

In 1915, the mounted quadrille was the second act and a huge hit due to the horses' speed and intricacy. In the beginning, these quadrille teams consisted of professional cowboys and cowgirls known for their precision as they "danced" on horseback. The *East Oregonian* described how the riders "went through the steps of the old fashioned cowboys' horseback dance."[133]

In the 1920s, professional cowboys and cowgirls came from Round-Up to ride in the quadrille. In fact, Bertha Blancett, well-known Round-Up champion, led the quadrille at Happy Canyon in 1921.

As a result of the Depression in 1931, the board could not hire professional riders due to funding restrictions. Together, show director Glen Storie and Floyd "Sandy" McDonald, an employee of the Storie Ritner Ranch, started the "Depression Kids." This quadrille riding team consisted of Carlton Luck, Louis and Robert Umbarger, Evelyn Caplinger, Janet LaFontaine, Mary Bond, Shirley Thompson and Sandy McDonald. In the late 1930s, the quadrille began performing as a finale or near the end of the show.

Opposite, top: Quadrille teams over the years. *Howdyshell Collection.*

Opposite, bottom: Bank robbers on well-trained horses shoot up the town. *Harper Jones II.*

Below: The quadrille team in 1967. *Howdyshell Collection.*

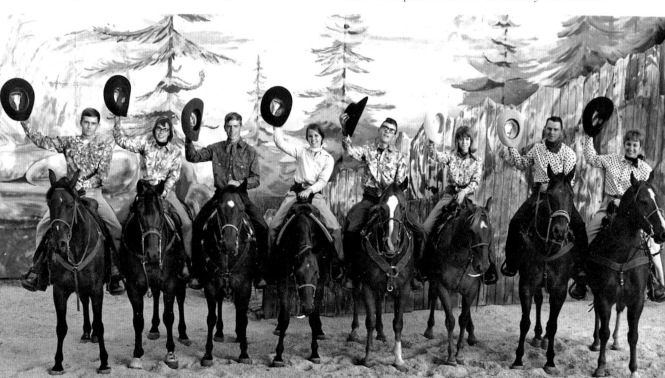

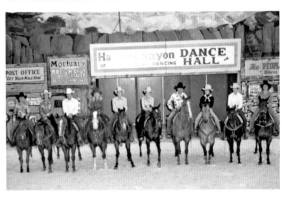
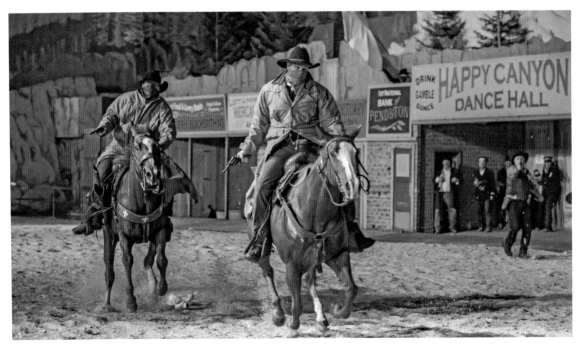

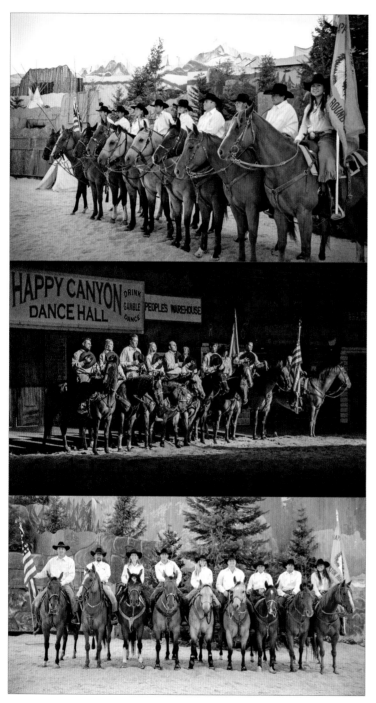

After a lapse of several years, local cowboys and cowgirls revived the quadrille as the show finale in 1948 under the direction of Bill Stram and Bob (R.A.) Fletcher Sr. It has remained a major and much-loved part ever since. Bob related how the act was so popular that a show producer once asked him if he would stage the quadrille in Hollywood. As usual, Happy Canyon said no, thanks.

Bob and Joyce Hales, who rode in the Old Canyon quadrille, shared stories of how the sparks flew from their horses' feet the moment they hit the pavement after leaving the old arena. They said it was always the most exciting part.[134]

In a letter to the editor of the *East Oregonian* in 1968, Major General Joseph Sweeney of Donegal, Ireland, said, "The figures were done at the gallop and a high degree of perfection was reached."[135]

The mounted quadrille takes hours of practice, and though the riders make it look easy, the dance can easily go haywire in

The current quadrille squad puts in many hours before the performance and is led by Liz Johnson Bronson. *Eye of Rie.*

the small arena. Jackie Culham remembers the night her horse hit the wet boardwalk and went down on its side. But Jackie and her horse never missed a beat; even though Jackie was injured, they finished the quadrille. Usually, the performance goes well, but sometimes, the riders come too close, resulting in banged-up knees and bruised muscles.[136]

The dance has a total of ten riders: four pairs of "dancers" and one pair of flag bearers. The fast-paced "dance" is done at a lope. They stop, spin and prepare for the next move. Former actor and director Bruce Boylen described how the cowboys and cowgirls of thirty years ago performed the quadrille with such skill that it was hard to keep up with each turn they made. These were the years when a mistake meant you could easily be replaced with a better rider.

One evening, the squad realized they needed an extra girl to ride but could not find one. They did the next best thing and dressed up Berk Davis as a girl, using balloons to help authenticate the look. The quadrille did not go quite as well that night, since Berk struggled to make the proper spin and turns of a "girl" part.

Sheriff

R.W. Fletcher began the sheriff role in the first show in 1914 on Main Street. The Fletcher family is one of the oldest in the show, with continuous participation covering five generations since the show's first year. R.W. played the sheriff part until his death in 1943. The part has been passed from father to son

to grandson and continues to be enacted by someone in the Fletcher family.

Bob Fletcher Sr., who played the part after his father, said, "It's possible that there'll be a fourth generation of the family playing the part of sheriff in a few years."[137]

He was right. Currently, fourth-generation actor Colby Marshall, husband of Shelley Fletcher Marshall, acts as sheriff in Happy Canyon's one-hundred-year history.

After Bob Fletcher Sr. played the part, his son Bill and Bill's two sons, Andy and Bill, enacted it. Bob's other son, Robin Fletcher Jr., and son-in-law Allen Waggoner, also took on the sheriff role.

The sheriff and the paddy wagon door are a bad combination, with most of the Fletcher men getting injured (usually an injured nose) one way or another as the drunk and the door land on top of the sheriff. One show, Sheriff Colby got his finger wedged in the door of the paddy wagon, but thankfully Dr. Gary Zimmerman, a real chiropractic doctor and part of the Hick Band, did a backstage "adjustment."

Doctor-Shorty Act

The 1915 show added a comedy stunt that has remained a crowd favorite for one hundred years—the wild Dr. Killum act. The first "shorty" in this act was a cattle buyer who had actually lost his legs at the knees in an accident.

As the *East Oregonian* explained, "By far the most developed portion of the play is the grisly surgery scene of Dr. Fritz Hill. The doctor rushes from the audience to amputate both legs of a gunshot victim; one leg being stolen and rushed off to the grocery store."[138]

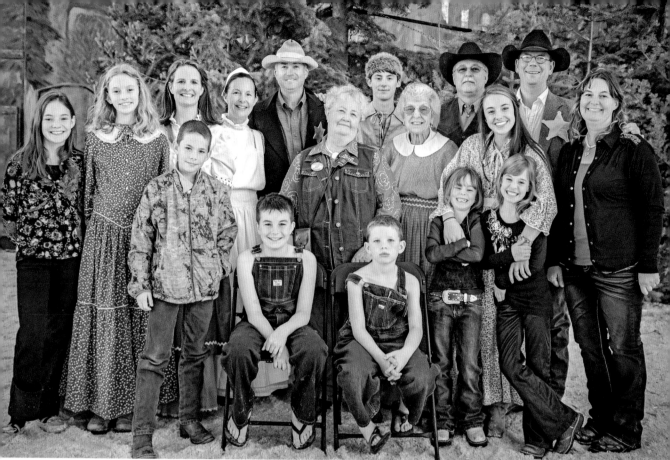

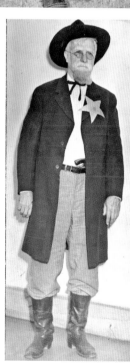

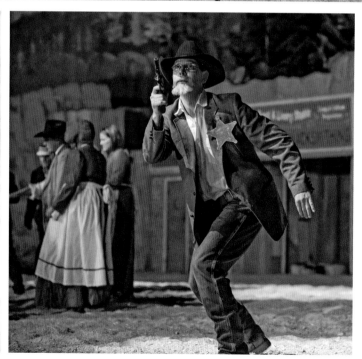

Sometimes, the cast and the audience are simultaneously taken off guard. The gambler often receives unexpected answers as he yells into the audience, "Is there a doctor in the house?!"

During one show, the audience produced three responses. One was Jason Hill, who currently acts as the doctor. The second was a gentleman in the crowd, thinking he was funny and trying to bring his own humor. The last was a real doctor who thought it was an actual emergency.

After a momentary silence, it was sorted out and the acting doctor, Jason Hill, continued on with the act, removing the poor fellow's legs. Imagine the real doctor's surprise when he realized he was not needed!

Opposite, top: Fletcher family, now with several fifth-generation actors in the show. *Eye of Rie.*

Opposite, bottom: *Left*: R.W. Fletcher, shown here in 1938, was the first sheriff, appearing in 1914. *Howdyshell Collection.* Colby Marshall (right), fourth-generation actor, currently plays the sheriff. *Harper Jones II.*

Below: Images of the current Doctor-Shorty act with Jason Hill as Doc Killum, Nurse Becky Waggoner and Brian Zimmerman as shorty. *Harper Jones II.*

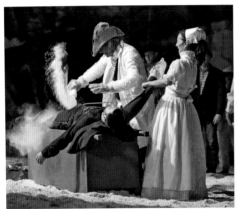
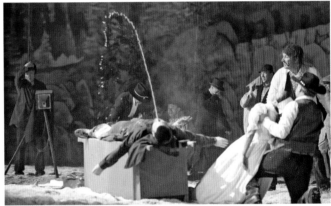
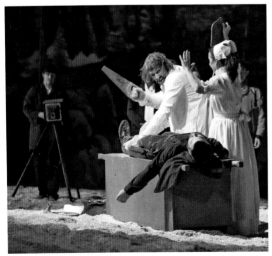
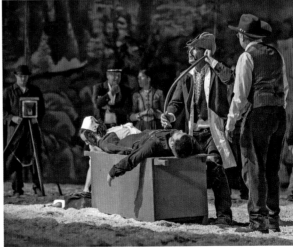

Happy Canyon—The Funny Side!

By Ann Terry Hill

Since the beginning of the western village part of Happy Canyon, the show has included a bad guy getting his legs blown off. A September 1915 article in the *East Oregonian* states: "One of the comedy stunts which caught the fancy of the crowd was the surgical operation performed by the village doctor."

This act has continued to delight crowds through the years. When Jim Hill Jr. took over the act shortly after World War II with Shorty Coffman, a double amputee, the act changed to the doctor running down from the stands after Shorty had been shot. The street scene actors carried

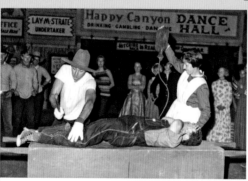

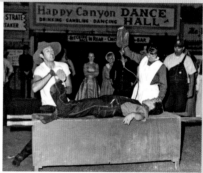

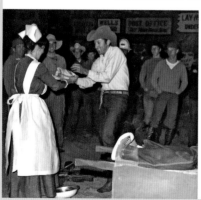

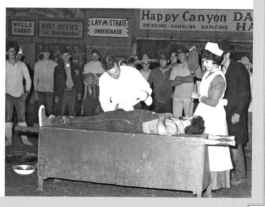

Shorty to a table and the magic began. The doctor did a brilliant double amputation with an axe and a saw and a great deal of finesse. Shorty jumped of the operating table and ran straight for Goldies Place, either to celebrate a miracle or for medicinal purposes. A real laugh getter for the entire audience.

Like so many of the acts in Happy Canyon, the Doctor-Shorty act was handed down to a family member. When Jim Hill Jr. retired in about 1961, Fritz Hill, Jim's nephew, took over as Doc Killum for the next twenty-three years, adding his own nuances to make things even more hilarious. Betty Branstetter was Fritz's nurse during the act, and together the two had a nonstop comedy routine that was a certain crowd pleaser. Key to this act for years, at four feet, three inches tall, was Tom "Shorty" Hayward. Absolutely tall in statute and heart, Tom's volunteering in the show is still missed today.

When Fritz retired in 1989, his son Jason took over as Doc Killum, and the fun keeps happening. With Becky Waggoner as his nurse and Brian Zimmerman as Shorty, the show goes on and the crowds keep laughing—this is one of the favorite acts in the western town part of the show.

Fritz Hill said in the *Pendleton Round-Up at 100* book, "Having this role stay in the family from the 1940s to the present isn't an obligation—it's a gift. The miracle after sixty plus years is that the Hills never lost a patient, have healed people with laughter and have never had to have malpractice insurance!"[139]

While I was checking the Happy Canyon records, I found a copy of a receipt that was made out to me for the use of my horse during one Happy Canyon year. Yes, it's a family affair!

Pendletonians love the fact that the Doctor-Shorty act, like many other of the parts, are handed down from family member to family member. The audience anticipates each move and is just waiting to laugh!

The out-of-towners go along with it; it's part of the show, and they don't want to miss any of the fun![140]

Opposite, top: A rare photo of Shorty Coffman, who played shorty in the Old Canyon. *Umatilla County Historical Society.*

Opposite, bottom: Images over the years of Doctor Fritz Hill, Nurse Betty Pedro Branstetter and Shorty, played by Tom Hayward. *Howdyshell Collection.*

Right: The Hill family. Kate and Grace Hill (in front) are the fourth generation to act in the show. *Eye of Rie.*

Fire Act

In the 1914 show, the hotel "catches on fire" and the volunteer fire department rescues the guests from the burning building. Through the years this act has been altered, such as in the 1950s and 1960s, when "Blondie" appeared in the window when the building caught on "fire," calling for help. Dr. Stram added this part with Wes Grilley playing the first "Blondie."

For over thirty years, a young man acted this part dressed in a blond wig and nightgown since it was not "proper" for a real girl to climb down the ladder and jump into the preachers' waiting arms. Jason Hill was the last of the "girls" in the 1980s, before the part went to Whitney Wagner Porter, the first actual girl to play the "Blondie" part.

Dressed in long red underwear, Henry has been following "Blondie" out of the burning building in one form or another for a century also. After his pregnant wife discovers him coming out of the hotel, she whacks him with a broom until, in desperation, he dives into the pool, never to be seen again. Later, this became two pregnant wives.

The Finale

For eighty years, the music of "The Star-Spangled Banner" has filled the Happy Canyon finale. As the Trail Horse ridden by the Indian runner trots up the wooden ramp to present the U.S. flag, the audience finds a feast for the senses in the perfect American combination. This final scene encapsulates the distinctiveness of the Happy Canyon pageant.

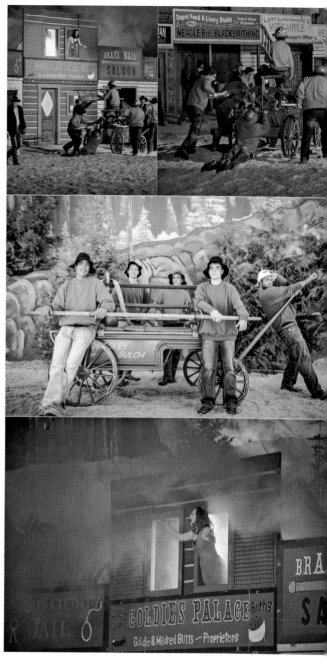

Above: The fire act has been an essential part since 1914. *Eye of Rie.*

Opposite, top: A view of Fire Act from the top of the scenery in 2015. *Eye of Rie.*

Opposite, bottom: Andrew Porter has pants on fire. *Eye of Rie.*

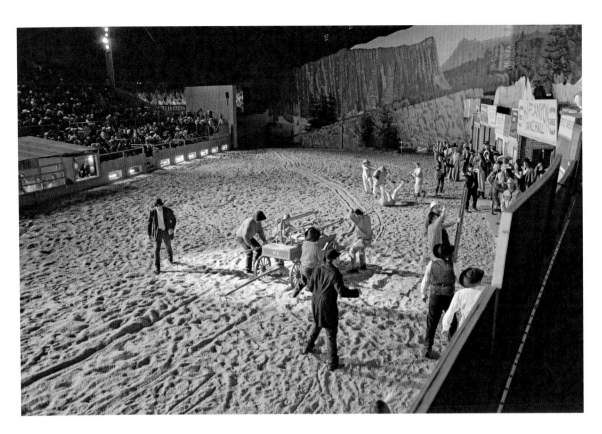

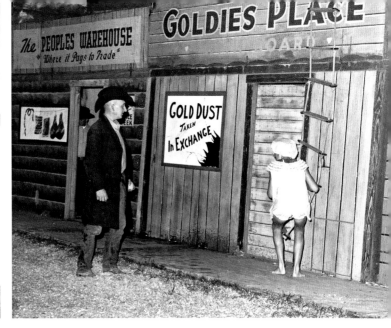

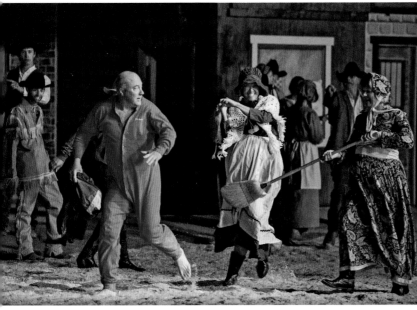

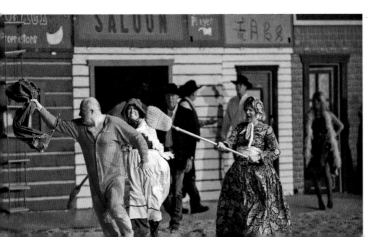

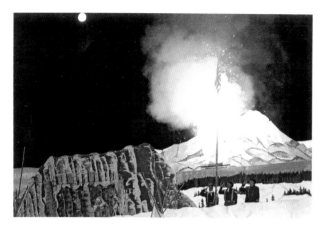

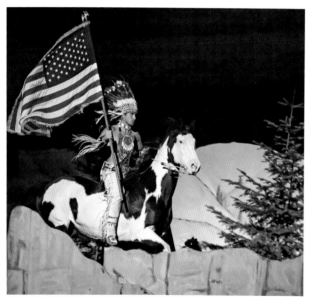

In a century of show history, acts have come and gone. New acts have been added, some acts cycle in and out depending on the year, but many have remained as one-hundred-year-old sequences—some just as Roy wrote them.

This page, top: The moon over the scenery and a flag with military men in the grand finale. *Don Cresswell.*

This page, bottom: Chinook and Bryson with the U.S. flag. *Harper Jones II.*

Opposite, top row: Blondie was first played by young men due to the "impropriety" of a young girl playing the part. *Howdyshell Collection.*

Opposite, middle and bottom: Various Henry act images. *Top, left*: Henry (Steve McMillan) makes his appearance with "wives" Lindsay Joseph Moors (left) and Debbie Hawkins-Shampine (right). *Eye of Rie.*

7

BEHIND THE SCENES

A lot of the Pendleton Round-Up's continued success can be attributed to the pageantry and dedicated workers involved in the Happy Canyon presentation. Workers and theatrical persons involved in the stage show have handed down their responsibilities through the generations to insure [sic] the same perfection that Roy Raley dreamed of when he wrote the play in 1913.[141]

Backstage is a different scene entirely. In fact, behind the scenes is almost as exciting as Happy Canyon itself. As people fill the stands and the orchestra warms up, a flurry of activity occurs in the properties room, at the gun window, in the wardrobe areas and in the makeup chairs. Before the acts are called in, Indians dressed in regalia and war paint joke and catch up with one another, calico-dressed women in sunbonnets and frontier-jacketed men in fringe.

Happy Canyon volunteers who have served behind the scenes during its one-hundred-year history are mostly unnamed due to the nature of their jobs, but they enjoy serving from the background. The show and evening events could not have flourished without them. This chapter is dedicated to all of them, highlighting just a few of the stories we know.

PROPERTIES

Good props became a show ingredient at the very beginning. The 1914 and 1915 shows included guns, "fire" at the hotel and even a silver water pitcher inscribed "Villard Hotel."[142]

Some of the props used today are actually considered valuable antiques. The organ used and played in the show is reported to have actually crossed the Oregon Trail. It is listed in

Above: Near the properties room, the cast and crew mill about. *Eye of Rie.*

Right: The pump organ, reported to have arrived on the Oregon Trail, has been used in the show for decades. *Happy Canyon Collection.*

the 1939 show along with an iron kettle, a keg and a wagon cover.

The show's century-old records list other notable antiques used in the show. The 1923 show listed props such as Major Lee Moorehouse's gold pan, used in the pioneer scene. The Lyon Curio Store in Clinton, Nebraska, provided several necessary props for the Indian scenes in the 1930s, including breechclout, buffalo horns, untanned deer hide, a pair of large eagle wings, a medicine man headdress and a fine porcupine head roach. Philo Rounds, a show director, even sent them several groupings of eastern Oregon elk teeth to reduce the price of these items.

An inventory in 1937 listed such things as Indian headdresses, quivers, arrows, bows, spears, a powder horn and a fire triangle—just to name a few. Hundreds of authentic items were listed, which were more than likely used in previous years. Currently, the Round-Up and Happy Canyon Hall of Fame displays a bow and arrows that are over 130 years old and were once used in the show.[143]

Sometimes props do not work like the properties director would hope. Take the year "break away" bottles were added to make the bar fight more realistic. As Billy Turner was hit with a "break away" bottle in a bar scene, it stayed completely solid, causing large gashes on his head. No one read the directions specifying the importance of soaking the bottles in water first.

The current properties director oversees hundreds of props. The key volunteers, without whom the performance would be impossible, arrive before the band even warms up or the actors arrive. A properties crew places every prop—from the teepees to the fire-starter setup and buckets full of confetti.

Western Weapons

You cannot have a Wild West show without the proper working weapons. The gun department of Happy Canyon is a busy place. On any given night, a line of several Indians followed by a sheriff and several buckskin-clad pioneers will be waiting to sign out their props.

Guns have been a key prop since the show's inception. In 1914, John Spain, Pendleton Round-Up 1912 champion bronco buster, almost lost his eye in the "barroom battle" scene in the September 24 show performance. At the end of the fight, as Spain was assisting the sheriff, a fellow performer's gun loaded with a blank went off three feet from his eye.

As Spain staggered toward the gate, the audience thought he was giving a very realistic performance until everyone realized his left eye was in need of medical attention. Dr. Guy Boyden, a local Pendleton doctor, took him to his office, where he cleaned Spain's eye, severely burned from gunpowder, and dressed the eyelid. Fortunately, he saved his eye and even "cowboyed up" to ride in the bucking contest in Round-Up the next day.[144]

Former show actor Dorys Grover recalled in 1967, "One of the most refreshing things occurred during this year's Happy Canyon shows that I have seen in many years. During the rescue of the white girl, the Indians on the cliff had to stop and reload their guns. It was very realistic and one could hear the murmur of the crowd who observed the act. One comment I recall was, 'I've never seen that done on TV!'"[145]

Over the years, several volunteers have given their time and expertise to prepare and care for the show guns. One of the gun stewards was Ted Johnson, who began passing out gun hardware in the Old Canyon in 1944 and continued the job for many years. Unfortunately, the antique guns used in the Old Canyon and records of their obtainment have been lost.[146]

For the last twenty-three years, Tom and Patti Baker have served in the "gun room" of Happy Canyon. The Bakers arrive at the show early in the evening—often eating dinner in the

Tom displays both his Ruger Vaqueros pistols, and Patti holds a Rossi .357 rifle and .38 revolver used in show. *Eye of Rie.*

gun room before the cast arrives. As they grew up, the Bakers' daughters, Becky and Wendy, would sit together and watch the show from this behind-the-scenes viewpoint.

As actors approach the window and write their names on the sign-out sheet, they can trust the Bakers' precision to prepare each of the nearly three dozen guns handed out each night. The children of the show, especially the boys, often stand at the window asking Tom for a gun. At times, they have younger actors ask for more ammo or an extra gun.

After a couple years, Tom had trouble getting the right blanks ordered every year. He found several sources, but they soon dried up. Finally, Tom got an ammo source that required a winter order. By learning how to reload the blanks himself, he solved this problem.

Each of the guns is given just the right amount of ammunition, using a total of about 250 rounds each night, adding up to over 1,200 hand-loaded blanks. This number seems even greater when you realize that Tom, in his expertise, now hand loads every single round.

When the Bakers began, several valuable 1873 Winchester rifles were used. They might have been some of the original guns used in

the show. Today's Happy Canyon pageant uses guns that are period reproduction pieces, although a few of the originals remain.

The Hall of Fame displays a Colt 44 rifle, an 1873 Winchester 44, a U.S. Model 1873 Springfield, a .50-caliber smooth bore and several army .38 six shooters. These guns were formerly used in the show and since have been retired, as guns are occasionally damaged in the events.

The Bakers replaced the historic Winchesters with .357-caliber lever-action Rossis to maintain authenticity. Although the guns are new, they are still stylistically authentic to the late 1800s time period.

The revolvers are .38 caliber and .32 caliber. Some guns are "non-shooters" used as the period-correct guns for the Lewis and Clark actors, and a double-barrel shotgun is used for the stagecoach holdup.

After the initial gun "check-out" before the show begins, Tom and Patty have a flurry of activity as a large group of guns comes for reloading between acts. "The pressure is on for around 30 to 40 minutes as we quickly clean out the chambers and reload with fresh blanks," Patti said. Sometimes, a cowboy holding the reins of his horse with one hand will hand the Bakers several pistols to reload. They look out the window to see a line of cowboys and Indians ready for them.

One of their jobs is keeping an accurate count. But guns are easy to lose, creating their yearly challenge. If any guns are missing, the hunt is on. "Once in a while, they drop them in the sawdust," Tom said. The Bakers usually have an idea where the guns could be—whether a fallen Indian has dropped his gun or actors have set them down and forgot to collect them. At times,

A few images for an inside look at the busy gun room. *Eye of Rie.*

a gun has ended up in the "pond," and a cast member will dive down to retrieve it.

Over the years, the Bakers have enjoyed answering the children who ask, "Are those real guns? What kind of guns are those? Do they shoot real bullets?" Or those who plead for their

Displayed on the wall are Rossi model 92 .357 rifles (left) and copies of Winchester model 92 (right) used in show. On the table, .38- and .32-caliber revolvers are displayed. *Eye of Rie.*

own gun and are kindly turned down. Patti said it is a "rite of passage" on the day a young man who has grown up in the show is handed his first gun, loaded with blanks.

Tom dedicates many hours during the year to cleaning, maintaining and oiling the guns, keeping them in top shape for the next show. A jammed gun requires extra work. He practices with the guns to see how they will perform based on the blanks he is loading. After experimenting, Tom has found the loudness of the boom depends on how much powder he puts in.

Throughout the year, Tom keeps his eyes open for firearms that could be used for the show, as it is always in need of a few more. Being a gunsmith comes in handy.

"It gets in your blood," Tom says. "We don't even give being down at Happy Canyon a second thought."

His wife, Patti, says she is certain Tom will be down at the Canyon as long as he is physically able to go. "We do it because we love the show," she explained. "The comradery is unmatched."[147]

Volunteers like Tom and Patti Baker, with rare gun expertise, make the show possible.

The Makeup Room

The small makeup room under the grandstands is a beehive of activity right before the show begins. Few audience members will see the women faithfully serving the show year after year. Actors flow in and out of this room as the makeup artists expertly apply war paint to young warrior's faces, freckles to small cast members, beards and crow's-feet on male actors and highlighting makeup on ladies.

Makeup has been used since the first show. In fact, in the 1930s, Dix Holaday came from Portland every year to render his makeup services, since Happy Canyon was one of his favorite times of the year.[148]

One of the longtime makeup artists was Ruth Huddleston Fletcher. Beginning around 1945 and continuing for over forty years, Ruth captained the makeup room. Her role there had come about completely by accident, and yet she loved serving in it. She never wanted to be in the show and, until her later years, never even saw the entire pageant.

"It just happened," she recounted years later. As she helped her young children get ready for the emigrant scene, show director Walter Holt said to her, "You're not doing anything. How about helping with makeup?"

For many years, she ran the makeup room at the Old Canyon by herself. Emile Holeman said going to Ruth for his face makeup as the dead son of the chief was one of his favorite parts of the show. Her kindness and consideration were legendary to the cast and especially for him.

Ruth always said Happy Canyon had a feeling of closeness. "All of us want[ed] the show to go off well," she explained.

Under the grandstands is a small concrete room called the makeup room. *Eye of Rie.*

Ruth remembered the year Bob Critchlow was sitting for his makeup when he learned his wife was about to give birth. Of course, he completed his performance and then headed to the hospital. His son later played the same part. "I don't think there is another show like it in the country," Ruth said. "It's like homecoming each year."[149]

Currently, the makeup room is run by Chris Ferguson and Ingrid Thamert, with steady help from Karen Ashbeck. These women and their assistants know just what makeup to apply for each actor in the chairs. For the women, this is a labor of love, and they enjoy watching the cast grow up through the years. It is a room full of joking and fun as the show participants come and go every night.

"Kids we started putting makeup on, like freckles, now have different parts and have kids themselves," Ingrid, who has volunteered for twenty-seven years, said. "I love seeing the families passing the roles down."[150]

For over thirty years, Chris has applied makeup for various actors. Chris, also a director

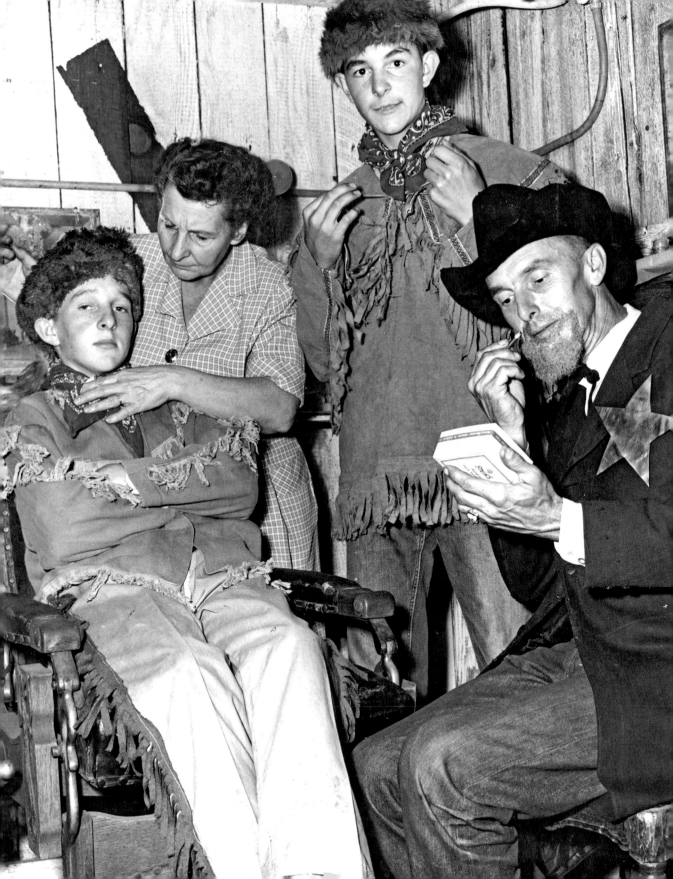

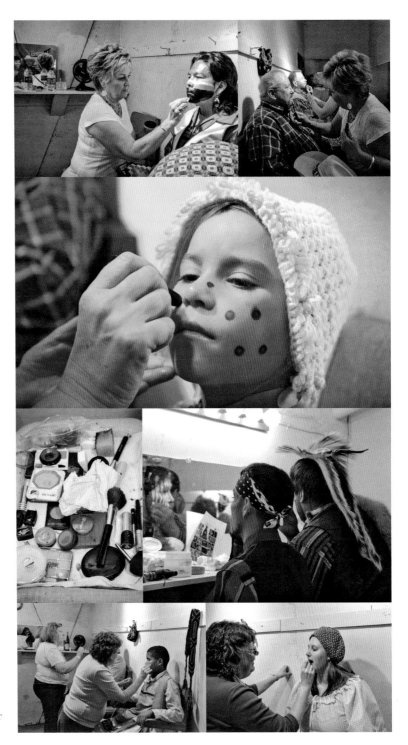

Right: The makeup room ladies expertly apply war paint, freckles and crow's-feet before the show. *Eye of Rie.*

Opposite: Ruth Fletcher ran the small makeup room at the Old Canyon for many years. *Howdyshell Collection.*

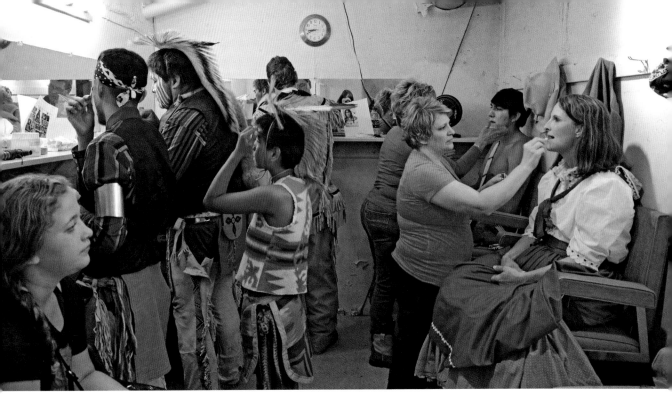

Above: The makeup room is a flurry of activity before the 2014 show. *Eye of Rie.*

Right: In costume and makeup, Petunia relaxes before the show begins. *Happy Canyon Collection.*

Opposite: The sound team. *From left to right, top*: Colton Potratz, Karen Licurse and Sherry Potratz; *bottom*: Joe Schenck, Nathan Garton and Fred Licurse. *Eye of Rie.*

for the Blue Mountain Community College Theatre group, said: "Wednesday begins with the show participants coming to get makeup in a steady stream, but by Saturday, they are running behind with minutes to spare. This makes the job a bit more challenging."

Sound

In the days before television and Internet, seeing a show and witnessing the Old West come to life was a treat for Happy Canyon audiences. The Old Canyon was a smaller arena in a semicircle, providing natural acoustics and creating a feeling of intimacy with the actors.

For forty-eight years, beginning in 1968, Fred Licurse has helped run the house sound. Currently, Fred and his crew (mostly family) are responsible for the house equipment, microphones and blending the orchestra's music from the sound board. Fred has watched the equipment evolve from buzzer phones and tube-type amplifiers to a transistor system with wireless microphones. With aging equipment used only once a year, his challenges have been many. To say he stretched the capabilities of an antiquated system is putting it lightly.

Fred has tried to retire over and over, but it just can't seem to happen. As rehearsals begin, he is faithfully down at the Canyon. In 2002, he received the Happy Canyon Appreciation Award for his years of service, which he describes as challenging but extremely rewarding.

Fred loves Happy Canyon—pure and simple. Watching him as the orchestra warms up, you can see a twinkle in his eye and joy in his face as the lights come up and the show begins.

One of the key sound volunteers is Nathan Garton, who uses his training and expertise in electronics. Nathan not only helps the show but also gives his time to the concert

and the Professional Bull Riders Only (PBR) show. He started volunteering for Happy Canyon as a teenager, serving as an usher, and now is indispensable.

One of the important parts behind the scenes is the phone cue system, which involves several electrical phone stations throughout the arena and set. This is where the standby cues, as well as the show cues, are relayed for each actor, wagon and animal.

As a general rule, the assistant show director calls out standbys and cues for each act to start at various locations. The show director monitors the show and makes adjustments to the script along the way. This is relayed to the cast via the phone system. The challenge is to call the acts at the right time so that they enter the set at the appropriate moment while always making sure everyone is safe.

As a former Happy Canyon board member and president, Wayne Low and his wife, Mary Ann Koch Low, put in many years serving Happy Canyon. Wayne is one of the many past directors who continues serving the show. He has served for years on the roof phone, where he receives the assistant show director's message to send in the various acts or animals off the top of the scenery.

Above: Before the show, key directors and volunteers ensure the entire set is checked each night. *Eye of Rie.*

Opposite: *Top*: Sam Lorenzen; *middle, left*: Bobby Corey; *middle right*: Doug Corey and Kelsey Garton. *Author file.* *Bottom*: Allen Waggoner (front) and Harper Jones II in the director's booth. *Eye of Rie.*

He remembers the year that Beauregard the elk went only halfway up the ramp and stopped. The young braves who carry the deer could not walk up the ramp and onto the scenery with Beauregard "guarding the way." As Wayne received call after call to let the deer carriers enter the stage, the young men finally crawled across the scenery, dragging the deer, to make their entrance.

Regarding his Happy Canyon service, Wayne said, "I found it to be the most rewarding thing I have ever done."

The cue booth at the West Gate, where most of the acts enter, is a place of practical joking. Many pranks are pulled on the volunteers sitting in this booth and calling show acts to enter the gate.

One night, as Doug Corey opened the cooler for cold water, he found a Chukar partridge flying out at him instead. Smoke bombs, fire crackers and even lit fuses have also been used to surprise the group at the booth.

LIGHTING AND SOME SMOKE

In the days of the Old Canyon, pyrotechnics and smoke were ordered by rail for the show. The 1929 show ordered white and yellow smokes and one-inch "changing gerbes with spikes" from

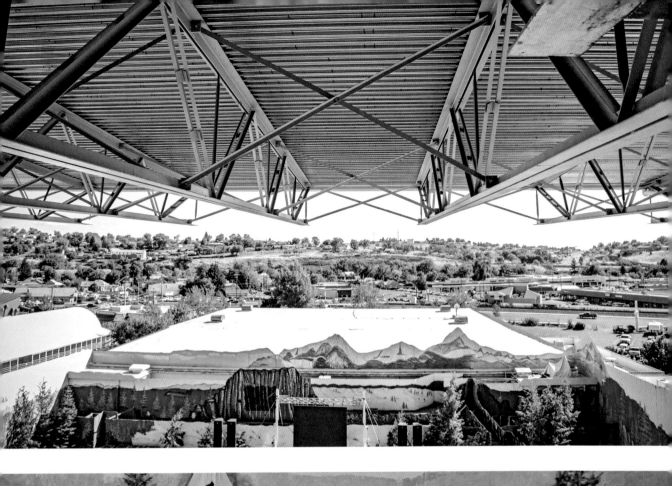
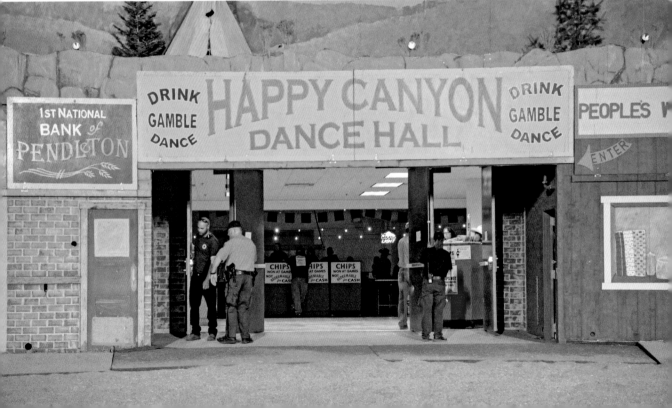

Hitt Fireworks in Seattle, Washington, and "serpents' eggs" for $3.60 from Johnson-Smith Company in Racine, Wisconsin.[151]

The show lighting can be taken for granted in today's age of technology. In the early years, Happy Canyon struggled to find good lighting, but finally, Lee Drake came up with the idea of locomotive headlights, which worked satisfactorily. As the headlights were installed for the 1915 show, the paper reported that Happy Canyon had also found a "big electric spotlight" to highlight performers.[152]

Currently, Ken Long and Mary Finney are unsung heroes as the lighting and pyrotechnic volunteer team. Ken arrived in Pendleton in the 1980s to work for Pendleton Electric. He began serving Happy Canyon on the lighting crew in 1988. He remembers how the spotlights in those days were World War II vintage, including a submarine spotlight. He wore big asbestos gloves, because the old lights would become extremely hot.

His job occurred in the old catwalk with three lighting booths and huge Dr. Frankenstein–like switches. During that time, Ken met his lovely partner, Mary Finney. Mary has been an active volunteer ever since.

Opposite, top: A rare view from the catwalk above the grandstands. *Eye of Rie.*

Opposite, bottom: A few security guards—there have been hundreds over the years—watch over the nighttime crowds. *Eye of Rie.*

This page: Ken Long and Mary Finney put in innumerable hours to oversee lighting and pyrotechnics. *Eye of Rie.*

Ken helped upgrade and install the new lighting system with electronics. Over the years, the lighting crew has grown from around five to now at least twenty. Besides helping in the show, Ken and Mary coordinate the power supply for the concert and PBR.

Ken and Mary, Happy Canyon Appreciation Award winners, put in over eighty hours—or, in Ken's words, "untold hours"—during the week of Happy Canyon. They are untold because, as Ken said, "It is hard to count that high."

As they give of themselves, he and Mary bring dedication and love of the show, its action and humor. They are a backbone of the inner workings, making all Happy Canyon things possible. Ken said he loves Happy Canyon. "This is sheer fun and pandemonium, animals, guns, water and fireworks, and maybe a skunk, all thrown into one show," he said.[153]

GATES

As a small boy of age six, Kent Bigsby rode in the wagon behind the oxen from the Round-Up grounds every night to the Old Canyon. He remembers how the only gate for wagons and horses felt to him like a tunnel. Even though he was instructed not to, he looked out on the crowd and saw the dark arena as the wagon came in and out.

The Old Happy Canyon location created a completely different set up for gates than today's location. Imagine only one gate for livestock and wagons to enter and exit! It's no surprise that the accident rate was higher then.

Top: Bob Forth with Betty Branstetter at West Gate; *middle*: Sorey family; *bottom*: Porter family on Gale Wagner's gate. Manning the gate is passed down through families. *Eye of Rie.*

Several times, the stagecoach did not quite make the turn, providing real-life excitement when it turned over. Bob Fletcher Sr. remembers that when he was performing one of his first parts, he was riding on top of the stagecoach when it flipped over in the Old Canyon.[154]

The current Canyon has two gates: the East Gate and the West Gate, both run by faithful volunteers with cue phones facilitating good communication. But Happy Canyon is not without incident.

Gale Wagner, until his passing, helped Bob Forth open and close the West Gate for many years. Now Gale's sons-in-law, Tom Sorey and Kevin Porter, carry on their father-in-law's job—another beautiful example of Happy Canyon's legacy.

Gale and Bob had been friends since junior high school, and they always looked forward to manning the West Gate together. In 1999, Happy Canyon honored them with the Appreciation Award for their faithful and fun years of service.

The "gate men," as they are called, can tell all kinds of stories. Gale and Bob had to pay attention. One night, the horse pulling the husband and wife buggy got spooked and ran out of control. They opened the gate just in time. The buggy was finally stopped over by the Dairy Queen.[155]

After first selling programs in Happy Canyon when he was in junior high school, Jim Loiland worked the East Gate for over twenty-four years. When he began volunteering at this gate, the show director used a flashlight cue to signal the gate operator, which was not always efficient for wagons, animals and people.

With advanced technology, a cue phone now helps cue the East Gate people. Jim loved working this gate since he got to see friends and every visiting dignitary. Jim continues to volunteer at the main gate from Round-Up into Happy Canyon and serves the Indian cast. In 2005, Happy Canyon honored Jim with the Happy Canyon Appreciation Award.

The Ushers and Program Sellers

Many Happy Canyon volunteers began by selling programs, taking tickets or ushering patrons to their seats. While these service areas are often overlooked, they are crucial.

Many directors began in behind-the-scenes service, as well. Wesley Grilley, who later served in the cast, and as a Happy Canyon president, began as an usher. When he was eleven years old, Stan Timmerman began selling programs and also served as an usher. He continued serving in various capacities, except while he was at college, and later became a president of Happy Canyon.

Danny Houle vividly remembers selling programs as a kid at Happy Canyon:

> *Like snapshots, the most vivid pictures of that night are a sense of wonder, the night sky and rumble of "anticipation" in the crowd. Roy Rogers was a TV favorite, but this was real—the gallop of horses, riders jumping on, flying off, singing, laughing, real West action! And the joy of being part of it all.*

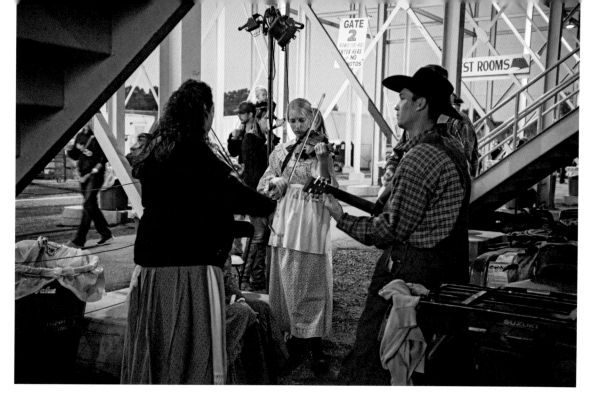

Pioneer musicians warm up under the stands before the show. *Eye of Rie.*

Words seem to fall short in describing the sense of wonder and delight of that magical night. As a kid, I was thankful for the opportunity to be involved, it was a privilege. That was fifty years ago, and it is still a fond memory of growing up Pendleton—my own personal highlight film.[156]

Volunteering as part of the Happy Canyon family has its own draw. George McClendon, 1997 Happy Canyon Appreciation Award recipient, spent over twenty-five years choosing and training around one hundred young people to usher and seat spectators at the Happy Canyon pageant and, later, the kickoff concert. Lyle Phelps, his good friend, talked him into helping.[157]

Part of his work included preparing young people to locate all 4,230 seats (sometimes in the dark) and to readily help those who have come from the Let 'Er Buck room or beer garden.

Being a backstage volunteer at Happy Canyon is one of the best ways to be involved.

It is the grand reunion of actors and volunteers of all kinds. Adults who began as children together in the show and those who feel the call to help put on this grand tradition. The show could not happen without each person deciding to give their time to a one-hundred-year-old treasure called Happy Canyon, whether they are putting freckles on a sweet little face or putting a key prop into place.

8

WHAT TO WEAR

A Pageant Wardrobe

It is also a fact that some of the Native American costumes are far more valuable than those made by many a king's tailor. The eagle feathers of a fine war-bonnet, which may number fifty to sixty, are valued at anywhere from two to five dollars a plume according to size and quality. Then there is the exquisite, solid beadwork of vest, trousers, belt and moccasins.[158]

A new Happy Canyon actor presents himself to the costume department. He is handed the appropriate outfit for his part: a large dress, curly blond wig, hat and bloomers. He is about to don the apparel of the "wife" in the husband and wife act. Without the costume, the part would be impossible. What is a show without a great costume department?

Starting with the first show, costumes were shipped in by rail from companies as far away as Salt Lake City. In the early years, Roy Raley used the Salt Lake Costume Company.[159]

A 1926 costume list from this company notes, "Indian wigs, frontier fringed coats, Lewis and Clark costumes, Blue Union officers' coats, Mexican vests, ladies' dark wigs and a large, light southern hat." The costumer also sent "mustaches, siders, Jew noses, whiskers and Chinamen hats."[160]

Even after moving to the current Happy Canyon location in the late 1950s, the board continued to order several key period outfits from the Salt Lake Costume Company. Some years, the company even added unusual costumes for color or comedy.[161]

Ordering, cleaning and shipping back each costume in decent shape was a major undertaking for the director in charge, even though some actors provided their own costumes. Records show the wrong costumes and sizes were often sent, causing huge headaches for the costume volunteers.

Later, a Portland costume company transported the costumes. Little by little, Happy

Canyon bought more pieces, decreasing the need to rent the main costumes. By the 1990s, the show ordered only a few specialty items each year.

CURRENT COSTUME DEPARTMENT

Through an open window, you can see a flurry of activity before the show. Racks of clothes—from buckskins and jackets to overalls—stand waiting for the actors. In the back, piles of assorted hats fill the tiny, closet-like room.

The wardrobe room, presided over by Verneda Wagner, is the show's nucleus. Verneda is rarely without a smile as she works, even as the costumes fly out of the storage area. Many actors do not arrive until the first performance on Wednesday night, creating more of a challenge and some amusing chaos at the costume window.

Mary Lou Fletcher (over fifty years as a volunteer and 2008 Happy Canyon Appreciation Award recipient) and Nancy Forth (twenty years volunteering) are Verneda's assistants. The trio can instantly locate each costume as actors come to the window. They use a great tool: gray duct tape with the name of each actor. These ladies bring years of experience and quickly outfit new actors in the correct hats, shirts or costumes.

Prior to Happy Canyon week, this dedicated group of women washes and repairs costumes. Gone are the days of renting specialty costumes or shipping them in by rail. In 2003, the Happy Canyon properties department purchased the important costumes from a Portland costume

company going out of business. These included Lewis and Clark outfits, as well as several other period pieces.

After each show, the ladies string a rope in the backroom to hang wet costumes, which are too full of sawdust to wash each evening. The ladies also work throughout the week on repairs, hemming and adjustments for new actors.

Once Happy Canyon week is over, Verneda and her crew often wash twenty to twenty-five loads of laundry. This is no easy task. After shaking out the pounds of sawdust each costume accumulates throughout the show, the ladies have to hang dry most of the laundered outfits, including buckskins, pioneer costumes and red long underwear.

Several summers ago, Verneda, Mary Lou, Janet Herbes and Linda Thorne expertly sewed the current set of unique cancan dresses. Hundreds of combined hours went into these beautiful costumes. Another year, the ladies redesigned the buckskins for the male actors' convenience. They split the pant legs below the knee and sewed Velcro in two parts, making them easier to slip on and off or to wear over street clothes. The fine seamstresses have also made the buckskin shirts from scratch.

Verneda, a 1998 recipient of the Happy Canyon Appreciation Award, has volunteered as head of the costumes for thirty-five years. In the early 1960s, she acted as a sidesaddler and

Opposite, top: The costume room is a busy place before the four nights of the show. *Eye of Rie.*

Opposite, bottom: *From left to right*: Mary Lou Fletcher, Nancy Forth and Verneda Wagner, costume ladies extraordinaire. *Eye of Rie.*

This page, top: Hand-sewn cancan dresses, just a few of the beautiful examples from the Happy Canyon seamstresses. *Eye of Rie.*

This page, bottom: Examples of men's clothing used throughout the show. *Eye of Rie.*

Opposite: New actor Dillon Hubbard and his horse, in need of a cavalry costume. *Eye of Rie.*

performed this part for several years, later helping her husband, Gale Wagner, at the West Gate. In 1981, Bob Fetsch, properties director, asked her what she was doing and requested her help with the costumes, where she has served ever since.

WOMEN'S DRESSING ROOM

Most of the women's costumes are kept in the small concrete Women's Dressing Room, located under the grandstands. Two long rows of pioneer dresses, cancan dresses, dance hall dresses and sidesaddle dresses wait for their respective actresses. These dresses range from newly stitched to various stages of decay.

For over fifty years, seamstress JoAnne Pedro, whose grandfather was R.W. Fletcher, managed this room—a place most audience members will never see.

JoAnne sewed many of the current costumes and provided mending and alterations over the years. In fact, she expertly made the beautiful matching white Indian costumes, worn for years by the duo performing the "Indian Love Call." She also sewed the original matching black-and-red cancan dresses, which are now retired. Before passing away, JoAnne received the Happy Canyon Appreciation Award for her countless hours of service.

Linda Thorne, a former U.S. history teacher, began volunteering for Happy Canyon in 1999. For the last seventeen years, Linda has presided over the Women's Dressing Room. "I was a little overwhelmed at first," she said, "but quickly began to understand the particulars such as dress zipping, repair torn dresses, bring lots of safety pins and duct tape, and how to make a girl pregnant by duct-taping on a pillow."

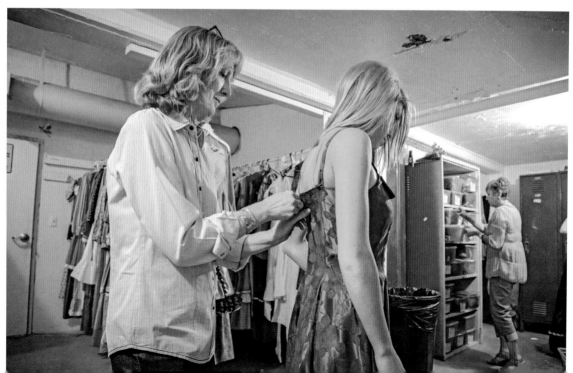

Linda has also sewn several of the costumes and made many major and minor repairs. This involves taking a dress home and quickly repairing it overnight for the show the next day.

Linda truly is the "mother" of this room—well loved by the women and girls who change under her watchful eyes for the four September nights of entertaining chaos. At times, up to thirty people fill the room, changing, fixing hair, visiting and donning all kinds of pioneer costumes.

Linda has made special bonds with several members of the cast:

> I have to have humor to defray some of the feelings that work to the surface on the younger girls, especially as Saturday comes closer. I have been their shoulder, confidant, and as one young girl matured to a young woman, she told me I would never know how much I have meant to [her] and how I have saved her….I just pick up from September to September. To see what has happened…high school and college choices. My favorite part is from since my time in Happy Canyon I have seen the little ones transition to mature young women in college, married and motherhood. What a thrill!

Opposite, top left: Rows of women's costumes with duct tape indicating their wearer. *Eye of Rie.*

Opposite, top right: Women's dressing room captain Linda Thorne is akin to a dorm mom each year. *Eye of Rie.*

Opposite, bottom: Ann Burnside zips up a dance hall dress for Laura Herbes. *Eye of Rie.*

One of her challenges is fitting the little girls for new dresses each year as they grow. She remembers having to sew one girl a new dress after she grew five inches. As Linda sits on a stool and cast members come in for a quick change, she can be seen unzipping dresses, helping tie bonnets and reminding teenagers to take off jewelry. "The challenge is, little girls grow into teenagers," she said.

Linda has managed the challenges of dressing cast members on the fly with many safety pins. She has carefully placed gray duct tape to hold the only dress for the captive girl one year, pinned up a zipper and replaced an entire zipper in another actor's dress overnight.

The Women's Dressing Room is a special place of reunion. Most show nights, the cast seems like a large family coming together to catch up with one another and exchange hugs. As a matter of fact, a lot of them are family. Sisters, mother-and-daughter groups and cousins all change together. But ultimately, the cast is its own family.

Regalia

A kaleidoscope of color appears before your eyes as the Indians come in all their finery. You see red, orange, purple, yellow and blue beads expertly worked into buckskin and worn by beautiful people.

Much of the regalia worn in the show has been handed down from generation to generation. To add up the years of regalia witnessed by the audience is virtually impossible. The costumes themselves could tell a story, and each carries its own fascinating history.

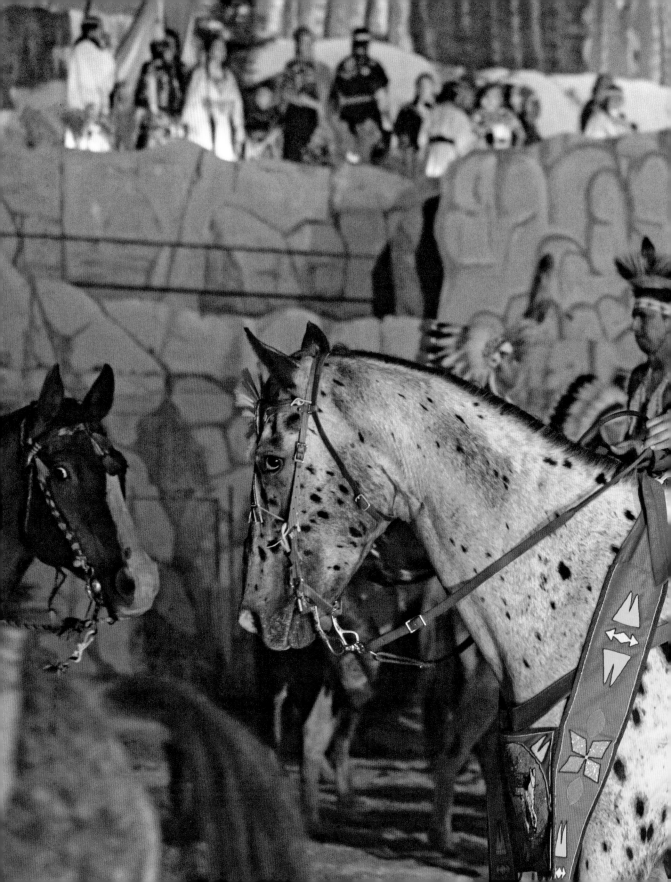

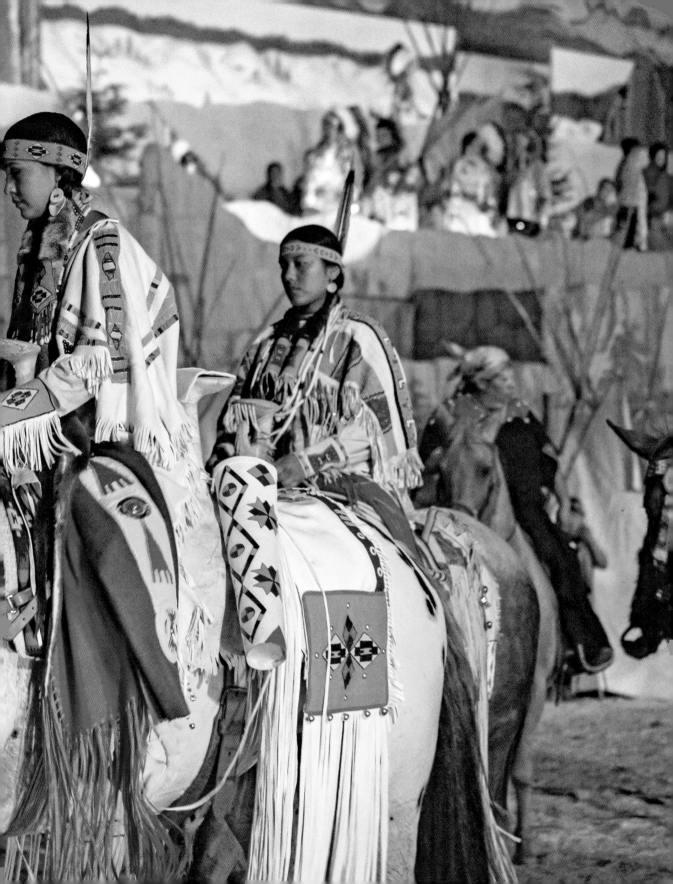

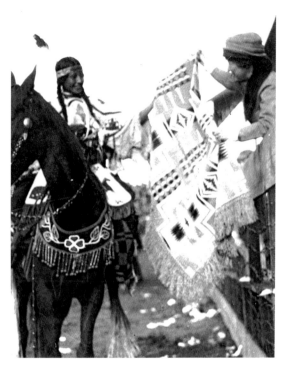

Above: Liza Cowapoo Bill (left), first Indian Beauty Pageant winner in 1923 and stickler for authentic regalia. *Howdyshell Collection.*

Previous pages: Anna Harris and fellow tribal members display multicolored regalia. *Harper Jones II.*

The 1937 *Oregonian* stressed the importance and beauty of the Native American regalia. The large color photo of Arthur Motanic shows him dressed in a war bonnet of eagle feathers, tipped with horsehair and trimmed with bone bead strands, which were highly valued. This war bonnet had been made by the Yakamas and passed down from generation to generation. Yet the regalia was beginning to disappear, even in 1937.[162]

One of the grandmothers of Happy Canyon, Liza Cowapoo Bill, was one of the early show supporters and leaders. She also won the first Indian Beauty Pageant in 1923. "I insist on the Indians being dressed authentically," she said. It was important to her to show the accuracy of the regalia by not wearing tennis shoes or glasses.[163]

The regalia and raiment worn by the Cayuse, Umatilla and Walla Walla peoples and other neighboring tribes is in itself a historic pageant display, easily overlooked. Each piece has significance.

Native regalia is not a tribal costume or uniform. It is a cultural set of clothing worn traditionally and currently by the tribe. It is the finest of traditional dress wear—much like a formal dress for women or a tuxedo for men in today's society—and it is viewed as your best "go to town" outfit.

Each accessory item—furs, fans, feathers, cuffs, moccasins, chokers and headbands—is culturally significant. Each piece of regalia represents a life that was given for the ornament, such as the deer used for moccasins and bone beads, and portrays the respect the tribe gives that life by carefully harvesting and applying the ornament.

Kathy Quaempts Burke explained how her father, Pete Quaempts, said it took a lifetime for her regalia to come together. Each piece is handed down, made new or given as a gift, and they all encompass the whole.[164]

The classic Indian regalia is an education in itself, and each has a story, as evidenced in the key classic pieces and their descriptions that follow.

WAR BONNET: The war bonnet is a sign of leadership, worn mostly at social gatherings.

Traditionally, it contains eagle feathers, signifying a brave deed during battle.

EAGLE FEATHER FAN: Made with sacred eagle feathers for spiritual protection. Traditionally, these were only carried by men, but in the modern era, women also carry them to keep cool. This piece of regalia is honored just as much as headdress feathers.

Eagle feathers are a traditional part of the local tribes. They can be from a golden eagle, primarily a meat eater common in eastern Oregon, or a bald eagle, primarily a fish eater and less common in the area. Historically, feathers were collected without harm to the eagles. The treasured feather comes from a juvenile golden eagle; it is light brown and sometimes spotted white with a brown tip, while the bald eagle feather is mostly white.

Feathers are used in many different ceremonies, including funerals and prayer, and in carrying messages. The eagle feather is never allowed to touch the ground, as this is representation of death. Traditionally, only tribal religious leaders wear downy feathers or the under-feathers of the eagle in religious dances.

BREECHCLOUT: Long rectangular pieces of cloth, leather, grasses, feather or fiber tucked over a belt; traditionally worn by men and often with leggings.

LEGGINGS: Worn with breechclouts. These are hide or cloth tubes that protect the legs of men from the waist or thigh to the ankle. The leggings hook to belts or sashes around the waist.

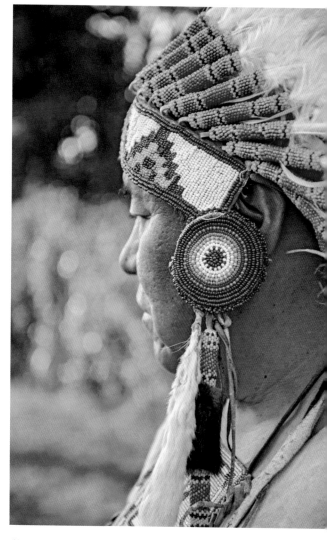

Above: Chief Gary Burke in his father's (Raymond Burke) war bonnet. Notice the beadwork done by Chief Raymond. *Eye of Rie.*

Page 190: Back view of Chief Gary Burke's plain-style war bonnet with eagle feathers. *Eye of Rie.*

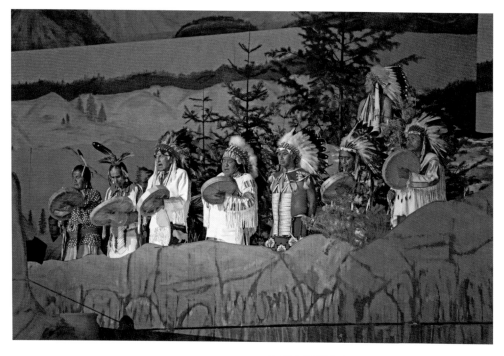

Above: Drummers in regalia and war bonnets, each with a story of its own. *Harper Jones II.*

Right: Chief Gary Burke with eagle feather fan and beaded buckskin shirt. *Eye of Rie.*

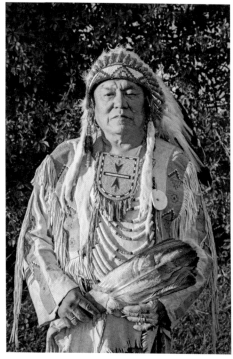

WAR SHIRT: Allen Patawa, Doug Minthorn's grandfather, obtained this authentic beaded buckskin shirt in a trade around 1900 when he was about twenty years old. At that time, the shirt was believed to be about fifty years old, most likely made before the Treaty of 1855.

Later, it was given to Doug's mother, Mamie Patawa Minthorn, who then passed it on to Doug. The tassels consist of ermine tails and human hair, which Mamie always explained was more than likely from scalps. It is one of the oldest war shirts in existence in this area. When Allen Patawa traded for it, it was too short for him and needed an extension.

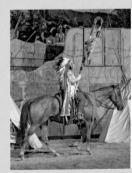 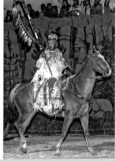

Left: Ashley Picard; *Eye of Rie*; Ashley's grandfather Doug Minthorn (right), wearing an over two-hundred-year-old buckskin shirt from his grandfather Allen Patawa. *Don Cresswell.*

WOMEN'S DRESS: As a one-of-a-kind work of art, a traditional buckskin dress can take up to a year to design, sew and bead. Each is a masterpiece. They are decorated with beads, shells, elk teeth and dentalia shells. What most people don't know, however, is how heavy these dresses actually are. Many weigh twenty to thirty pounds, making dressing in the summer a challenge.

The Indian dress for women has a class order. The first is the solid white buckskin dress, followed by the ornamental buckskin dress. Buckskins are the "best dress" for special events and dress-up occasions.

The shell or elk tooth wool dress is next in order and then, last of all, the everyday wing dress, which is usually made of calico.

Chelsey Dick in buckskins made by her grandmother Marie Dick. The eagle bag belonged to her great-grandmother. *Eye of Rie.*

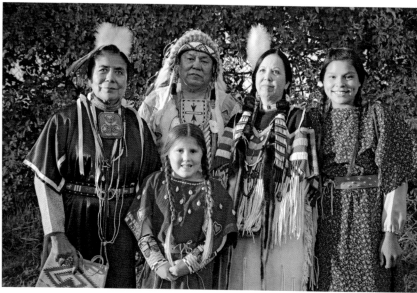

Left: Marie Dick in a wool dress decorated with traditional shells, a gift from her husband, Louie. *Eye of Rie.*

Right: The Burke family displays wing dresses, wool dress and buckskins. *Eye of Rie.*

EAGLE FEATHER: A single eagle feather indicates a girl is single while two reveal she is married.

HAIR DROPS: Men and women traditionally wear otter wraps or beaver wraps to adorn braided hair and for added decoration.

BELT BAG: Women commonly wear a knife and scabbard as a multipurpose tool for preparing meats, digging roots, making clothing, preparing meals and also protecting themselves. These are more commonly worn with a wing dress, which is the everyday dress women work in.

MOCCASINS: The universal component of native dress, these sturdy slip-on shoes are made of sinew and soft leather. They are often decorated with cuffs, porcupine's quills, paint, heel fringes and beads. Sometimes, they are lined with fur.

Animal furs, feathers, shells, etc. are repurposed as a different yet functional reason for the life, ceremonies, traditions and cultural methods of the tribe. No living thing or animal is ever abused, taken for granted, or even killed for any reason other than these things.

Often, the Indians pray for the animal prior to the hunt and thank it and the creator afterward—always respecting the living creatures.

Leverett Richards said of the show in *Reader's Digest*, "But the Indians really come into their glory each night when the pageant called Happy Canyon is presented—almost as compelling a thing to see as the roundup itself."[165]

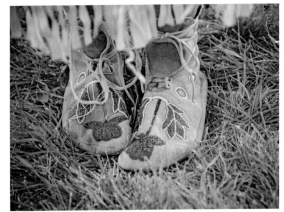
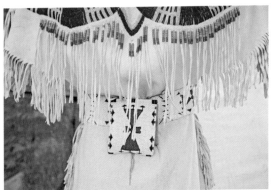
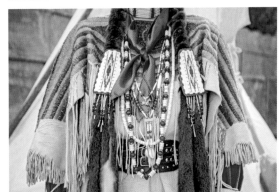

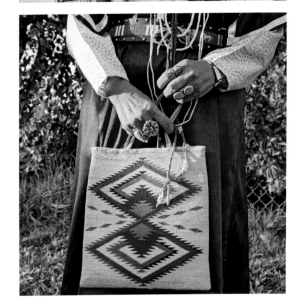

Not another place in all America can boast of the beauty of the authentic regalia used in the Happy Canyon pageant. The regalia display alone is reason enough to witness this Indian pageant and these works of art worn by our First Peoples.

Clockwise from top left: Marie Dick braids granddaughter Randy Dick's hair before the show. Traditionally, hair is sacred and only touched by close family. Six-year-old Kamiah Dick, sixth-generation actor, wears her great-grandmother's one-hundred-year-old moccasins. A 2014 Happy Canyon princess, Jory Spencer, displays her otter hair wraps. The traditional cornhusk bag given to Judy Burke Farrow by her grandmother Ada Patrick Jones. Traditionally, a family member ties the moccasins. This pair, worn by Daniel Dick, are Louie Dick's childhood moccasins. Happy Canyon princess from 2014 Marissa Baumgartner displays her belt bag. *Eye of Rie.*

9

ARENA AND SCENERY

For the time being, you are in a little frontier world of fifty years ago. You look out from the bleachers on its "Main Street," backed by the saloon, Chinese laundry, millinery shop, a few smaller shacks, and the hotel all bedecked with signs as witty as they are crude.[166]

Apageant is "a parade with scenery" according to Roy Raley.[167] Each year, volunteers dedicate hundreds of hours to make the Happy Canyon arena, scenery and grandstand shine and come to life. This has not always happened at the same location, which adds to the show's intrigue and color.

Most Pendleton residents driving down Emigrant toward Main Street do not realize they are passing Happy Canyon's first two historical locations. Amazingly, Happy Canyon survived both moves and, in 1955, reached its third location, where it remains today.

First Location

The show's first location was near the corner of South East Frazer and Main Streets, where the bus depot and adjacent buildings were in 1954. Currently, the Eagles lodge sits in this place. Using the old district fair's board fence and location, Happy Canyon included a tent on Frazer Street for a dance hall with "dancing platforms 150 by 50 feet in dimensions."[168]

Meanwhile the first bleachers on the north side of the pavilion had seating for three thousand and standing room for one thousand, facing south, opposite the frontier setting.

As Roy Raley and his friends designed the set for Happy Canyon, it wasn't hard for them to imagine a frontier town from the 1880s. Pendleton

had been one. The Pendleton establishments in 1880 included saloons, a Chinese laundry and several false-front buildings.[169]

As the set was constructed, the *East Oregonian* noted: "'Cities can be built in a week but it takes generations to grow a forest…' The first part of the quotation has been fully demonstrated here in Pendleton during the last week for the town of 'Happy Canyon' has grown from nothing to a thriving frontier metropolis."[170]

The first Happy Canyon was elaborate, detailed and meticulously planned. The *East Oregonian* explained its unique set:

> To the right of "Stagger Inn," down a short side street, the front of "Tim Hogan's Livery Stable" may be seen. Going east down the Main Street, there is a solid row of weather-beaten buildings, some whitewashed, a few decorated up in brilliant hues.…The first building on the corner is the Chinese Laundry, which flaunts a sign reading "How Ling Li Kell & Co." Then follows a building painted a delicate pink in which the latest frontier styles of millinery will be displayed. "Spender's Bank," where interest is charged on deposits, stands on the corner of Main Street and Jack's Alley, and across the street from it is the First Chance Saloon.

The article also described the old Villard Hotel; Raley & Sommerville's Drug Store, which was named after a pioneer Pendleton shop; the post office; the stagecoach office; the jail; the fire department; the blacksmith shop; and the Log Cabin Saloon. The saloon offered an entrance to the dancing pavilion, which could hold five hundred couples, while the Villard Hotel held the entrance to the gaming area in the Red Dog Saloon.[171]

The first Happy Canyon drained the pockets of its visionaries, though. The dancing pavilion alone reached a price of $1,500, contributing to the overall cost of $5,000. With the show's success, however, the crowd quickly outgrew the bleachers and the dance hall.[172]

For reasons not evident, the set was rebuilt by the Happy Canyon men the second year. The *East Oregonian* reported how the Red Dog Saloon was expanded by twenty-five feet to add to the gaming area, after gaining approval from the Oregon-Washington Railroad & Navigation Company superintendent Bollons. Even with the additional space, the 1915 show set and dance hall were taxed to overflowing capacity, emphasizing the need for a permanent and more spacious venue.[173]

SECOND LOCATION

In August 1916, after the Happy Canyon Company was formally organized, its first agenda item was to find a new venue. The majority of the old pavilion at the Umatilla Morrow Fair location had once again been torn down, making a new location necessary, but the Happy Canyon board knew this would incur a large expense. The new board had only about six weeks until the show and they still had four locations to consider.

Their first possibility was to remain at the Main Street and Frazer location, but the show and the audience had outgrown this locality.

The new board shared with the *East Oregonian* that there was "not sufficient room for a show of the magnitude to which Happy Canyon has grown and the necessity of tearing down and rebuilding year after year remains a waste of money."[174]

The second option was "Walter's Island" (just below Main Street Bridge), which received serious consideration due to its proximity to Main Street. It had already been the site of a well-attended Chautauqua.[175] Nevertheless, the newly formed board of directors decided that building Happy Canyon in this location would be considerably expensive.

The third choice was the entire block of East Alta Street, owned by the Catholic Sisters, which was about where Til Taylor Park sits today. It also offered the advantages of downtown proximity.

The fourth and final option was Round-Up Park (currently Roy Raley Park). This location would seem a logical choice today, but the Happy Canyon board felt it was too far away from Main Street, the nighttime crowd and action. In the stockholders' view, the last two options were too far from Main Street, which is ironic considering that the current Round-Up location is many blocks from Main Street.

Once again, the visionary group of Pendleton leaders took a gamble. They knew building a more permanent location would require a large expenditure up front, but they felt the improvements were worth it.

At the second formal meeting of the Happy Canyon Company on August 19, the Happy Canyon board reviewed a fifth location: a feed yard owned by the Northern Pacific Railroad and used as a livery stable. The owner, Mr. Potter, was willing to sell the block and the buildings, but at this meeting, with Round-Up only a month and half away, the company discussed rebuilding again at the old location.

Time was in short supply.

Just a couple days later, the board made a verbal agreement to immediately begin rebuilding Happy Canyon, incorporating some of the feed yard's buildings and the corral already on the city block. The *East Oregonian* reported that some of the new acquisitions could be left as they were found since they were in respectable condition.[176]

On August 28, C.A. Lansdowne, known for constructing the Blewett Harvester facility in just thirty days, began rebuilding the "town" of Happy Canyon and the accompanying grandstand. He seemed the perfect man to create an entire "town street," a new stadium seating up to 4,800 and a dance pavilion and gambling palace, which were added to the buildings in the back. As Landsdowne submitted his drawings for approval, the board agreed to pay him seven dollars per day and his transportation costs to and from Spokane. Meanwhile, the Happy Canyon Company leased the grounds for the project.

The town of Pendleton was abuzz with this grand building project downtown, which the newspaper reported would be a great location for Chautauquas. The board already saw this permanent facility as a huge benefit to Umatilla County, but it raised the admission price to fifty cents to help offset the initial cost.

"The grandstand will be in the form of a semicircle around the north and west sides of the

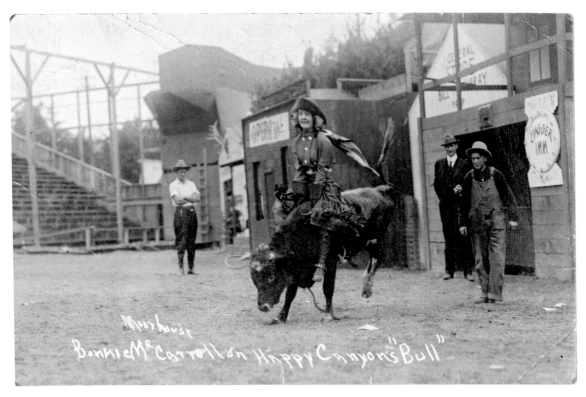

Above: Bonnie McCarroll on Happy Canyon Bull, 1916. Notice the lack of roof, the real fir trees and the hastily built set that utilized parts from 1915. *Howdyshell Collection.*

Opposite, top: The 1916 Happy Canyon is built. *Wayne Low collection.*

Opposite, bottom: Workers use some of the buildings from the old feed yard to construct the 1916 Happy Canyon. *Wayne Low collection.*

block so that the audience will be facing east and southeast," the *East Oregonian* stated, describing the project. "The grandstand will accommodate between 4,000 and 5,000 and there will be standing room for another 1,000."[177]

Those who remember the Old Canyon do so with fondness. "The street scenery itself was built also in a kind of wraparound fashion, giving you the feeling you were a part of the set and the action itself due to its intimacy more so than the current facility," Emile Holeman recalled.[178]

Show Opens in New Location

Even though the grandstand and scenery were not complete in 1916, the show went on anyway. "The sound of the hammer and saw had hardly died away before the yips of the cowboys announced the show was on," the *East Oregonian* reported. "The work of

201

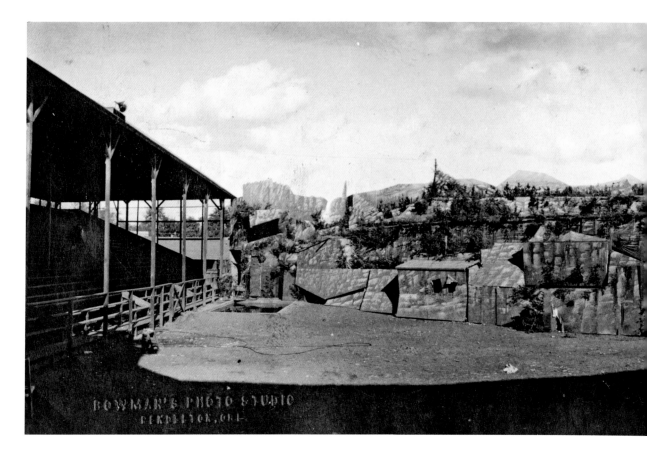

building the new $12,000 pavilion was not completed last evening but enough of it was done to enable the show to be staged in spite of this handicap and in spite of the fact that no rehearsals had been held, the street program was presented in a way that kept the crowd in laughter and applause."[179]

The roof looked like a woodland stage with a mountain trail wandering through it. The *East Oregonian* reported, "Trees are being 'planted' in the background and huge rocks and cliffs are being painted so that, under the glare of the spotlights, the scene will rise above the old town as a most appropriate setting."

The article stated that though the grandstand roof was not completed, the weather looked like it was not necessary. But an open-air show does have its challenges.

In 1917, Roy Raley designed, constructed and christened the "wonderful transformation scene," where the Happy Canyon scenery changes into an Old West town—an addition that thrilled and fascinated the audience. Remarkably, the current show continues to use Roy's creative design with upgrades.

The *East Oregonian* explained the scene:

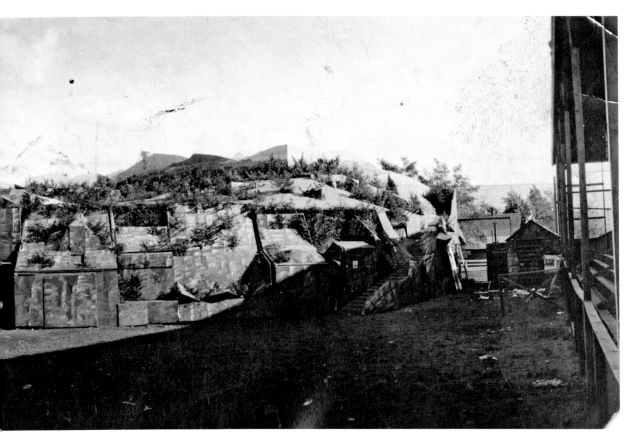

Panorama of the Old Canyon, no date. *Photo by W.S. Bowman; courtesy of the Raley family.*

As the crowd gathers, it will look upon the sheer wall of a great cliff. There will be no street front. At the top of the cliff, in a little clearing, an Indian camp will be in evidence. Down the side of the cliff pours a waterfall—a real one. Here, for 30 seconds, the lights will be turned out. In the darkness, by means of the mechanical shifts that have been worked out, the entire scene is changed in a twinkling.[180]

In December 1936, the Happy Canyon Company finally purchased the land under the Happy Canyon pavilion from the Northern Pacific Railway Company. This gave the Happy Canyon Company a complete asset.

The wooden stands and facility were a known fire hazard. In fact, the phrase "firetrap" is most often mentioned by those who participated in the Old Canyon location.

By 1940, the Happy Canyon board made vital improvements to the entire facility, spending $11,000 to improve the grandstands, bleachers and dance pavilion.

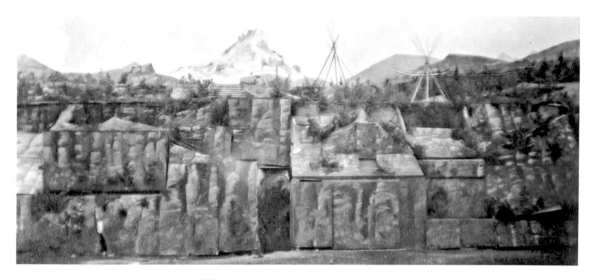

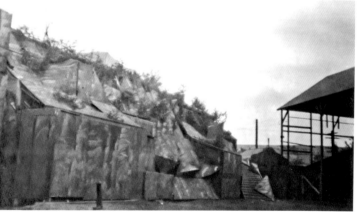

The grandstand roof was lifted so the topmost seats had improved visibility of the arena and surrounding scenery. The seats were also completely rebuilt with "backless but comfortable" seats—a definite oxymoron—and everything was freshened with a new coat of paint. Lastly, a "rodeo" fence was added across the bottom of the stands.

Since the 1940s population included a large number of habitual smokers, the board posted "NO SMOKING" signs everywhere and had

This page: Taken by Roy Raley in 1917, these photos show the "transformation scene" before. *Raley family.*

Opposite: Photos from 1917 by Roy Raley showing the "town" scene. *Raley family.*

the area under the stands doused with water before each show.

Emile Holeman remembers the liability of the dry wood facility. Each year, several teenagers were hired during the show and

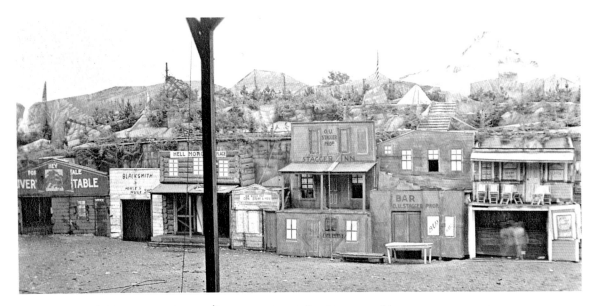

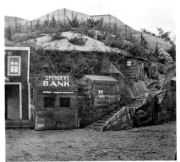
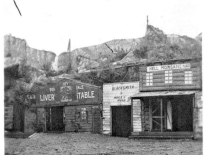
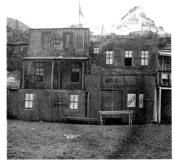

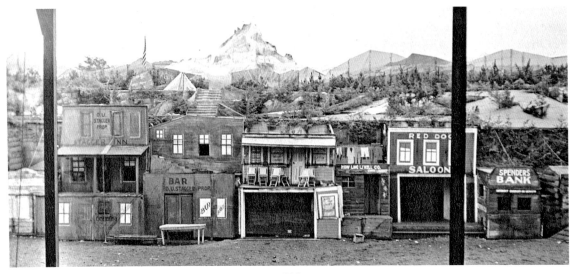

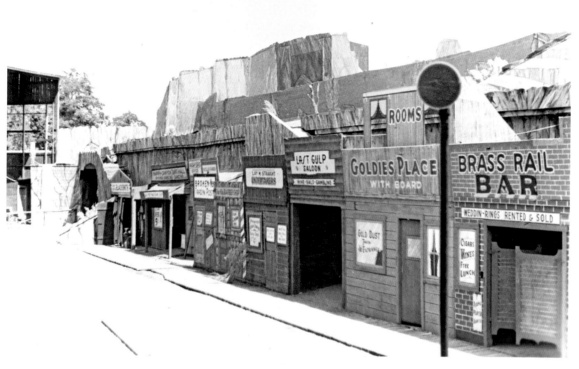

Inside the Old Canyon in later years, no date. *Author file.*

given buckets of water. They kept the sawdust wet under the stands and put out the small fires ignited when smoldering cigarettes were dropped from the patrons in the stands above.

The wooden bleachers and scenery were not the only flammable parts of the show, however. As a small boy, Fritz Hill remembers noticing how the canvas on the ramp often caught fire when someone shot a blank into it. The whole facility required constant vigilance.

The Happy Canyon board felt the 1940 improvements gave the grounds the finest maple dance floor in all of eastern Oregon. The bar area was streamlined, and new backgrounds were added. The orchestra pit, checkrooms and game room floor, which were in the balcony area, were remodeled.

Nevertheless, fifteen years later, this would all be torn down.[181]

In the 1940s, two weeks before Happy Canyon, the Dress-Up Parade kicked off the sale of Happy Canyon and Round-Up tickets, and patrons lined up for tickets for the upcoming shows. After the Dress-Up Parade ended in the Old Canyon, the board hosted the kickoff dance in the dance hall.

The ticket booth for the Old Canyon sat on Southwest Third and Emigrant Streets. By 1941, bleacher seats to watch Happy Canyon were only seventy-five cents each and reserved seats had the bargain price of $1.50.

Left: The view outside Happy Canyon's pavilion grandstands from Emigrant Street, 1940. *Umatilla County Historical Society.*

Below: Inside the Old Canyon with teepees set up. *Happy Canyon Collection.*

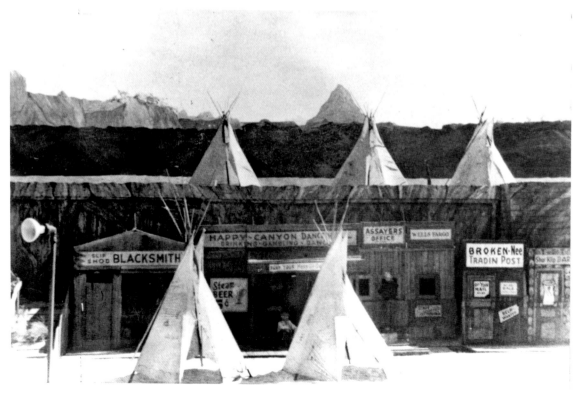

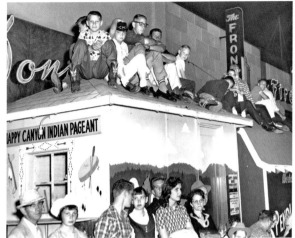

As ticket director, Emile Holeman remembers even in the 1960s and '70s dragging the old ticket booth downtown behind a pickup to promote the show and sell tickets with Bob Hawes on Main and Southwest Emigrant Streets. Emile remembers how often the show sold out in those days. In fact, 1971 brought a board discussion about the need to expand the grandstand to increase seating capacity.[182]

The years at the old location (1916–54) were the glory years for the show. Since the pavilion was close to Main Street, it gave the entire downtown area the feel of a street party. Hamburger stands and wooden benches lined the streets from Happy Canyon to Main Street, while people wandered back and forth.

"There were always dances," Ella Lazinka Granger reminisced in a 1970 interview with Celia Currin of the *East Oregonian*. "That was the only recreation for the visitors and a lot of times people couldn't find rooms so they would wander around downtown."[183]

The years during World War II brought wear and tear to the facility without the funds

Top: Left: people sitting on old Happy Canyon ticket booth downtown. *Howdyshell Collection. Right*: current photo of ticket booth. *Eye of Rie.*

Above: September 13, 1941 *East Oregonian* ad. *From the* East Oregonian.

Opposite: Views of Old Canyon looking southwest. *Happy Canyon Collection.*

to correct them. The board even bought $10,000 in war bonds for the improvement and maintenance of the Happy Canyon facility. Once the war was over, they had serious needs and improvements to address after the several-year hiatus of the show.

By the early 1950s, Happy Canyon needed a serious upgrade. The parking around the

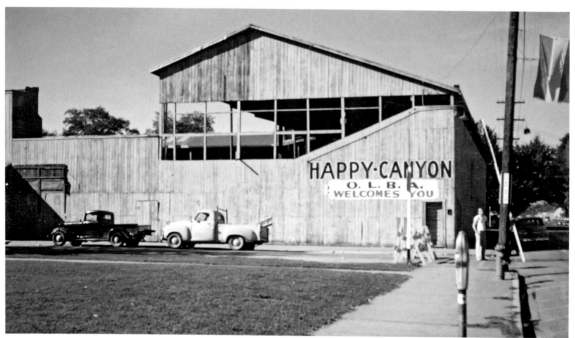

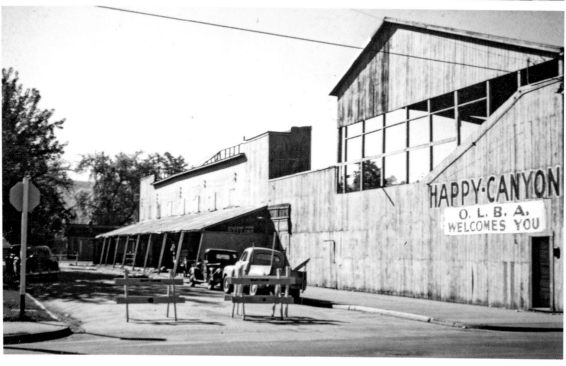

Above: A 1950s Happy Canyon board photo shows a rare view into former grandstand. *Happy Canyon Collection.*

Opposite, top: A rare view showing the current show's lot before the Happy Canyon grandstand was built. *Author file.*

Opposite, bottom: Proposed Happy Canyon site with drawing. *Howdyshell Collection.*

Old Canyon was sparse, according to former director Bruce Boylen, and the show itself needed more space. Bruce remembers that the scenery and hallways to the dance retained their original dark and narrow design. Plus, each evening, all livestock, wagons and cast paraded up from Round-Up, which was wonderful for people to watch but not convenient for all involved.[184]

For the second time in the show's history, the board again faced the choice to move to a new facility or to rebuild and expand the current home.

Roy Raley suggested moving to "the John Carroll tract" on Pendleton's North Hill, east of Jack Stangier's home. At the time, this location formed a natural amphitheater, surrounded by hills on three sides. The plans Roy drew up show amphitheater-type seating built into the side of the North Hill.

In a 1950 letter to Happy Canyon president Syd Laing, Roy urged "immediate acquiring of and development be commenced upon, the John Carroll tract." He felt time was of the essence and encouraged the board not to hesitate for "the best interests of the city and the Happy Canyon Company."[185]

In his mind's eye, Roy saw what a dramatic setting this would be for the show. In 1952, he

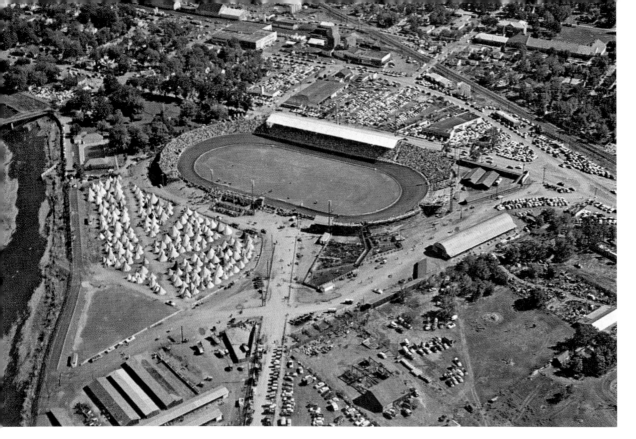
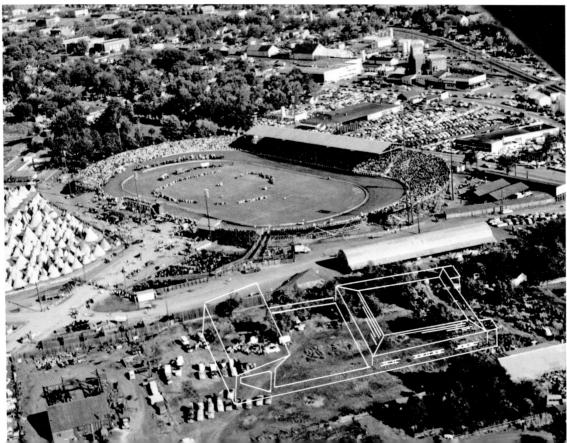

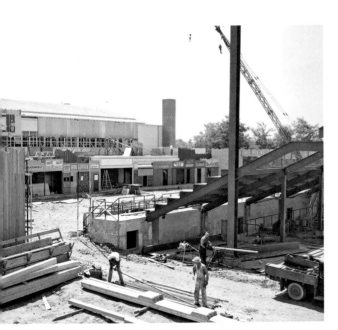

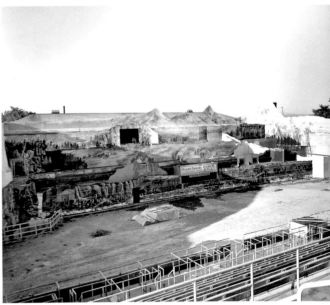

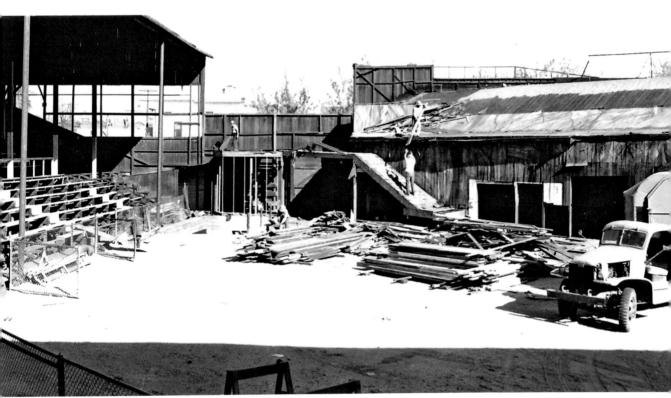

presented his ideas to the board, stating: "From the seats in the amphitheater and the windows of the 'Dance Hall' would be afforded an unsurpassed view of the Blue Mountains and Emigrant Hill with the historical associations of the Old Oregon Trail, and of the moon (when it comes up on time)."[186]

Whether or not the board caught Roy's vision, it did not choose his North Hill suggestion but instead decided to move and build Happy Canyon next to Round-Up. One of the attractions for all involved was this proximity, which facilitated easier use of livestock and wagons while also saving the time and effort of riding or driving the teams several blocks to downtown.

After legal matters were settled, the Happy Canyon site between Southwest Second and Fourth Streets and Southwest Emigrant and Frazer Avenues sold to Safeway. The board of directors hired A.P. Herman to demolish and level the old Happy Canyon facility, making way for the new Safeway store. This building now contains the Baxter Auto Parts and Western Auto businesses.

By November, the Old Canyon was nearly gone. The article said, "The Old Happy Canyon building saw the fledgling pageant conceived by Roy Raley grow to national prominence."[187]

Bill Shaw began acting in the show at age thirteen and had many fond memories of the Old Canyon. "I'm from the old school,

Opposite, top: Current Happy Canyon in the building stages, 1954–55. *Howdyshell Collection.*

Opposite, bottom: Herman's men tearing down the Old Canyon, 1954. *Umatilla County Historical Society.*

I guess," he said, "but it's hard to put it into words how great it was. Yeah, it was a firetrap, but it helped make the Indians and the actors what Montie Montana always said about the show—'hard to beat.'"[188]

William H. Stickney, Canyon director, summed up the transition by saying, "The Grand Old Lady of Emigrant Street will step aside for progress, but she will never be forgotten."[189]

HAPPY CANYON'S CURRENT HOME

During Happy Canyon's search for a new facility, the local National Guard unit was also on the lookout for a permanent new home. With the convergence of mutual need, discussions began among Happy Canyon, the City of Pendleton, the National Guard and the State of Oregon, fitting with Happy Canyon's long-standing value of honoring the veterans and the military. The discussions concluded with Happy Canyon's major contribution to the construction fund for the new shared facility, which included whatever funds it could obtain from selling the downtown property.

Since the current facility was planned for multicommunity use, the construction began in cooperation with local, state and federal government agencies. In 1955, the first show took place in its present location, featuring a seating capacity of 4,230.

Since its construction in 1955 for approximately $750,000, the current Happy Canyon and Convention Center complex has provided

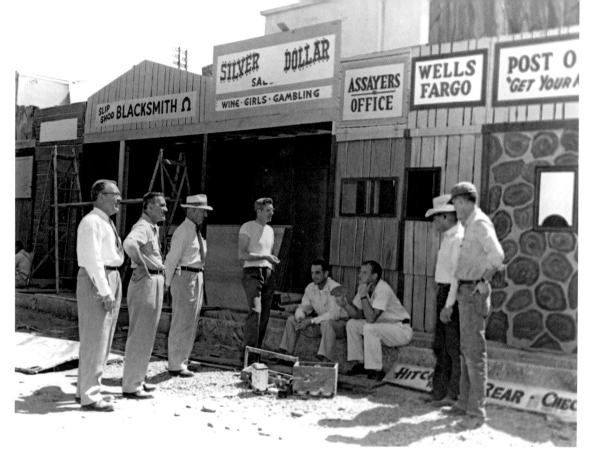

Above: Building the new "town" scenery. Later crews found parts from the Old Canyon. *Howdyshell Collection.*

Opposite, top: The view from Round-Up: the current grandstand in its glory. *Eye of Rie.*

Opposite, bottom: The famous Happy Canyon pool in 2015. *Eye of Rie.*

Pendleton with one of the finest civic facilities for a city its size in the country. Happy Canyon joined its resources to those of the city and state to "work together on projects of mutual benefit."

By August 3, 1955, the decking and seats were secured to the grandstand. With over a month to go, the building project resembled that of 1916 as hammer and saw worked steadily until show time.

There were a few hiccups, however. For instance, during the summer of 1955, the cast discovered the new Happy Canyon pool was too short, making an extension of almost a foot necessary the next year. Even though this extension cost another $275, today's actors are thankful the board of directors decided to add it. Until this happened, the 1955 cast referred to the pool as "the puddle."

As the 1916 set was built, Roy envisioned a pool as a part of the scenery. The current pool is ten feet deep and twelve feet wide, holding over 15,500 gallons of water. Currently, around nine key actors enter the water every show, but only three dive in from the top of the waterfall.

On August 25, 1955, the Happy Canyon directors celebrated with city of Pendleton officials, McCormack Construction and the Umatilla Confederated Tribes. For the first time,

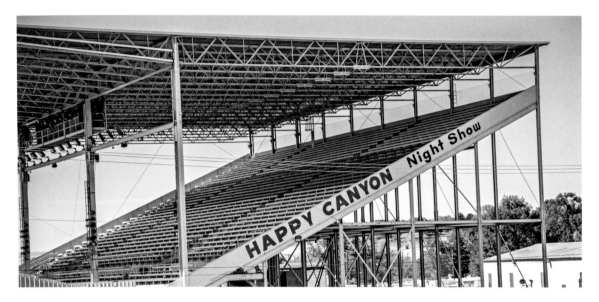

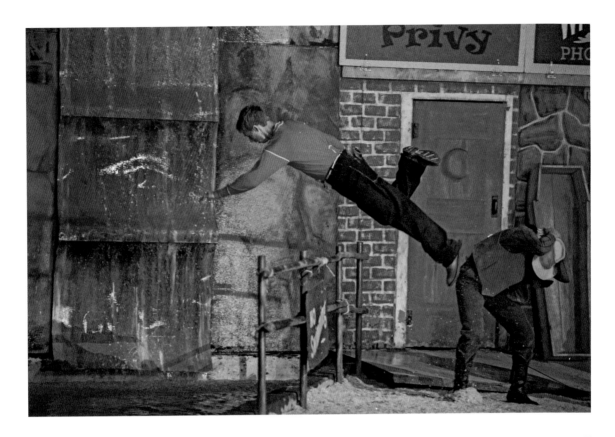

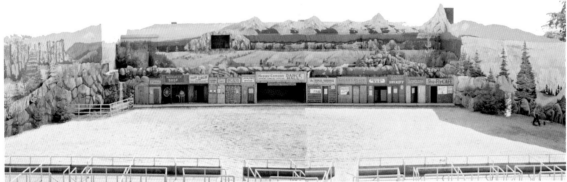

This page, top: Andrew Porter dives in! *Eye of Rie.*

This page, bottom: Panorama taken by board before scenery was rebuilt in the 1980s. *Happy Canyon Collection.*

Opposite: The current Happy Canyon "fireproof" grandstands. *Eye of Rie.*

the new Pendleton Memorial Army and Happy Canyon Arena held a free dance featuring the 234th Army National Guard Band in the new building following the dedication. Sadly, Roy Raley was in poor health and unable to attend the opening ceremonies.

As the first patrons attended the 1955 Happy Canyon pageant in the new location, they sat in what was hailed as the finest complex of its kind in the northwest. "Heightened interest in the Happy Canyon this year, as evidenced by ticket sales, can be traced in part to the new fire-proof Canyon facilities as well as the new setting that will be seen for the first time," said William Stickney, Happy Canyon director. The words "fireproof" certainly had a lot of meaning to those volunteers who had worried about that constant hazard.[190]

"This review of the Happy Canyon pageant has to be a fan letter to everyone concerned with the colorful production," Bernice Riley wrote in the *East Oregonian*. "It was the first time I've seen the show since it moved to the present location. The beautiful backdrop against the dark sky seems more brilliant than it did in the old setting."[191]

Happy Canyon had the opportunity to purchase adjacent property in 1976 and did so to

OFFICIAL CAR
HAPPY CANYON

create an additional parking area. The same year, after years of using a graveled parking area, Happy Canyon paved it with the help of the National Guard and the City of Pendleton. As any Happy Canyon participant will tell you, the parking spaces during Round-Up week are like pay since Round-Up parking is often at a premium; participants value their spots.

In fact, an unsung hero of Happy Canyon was Mel Peterson, who served as parking lot supervisor for over thirty years, ensuring that only cars with the Happy Canyon window sticker were allowed in. Mel considered it *his* lot, and it did not matter who you were. At times, even Happy Canyon presidents had to go back home and get their stickers.

Above: An official Happy Canyon parking sticker. *Author file.*

Opposite, top: A few grounds crews from over the years. The men on these teams put in long hours out of sight. *Happy Canyon Collection.*

Opposite, bottom: Happy Canyon arena and scenery ready for action, 2014. *Eye of Rie.*

GROUNDS CREW

One of the biggest jobs on the board of directors is overseeing the maintenance of the Happy Canyon grounds and arena. Beginning in May, weekly work parties on Wednesday evenings assess the maintenance or improvements needed for the coming show season. Every year, the grounds director carefully checks each part of the scenery for repairs and upgrades since the open-air theater receives constant wear and tear.

In the current arena, several scenery renovations have occurred over the years. With wooden scenery in the elements, weathering is a constant maintenance concern. The 1992–93 renovations built the scenery of metal, since

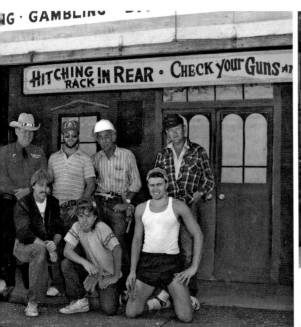

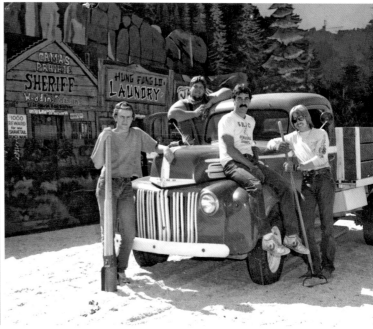

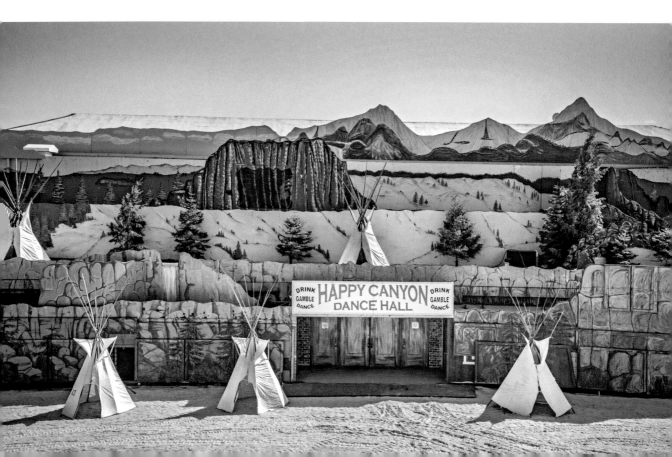

This page: Scenery renovations were needed due to weathering. *Happy Canyon Collection.*

Opposite: Wear and tear on wooden scenery led to replacement. *Happy Canyon Collection.*

the City of Pendleton stipulated only non-flammable materials could be used, reflecting the age-old Happy Canyon concern for "fireproof" materials.

An example of faithful grounds crew volunteers are brothers Matt and Greg Duchek.

Together, they have built, repaired or even replaced virtually every part of the Happy Canyon pageant grounds. Matt also served as Happy Canyon grounds director and president.

Greg has been in Happy Canyon from top to bottom—from three feet underground, where he put in a sewer system, to the top of the roof over the grandstand. Greg said he has "dug, drilled, screwed, painted, sawed and nailed everywhere." Greg figures he put more than 100,000 screws in the roof the first time it was replaced. He even stealthily

221

crept onto the top of the ramp to nail down a loose board one night during the show. Greg won the Happy Canyon Appreciation Award in 2005.

In 2010, Matt and Greg helped rebuild the current West Side of the scenery. This has been an excellent upgrade for the cast behind the scenes and for the volunteers in Happy Canyon Dance Hall, who find the wider hallway easier to navigate.

The construction also enlarged and rebuilt a pedestal at the top of the scenery for the current star and Trail Horse, Chinook, making it possible for this large horse to make a 360-degree turn and improving horse and rider safety.

From May to September, you will see the brothers at the pageant grounds doing their duty. Their time in Happy Canyon has made it a family affair. Greg's son and grandson are in the show, and his wife, Roxanne, helps with the makeup room and also has spent hundreds of hours painting the scenery, which is no small feat.

SCENERY PAINTING

As the first "frontier town" was built in 1914, Happy Canyon hired H.D. Kem, a theatrical scenery painter, to not only paint the set, but also to assist with authentic design and decoration.[192]

Since the first show, scenery painters have brought their gifting to the town of Happy Canyon. One of the talented painters, whose work you can still see today on the large metal flank pieces of scenery, was Phil Jamison.

For over twenty years, Phil was seen painting scenery (mostly with a long-handled paint-roller). As he was passing away from cancer, the grounds crew made a pine coffin for Phil, with a large panorama of the Happy Canyon scenery on its side.

REAL TREES

The Happy Canyon arena and accompanying scenery are full of details easy to overlook, such as the fresh-cut coniferous trees.

From the beginning, Roy planned to use real trees from the abundant Umatilla National Forest in the scenery. Some years the railroad shipped in the trees, but currently, a tree crew with special permits makes the journey to the Umatilla National Forest a week before the show, keeping an eye open for the "big tree" to place at the West end of the scenery.

In his diary, Roy explains the use of the trees:

Above: Roy Raley's drawing of his "tree horse" from his diary. *Raley family.*

Opposite: *Top*: the 1990s tree crews with a permit in Umatilla National Forest. *Author file. Bottom*: trees for the 2014 show, ready for placement in scenery. *Eye of Rie.*

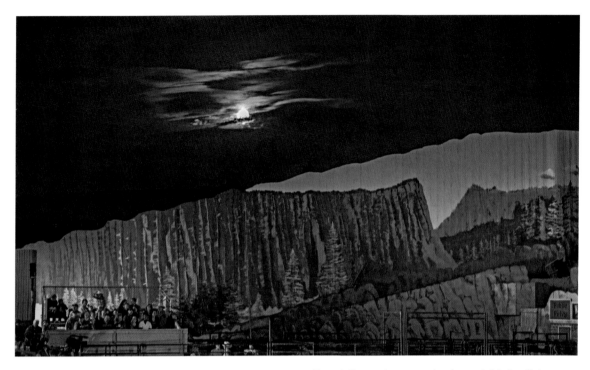

Above: A September moon has been visible in all three Happy Canyon locations. *Eye of Rie.*

Left: Behind the scenery before the show—it is ready for the cast and crew. *Eye of Rie.*

Opposite: The newly built Happy Canyon mezzanine project provides ADA access and safety for patrons. *Eye of Rie.*

I spent several years in developing the use of evergreen trees as part of the scenery of Happy Canyon and am sure if ever to again direct the show I would revive their use. They soften the scenery and make it more realistic. They can be used to hide boards and joints in the scenery and dress up the stage much more than one would think.

When the Whitman Pageant was produced in Walla Walla (written by Dr. Penrose and a beautiful script) a distinguished pageant producer was brought out from Boston or New York and he made extensive use of firs in his scenery.

Tree horses are my own idea and I think give a better effect than any other arrangement I have seen.

One of the real-life features the audience is likely to see is the full moon that often rises over the Happy Canyon scenery; it is one of the most entrancing parts of the show.

Since the grandstand faces southwest, the moon in a dark blue sky enhances the scenery of the stage, giving it a dramatic flair. In fact, all three locations of the Happy Canyon scenery have had the bleachers or the audience facing south to southwest, enabling viewers to observe the beauty of a full moon in the September night sky.

An open-air arena does have its complications, but Happy Canyon goes on, rain or wind.

Newest Renovation to the Canyon

After several years of fundraising and setting aside the nonprofit's funds, the Happy Canyon board celebrated the new mezzanine project in 2015. Their goal was to keep audience members above the action of the show and out of harm's way.

The potential for injury has always been an issue with the speed of the stagecoach entering the arena or the quick exit of several horses throughout the show. At any time, a curious audience member could spook a horse or accidently step in front of a wagon.

This $1.4 million project (compared to the 1940 $11,000 improvements) is a necessary addition and improvement to the overall facility. The raised floor moved the bathrooms

and grandstand entrances to a new second story, allowing the audience members to arrive at their seats without ever entering the ground-level backstage area.

The stadium seating climbs to over sixty-two feet aboveground. The mezzanine provides an intermediate level accessible by staircase or by elevator, which is more convenient for those with disabilities and doubles the ADA (Americans with Disabilities Act) seating, improving the facility and bathroom accessibility for all patrons.

The funding for this project has come mainly through donations from nonprofit support foundations like Wildhorse Foundation, the first to make a commitment to it, but volunteers made the addition possible. The entire project is a much-needed facelift for the facility, which is sixty-one years old in 2016. With typical Happy Canyon ingenuity, the old set of metal stairs were repurposed and moved, saving money as well.

As the 2016 Happy Canyon pageant prepares to delight the audiences for its 100th anniversary year, the volunteer crews will be working hard weekly to paint, hammer and spruce up this unique set for another entertaining Happy Canyon week.

10

MUSIC UNDER THE STARS

Once again the old loved music of Happy Canyon will thrill thousands.[193]

As the audience filled the stands, the September quarter moon in its glory rose over the Happy Canyon scenery and the orchestra played the preshow concert—not just any music, either. It played the difficult but lovely John Philip Sousa marches "Liberty Bell" and "Hands Across the Sea" completely unrehearsed.

Music under the stars is still a rare treat today, just as it was a century ago.

From the first show in 1914, Roy Raley knew music was the key ingredient to a special pageant. Without it, the Happy Canyon pageant would not have the same effect. In fact, the orchestra performs so well that some audience members assume the music is piped in.

Through the years, talented musicians from the Northwest and California have played the Happy Canyon score. Many standout performers, such as Rod Esselstyn and Doc Severinsen from Arlington, Oregon, have also joined the band.

Former actor and director Bruce Boylen noted how the accomplished musicians in the Old Canyon were worth the price of the ticket. "The before-show concerts were so fantastic, I would stand at the gates with several cast members just to hear the beauty of the live outdoor music," he said.[194]

The music is still beautiful today, but the orchestra has undergone years of growth and transformation. The musicians are currently directed by Andy Cary, who played the alto sax nine years before picking up the Happy Canyon orchestra baton in 2014.

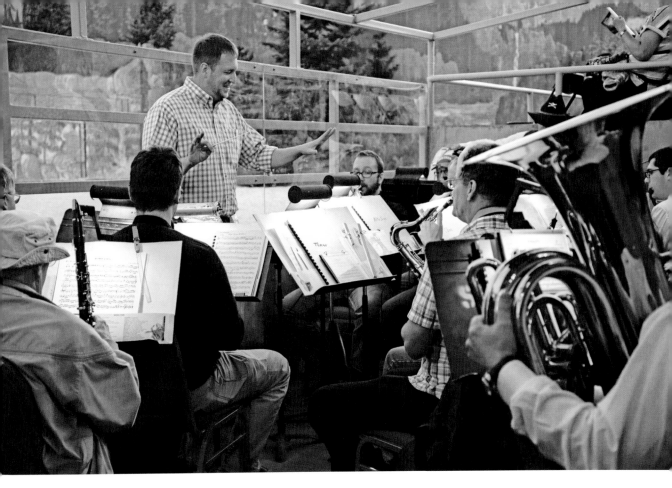

Above: Andy Cary conducts the 2015 Happy Canyon Orchestra in a preshow concert. *Eye of Rie.*

Left: Some of the sheet music for the "preshow" concert. *Eye of Rie.*

THE HAPPY CANYON SCORE

Bert Jerard, early Happy Canyon board member and musician, is credited with arranging the first musical theme for Happy Canyon, collaborating with Raley's vision. Bert was known as the "Music Mix Master," which might explain the John Philip Sousa selections interspersed with classics and folk music.

As the show grew over the years, the score grew with it. By 1938, its beauty was famous, having been used for over fifteen years. Some of the music used that year was "Eleanor" by Deppman, "Waters of Minnetonka," "Indian Love Call," "Death of Custer," *Le Prophète* and "There'll Be a Hot Time in the Old Town Tonight." Each of these pieces is still played today.[195]

Howard Deye, known for Deye Music Studio-Shop in Pendleton, also directed

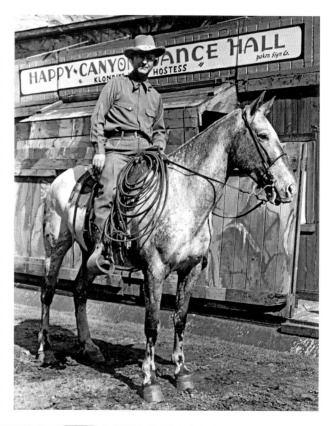

This page, top: Bert Jerard, Happy Canyon director, was credited for the score arrangement. *Wayne Low collection.*

Right: The Cowboy Mounted Band in the Old Canyon also played as the pit band for years. *Howdyshell Collection.*

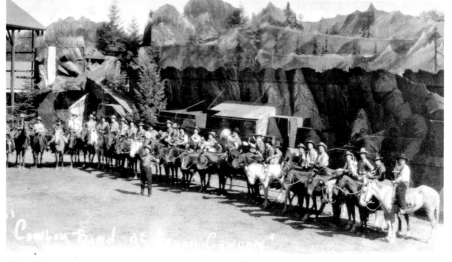

the orchestra for several years—first wielding the baton in 1941. His wife sang in the show, adding her voice to that of Ted Roy, a local music teacher. Howard added to Bert Jerard's score, improving it with show director Dr. William C. Stram.

In the first several years, the show saw different orchestra groups. The forty-five-piece Campbell American Band, brought to Pendleton from Portland at great expense, played for the show in 1919. It was touted as the best band on the West Coast and known for its expertise. Many times, the bands playing for the show also doubled as the dance bands.

THE MOUNTED COWBOY BAND

In 1910, the Pendleton Round-Up Mounted Cowboy Band was formed, organized and led by Round-Up and Happy Canyon Hall-of-Famer R.W. Fletcher. Basically, he gathered a bunch of musicians and put them on horseback.

For its first appearance, the original band led the Westward Ho! Parade. Some thirty cowboy-musicians prepared and practiced, using the less difficult bucking stock as their mounts. The band appeared throughout the Northwest and even as far away as Calgary, performing in the Portland Rose Parade, the Spokane Lilac Parade and other regional rodeos.

"Most of them rode the Round-Up's bucking stock," Judge Richard Courson, cofounder of the current band, said. "They were quite a sight, riding down the street with their sousaphones. They had the old kind that went straight up."[196]

The original group of eighteen began a tradition that lasted until 1940. That year, the Round-Up bucking stock was sold, and unionized labor made its appearance, ending the band.

The Mounted Band in the late 1930s, also named the Pendleton Municipal Band, had the honor of playing for Happy Canyon as the pit band for several years, receiving the title "Happy Canyon Pit Group" in 1938. Not only did the group play for several years in parades promoting Round-Up and Happy Canyon, but it also played for city events and held concerts. Interestingly, by 1938, several Portland Symphony members had joined the band as well. [197]

Many band members continued playing for the Pendleton Municipal Band through the 1940s. Happy Canyon used them as the orchestra, since they were funded in part by Happy Canyon.

After disbanding for many years, the Mounted Band was revived in 1985 to celebrate Round-Up's seventy-fifth anniversary. Judge Richard Courson and area musician Bob Herbig partnered for a one-year performance that became a yearly event. The group ranges in size from twelve to fifteen, offering daily performances, parades throughout the region and, of course, music at Happy Canyon.

Now under the leadership of John Groupe, Gary Zimmerman, Greg Dennis and Randy Morgan, the Mounted Band continues a century of tradition. It continues to be a crowd favorite in the Happy Canyon arena, usually playing Friday and Saturday nights before the show. The band members themselves are a joyful and close-knit group, and many also play in the famous Happy Canyon Hick Band.

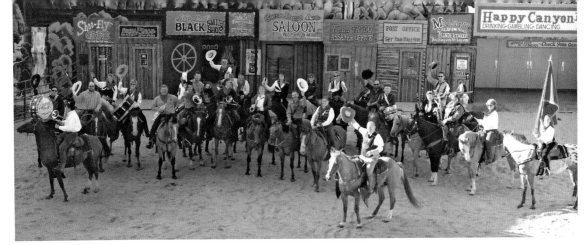

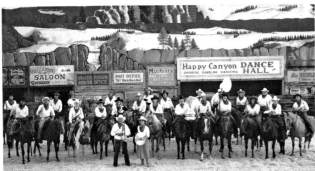

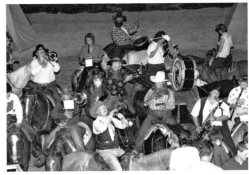

Above: Revived in 1985, the Cowboy Mounted Band continues to entertain at the show. *Top and bottom, left: Howdyshell Collection; bottom, right: Don Cresswell.*

Right: John Groupe, a leader of the Cowboy Mounted Band, in the Westward Ho! Parade, 2014. *Eye of Rie.*

MUSICAL HIGHLIGHTS THROUGH THE YEARS

In one hundred years of Happy Canyon music, high points have varied from grand finales to guest performers.

In 1918, the Camp Lewis Military Band gave a concert as the grand finale, bringing the entire audience to its feet as the band marched in to "Over There." Pendleton girls represented each of the Allied nations by carrying the flags of England, France, Italy, Japan, Serbia, Belgium, America and the Red Cross.

Jewett G. Kepley directed the Happy Canyon Band for many years. *Author file.*

Ray Burgin, a professional San Francisco musician and a member of the Shrine Circus Band, came every year from California to play the euphonium.[198]

Trombone player Edwin "Buddy" Baker played with the "Hick Band" as a special featured musician; he also played in the pit band in 1967. Baker was known throughout the nation as a special guest of university and big-name bands. He had several special recordings and played with Stan Kenton and Woody Herman while also serving as a professor of music at Colorado State University.

The 1968 pit band included Dr. John Richards, who used a tuba to play the piccolo solo from John Philip Sousa's march "The Stars and Stripes Forever." At the time, Richards had played in the orchestra for twenty-five years and was assistant dean of Lewis and Clark College, as well as personnel director of the Oregon Symphony Orchestra.

The same year, three musicians came from the University of Oregon and three from Washington State University. The tuba player arrived from Lewis and Clark College and the Portland Symphony, playing in the Hick Band that year as a feature soloist.

In the late 1920s and 1930s, Cole McElroy's group, from Portland, Oregon, was the dance band. He helped direct the Happy Canyon orchestra and acted in a few show comedy scenes in 1929. Cole's group not only played, but it also sang, bringing violins, a banjo and an accordion in addition to singing.

The highlighted 1950s musicians included George Phillips, a member of the Portland Symphony who played the trombone. He was widely known for his solo work of "At Dawning."

LEADER OF THE BAND

For over a century, the men leading the Happy Canyon orchestra have been the finest of Pendleton's musicians.

For around twenty-two years, Jewett G. Kepley expertly directed the orchestra, beginning in the Old Canyon. He began around the time the

Municipal band and the Mounted Band ended their run.

At the time, he also served as the director of music for the Pendleton School District, having bachelor and master of music degrees from Illinois Wesleyan University. He also had broad experience in producing musicals.

In 1969, Kepley spent 457 hours writing and reorganizing the Happy Canyon music. Without a computer or Xerox machine, he handwrote every musical part out of his love for the show, though he was beginning to lose his eyesight. By the time he completed the project, his eyesight was nearly gone. After sixty years, his arrangements are still used today. Each musician lists his or her name at the end of a long line of those who have previously played the same musical part.

"Kep," as he was affectionately called by those who knew him, was key to the Happy Canyon orchestra for several years, while also leading the Pendleton High School band. Sherrill McKee Byers, a clarinetist who played under Kepley at Pendleton High School in 1953, described how the students' goals were to be

Examples of Jewett Kepley's handwritten music arrangements that are still in use. *Eye of Rie.*

good enough to play in the Happy Canyon orchestra because it was regarded so highly. This fact still sticks out in her mind today. Kepley would use the orchestra as a carrot—if they became proficient, they might get to play in it![199]

One Pendleton High School student got his chance in 1966. Kepley asked Roger Allen to perform the drum solo featured every night in the town scene.[200]

When Bob Henson picked up the director wand in 1975, he had already put in twenty years as a member of the band. As a clarinetist, he served as assistant director under Kepley. Bob had received his BA and MA degrees from the University of Colorado and ended up at University of California–Berkeley, where he continued graduate work in music education. He also served in the Pendleton school district as junior high and elementary school band instructor.

Because Bob felt some of the music they played wasn't the easiest, he quickly pointed out how, with only one rehearsal, each musician must "pick it up immediately."[201] Today's music artists, such as clarinetist Jim Straughan, concur.

Serving Happy Canyon for over fifty years, Bob Herbig played in and conducted the Happy Canyon orchestra. At times, he was known for his quick temper. Bill Ryder remembered how if they pushed Bob too far, he might even throw his baton at the culprit.

Both Bob Henson and Bob Herbig were remembered for their hospitality to the out-of-towners in the orchestra. After the first night of Happy Canyon, they often held a dinner or took the whole group to eat—an outing the band members always anticipated. The band itself became a yearly reunion of amazing Northwest and Californian musicians.

Continuing its musical excellence, the most recent orchestra of 2015 featured professional musicians from Oregon, Washington and California.

Below: Maestro Steve Muller directing the 2000 Happy Canyon Orchestra. *Don Cresswell.*

Bottom: Merv Cutright, former Happy Canyon conductor, continues to play the tuba in his thirty-seventh year with the production. *Eye of Rie.*

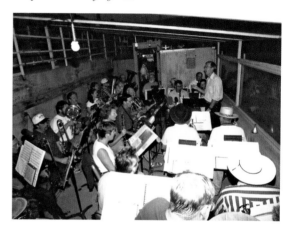

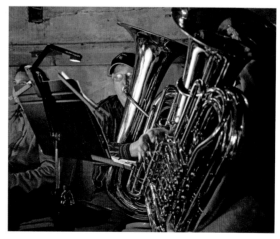

Only One Rehearsal

It is Wednesday afternoon of Round-Up and Happy Canyon week, and while the rodeo contestants enjoy their first day of competition, the Happy Canyon Orchestra rehearses for the first and only time before the show begins at 7:45 that evening. Gathered under the grandstands, the band follows Andy Cary through each of the musical pieces. At the end, they play for the cancan girls' dance rehearsal (the only live rehearsal for them as well).

You would never know the Happy Canyon orchestra gathers to perform only once a year. This rehearsal, over the last forty years, has been held on Wednesday afternoon—right after the musicians arrive in town from as far away as Portland and northern California. By 6:30 p.m., they have tuned up, renewed friendships and started the overture as the crowd is seated.

For years, the pit area, where the orchestra is seated right beside the directors' booth, was surrounded only by chicken wire. A much-needed Plexiglas wall replaced the wire fence for protection and sound improvement in 2003.

Many of the orchestra members remember the year the oxen pulling the covered wagon came too close to the orchestra pit and kicked the Plexiglas, causing it to collapse on several of the trumpet players. Amazingly, no one was seriously injured, and of course, the

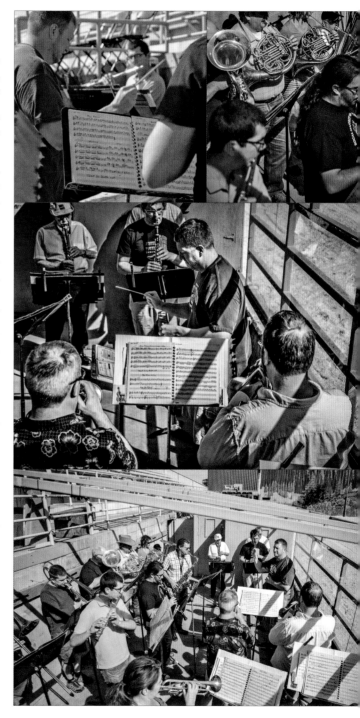

The orchestra in 2014 had its one and only rehearsal on Wednesday afternoon before the show. *Eye of Rie.*

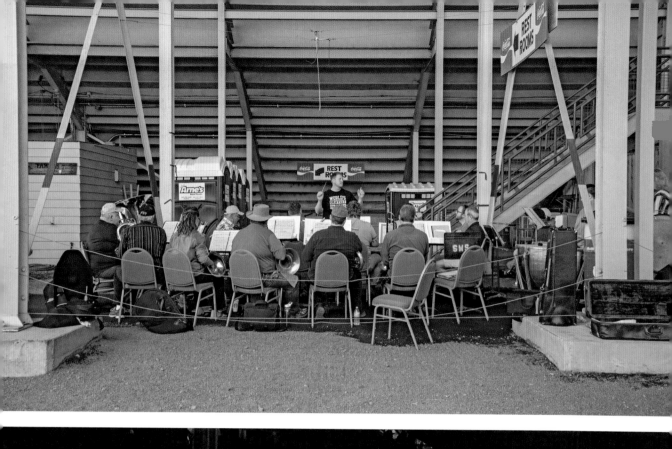

show and the music went on. You never know what might happen at Happy Canyon!

The band's chief role is to supply the background music for every show action, requiring it to speed up to a frenzied pace at times and then stop abruptly at the director's signal. Not only are skilled musicians needed, but endurance is required as well. Four nights in a row, they play from 7:00 p.m. until sometimes 9:30 p.m. with only a brief break during the doctor act and several Indian parts.

One of the biggest challenges outside the music difficulty is show changes. The music the band played on Wednesday can be altered, and by Saturday, it is possibly playing different pieces in a completely different sequence to go with show fluctuations. The orchestra is incredibly adaptable and unflappable. These musicians are professionals.

Their instruments require constant tuning. September evenings can begin hot and cool down rapidly, causing headaches for the band members as they readjust instruments throughout the evening.

Colleges throughout the Northwest have provided musicians for scores of years. Currently, the orchestra contains a perfect blend of new members and those who have proudly played with it for years.

When asked how they became a part of this special band, they answer: "The only way you get in the orchestra is if someone passes away." Through the year, the director of this unique band is always looking for the right replacements.

Just as the show boasts of generations of volunteer actors and volunteer lists, so does the band. The current orchestra contains Eric

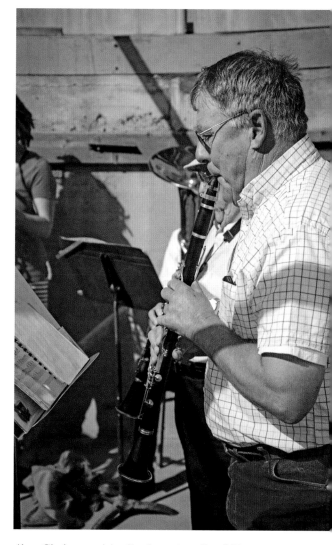

Above: Clarinet musician Jim Straughan. *Eye of Rie.*

Opposite, top: With the threat of rain, the 2015 Happy Canyon orchestra rehearsed once under the grandstands. *Eye of Rie.*

Opposite, bottom: The view toward the orchestra pit, showing protective Plexiglas wall. *Eye of Rie.*

Cutright, son to Merv Cutright, who has not only played for over twenty-seven years but has also directed and led the group for several years. Eric plays the euphonium (baritone horn) and for many years witnessed his father drive from La Grande "to play with this thing called the Happy Canyon band." In 2015, Eric drove from Happy Camp, California, to play in the Happy Canyon orchestra with his father.

Bill Ryder, a percussion musician, followed in his dad's musical steps. "My dad, Tom, started playing the snare drum at age eighteen in 1944 in the Old Canyon," he said. "He continued playing for Happy Canyon for sixty-six years and remembered playing with musical greats, such as Rod Esselstyn and Doc Severinsen."[202]

Tom Ryder also played for the Happy Canyon dance, joining some of the orchestra members. "Dad always told the stories of sawdust coming through the ceiling onto the dance band as they played in the Old Canyon," Bill said. Currently, Bill has played with the orchestra for many years, "Just because I love the show."

Over the years, Bill also joined the Hick Band, playing the snare drum. One of his most poignant memories is when Jeff Zimmerman got hit hard by a girl who was playing the role of a dance hall girl for her twin sister. As Jeff entered to perform his act, the gal thought he was a bit too fresh and let him have it.

The music was so key at the Old Canyon, Bruce Boylen said the makeup line was governed by what music was playing. For years, Happy Canyon's music has been the "cue" as the Indians make their way from the village to the East Gate or listen to it drifting over the grounds. Their entrances and timing are often tuned with the music.

Top: Bob Svboda plays the euphonium. *Eye of Rie.*

Above: Keith VanVickle plays the tenor saxophone. *Eye of Rie.*

In the pageant, the music tells of things to come. A key show cue from the music is the fast notes of the piece "Hurry" by Kling—a song easily recognizable as the start of the stagecoach scene. Sure enough, the stagecoach comes rattling in at full speed soon after its

bars begin. Most cast members leave the show humming a line of its music, such as the "Coronation March" from *Le Prophète* or "Red River Valley."

Members of the orchestra return year after year to make the pageant a remarkable show. Currently, key instruments have been expertly played for over thirty years by John Weddle, clarinet (forty); Jim Straughan, clarinet (thirty-five); and Bill Ryder, percussion (thirty). Pete Exline finally retired at the age of ninety after playing for the Happy Canyon orchestra for forty-one years. Jim said, "To play all these years is an honor and joy."

John Weddle started in the orchestra when he was teaching music in eastern Oregon in 1971 and has never stopped returning. John is such an accomplished musician that he plays an A clarinet instead of a B clarinet, which means he has to transpose every note by a half step—just for the fun and challenge of it.

Elburn "Coop" Cooper has played in the orchestra for over twenty-five years, driving from La Grande to add his clarinet expertise in the wind department. "It is a paying gig that I so enjoy," Coop said.

One of the trumpet players, James Smock, proudly displays the antique cornet he recently bought and refurbished. It belonged to former Happy Canyon president Stan Timmerman when he was in junior high in the late 1940s, and Stan used it in the Oregon State University marching band. In 2015, James played this special instrument for the show's preconcert portion.

"This is the most unique thing I do outside of the Elvis impersonator," James said. James is a professional musician who lives in Boise, Idaho.

James Smock displays an antique cornet belonging to former Happy Canyon president Stan Timmerman. *Eye of Rie.*

The band also has new members. For instance, the current show's oboe musician, Andrew Carder, played for the first time in the 2015 Happy Canyon, though he has played oboe since 1990. He described the honor and excitement in joining this special

group of musicians. Since he is from the Tri-Cities, Washington area, he was surprised when he was asked to join. "It means a lot to be asked," he said.

Andrew sits next to his former band teacher John Owen, who plays the French horn for Happy Canyon. Andrew described himself as one of John's "struggling" musicians who has continued to play because he loves it. He has not lost the awe of sitting alongside his teacher-hero.

Garen Horgen, a trumpet player from Portland, was asked to play for the orchestra because former trumpeter Phil Cansler passed away. He has now played in the group for eight years, and he compares this once-a-year performance to attending camp. "You get to rekindle friendships, get out of Portland and relax," he said.

Even though the orchestra is made of professionals, they still consider the show a yearly high point. They describe it as a reunion and as one of their favorite "gigs."

People still tell the story of an older tribal member who had served in World War II and fought in the trenches. He remembered lying in those dugouts and suddenly hearing some of the Happy Canyon score—instantly finding himself in tears since the music expressed all things Happy Canyon, Pendleton and home for him.

This beautiful story helps sum up the love of those who know and experience the show's live musical background.

The trumpet trio expertly plays "Bugler's Holiday." Phil Cansler began playing this piece in 2002. *Eye of Rie.*

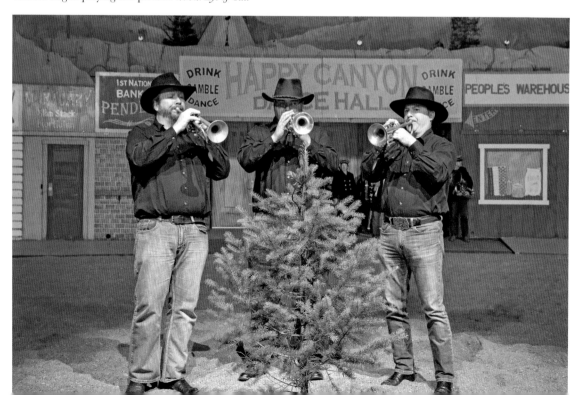

11

ANIMAL CAST

From the opening sequence, with the startled deer on the hilltops, the fluttering wild birds—to the close, with Old Glory brilliant against the dark of the September sky, Happy Canyon is a glorious show, it has everything—plot, color, music and, above all, a splendid cast, 300 Pendletonians, Indians and whites.[203]

In 1917, the cast cheered as a horse and rider practiced leaping from the top of the "waterfall" in the Old Canyon, landing successfully in the square "lake" below. Unfortunately, the horse's rider, Bob Hail, was unable to perform the act days later after his bucking horse fell with him at Round-Up.[204]

Later, they reattempted the act. Lee Drake described how the horse dove off beautifully during practice but experienced stage fright from the glare of the floodlights during the show.[205]

Since 1914, when the first horse rode into the small Main Street location, the animal cast has been an essential part of Happy Canyon. The newspaper described the first wild steer the performance brought on in 1916: "The steer in question is one of the most beautiful steers ever brought to Pendleton. It is a spotted animal with long horns, curving back, lithe in build and a challenging eye that indicates its spirit. It was selected after a dozen of the wildest of the Round-Up herd had been tried out in separate corrals to test their fighting spirit."[206]

During one performance, this steer crashed underneath the grandstand and somehow managed to make it into the dressing room where the high school "wood nymphs" were gathered. The crowd was treated to "shrill feminine cries" and all of a sudden, the steer ran back onto the street again. They don't make acts like that anymore.[207]

The animals' welfare and care is important to the participants and behind-the-scenes

safety, especially when the stagecoach enters the arena at full speed and horses gallop through the gates.

Over the years, an animal menagerie has unfolded, revealing different types of stock and wildlife.

Remarkably, three trick bears participated in the pioneer act in 1917 and 1918, providing a touch of realism—especially for the pioneers. Several coyotes, including a coyote pup and two coyotes trapped stealing watermelons in Hermiston, became cast members for a couple years.

In some years, the show's opening sequence featured a beautiful deer or elk. In 1929, a deer was spotlighted as the lights gradually came up, and in 1969, there were two deer, one of which was a four-point buck.

The 1974 four-point mule deer from Heppner, a buck named "Robin," did almost anything for potato chips and candy. On his opening night, he so enjoyed the spotlight that he had to be coaxed off the mountain scenery. He was in the show until 1977.

Sometimes, the show also used a stuffed deer until its hair began falling out. One year, Jim Rosenberg even trained a badger for the opening sequence.

The show is not limited to four-legged wildlife, though. Feathered friends, most especially pheasants, have been an animal cast staple for years.

Each night, as the lights open on a "new morning," the pheasants flutter across the arena. With minds of their own, they sometimes land in the audience or even on cast members. Recently, perhaps blinded by the lights, a pheasant flew right into the support

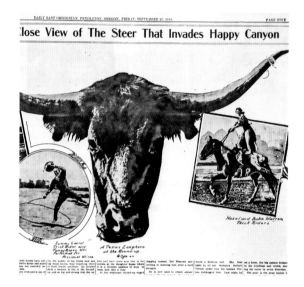

An *East Oregonian* depiction of the wild Happy Canyon steer in 1915. *From the* East Oregonian.

Above: The 2014 quadrille horses follow in the line of the hundreds that have been trained and brought in for the show. *Eye of Rie.*

Opposite: Yearly, an animal menagerie becomes cast members. *Eye of Rie.*

beam in the stands, leaving him stunned for a couple minutes.

Bill Maclin, who sang the "Indian Love Call" for twenty-five years, tells of his predecessor, Tom Blaylock, singing the love call when they released the pheasants. Instead of fluttering across the set, two pheasants flew into poor Tom's war bonnet right as he was singing, "When I'm calling youuuu." Poor Tom did not know immediately what hit him!

Currently, the show features six oxen, about seventy-five horses, four mules, one sheep, four pheasants and even a lone chicken. Each of these animals plays an important role.

Beauregard the Elk

Mark Rosenberg provided four different elk and two trained deer for Happy Canyon. However, Beauregard the elk was the audience favorite and a key participant in the show from 1982 until 2000, performing seventy-two times. He was orphaned in the Blue Mountains and bottle-fed by the Rosenberg family during Mark's time as livestock director.

The bull elk brought the show several management challenges. It took two years and an Oregon state senator to legalize his show performances, along with a yearly permit for "1 Rocky Mountain Neutered Male Elk" from Oregon Fish and Wildlife. Once again, this is an example of the show's importance. The state retained ownership while the Rosenberg family cared for the elk.

When Beauregard suffered a broken shoulder, an orthopedic surgeon and a veterinarian did not think he would survive the surgery, but he amazingly recovered. It just so happens that elk are in the rut during August and September—the same time as Happy Canyon. When Beauregard became unpredictable and dangerous to handle, he was castrated and the veterinarian was once again uncertain if he would make it. But yet again, he did.

Having been raised on a bottle, Beauregard still sucked a bottle as a five-point bull. When he heard the pickup pull into the barnyard at Mark Rosenberg's ranch, he would run to the fence squealing or bugling until his bottle appeared. He also woke a neighbor one night by polishing his horns on the side of the house.

Many cast members miss Beauregard and share stories of his performances. T.C. Conner remembers one night in particular when he performed the Indian dance on top in the opening "morning" scene. Beauregard was supposed to enter when the lights went off, but he had stage fright and would not come out. They tried leading him out, but when the lights came on, they were still pulling on the elk. This went on several times as the guys tried to wrestle the elk out on stage. Needless to say, the young Indian dancers were laughing out loud.

Wayne Low was stationed at the roof phone when he received the cue to send out the Indian hunters, which he relayed. He soon received another cue call to send out the hunters. After the third call, the Indian actors communicated

Opposite, top: Left: Beauregard as a calf; *right*: Mark Rosenberg working with Beauregard II. *Mark Rosenberg.*

Opposite, bottom: Beauregard in his glory in show's upper scenery. *Mark Rosenberg.*

Morgan in 2006, the last elk trained by Mark and Kelli Rosenberg. *Mark Rosenberg.*

they could not go out because Beauregard was "guarding" their entry point, blocking their way to the scenery.

Since elk are highly intelligent, Beauregard recognized the Happy Canyon music, remembering his cue. However, for some performances he did more than his part.[208]

One evening, as Bill Maclin began singing the "Indian Love Call," Beauregard decided to investigate the song. As Bill continued to sing, the elk crept closer and closer, trying to figure out where this sound was coming from. He thought Bill was singing to him with a different elk call than normal. The audience loved it!

In 2000, Beauregard was rightly inducted into the Round-Up and Happy Canyon Hall of Fame.

THE OXEN

The ninetieth anniversary celebration of Happy Canyon in 2006 included an ox in the Portland Rose Festival parade exhibit. For the entire four miles of the parade route, the Portland crowd cheered it on. After all, you don't often see an ox pulling a wagon these days.

Robert Lazinka of Pilot Rock remembers his dad helping train some of the first oxen teams used in the Happy Canyon pageant. These teams were much larger than what we see today. In fact, the 1929 show featured a team of twenty oxen that extended the full length of the arena.[209]

In the 1940s, Ben Jory managed, raised and fed around thirteen oxen throughout the year in Baker, Oregon. He estimated each ox ate over 850 pounds of feed a month.

Jim Rosenberg and Bob Schuening agreed to break the oxen team in the late 1950s. Bruce

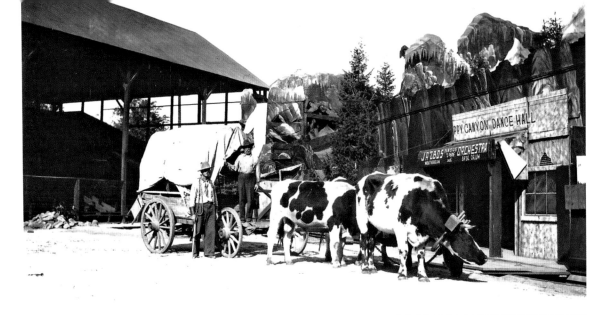

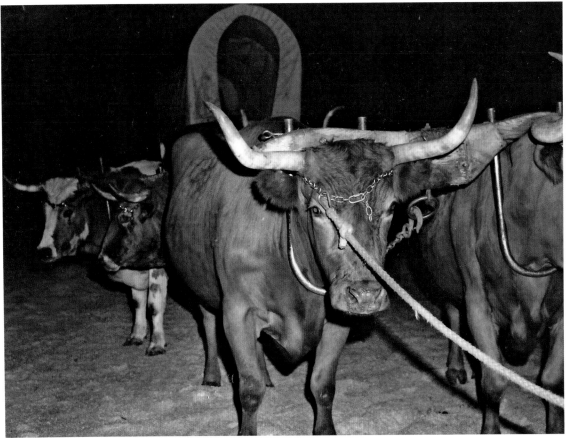

Top: H.O. Powell standing by the wagon pulled by the 1922 oxen team in Old Canyon. *Howdyshell Collection.*

Bottom: The 1983 Happy Canyon oxen team. *Howdyshell Collection.*

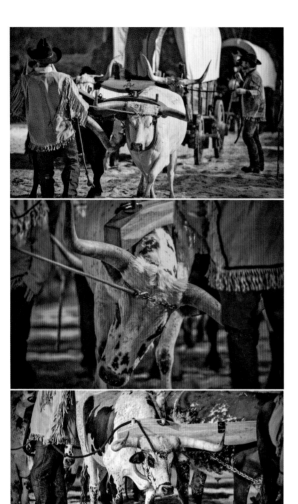

This page: The Happy Canyon trained oxen are a rare treat for the audience, 2014. *Eye of Rie.*

Bottom image: Berk Davis, Pat Smalling and the oxen crew training the team for the show. *Happy Canyon Collection.*

Boylen describes Jim Rosenberg as "being one with the oxen" when he trained and cared for them. He said Jim "worked his rear end off" to prepare them for the show and parade, breaking them to the wooden yoke.[210]

Currently, Happy Canyon Company Inc. owns fourteen oxen, cared for by Berk and Roger Davis, who have willingly pastured them since 1994. When Berk first took on the Happy Canyon oxen as livestock director, he found the small group of oxen needed an upgrade.

Berk began purchasing and raising the oxen to create a full team. "In the old days, Happy Canyon would even acquire the old roping steers used at Round-Up and break them to be the oxen for the wagon," Berk said.

Each year, the Davis family spends thousands to feed and house this special team of animals. The unseen service of families who provide these key parts and resources is one of the most amazing aspects of the show.[211]

MONTY THE "FALLING HORSE"

In 1937, Bill Shaw first met Montie Montana, who introduced him to trick roping and riding. Bill acted in Happy Canyon in the rescue, bank robbery and cavalry. After Walter Holt and Paul Lieuallen witnessed the falling-horse act Bill created for the rescue, they said, "Hire him!"

Bob Shaw and his son Bill trained a range horse that they named "Monty." Monty performed the wounded-horse act for years. He first appeared in the original act in 1939, and he continued through 1954. He was trained to "fall" with his rider and then "limp" out of the arena carrying the fallen cowboy. [212]

In 1990, Monty was inducted into the Round-Up and Happy Canyon Hall of Fame as one of the special animal actors of the show's history.

Molly the Buggy Horse

For almost thirty years, a Paint Welsh horse named Molly, owned by Mark and Kelli Rosenberg, pulled buggies, paddy wagons, surreys and carts in Happy Canyon.

Molly was a mainstay until she dropped dead in her harness at the East Gate during the show. They found another horse to complete her role that year, but the cast mourned her passing. A faithful performer to the end, she left a gaping hole. In 1986, Molly was inducted into the Hall of Fame.

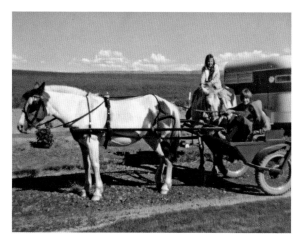

This page: Mark Rosenberg's buggy horse, Molly, who performed in the show 108 times. *Mark Rosenberg*

SHORTY

Dick Severe purchased and trained a horse named Shorty, born at the Irvin Mann Ranch, for the falling horse part. After about a year of training, Shorty debuted at only four years old.

For several years, Shorty also performed as the horse whose rider sports an arrow in his back, warning the pioneers of coming trouble. The Happy Canyon Association purchased Shorty in 1980, and Mark Rosenberg cared for him while he was in the show. Shorty retired from Happy Canyon in 1990 after serving for twenty-one years.

ECHO "MAGIC"

In 1991, Echo "Magic," a mare owned by Mike and Janet Herbes of Pendleton, began performing in Happy Canyon. She charged with the cavalry and stagecoach robbery, eventually becoming the horse galloping out for the rescue scene.

After she exited the arena for the rescue, her wet saddle would be hastily dried off and the wagon master would jump on her to lead the wagon train in. She also served the Herbeses' daughters as a faithful sidesaddle horse.

Left: Shorty, the "falling horse." *Hall of Fame Collection.*

Opposite: Echo "Magic," a key horse in several show parts. *Mike Herbes.*

Next pages: The cavalry actors and their well-trained horses, 2014. *Eye of Rie.*

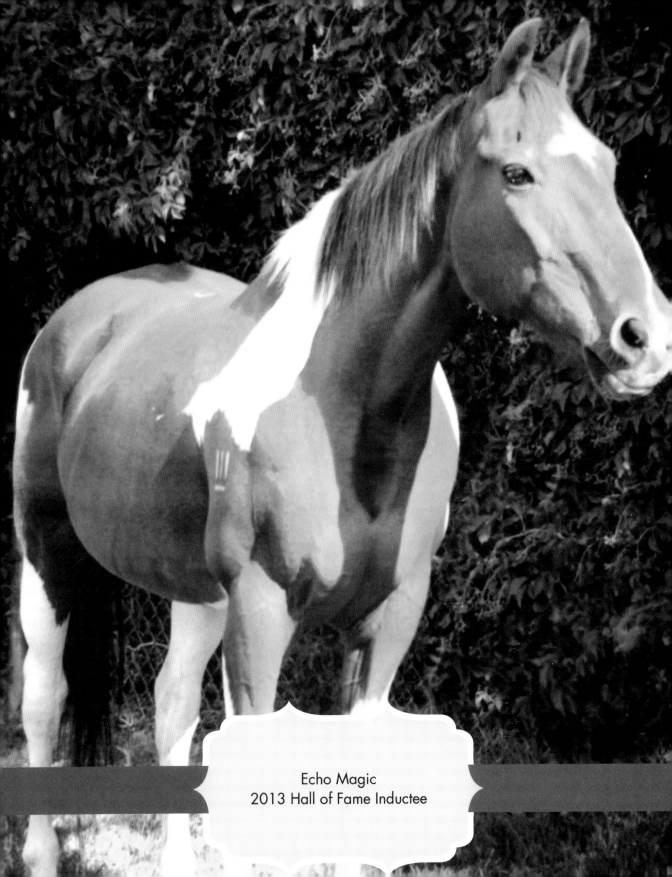

Echo Magic
2013 Hall of Fame Inductee

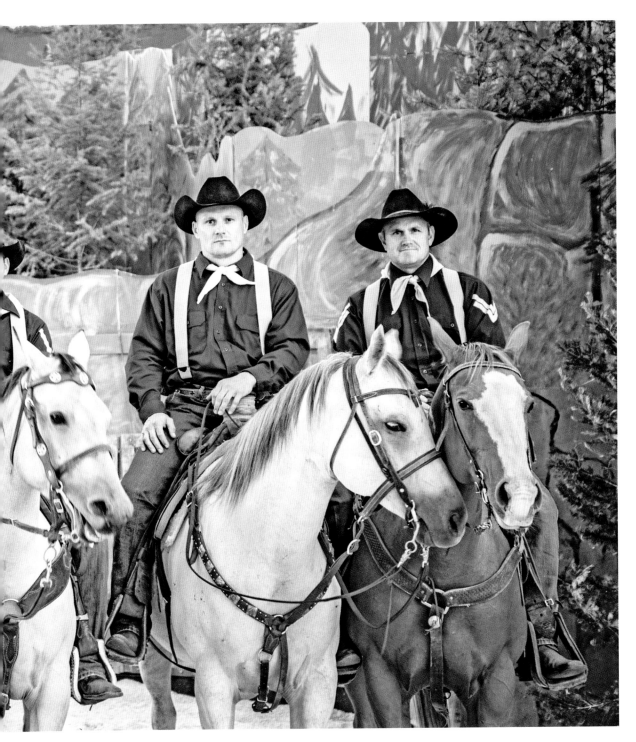

STAGECOACH TEAM

Continually used since 1914, the stagecoach is an important element of the show. In the early years, the board hired someone to bring the stage and the team into Pendleton for the show.

In 1932, Kenneth Depew of Long Creek, Oregon, was reimbursed $150 to supply a falling horse and rider for the rescue scene and four horses, a harness and a driver to pull the Happy Canyon stagecoach. Ken was known for his wild stagecoach driving. One night, when the stagecoach rattled at full speed into the Old Canyon, Ken accidently overturned it as they went by the fence in front of the grandstands.[213]

By 1942, the board had decided to purchase its own stagecoach, selecting one from the John Day western show along with other wagons and harnesses. From all accounts, this is the current stage used today. In the early 1900s, it was originally used to deliver mail. Now it is a multipurpose stagecoach that hauls the directors in parades, especially the Westward Ho! Parade, as well as in other events.

In 1975, Odie Payne and Billie Hindman began providing horse teams and drivers for the stagecoach and emigrant wagon. They participated in the Round-Up relay and pony express races, and both led stagecoach racing teams until the Round-Up stagecoach races were discontinued. Even though they lived in Elgin, Oregon, Odie and Billie willingly make the trip to Pendleton every year, bringing at least eight horses and a group of friends to assist in this endeavor.

The speed the stage needs to make the turn into the arena is one of the gatemen's biggest safety concerns at Happy Canyon. Before

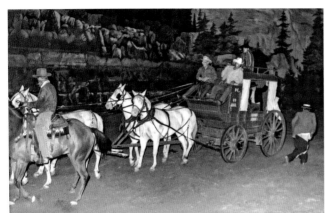

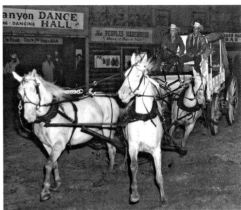

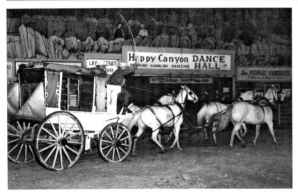

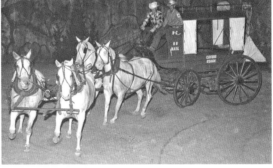

This page: The stagecoach through the years. Notice the teams of matching white horses. *Howdyshell Collection.*

Opposite, top: The Happy Canyon stagecoach can tell many stories. *Eye of Rie.*

Opposite, middle: Pendleton firefighters serving Happy Canyon. *Hall of Fame Collection. Bottom*: Ryan, Tiah and Patti Ann DeGrofft paint the stagecoach. *Patti Ann DeGrofft.*

the stagecoach enters the arena, it begins at a significant distance away to build up speed. It has ended up on its side in the current arena and has had several close calls.

One year, while attempting to make the tight turn by the pond, the stagecoach tipped up on the outside wheels and just barely came back down as the occupants shifted their weight—much to the relief of the director and the cast.

INDIAN ANNOUNCER—TRAIL HORSE

A surefooted horse is essential. A first-time spectator to Happy Canyon is always drawn to the Paint horse and his rider every time they enter the arena. The Indian brave, wearing only a breechclout and feathered headdress,

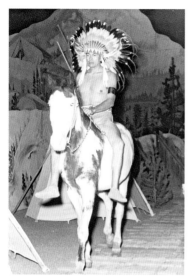

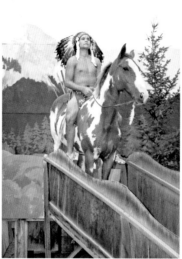

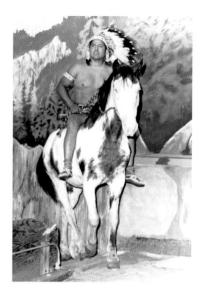

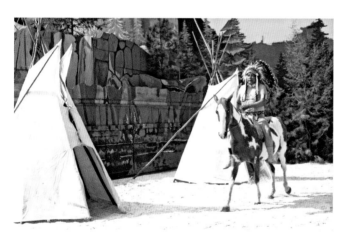

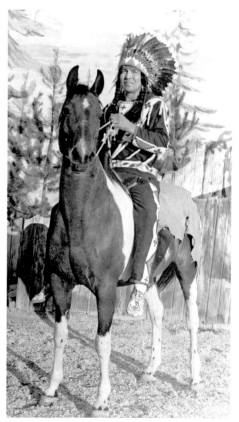

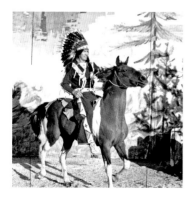

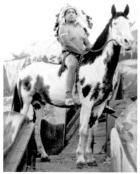

Above: Happy Canyon's wooden trail ramp, 2015. *Eye of Rie.*

Opposite: *Top, left to right*: Bryson Liberty and Domino, Curtis Sampson and Win-Sauki and Jesse Jones on Domino; *middle, left*: Louie Dick on Win-Sauki; *middle, right*: J.C. Penney on unidentified horse; *bottom, left to right*: J.C. Penney on unidentified horse and Jesse Jones on Domino. *Howdyshell Collection.*

rides the striking horse up the ramp, climbing altitude quickly and expertly.

This scene is done "slick style" with only a "war bridle" (a sturdy string stretched through the horse's mouth). Through the last one hundred years, several well-trained horses have run through the arena and up the wooden mountain trail, coming to a sudden stop at the top. This performance is a crowd favorite.

One of the first famous trail horses was Tony. In the late 1930s and early '40s, Tony was as well known by the audience as the current trail horse, Chinook, is today. This big white horse, owned by Mike and Pat Folsom, was ridden by Johnson Chapman and Philip Bill. He was known as the star of the show—guided only by a war bridle through each scene and over the wooden mountains of the Old Canyon.

Tony was followed by a well-trained Pinto named Cloudy, owned by Roy Raynor of Kennewick, Washington. Cloudy carried Philip Bill with the American flag, making trip after trip up the ramp in the Old Canyon for eight years. The 1953 *East Oregonian* noted Cloudy's death and his missing presence on the narrow wooden ramps.[214]

Philip Bill was key in envisioning the authentic reenactment of his tribe's past, including riding the trail horse. He missed only one show during World War I when he served in uniform with the Battery A Field Artillery.

"I've worn out a dozen horses playing the role of the Mounted Warrior these many years," he said. He acted even though he became nervous before each show began. "It's important to me that people see how Indian life really was in the old days," he said.[215]

Rusty Black

Happy Canyon got lucky the day Rusty Black led her first horse into the arena. She has

trained the trail horse for sixty-one years now, gifting the pageant with her striking horses, her time and her love.

Rusty's love for horses began when she was a small girl in Pendleton. After she begged her parents, who were not horse savvy, they finally gave in and bought her a Paint horse when she was nine years old.

She spent most of her time at the riding club Mustangers, entering all the events and learning how to train a horse. "Buck Lieuallen was a great help to me," she said. "He could never train my horses, they didn't like men, but he taught me what to do."[216]

At age thirteen, she spent her summer on the Bakers' Bar M ranch at Bingham Springs, where she fell in love with Duke, a feisty chestnut gelding no one could ride. After chasing him around the corral, Rusty won his heart and soon was able to lead him around.

The Bakers gave Duke to Rusty. The horse carried her through the "Omak Suicide Race," a two-hundred-yard race where riders compete on level ground, plummet down a sandy slide into the river, swim across and sprint to the finish line. Rusty was only seventeen at the time.

In 1956, at the tender age of fifteen, Rusty bought Domino from a gentleman who had used him in the show the previous year. Domino was spoiled, and the board was skeptical about having him back. After Rusty trained Domino, a black-and-white Overo Paint, for a year, he came back a different horse. From then on, he never missed a cue. This was the beginning of the long line of horses Rusty owned and trained for Happy Canyon.

Domino performed as the trail horse in Happy Canyon from 1956 through 1973.

Bryson Liberty first rode him in the show, followed by Jesse Jones Jr. The *East Oregonian* even mentioned Domino, saying: "And speaking of animals, this fan letter is also to a horse. There was a piebald pinto in the Indian scene of the pageant that never missed a cue. He walked, trotted and cantered within the confines of the stage with all the assurances he must show on the open range."[217]

Over the years, Rusty has trained five more horses to be the famous trail horse. Those horses include: Poky Joe Bailey, a bay-and-white Appaloosa; Teah Kash, a black-and-white Appaloosa; Win-Sauki, a sorrel-and-white Overo Paint; Cataldo, a sorrel-and-white Overo Medicine Hat Paint; and, most recently, Chinook, a black-and-white Overo Paint, who is a great-great-grandson of Secretariat, the 1973 Triple Crown winner.

Rusty's task of supplying horses has not always been an easy job. In 1975, the horse Teah Kash was killed by a train. He was Rusty's very favorite horse. Within a month of that accident, Domino had to be put down after contracting cancer. With only six weeks until show time, Rusty and her late husband, Charlie, drove hundreds of miles trying to find a horse with the right coloring, confirmation and personality.

After almost giving up hope, she and Charlie happened to notice their own Paint horse, Win-Sauki, grazing in their pasture as they drove home. In only six short weeks, Rusty gentled and trained Win-Sauki to carry on the Happy Canyon tradition that year.

Some of Rusty's fondest memories are of Cataldo, a twenty-year Happy Canyon equine veteran that she raised from birth. He began performing in the show at the age of

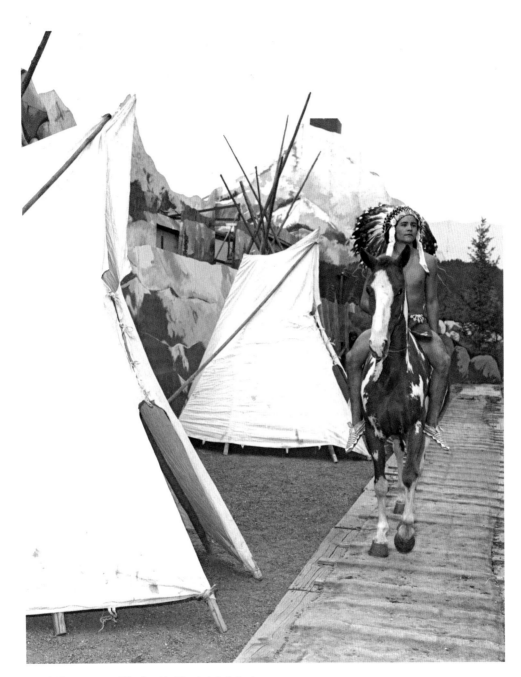

Curtis Sampson on Win-Sauki. *Howdyshell Collection.*

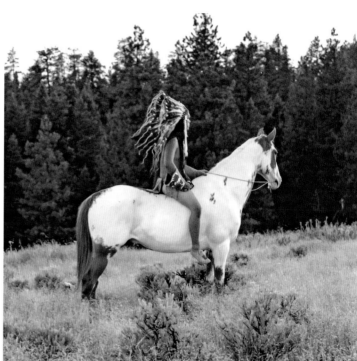

three and was ridden by Lance Dick from 1990 through 2004.

A bit of a prankster, Cataldo decided to apply the brakes one night as a duck came into the arena—just when Lance wasn't expecting it. Lance simply got up, dusted off the sawdust, mounted the horse and continued with the scene.

In a tragic turn of events in August 2005, Cataldo passed away at the age of twenty-three, just two weeks before the show. But Rusty's sixth horse was waiting in the wings: Chinook.

Chinook was born on a winter morning when the warm wind was melting six inches of ice and snow. As Chinook received training, the board of directors hoped he would make the grand run up the ramp and become the newest four-legged star of Happy Canyon. Rusty worked with Denny Davis to prepare Chinook for this moment.

Everyone held their breath during his first performance. However, Chinook proved he was an exceptional horse. In spite of booming music and fireworks, he was successful in his first official gallop up the ramp, with Old Glory waving in the wind.

Chinook is now a star. In April 2015, Chinook and his current rider, Bryson Bronson, traveled to Las Vegas, Nevada, to present the American flag in the opening of the Federation Equestre Internationale World Cup. At the event, the National Finals Rodeo evaluated the pair fit for their own opening.

Together, Chinook and Bryson made Happy Canyon history as they presented the U.S. flag

at the National Finals Rodeo's grand entry in December 2015, celebrating the real Old West and a century of Happy Canyon.

Over the years, Rusty's contributions have included "breaking in riders"—even those with little riding experience. On one occasion, she graciously cued a new rider through each scene since the rider was unfamiliar with the Happy Canyon scenery. Rusty claims it is easier training the horses than the riders, though.

Rusty also tells a story about Bryson Liberty, who was riding Domino up the ramp when the war bridle broke. Bryson rolled off Domino's back, but he quickly ran up behind the horse and stood with the American flag as the entire house rose to their feet.

The audience never sees the hundreds of times Rusty has prepared the horses to act these scenes. If 100 times will do the job, she will run the horse through the scenes and up the ramp 103 times—just to be sure.

In addition to working with the live horses, Rusty collects model horses. To Rusty's delight, Breyer Reeves International used Domino as the 1993 Commemorative Edition horse entitled: Domino, Happy Canyon Trail Horse.

In 1992, Rusty received the Happy Canyon Appreciation Award with Chief Raymond Burke. Domino was inducted into the Hall of Fame in 1977, and Cataldo followed in 2005. Both of these horses hold a special place in Rusty's heart.

Opposite: *Left*: Cataldo with Rusty Black at a photo shoot; *right*: Lance Dick on Cataldo. *Photo by Don Erickson; courtesy of Hall of Fame Collection.*

Right: Various images of Bryson Bronson and Chinook. *Eye of Rie.*

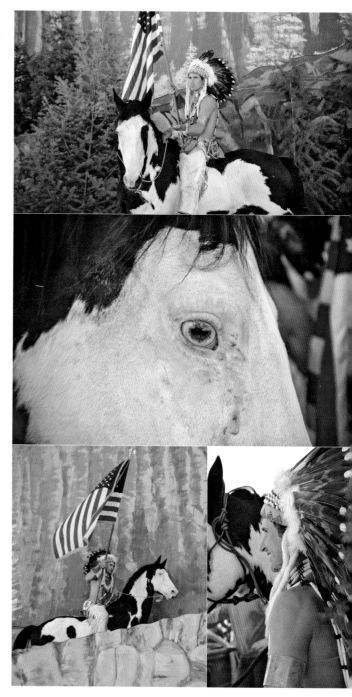

"The Happy Canyon show has such special meaning in my life, because it is unique and depicts a part of our history," Rusty shared. "I come back each year to see old friends and make new ones. It just gets into your blood; you have to keep coming back. Happy Canyon has played a large role in my life."

No display equals Rusty's beautiful horse running up the ramp to the top of the scenery, carrying the proud Indian who is holding an American flag. Many people remember how this scene brought the house down in 1989 as Lee Greenwood sang "God Bless the USA" at the end of his concert.

Always with an eye for the next horse, Rusty has a replacement horse waiting in the wings named Canyon Moon Dancer, which will be the seventh horse she has trained for Happy Canyon.

Rusty has left an indelible mark on the history of Happy Canyon. Her love of horses, ability as a horsewoman and deep dedication to the Happy Canyon pageant are truly irreplaceable.

"Some people call them livestock. We call them props," Fritz Hill, former show director quipped. From Chinook to Beauregard and trained bears, exceptional animals have always filled the show. In a century of history, these furry stars have not just contributed to the show; they have added the right amount of magic to transport audiences back in time.

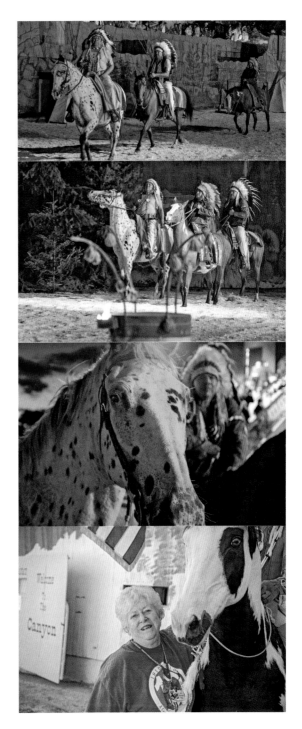

This page, third from top: Chief Gary Burke rides Omega, owned by Doug Haney. Omega is one of the hundreds of beloved tribal horses that have been used in the show over one hundred years. *Eye of Rie.*

First and second from top: Harper Jones II.

Bottom image: Rusty Black and her sixth horse, Chinook. *Eye of Rie.*

12
FRONTIER FUN PALACE
SINCE 1914

Indians in their war-paint dance.
As tom-toms sound in resonance.
Their teepees stand nearby, serene,
To lend a background to the scene…
At night a vivid pageantry
Of stirring Western history
Unfolds at Happy Canyon show;
Where afterwards the people go
To trip the light fantastic swing.
Such old-time Western Reveling!!
—W.S.F., from a poem entitled "The Round-Up!"[218]

With the last note of "The Star-Spangled Banner," the Happy Canyon Dance Hall doors swing wide and ticket holders are invited to dance, enjoy refreshing drinks and try their luck in any of the Old West games.

This popular audience-participation feature at the end of the show is one of the greatest ideas Roy Raley and his friends had when they created Happy Canyon. In 1914, they decided to invite the show crowd through the doors of a saloon or dance hall for some old-fashioned fun, offering jitney dances and gambling.[219] "The whole thing was designed to help people enjoy themselves to the utmost," Roy said.[220]

That year in the town of Pendleton, the number of saloons, brothels and dance halls exceeded that of churches. Some saloons had such long poker games that the floors "would

be covered with decks of cards discarded by unfortunate players," according to Colonel J.H. Raley. The city had to limit horse and mule riders on Main Street to six miles per hour and had to prohibit children from hanging around the saloons.[221]

In 1914, gambling was illegal in Pendleton, but several saloons offered games of chance in backrooms, receiving occasional fines or paying "hush money." To avoid the city ordinance on illegal gambling, Happy Canyon, with its typical ingenuity, had its own paper money printed.

For the staggering cost of one penny each, you could purchase bundles of Happy Canyon bucks and then gamble to your heart's content, buy a dance or wet your whistle with a drink. Because they remembered the Pendleton of old, the men planning Happy Canyon duplicated it for the crowd's enjoyment, though some people speculate that locals were also running games behind the scenes at Happy Canyon for real money.[222]

The "Log Cabin Saloon" in the 1914–15 scenery provided an entrance to a pavilion where five hundred couples could dance at a time. Meanwhile, the false front of the "Villard Hotel," named the "Red Dog Saloon," opened to the gambling palace games of roulette, faro banks, poker, Klondike and keno.[223]

GAMING FOR FUN—"YOU BET"

When the Happy Canyon Bucks were printed, the Happy Canyon men began distributing them to advertise as far away as Walla Walla. It cost a gentlemen one of these "Ten Buck" notes to dance with a girl of his choice. The gal, of course, had a free dance.[224]

As the gaming feature was planned, the owner of the Domestic Laundry Service in Pendleton, J.F. Robinson, attended the yearly

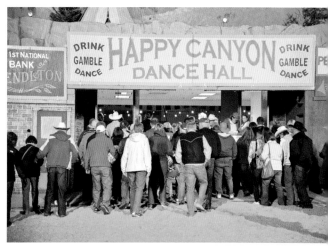

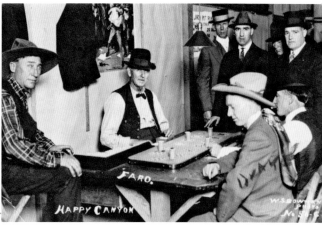

Right, top: The audience enters Goldies for frontier fun and games, 2015. *Eye of Rie.*

Right, bottom: Lee Drake, Happy Canyon originator (closest on the right) with other gamblers around a Happy Canyon faro table. *Wayne Low collection.*

laundrymen convention in Seattle, procuring gambling tables and wheels for the first year of Happy Canyon nightlife.[225]

Meanwhile, the gambling area was expanded to fit the enthusiastic crowds in the 1915 show. When Happy Canyon created the catchphrase "You Bet," the *East Oregonian* explained, "That's exactly what you do and that's why it is the slogan and the mouthword [*sic*] of Happy Canyon."[226]

"Roulette Draws Throngs to Bet Round-Up Bucks" an *East Oregonian* headline announced. The article continued: "About everything that characterized these pioneer towns was to be seen in Happy Canyon. In the 'Red Dog Saloon' roulette wheels whirled, wheels of fortune spun and faro banks, crap games, poker tables and many other early day gambling devices lured men and women to hazard their 'Ten Buck' bills which are good for fun and fun only."[227]

The second year of the Red Dog Saloon saw great success, and the *East Oregonian* reported, "Until far in the morning the yipping, the yelling and pistol shots testified that the 1915 Round-Up crowd was still celebrating." Winners at the games of chance bought up every bit of cigars, tobacco, gum and ice cream offered.[228]

After several years, the show added a Happy Canyon chip and currently produces commemorative chips, sometimes featuring Happy Canyon princesses. The first chips were made of clay and imprinted with "HC," but plastic chips and wooden "nickels" were used later. Over the years, organizations have inquired how the "bucks" were made and how the gambling area worked, using them as a model for gaming fundraisers. Amazingly, by

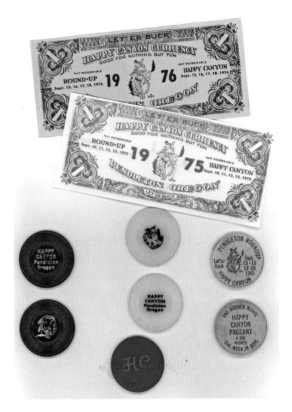

HAPPY CANYON TONIGHT

Don't miss it! Have a happy time in the happy town.

Doors open at 7:00; Shows begin at 8:00; You "take in" the town at 9:00

Program of thrills, music and fun. Dancing. Make-believe gambling, barroom, etc.

GET YOUR BUCK BILLS AT THE BANK AND CUT LOOSE

25c Admission and you see the wildest and most original show in the livest little burg on the map. **"YOU BET"**

Top: The first ever Happy Canyon ad in 1915 *East Oregonian*, "You Bet." *From the* East Oregonian.

Above: A collection of Happy Canyon chips and bucks. *Author file.*

1948, the Happy Canyon "bucks" were still sold for ten cents each and used for gambling, dancing and merchandise.

After just two years of the show's running came discussions of whether the gambling should end because of minors in the crowd. The board had received complaints about gambling's bad influence on the boys and girls but was unwilling to abandon the popular feature. Eventually, the board compromised and decided "no minors will be allowed to play any of the games or congregate around the tables hereafter."[229]

WETTING YOUR WHISTLE

In 1916, prohibition was established in Pendleton—inconveniently for Happy Canyon. In 1914, the people of Oregon had voted on a state constitutional amendment to ban alcoholic beverages after January 1, 1916. Of course, this meant no refreshments other than soft drinks at Happy Canyon.[230]

Happy Canyon without spirits of any kind? The stories in these years are strangely silent, but Pendleton's underground was alive and well. After seventeen years of prohibition in Pendleton and dry dancing and gambling in Happy Canyon, the 1933 show saw the return of alcohol. Of course, one must imagine that it had a little bootleg liquor available before. It was Pendleton after all.

One wild chase began at Happy Canyon in 1917. After an officer noticed a man in the first stages of inebriation, he checked him and found an illegal whiskey flask. Somehow, Mayor

Best became the owner of said bottle. Naturally, he took care of it.[231]

As a coat-check boy in 1922 at the Old Canyon, Bob Fletcher Sr., discovered gentlemen checking their coats in, checking them out just an hour later and, after a small amount of time, checking them in again.

Upon investigation, he found some bottles of bootleg alcohol hidden in those coats— not terribly surprising since the underground bars and speakeasies were only a couple blocks away.[232]

With the return of legal alcohol in 1933, beer bottles became a cleanup issue at the dance. Robert Pahl remembers the stories his dad, Glenn Pahl, told of the large crew it took to pick up the numerous bottles on the old Happy Canyon dance floor every night. Jim Duff clearly remembers being paid a silver dollar to fill a large bushel basket with these said bottles after the dance.

Also, due to bottle shortages, they were cleansed—no one really knows how well— refilled and capped before the next night, sitting in big metal tubs filled with ice and waiting to be purchased with Happy Canyon bucks. It is not hard to speculate how a bottle with a cigarette butt became a gift with purchase.

In 1944, after the show had taken a two-year hiatus because of World War II, it took around fourteen men to run the bar. Each bottle of beer or soft drink cost twenty-five cents, or three Happy Canyon bucks. This was the age of smoking, and in spite of rationing, the board made an effort to acquire the needed cigarettes.[233]

On the Old Happy Canyon set, someone on the railing-surrounded balcony reserved for gambling could simultaneously watch the gaming and the dancing on the large wooden

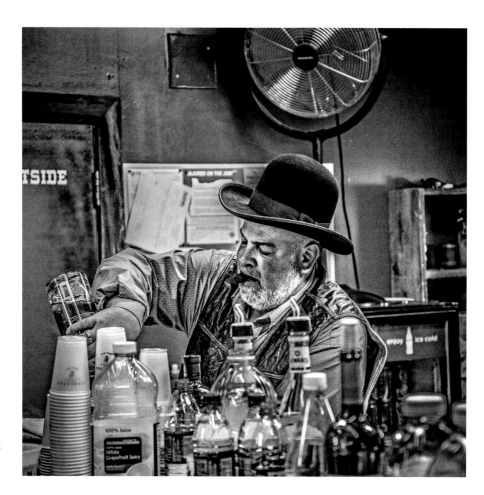

Dave Rossi is one of the hundreds of volunteers who have served drinks at Happy Canyon. *Eye of Rie.*

floor below. This arrangement allowed minors to attend after the show and take part in the jitney dances with family and friends. Beer bottles often fell from the railing onto unsuspecting people below.

With the move to the current facility in 1955, the board worked closely with Oregon Liquor Control Commission (OLCC) to close off the alcohol areas to minors and ensured a smooth crowd flowed through the doors of Goldies, past a roped-off gaming area in the "Happy Canyon Room" and into the armory, where the dance hall allowed all ages. In fact, they did not allow the bar area to open until all the minors had exited the back gaming area.

The addition of hard alcohol in 1984 brought increased drink sales and has remained an option ever since. In 2003, the ever-popular Pendleton whiskey became the drink of choice.

HAPPY CANYON DANCE AND GAMBLING—WILD AND WOOLY

The early years of the Old Canyon dance and gambling were highly successful. The last night of the show in 1918 saw a record crowd so large that it was standing room only and there were people waiting in the street to enter. Those who could not fit in the dance hall drove around town blowing their horns full blast. Upstairs in the gambling hall, war savings stamps were put up as winnings. The winning number at the roulette table earned a five-dollar war stamp—thirty cents of which went into the Happy Canyon treasury.[234]

The next year, the *East Oregonian* described the fun chaos of the gambling area, with "thousands in bucks passing over the card tables and bars and with the air heavy with bullet smoke, she was a wild night."[235]

Amazingly, Happy Canyon bucks even went overseas during World War I.

In 1919, returning soldiers reportedly used Happy Canyon bucks as currency in France and Germany. As part of a remembrance packet from home, every Umatilla County soldier received several bucks. Those bucks became the most plentiful currency in that group of American forces. Soldiers used them in trade for souvenirs or even in crap games.

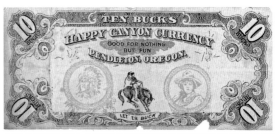

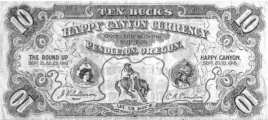

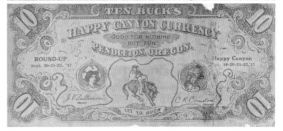

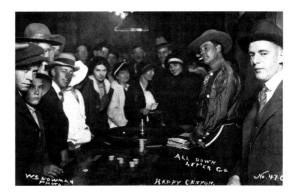

This page, top: Samples of the 1916, 1917 and 1918 Happy Canyon bucks. *Author file*.

This page, bottom: Gambling at the Old Canyon. *Wayne Low collection*.

In France, the bucks were taken in trade for food or fun. Even when John Kelly of old Troop D and a group of friends took a liberty day trip into the German villages and realized they were out of funds, they pulled

out their good-for-fun Happy Canyon bucks, and the money lived up to its name.[236]

The 1920 *East Oregonian* noted the following games in the pavilion: Hip-Shot Pete, Dick Deadeye, Cayuse Jim, Faro Bank, African golf, roulette, chuck-a-luck and straight draw poker. "One young buck carried away enough Happy Canyon money to take a first mortgage on the Salvation Army doughnut stand," the article stated. "There were shots and there were shouts perforating the air.…Happy Canyon was wild."[237]

With winnings from the games of chance, a gambler could purchase refreshments or goodies. For decades, the Saturday gaming area offered a country store, exchanging groceries for winner's bucks. In the early days, you could walk away with a ham or a Pendleton wool blanket if you had won enough.

The gambling apparently became too real—the next year, the board was forced to reduce the high-stakes items you could trade bucks for, such as Indian robes. The board came under heavy criticism, and the police force was increased to ensure gamblers were not "hoarding" winnings to cash in.

Currently, a gambler can buy Happy Canyon chips from several locations in the Goldies venue. In years past, "Buck Girls" distributed Happy Canyon bucks and chips from trays they carried around their necks.

In 1970, some of the gambling tables were reportedly as old as Happy Canyon. Today, the antique big wheel and the roulette table are still used, and blackjack and craps have been played for one hundred years.

Happy Canyon Gambling Closed

Unfortunately, the enforcement of Oregon's no-gambling law by Pendleton's former district attorney Joe Smith shut down all the gambling at Happy Canyon in 1970. Smith decreed the games at Happy Canyon violated the state lottery laws.

If anyone had noticed this before, they had not mentioned it. Smith welcomed a court test of the gambling laws, but the Happy Canyon Board of Directors declined. Smith stated authorities and law enforcement often overlooked Happy Canyon's "illegal gambling." Smith said, "We need meaningful law enforcement."[238]

Emile Holeman, president of Happy Canyon in 1970, recalled several meetings with Smith to discuss various avenues to solve the matter without completely shutting down the games. One of the issues brought up was the merchandise, such as the hams, coffee and sides of bacon available for "purchase."

"In the end we really had no choice," Emile said. "The district attorney's ruling meant no police could be provided at Happy Canyon if the games were continued by the long-standing format. We felt that the presence of police was mandatory to assure [*sic*] the safety of the large crowds."[239]

From its first showing, Happy Canyon had conducted a gaming area, but in its place in 1970, the show set out bales of straw at the armory. For the first year since 1914, the show took place without games. "It was like a morgue in the back room," Emile recalled.[240]

During the show that year, former Umatilla County district attorney Riney Seeger,

playing the Happy Canyon role of a frontier preacher, or "sky pilot," stood on top of his mule to hang a blank white sign over the word "Gambling" on the scenery. The crowd responded with appreciative laughter every evening.

The lack of gaming had an effect on beer sales that year, according to Emile. Since the revenue was used to support the pageant, it affected the show's overall funding.

President Holeman traveled to Salem with board members Dr. Richard Koch, Bruce Boylen and Joe Temple as soon as legislature went into session, seeking to appeal the decision. They all appeared before the subcommittees in the house and senate, testifying in favor of a bill to legalize exhibition gambling.

Stafford Hansell and Irvin Mann Jr. (Republican, Stanfield) in the House of Representatives backed new legislation for Happy Canyon gambling. Raphael "Ruff" Raymond and Jack Duff, Umatilla County farmers and former Happy Canyon directors, were also key in passing the House Bill 1355, the "Happy Canyon Bill."

In 1971, the legislature passed a bill permitting gambling for nonprofit groups with certain restrictions for disposing the players' winnings. The "Happy Canyon Law," or the Happy Canyon Gambling Act, passed without much opposition and permitted gambling to resume at the night show, making the Happy Canyon games the first "legal" gambling in Oregon. This act is currently used by other nonprofit establishments throughout the state.

GAMBLING RETURNS TO HAPPY CANYON

"It'll be belly-up to the gambling tables again for the Round-Up's small time gamblers," Virgil Rupp reported in the 1971 *East Oregonian*. "Gambling is back at Happy Canyon. Last year was the first time in the history of the pageant the games were not allowed. The Oregon Legislature approved a bill sponsored by Rep. Irvin Mann Jr., R-Stanfield that will allow the Happy Canyon games this year. Participants were limited in the amount of Happy Canyon bucks they could buy."[241]

In 1971, the Wednesday Happy Canyon gaming crowd was large. Joe Temple, gaming director that year, happily reported resumed games of chuck-a-luck, twenty-one, roulette, dice and stud poker.

Of course, after the passage of the "Happy Canyon Bill," Smith was quick to point out to the press that not all lottery-type games were legalized for charitable organizations.[242]

This new bill allowed roulette, poker, blackjack and other games of chance, although the gambling law is strict and precise. Since no legal tender is allowed, tokens or paper money are used instead.

The new bill allowing gambling brought changes to how the gaming was conducted. Players were limited to the purchase of chips (ten dollars in each twenty-four-hour period), and none of the chips could be exchanged for cash. Instead, they could be redeemed for merchandise that could be consumed on the premises, such as beverages, candy and cigarettes. No longer could big items, such as coffee and a side of bacon, be purchased with

large winnings. Lastly, except for charitable organizations, no owner, agent or employee of the gambling organizers could legally profit from the gambling operation.

Interestingly, the Indian gaming casinos throughout Oregon owe a thanks to Happy

This page: Gamblers in the current Happy Canyon gaming area, 1983. *Happy Canyon Collection*.

Page 272: Gaming fun after the show. *Happy Canyon Collection*.

Canyon for establishing an important path and precedent. The Happy Canyon Law of Oregon allowed for nonprofits within the state to provide all games of chance. Since the national gaming law did not clarify whether it applied to nonprofits or not, Oregon tribes used the Happy Canyon Law to demonstrate how gaming was legal within Oregon.

"Because Happy Canyon, part of the Pendleton Round-Up, allowed craps, blackjack and roulette, those activities became fair game for Oregon tribes," the *East Oregonian* stated.

"Happy Canyon served as a kind of springboard to get into that type of gaming," Gary George said.[243]

As the Indians helped tell their story in Happy Canyon, the Happy Canyon Law, in turn, helped them to establish gaming resorts.

Gaming Volunteers

Currently, the gambling room includes longtime volunteers who enjoy their service in the "gaming" area each year at Happy Canyon. Bruce Reynolds, for instance, has served forty-five years at Happy Canyon:

> *I got started when I was playing craps with a dealer who was alone and having some trouble with the table. I was winning a lot and kind of helping him out with bets and pay-offs.*
>
> *The dealer said, "Why don't you come over here and help me." I said, "OK." He asked permission, and I went around, put on a red vest and worked the rest of the week. I have been working the craps table ever since.*

Unexpected moments can happen even in the games. One night, a young Indian player who had enjoyed playing craps with Bruce for over ten years handed him a hand-beaded scarf slide he had made. Bruce felt incredibly honored.

Unfortunately, Bruce has seen the angry side of folks come out, too. He witnessed a player trying to enlarge his bet, and when Bruce refused to pay it, the man came around the

This page and next: The gaming volunteers have many stories to tell, 2000. *Don Cresswell.*

table, threatening him. The security personnel were called and averted the danger, escorting the player from the building.

Over the years, Bruce has taught numerous gamblers the simple but fun game of craps, which has been played since the first year of Happy Canyon gaming in 1914. "We have had a lot of fun over the years and will continue to have fun with the craps table," Bruce said.[244]

GREAT BANDS AND DANCES TO REMEMBER

For over a century, couples have enjoyed dancing when the saloon and dance hall open up after the show.

The 1914 dancing pavilion accommodated several hundred couples, bringing in a twenty-three-piece band to keep the music flowing throughout the four evenings. This first dance hall had a wooden dance floor with a canvas top. Several participants recalled pickpockets working the Happy Canyon dance crowd and thieves cutting through the tent, stealing the ladies' purses from benches. [245]

The Happy Canyon dance floor was expanded by twenty-five feet in 1915 and became the "largest dancing floor ever built in Pendleton," keeping its canvas roofing. "From elevated platforms, fiddlers sawed away those ancient tunes to which cowboy spurs used to jingle and in the mammoth dancing pavilion hundreds of couples danced with a democracy never seen any place else," the *East Oregonian* stated. "Cowboys swung society dames about the floor and the society dames felt honored."[246]

The new 1916 Happy Canyon dance pavilion was all the talk. *East Oregonian* reported, "The dancing pavilion was completed today and dancing will begin there tonight, according to James H. Sturgis, director of dancing. The floors have been sanded to a fine smoothness, the pavilion is well lighted and the best of music will be provided."[247]

Happy Canyon even brought in a cabaret orchestra from San Francisco to kick off the first dances on the new dance floor. "The orchestra has been passing the summer season at Seaside and for ability for making folks step they are said to be in a class by themselves," the *East Oregonian* explained. "The instrumentation of the orchestra is a banjo, a piano, drums and traps, xylophone and saxophone."[248]

By 1919, due to the large crowds attending the dances in the new facility, the board was continually improving the experience and managing the dancers. It took twenty-five men to manage the dance floor, even after they had built a railing to surround it.

After every dance, the men swept the ropes through the crowd to empty the space before filling it again with festive people, and gentlemen paid a Happy Canyon buck to take a girl for a

East Oregonian advertising for the new 1916 Happy Canyon Dance Hall. *From the* East Oregonian.

whirl, creating a huge chore for workers who counted the bucks. Chief Raymond Burke remembers how he and his wife, Velma, relished the yearly tradition of jitney dances together.[249]

Even in Happy Canyon's early years, opportunities existed to meet a spouse. Rita Kirkpatrick appeared in Happy Canyon for eighteen years, and after each show, she

volunteered at the dance, selling bucks in the main dance hall. One evening, Chester Kirkpatrick was stationed at the roulette wheel and fixed his eyes on Rita as she sold the Happy Canyon bucks. They fit in some dances that night and began a fourteen-year courtship, culminating in marriage on September 9, 1942—nine days before the navy claimed him. They were married for forty-two years, until Chester's death in 1984.[250]

MaryAnn Stangier remembered the jitney dances with fondness and described a long rope separating the dancers from the nondancers. "The girls knew how popular they were by the number of tickets the boys paid to dance with them," she explained.[251]

The right band was key to a great dance, of course. Over the show's one-hundred-year history, the board has hired exceptional talent to keep the dancers moving and the nighttime crowd enjoying themselves.

For instance, the Bungalow Jazzers played in 1918, and the *East Oregonian* reported, "It sure was some night." The Paul Pendarvis twelve-

Fletcher Family Jazz Band. *Author file.*

HURRY, HURRY, HURRY

If you ever happen to be in Pendleton and hear it—"Hurry, hurry, hurry!" strongly accented on the first syllable and with an intonation all its own—you can figure its just a Happy Canyon phrase applied to everyday life. It's heard in its own realm on the dance floor during the jitney dance nights when some couple lags behind—and the attendant strives to prevent unnecessary delays.[252]

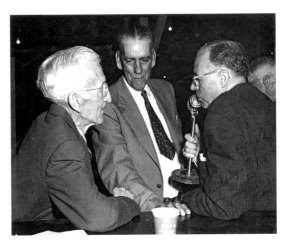

Left to right: Past directors Bill Stram and Syd Laing with an unidentified man at the last dance at the Old Canyon, 1954. *Happy Canyon Collection.*

piece band even came from Nob Hill in San Francisco, boasting of playing in Hollywood for the likes of Mary Pickford and Joan Blondell.

R.W. Fletcher's Round-Up Orchestra or Jazz Band played for many of the Happy Canyon dances from 1917 until 1936. After performing in Happy Canyon, R.W., his sons (Robin [R.A], Billy and Wesley) and daughters (Marie, Eleanor and Florence) would play all night for the dancers.

In 1947, the radio station KEX broadcasted live from the Happy Canyon dance on the final night of the show. It set up on the edge of the back balcony railing with a view of the dance floor and with access to the games and crowds upstairs. The broadcast was widely received and helped to not only promote the Happy Canyon evening festivities but also make those who were housebound feel part of the celebration.

The dances and gambling after the show were the highlight of Round-Up week, but things could get a little wild. One woman reported she became tangled up when some "jitter-bugs" got too close and her feet were pulled out from under her. She fell so hard she passed out and cracked three ribs. Happy Canyon volunteers found a doctor and got him out of bed to attend to the poor lady, who required X-rays. They also helped her uptown to her car.[253]

Armory Dances

For the first several years at the new armory location, the jitney dances were still popular and continued for several years before giving way to dance admission and Happy Canyon

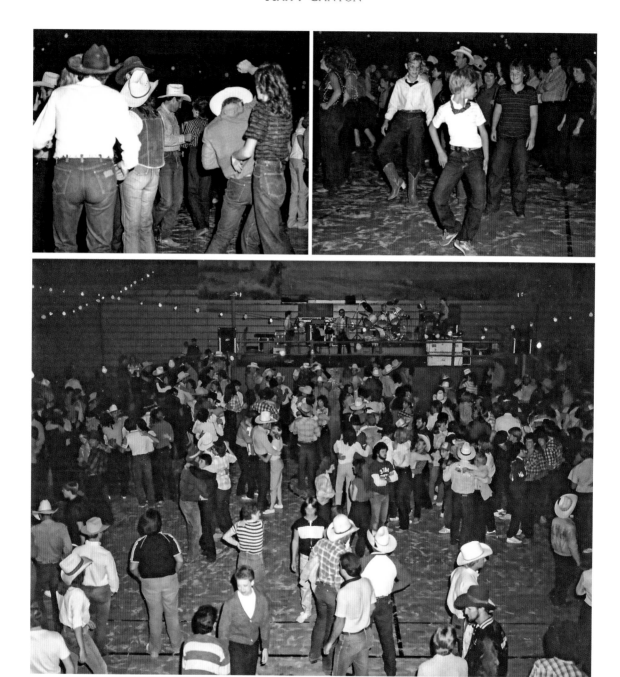

This page: Dancers of all ages enjoy the Happy Canyon dance, 1983. *Howdyshell Collection.*

Opposite: The Locash Cowboys perform in the sawdust with the Pendleton Whiskey Girls. *Harper Jones II.*

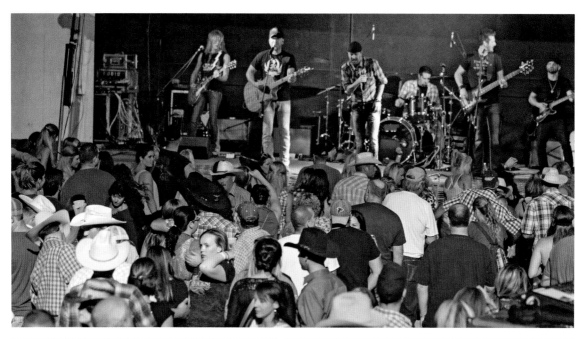

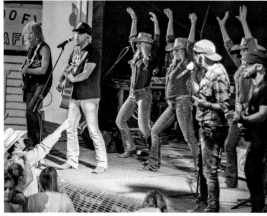

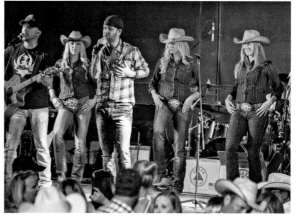

tickets as entries. Former director Don Hawkins remembered the year the board voted to do away with the jitney dances and begin to charge entry fees; he described how many missed them and felt revenue was lost.

Of the big-name bands hired for the armory dances, a few highlights stand out.

For instance, Si Zenter, the 1967 Playboy All Star Band. Zenter, who received two Grammy Awards, brought Las Vegas, his sixteen-piece band, which played its popular music for years.

Later bands included Susan Raye (member of the Buck Owens All American Show),

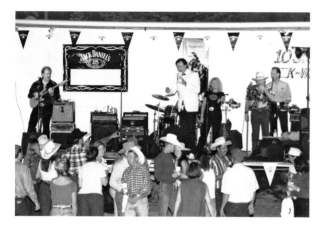

A dance in the sawdust under the stars, 2000. *Don Cresswell.*

Barbara Mandell, Tommy Overstreet and even Reba McEntire in 1980.

The Western Swing became the popular dance, especially in the 1980s and 1990s. The armory, and later the convention center dance floor, was the place to be. The McKenzie River Band and, later, Countrified were the last full bands to play inside the convention center for the dancers.

More recently, Happy Canyon's after-show entertainment became a twenty-one-and-older function. Adults are invited to dance under the stars in the Happy Canyon arena to a live band, which for many years was Ricky and the Redstreaks. They can also take part in the games of chance and in drinks. Inside the convention center, a DJ offers favorite dance tunes, and a mechanical bull waits for its next rider.

When the dance in the convention center moved away from allowing all ages, many people stated how much they missed the yearly function. The dance after Happy Canyon was a place for young and old to enjoy hometown fun. Young people looked forward to these dances as some of the best in the entire year within Pendleton. Numerous couples can tell of meeting at "the Happy Canyon Dance" and beginning a courtship. In fact, most who first met "during Round-Up" can trace those stories back to a first dance during Happy Canyon nightlife.

The crowd participation feature of Happy Canyon provides the same invitation as it did in 1914 on Pendleton's Main Street. The band names have changed and the Happy Canyon tender is updated, but the offer to join the celebration through the Happy Canyon Dance Hall doors is still available!

13

HAPPY CANYON ROYALTY

At the time, I didn't realize the total impact[,] that I was the start of something
—Caroline Motanic Davis, first Happy Canyon princess, quoted in the
East Oregonian[254]

No royal court can equal the Happy Canyon princesses. People constantly ask for their photos, and they bring something special wherever they go. Since 1955, each selected girl has represented the show and the unique local tribal heritage.

It is said the first rodeo queen in the United States reigned at the Pendleton Round-Up. Similarly, Happy Canyon created one of the first official Indian princess courts.

Happy Canyon did not always have a court representing the show. However, Round-Up selected five Indian girls as queens. They were Esther Motanic in 1926, Melissa Parr in 1932, Virginia Wilkinson in 1948, Leah Conner in 1952 and Diana McKay 1953. The next year, the Round-Up board suggested that Happy Canyon's Board of Directors use an Indian princess to represent the importance of the tribes. This idea became an important part of the pageant.[255]

CAROLINE MOTANIC DAVIS

As she waved to the crowd in her first parade in 1955, Caroline Rosemary Motanic Davis could not have imagined she was blazing a trail for over one hundred lovely girls who would follow in her footsteps as Happy Canyon royalty. Caroline willingly became Happy Canyon's original princess and ambassador, generating support as a show essential was born.

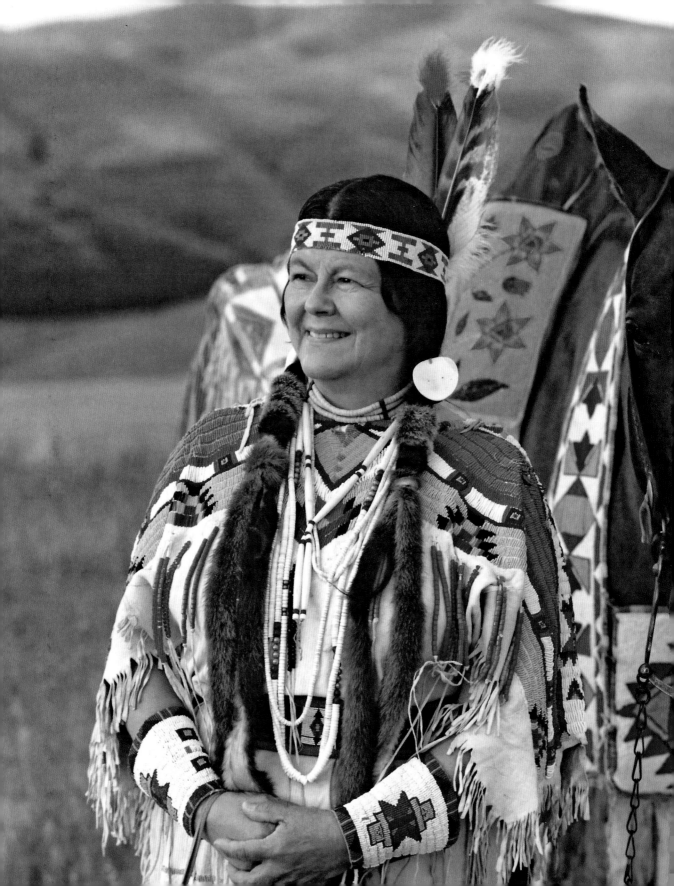

Since she was the first Happy Canyon princess, Caroline had no application process and no court chaperone. In fact, she was the only Happy Canyon princess for two years, traveling with the Pendleton Round-Up Court to its official appearances. As a result, the Round-Up Court chaperones, Beryl Grilley and Ruth Duff, helped oversee and guide her in the developing role.

When Caroline began, she was "scared to death. Just terrified." She had not been away from her mom and dad, but eventually she learned to speak in public with more confidence.

Unlike princesses today, Caroline received few gifts and no additional clothing to what she provided herself. She mostly wore the buckskin regalia her parents, Art and Myrtle Motanic, made for her. Art shot three does and asked Susie Williams and her daughter Armena Bill to tan the hides and create the unique dress with matching moccasins, leggings and cuffs. The dress, with beadwork using pink beads from Caroline's grandmother, took two years to complete.[256]

In 1956, Caroline was asked by the board to be the princess again. Her second year proved much easier. She joined the Round-Up Court again for the Portland Rose Festival, traveling in a yacht down the Columbia River from Bonneville Dam and up the Willamette River. After the royalty's unprecedented arrival at the sea wall in downtown Portland, the mayor of Portland and Rose Festival dignitaries greeted them. But Caroline's unmatched legacy had just begun.

Caroline's daughter Katherine Minthorn was the first second-generation princess in 1974 and 1975, serving two years like her

Above: Artisan tribal member Susie Williams in a parade. *Howdyshell Collection.*

Opposite: Caroline Motanic Davis, first Happy Canyon princess, taken in 1997. *Photo by Don Erickson; courtesy of Hall of Fame Collection.*

mother. Katherine's daughter, Shannon Galloway, was the first third-generation princess in 1993 and 1994. Two more of Caroline's own daughters, Toni and Julie, followed her as Happy Canyon royalty.

Caroline's trailblazing continued down through her family. Her daughter Toni later joined the Round-Up Court as the first Happy Canyon princess to serve on both courts. Now, four of Caroline's granddaughters (Shannon

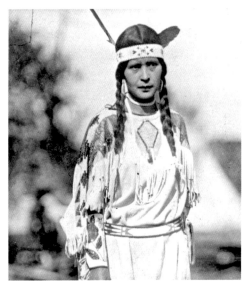
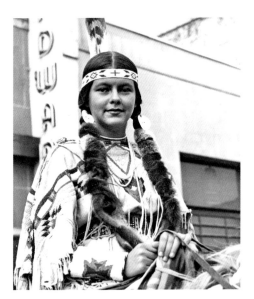

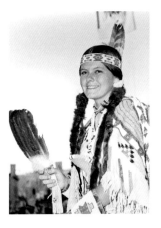

Galloway, Ashley Picard, Britanny Cline and Chelsea Minthorn) have followed her as Happy Canyon princesses—each wearing Caroline's beaded buckskin dress.

"When I put on my first prom dress, it didn't hold a candle to the feeling that this dress gave me," Ashley said.[257]

Caroline's family history with Happy Canyon is deep. Her grandfather Parsons Motanic was an original cast member, and her father, Art Motanic, created the show's "Indian Love Call." Caroline herself played the groom's mother in the Wedding Scene—a part handed down to her from her mother-in-law, Mamie Minthorn.

Caroline died in November 2012, leaving a void in her family as well as in the Pendleton and tribal communities. She is deeply missed.

One of Caroline's childhood playmates was Marie Alexander, who often rode double with her. Thus, it is fitting that Marie became the second princess. These two paved the way for the princesses following their moccasin steps to display their regalia and culture.

MARIE ALEXANDER DICK (E-WATS-SIN-MI)

Marie won awards for her expert marksmanship, and as soon as she put down her gun, she picked up many artistic endeavors. Marie Alexander Dick is also one of the most giving people you will meet.

Her Indian name, E-Wats-Sin-Mi, which is hard to translate, refers to a swan—an apt description, since her presence holds abundant joy and beautiful creativity. Her

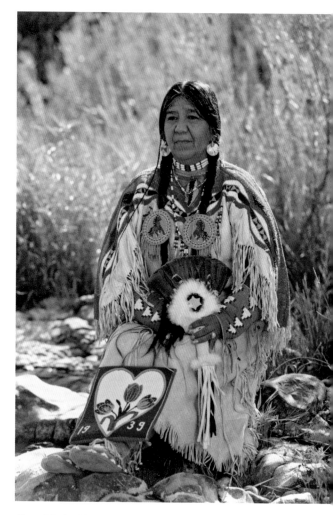

Above: Marie Alexander Dick in buckskins made by Inez Pond, Susie Williams and Armena Bill when Marie was a princess. *Photo by Don Erickson; courtesy of Hall of Fame Collection.*

Opposite: *From left to right, top*: Art Motanic and Esther Motanic; *middle*: Caroline Motanic Davis and Katharine Minthorn; *bottom*: Julie Minthorn, Sara Minthorn and Toni Minthorn. *Howdyshell Collection.*

parents nicknamed her "Butch," however, after their close friend.

In 1957, at age eighteen, Marie became the second Happy Canyon princess. Before she was chosen, a large group of girls dressed in regalia were interviewed and even evaluated on how well they spoke. Then Marie—with the Queen of Pendleton Round-Up, Ann Terry Hill—was presented at the opening Queen's Presentation Dance, which took place at the Happy Canyon dance hall in May 1957. She placed third in the Indian Beauty Pageant and went on to compete in the Miss Indian America contest, during which she represented the local tribes for two years in Sheridan, Wyoming.

The Happy Canyon board presented Marie with a purse and matching moccasins from the Curio Shop, which she appreciated, though she acknowledges they were not authentic. Today's Happy Canyon princesses receive scores of gifts, beginning at Tack and Trappings, which provides the courts with several outfits for their events throughout the year.

Marie continues to serve Round-Up week, helping with the Saturday dances in the arena and with the young girls in the Junior Indian Beauty Contest.

"The princesses of today have it much easier," Marie said. In her time, she had few gifts and the lack of a chaperone made logistics, such as where she should change after an event, more difficult. At the time, the board was still

This page, top: As the second princess, Marie received this red dress from the board to wear to events. *Marie Dick.*

This page, bottom: Marie on the Happy Canyon float at Chief Joseph Days. *Marie Dick.*

developing the role. "They did not know where to put us," Marie said. [258]

The princesses traveled to local rodeos, such as Heppner, Walla Walla, Kennewick and Joseph, but the exchange with the Rose Festival is something newer in the schedule.

Both Caroline and Marie rode in the Westward Ho! Parade, representing Happy Canyon and their tribes. This tradition has continued for over sixty years.

In 2007, Marie's granddaughter Chelsey Dick followed her as a princess.

PRINCESS SELECTION PROCESS

After Marie served as a single princess, she suggested that a pair should represent the organization. As a result, the 1958 Happy Canyon featured Janie Wilkinson Pond and Joyce Hoptowit Mardal as the first dual princesses. When Janie was unable to come to an event, Marie filled in so Joyce was not alone. The next year, the Indian princesses were chosen at the Root Festival.

Bertha Cater Case, who served as a princess in 1960, noticed the schedule was much different. The girls trying out performed the "circle dance," provided all their own clothing, learned how to conduct interviews and answered questions—especially regarding the regalia and what each design represented. The board picked Bertha again in 1961.[259] The other princess chosen in 1960 was Brenda Bearchum, who became Miss Indian America in 1961.[260]

Over the years, the selection process has changed. At first, a tribal committee selected

the candidates, and the board approved them. The *East Oregonian* reported how by 1965, the princess requirements included being a member of the local tribe, living in the community and being at least sixteen years old. Additionally, "She must be named a candidate by a committee of her fellow tribesmen."[261]

In the spring, the potential candidates appeared before the Happy Canyon Board of Directors at the Indian Root Festival. After an interview where they judged poise, personality and ability, the board selected two princesses.[262]

Later, the complete process of selection occurred during the Root Festival at the Longhouse. Each potential princess wore her regalia, made a speech and then answered questions from a panel of judges from the tribe and Happy Canyon board. During the 1990s, tribal representatives and the board still continued this process.

Currently, an application process involving an interview is used by the board. The girls are selected by poise, regalia, personality and beauty.

Longhouse selection of princesses. *Hall of Fame Collection.*

They act as Happy Canyon's ambassadors at events, parades and appearances throughout the year. Each year, audiences regard them with awe and interest since they are unlike any other court in America.

The 2016 court was chosen from the largest pool of applicants seen in recent years, which demonstrated the desire to continue this important sixty-year-old tradition.

COURT CHAPERONES

Doris Bounds

Doris Bounds says of her taking on the role of Happy Canyon chaperone, "It just happened." After several years of the Happy Canyon Court joining the Round-Up Court and sharing their chaperone, the Happy Canyon board chose Doris Bounds to be the Happy Canyon Court's own chaperone.

A collector of several thousand Indian artifacts—including jewelry, handcrafts, artifacts and regalia—and a historian in her own right, Doris loaned trappings and Indian saddles to the princesses for years, as they were in short supply.

Serving for fifteen years as the first official Happy Canyon Court chaperone, Doris saw many changes in the Happy Canyon Royalty activities. "At first we made just a few appearances," she said. "Then we worked up to where we went to the Rose Festival in Portland and a number of other places. Now we are somewhere in the middle."[263]

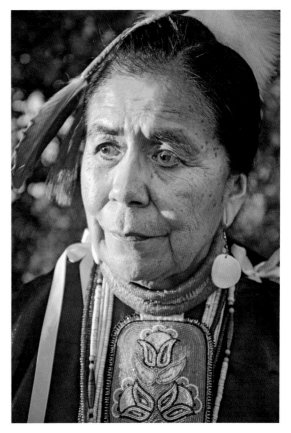

Judy Burke Farrow was a princess in 1966. *Eye of Rie.*

Judy Burke Farrow, Happy Canyon princess of 1966, described Doris as a kind-hearted person who advocated for the Indian girls whenever the need arose. Judy loves to tell of the year after she served as princess, when Doris often came speeding to McKay Creek to ask her to fill in for a princess. "This is all before the convenience of cellphones," Judy explained. Doris was always gracious, which made Judy easily agree to accompany her. She was also well loved by each of the girls she chaperoned.[264]

Mary Hines

Mary Hines never missed a Round-Up. She started camping in the village as a baby and paraded in a baby board on her parents' saddle. She agreed to chaperone when Doris retired, holding the post for three years before her niece Tessie Williams took her place.

Tessie Williams (We-opp-sa-sie)

Tessie Williams still remembers Dr. Richard Koch, Happy Canyon Indian director in 1976, asking her to serve as chaperone.

For nine years, Tessie helped choose the two girls to represent the Happy Canyon pageant. She enjoyed overseeing each girl—they never had a dull moment. She watched each princess develop confidence as she guided them through the year's demanding schedule. "It was very special to be the chaperone because you did it for the whole community," Tessie said.

One of the highlights during Tessie's tenure was when her daughter Nancy Parker Minthorn became a Happy Canyon princess for 1975 and 1976.

During the summer of 1975, Tessie chaperoned Nancy as she represented Happy Canyon and the Western Wheat League in Japan at the American Fortnight Trade Show. They toured Japan, the Philippines and Hawaii. Several other courts have also traveled overseas to share Happy Canyon and tribal culture with the world.

Tessie summed up her commitment and love for Happy Canyon, saying, "It becomes your family, as you hurt with them and celebrate with the people you are involved with. All my involvement with Happy Canyon and Round-Up is from my heart because I want things to improve and pass it on to the next generation."[265]

 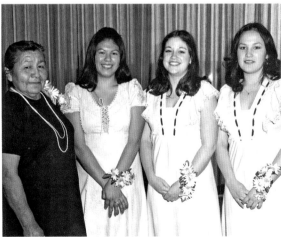

Photos from 1974 of the Indian princesses. *Right, from left to right*: Mary Hines, Katharine Minthorn, Michelle Liberty and Lorena Thompson. In the image on the left, Dr. Richard Koch stands behind. *Howdyshell Collection.*

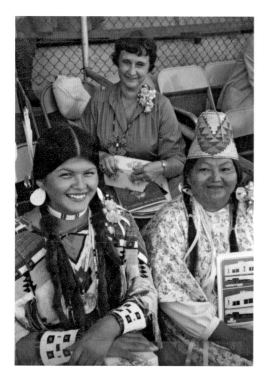

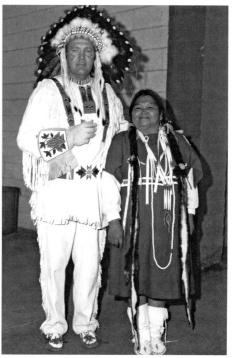

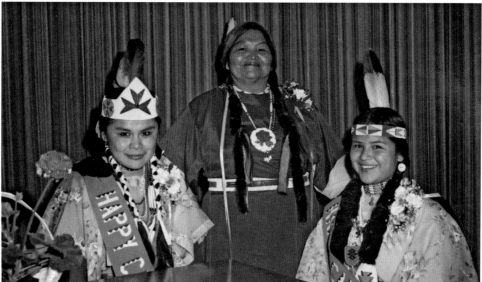

Top, left, from left to right: Julie Minthorn, Millie Grilley and Tessie Williams; *right*: Dr. Richard Koch with Tessie Williams. *Bottom, from left to right*: Lona Pond, Tessie Williams and Sandra Craig. *Happy Canyon Collection.*

Sheila Pond

Sheila Pond's grandfather was Willie Wocatsie, chief of the Walla Wallas, and her other grandfather, Amos Pond, was chief of the Umatillas. For years, she escorted the captive girl up the wooden ramp to the top of the scenery and tied her up, a part passed down through her family for many years.

While Sheila volunteered as Happy Canyon princess chaperone for eleven years, she also held a full-time job as the coordinating counselor for the Umatilla Reservation Tribal Housing Authority. She used up vacation and comp time to accompany the court to its functions, but she called this job enjoyable.

Sheila always looked forward to the show. She felt the tradition of Happy Canyon made the pageant worthwhile. All four of her sons—Cedric Bill, Emile Bill, Philip Bill and Robert Bill—have participated in the show.

Dennis and Colleen Hunt had the honor of working alongside Sheila as Indian and court director. "During the years she was princess chaperone, she never missed an event, was always there for the girls and was able to juggle being a single mom of four active boys," they said. "Even with that hectic schedule she always insisted on good behavior, tradition and pride in doing a good job. She was stern and fair and had high expectations."

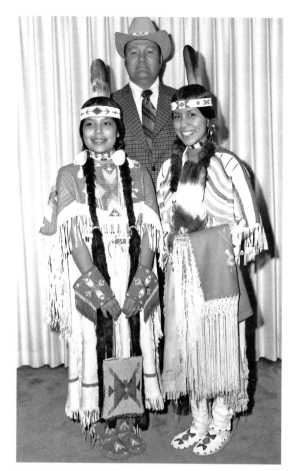

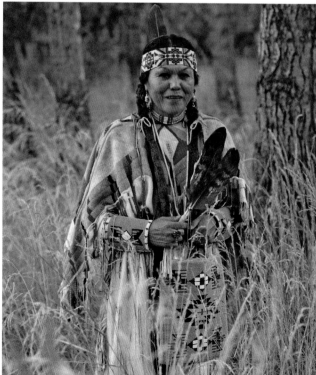

This page, top: Nancy Minthorn and Marcella Lloyd, with Dr. Richard Koch (behind). *Howdyshell Collection.*

This page, bottom: Sheila Pond in regalia, 1995. *Photo by Don Erickson; courtesy of Hall of Fame Collection.*

Sophia Enos

Sophia Bearchum Enos was chosen as a princess in 1964. Sophia Charley, who was the daughter of Chowisiipum, was Sophia Enos's grandmother, and it was her dress that Sophia Enos wore as Happy Canyon princess. Fourteen Happy Canyon princesses can trace their ancestry back to Chowisiipum, a Wallulapam woman.

Sophia will never forget the day President Wayne Low asked her to chaperone, a job she graciously did for seven years. She also chaperoned two of her own daughters, Claudette and Vanessa. Sophia said, "It was an incredible honor to be asked to help the girls." Sophia always had a camera and her bag of princess essentials.[266]

"Sophia was always soft spoken as she coached us," Tara Burnside, princess in 2001, said. "She helped us develop poise and public

speaking skills. She never put herself in the spotlight; she worked from the background to keep the focus on the princesses. Her knowledge of traditional ways and values made her a great chaperone. I appreciate all of the time that she spent with us."

Toni Minthorn

Toni Minthorn follows her mother, Caroline Motanic Davis, as a trailblazer. After serving as a Happy Canyon Princess in 1978, she became the first to also serve on the Round-Up Court in 1982.

Toni appreciated Don and Helen Cook—the Round-Up Court chaperones at the time—who "had her back." Currently, Toni strives to do the same as a chaperone to the Happy Canyon court.

In 2004, Toni also began preparing the Indian princesses' horses. She helps them throughout the year with each horseback parade and rodeo introduction. The Happy Canyon princesses currently spend hours during the summer, grooming their horses and increasing their riding skill. Toni ordered specially made new Indian women's saddles for safety and also makes sure the girls have the needed horse trappings.

"Nothing is more important than Happy Canyon," Toni said in an interview. "It's fun, exciting and full of tradition. It's a way of life, part of who we are, just part of what we do."[267]

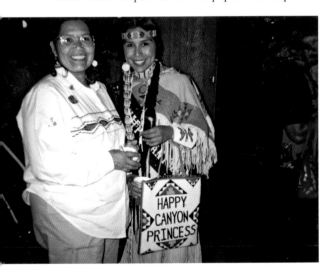

Sophia Enos (left) with Claudette Enos at Parents' Party, 1996. *Happy Canyon Collection.*

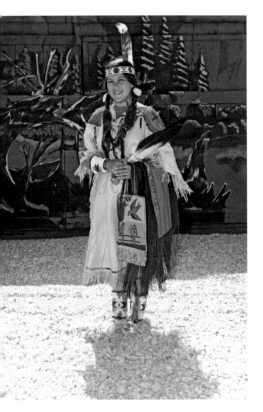

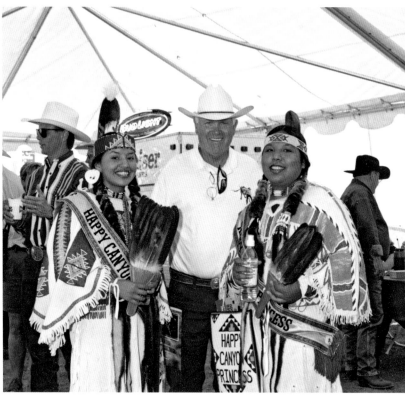

Left: Toni Minthorn in the Happy Canyon arena. *Howdyshell Collection.*

Right: *From left to right*: Donna Nez, Jim Duff and Victoria Allen. *Happy Canyon Collection.*

Regalia: The Dress

The princesses turn heads everywhere they go. Today, the regalia worn by the beautiful girls of the local tribes is a rarity.

The beaded buckskin dresses, sometimes over one hundred years old, are priceless. Even if the beaded outfits are newly made, they can take up to a year to sew, bead and embellish.

The buckskin dresses can weigh twenty to forty pounds, adding to the heat as the princesses wear them all summer. Dressing itself can take an hour from beginning to end—from braided hair and feathers to moccasins.

When Caroline became the first Happy Canyon princess in 1955, she had "the dress" to complete her reign—a doeskin regalia that took two years to complete.

Caroline's famous dress is a perfect example of what helps make the Happy Canyon princesses unique. They each have the honor of donning a buckskin beaded dress that is usually a family heirloom.

These dresses are part of the package and each is considered a masterpiece. Happy Canyon princess in 2010 Alex Nilo demonstrated this sense of history, wearing a dress of ram hide estimated to be over two hundred years old. It was in good condition, as it had been carefully stored and seldom worn.

Sometimes the dress is new, but it is no less unique, taking up to a year or two to complete. For instance, Chelsey Dick was honored to wear a specially designed dress her grandmother and second Happy Canyon princess, Marie Dick, made just for her.

What the Year Holds

During the summer, the princesses rarely have weekends at home.

After they are chosen and have signed the Happy Canyon Court contract, the court is introduced to the public at the Happy Canyon princess announcement reception, where they officially receive the beaded Happy Canyon princess bags.

Former chaperone Tessie Williams had an eye for incorporating native traditional style into the Happy Canyon princesses' wardrobe. She and President Wes Gilley commissioned the exquisite beaded bags used by the Happy Canyon princesses.

Both bags were designed and made by Elaine Hoptowit, incorporating the pattern from her grandmother Rosaline Kanine Wilson, a Round-Up princess in 1932. Elaine designed them to fit the public relations poster dimensions. They are now thirty-seven years old—handed down from one successive court to the next like a crown.

In 1977, the princesses began receiving unique "princess banners" when chaperone Tessie Williams asked Marie Dick to design and make the first set. The banners were made out of leather for Terri Parr Wyncoop and Eleanor Bearchum and became the first of many.

Known for her gifting in handwork, Marie Dick designed the banners for thirty-eight years, until 2014. The year Janine Winn was princess, Marie needed almost a year to finish them, as the design included needlepoint.

Marie's banner successor is Keisha Ashley. Each princess still treasures these one-of-a-kind creations.

After their official introduction to the public, the princesses begin an extremely busy and exciting year. Starting in May, they promote Happy Canyon and the beauty of their cultural traditions in scores of official appearances from parades to Portland's Rose Festival, Cheyenne Frontier Days and, some years, even the Calgary Stampede.

The Happy Canyon Court has often won first place in parades, including the Rose Festival in Portland.

Currently, the princesses receive a scholarship at the conclusion of the year, as a thank-you from the board for their service and promotion.

Second Happy Canyon princess Marie Dick believes the court is good advertising for the tribe. She said that cutting a path for the girls who have followed "was an adventure."

"Being a princess has really helped my public speaking skills," 2014 princess Marissa Baumgartner shared. "My favorite part of being on the Happy Canyon Court has been

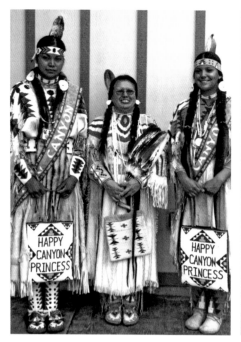

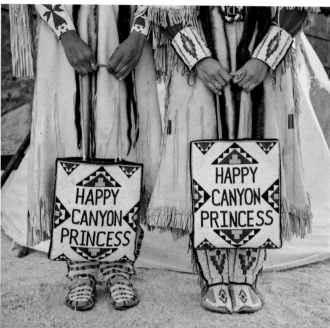

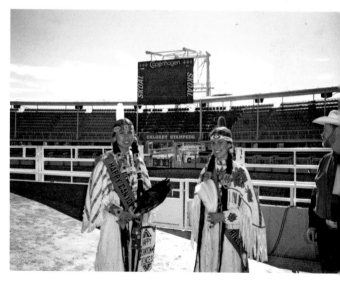

Top: Elaine Hoptowit (left, center) designed and handcrafted the princesses' beaded bags. *Marie Dick.*

Above, left: Several examples of the many princess banners made by Marie Dick. *Marie Dick.*

Above, right: Sydell Harrison and Tara Burnside visit the Calgary Stampede. *Happy Canyon Collection.*

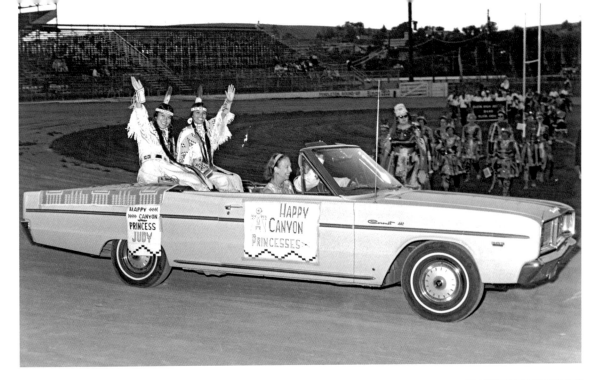

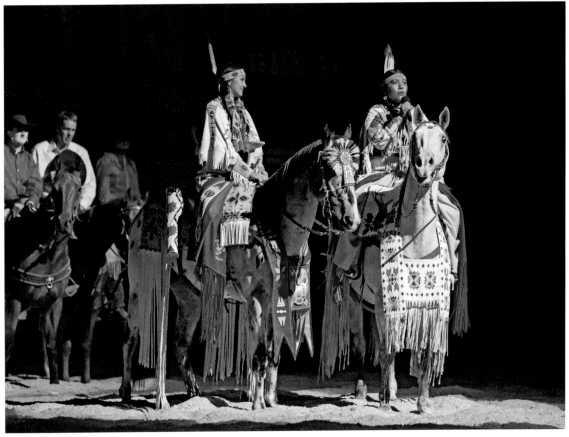

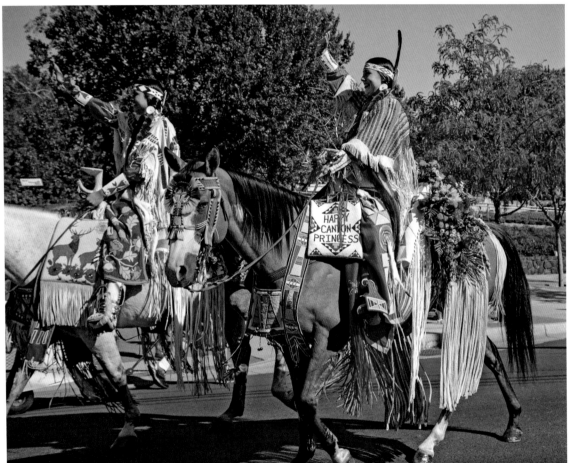

This page: *Top, left and right*: Toni Minthorn and parents preparing horses for parades. *Clayton Briscoe*. Bottom: Marissa Baumgartner and Jory Spencer in Westward Ho! Parade. *Eye of Rie*.

Opposite, top: Princesses in Dress-Up Parade, ending in the Round-Up arena. *Hall of Fame Collection*.

Opposite, bottom: Princesses Anna Harris (left) and Carina Vasquez-Minthorn. Carina sings "The Star-Spangled Banner" in the 2013 show. *Harper Jones II*.

Luncheons and rodeo visits consume many weekends for the princesses. *Center*: 2014 princesses at Round-Up performance. *Eye of Rie.*

meeting all the different people. It has truly been an experience of a lifetime."[268]

All of this does not come without several individuals' sacrifices—from the court director and his wife to the current chaperone and each set of parents. For instance, many help outfit the Rose Festival horse and princess in regalia and trappings at around 3:00 a.m., preparing for the parade kickoff at 10:00 a.m.

Indian Saddle and Horse Trappings

The horse regalia is unique and beautiful in itself. The women's saddle has high posts with a large top in front and in back for hanging bags. It is shaped much like a packsaddle to transport food, supplies and personal belongings from place to place.

The front post is forked to attach "baby boards" so the mother can ride the horse and attend to her baby. This saddle is made of wood, rawhide, buckskin and beadwork.

The horse's facemask trapping was traditionally used in battle to intimidate the enemy. The breast collar trapping hangs around the horse's neck and is often beaded and decorated. Traditionally, rounded collars were used by women and rectangular shapes by men. The bonnet tubes were used as a multipurpose carrier, such as a woman's overnight bag, but they are not a quiver, even though they could carry arrows.

Aside from trappings, horsemanship has been a long-standing tradition among the princesses. Katherine Minthorn remembers

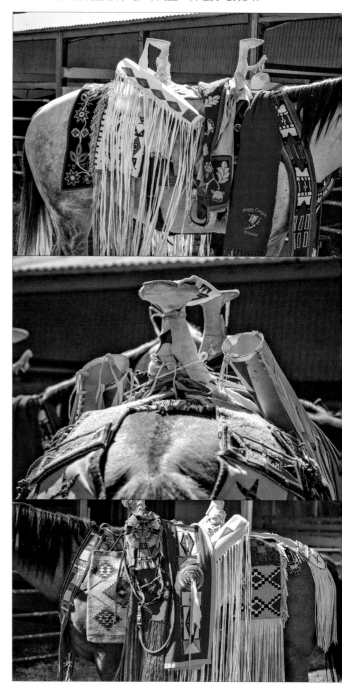

Woman's saddle showing a bonnet tube, wool blanket strip and beadwork. *Eye of Rie.*

299

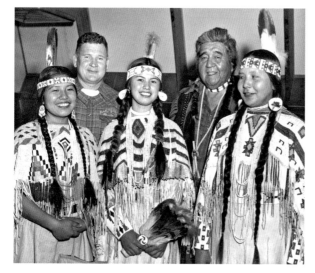

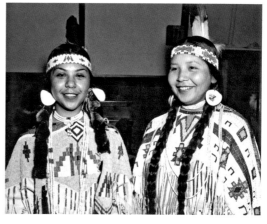

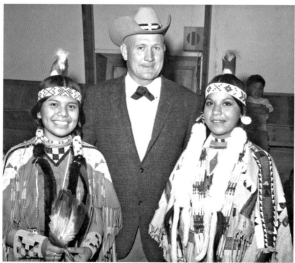

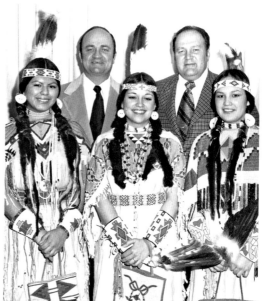

Princesses over the years. *Howdyshell Collection.*

the 1975 summer when she spent hours riding her horse, Topleo Beggar Boy. Her fellow princess, Nancy Minthorn, rode alongside her on her horse, Babe. They had the foresight to take the horses through "the housing project where there are lots of kids and noise," preparing their mounts for the Round-Up parades, the grand entrance in the arena and Happy Canyon.

Over sixty years have passed since Happy Canyon picked Caroline Motanic Davis to be the forerunner of the royalty. Compared to the early years, the changes in the court activities are remarkable. Each Happy Canyon princess closes out her year with mixed emotions as she literally turns over the reins to the next royals.

The princesses are not only ambassadors for Happy Canyon, however. They also represent the Confederated Tribes and Pendleton. Each would tell you that representing their tradition on the court is an honor, allowing them to take pride in their heritage and identity. The girls form lifelong relationships with the board members and their families. But most of all, the girls step into a long line of role models for little girls. Each court and girl representing Happy Canyon has been unique, displaying their culture and regalia with a beauty all their own.

14

IT TAKES DIRECTION

Happy Canyon was a gamble last year but it proved a financial success.[269]

WANTED: Skilled manager. Strenuous physical labor required. People skills needed. Long hours. No pay. Apply at Happy Canyon Association.[270]

It was a gamble. Did a small group of visionaries have enough time, money and ingenuity to pull off something new in the Pendleton community?

During the winter of 1913 and spring of 1914, these city leaders sat around the glowing fireplace in the Pendleton Commercial Association on the north end of Main Street, envisioning a new nighttime show. With cigars and drinks in hand, they dreamed, discussed and planned an event they christened "Happy Canyon."

Without its directors' commitment to tradition and vision, the show's one hundred years depicting regional history and offering Round-Up entertainment would not be possible.

Until the incorporation in 1916, the directors were called "committeemen" and wore bright red ribbons, displaying the event's signature color as well as a listing of their responsibilities. The group included a constable, an attorney, an assistant sheriff, a bartender and a councilman.[271]

These men of vision had been "draining their imaginations in building a frontier town out of the traditions and memories of other days," according to the *East Oregonian*. "Any one of 'em will wager a barrel bucks that it will be 'some show' for they have inside information."[272]

In reality, the committeemen were sons of pioneers or pioneers themselves who had lived the show. Hollywood might have capitalized on

The Men Who Put the "Hap" in Happy Canyon

The first group of men overseeing Happy Canyon were Joe V. Tallman, president; J. Roy Raley; Frederick Steiwer; Lee D. Drake; J.F. Robinson;[273] W.L. Thompson; George A. Hartman; C. K. Cranston; Mark Patton; Harry D. Gray; Roy Alexander; Dr. Guy L. Boyden; Dr. M.S. Kern; Clarence S. King; Merle R. Chessman; George C. Baer; Osmer E. Smith; Royal M. Sawtelle; and Dr. O.N. Reber. This group served without pay, dividing the areas of work among its members.[274]

the "cowboy," but in 1914 Pendleton, cowboys were a reality, as were the First Peoples and rugged men "taming" the West.

Happy Canyon's first year was successful enough to warrant the second. In 1914 and 1915, the festivities were planned, directed, funded and produced by the Pendleton Commercial Association.

Pendleton merchants formed the Commercial Club—or Commercial Association, as it was later known in 1893—to promote businesses and the community. By 1929, the organization had become the Pendleton Chamber of Commerce.

> The Pendleton Commercial Association is an organization of the business men for mutual and community betterment. It has maintained its maintenance for more than twenty years and there is scarcely anything of a beneficial nature that has been done during that period that has been helped, if not originated, by this organization. It occupies comfortable headquarters, located in the center of the business section equipped as club rooms for the use of the members.[275]

The Commercial Club operated in the old Hamley building on the north side of Main Street (751 Main) until it moved to the new Elks Temple in 1920.

The Happy Canyon Company began and conducted business in the Commercial Club location for thirty-nine years (1914 to 1953). *Polk's Umatilla County Directory* describes the club's location:

> One of the most important features of the city is a live up to date Commercial Club with a well-equipped club house including hospitable reading and recreation rooms, with pool and billiard tables, a first class gymnasium, where the business and recreative activities of the citizens of the City of Pendleton and Umatilla County are carefully nurtured.[276]

Incorporated in 1916

The 1914 and 1915 shows had been informal operations at best, but in Happy Canyon's third year, the committeemen began to incorporate

the business side in earnest. Enthusiastic crowds had outgrown the Main Street show location, making the visionaries' nighttime show a true success.

In the summer of 1916, the Pendleton Commercial Club advertised Happy Canyon stock, realizing the need for a permanent home and an organization. It was an excellent investment.

With Roy Raley spearheading the process, the Happy Canyon Company formally incorporated in 1916 with a capital stock of $600. One hundred shares sold for the bargain price of $1 each and included voting rights but not profits. The newly formed Happy Canyon Company organized under the Pendleton Commercial Club, which bought five hundred preferred stock with possible dividends but without voting rights. Meanwhile, Roy had the Happy Canyon pageant copyrighted.

People have often debated about when the show should begin "counting" the years. In 1991, the seventy-fifth anniversary board resolved this when it recognized 1916, the year of incorporation, as the official beginning of the show and organization as we know it.

M.S. Kern, Lee D. Drake and G.L. Boyden were the original incorporators. The incorporation document states: "It having been decided to organize a corporation to be known as the Happy Canyon Company for the purpose of conducting entertainments in the city of Pendleton."[277]

At the start, the Happy Canyon Committee was one and the same as the Commercial Club of Pendleton. When J.V. Tallman presided over the first year as president, he was simultaneously the Commercial Club president. Those

Sign Up and Get a Share of Happy Canyon Co. Stock

I hereby subscribe for one share (par value one dollar) of the common stock of the happy Canyon Company and waive notice of the first meeting of stockholders to be held at the rooms of the Pendleton Commercial Association Tuesday evening, August 15th, 1916, at 8 p. m.

Top: A 1916 *East Oregonian* front-page article offering Happy Canyon stock for one dollar! *From the* East Oregonian.

Above: Canceled 1916 stock certificate. *Author file.*

A 1916 board photo in newly constructed scenery.
Umatilla County Historical Society.

attending the first meetings created a board of eleven members with a president, secretary and treasurer, along with a director responsible for each area. Thus, in 1916 the Happy Canyon Board of Directors began.

The first official Happy Canyon Board of Directors were J.V. (Joe) Tallman, president; C.K. Cranston, secretary; W.E. Brock, treasurer; W.L. Thompson, director of grounds; J. Roy Raley, director of program; J.H. Sturgis, director of dance; W.N. Matlock, director of games; L.D. Drake, director of music; Dr. M.S. Kern, director of "saloons"; James R. Bowler, director of bank; M.R. Chessman and Clarence Ash, special committee on publicity.[278]

In the early years, the simple paper program stated, "The Happy Canyon pageant is owned by the Pendleton Commercial Association. This event is staged each year by the business men

of Pendleton, who devote their time and effort without pecuniary reward."

Under the supervising contractor's direction, the entire board helped build and outfit the permanent 1916 facility. This became a pattern throughout the years as the board gave its time and resources to continue the show.

The show flourished in its new location. Even as World War I expanded, the board opened Happy Canyon's doors to support the local troupes of soldiers. Umatilla County saw wheat selling for forty cents a bushel and eggs for twenty cents a dozen, yet Happy Canyon weathered the lean Depression years.[279]

The board made several big decisions during World War II as servicemen stationed in Pendleton sought after the Happy Canyon facility. Even one of Happy Canyon's directors, Charles Erwin, left to serve overseas. Thankfully, he returned to Pendleton.

The directors hosted dances in the Happy Canyon pavilion for the USO, but it also saw the need to encourage its own unity and comradery. The men set out to hold several dinners to keep "the board's interest alive."[280]

Mildred Searcy at Round-Up/Happy Canyon offices. *Umatilla County Historical Society.*

Reorganization in 1952

After the war years, tax implications became more complex and prohibitive to future saving. Thus, the Happy Canyon board reorganized. The 1952–53 board dissolved the Happy Canyon Company and formed the nonprofit Happy Canyon Company Inc. on April 4, 1952.

The new corporation freed Happy Canyon proceeds from income tax and laid the groundwork for building the show's new home. Ironically, this meeting took place at the chamber of commerce rooms, 234 Southeast First Street, where all correspondence and ticket inquiries were handled for Happy Canyon.

Happy Canyon Company Inc. was formed in 1952 as a nonprofit, educational and community corporation. In the Articles of Incorporation the main objectives are set forth as:

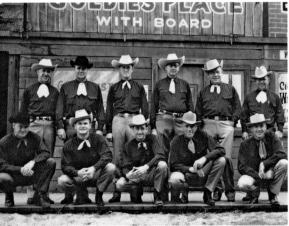

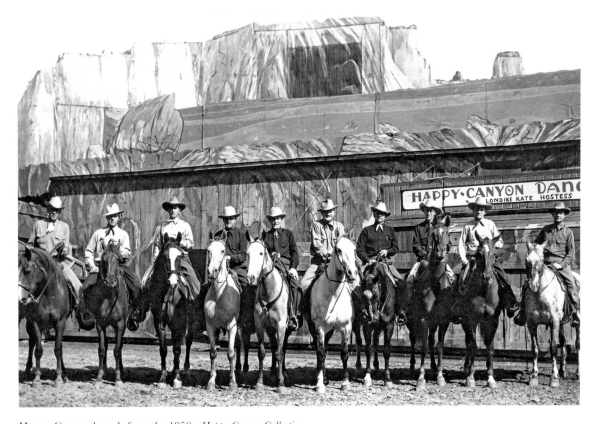

Happy Canyon boards from the 1950s. *Happy Canyon Collection.*

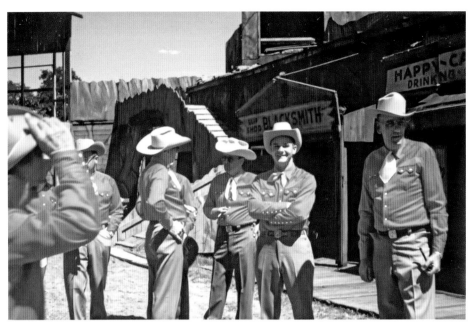

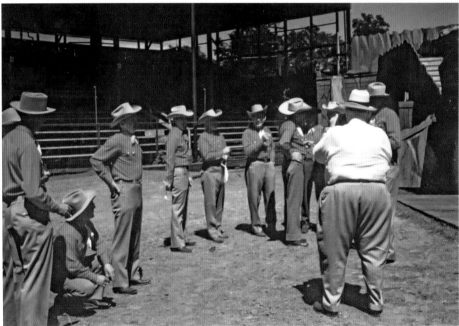

Top: Happy Canyon board preparing for group photo in Old Canyon. *Bottom*: The Happy Canyon board in the Old Canyon with the old grandstands behind the members. *Happy Canyon Collection.*

1. Produce and conduct public and private shows, pageants and amusements in the County of Umatilla, State of Oregon, of every educational character and nature;
2. Foster and perpetuate by the conduct of such shows, pageants and amusements, the memory and spirit of the frontier and of the old west, preserving for future generations the memory and the manner of life, pleasures and hardships of the emigrants on the Oregon Trail, and the pioneers in Oregon Country;
3. Preserve the customs and manner of life of the Indian tribes occupying the Oregon country before the coming of the white man;
4. Preserve, protect and honor the memory of veterans of any and all wars or military conflicts in which the United States of America has been or shall be engaged and particularly the memory of such residents of Umatilla County.

The corporation also had to break away from the chamber of commerce since the Happy Canyon Company paid the chamber to use the Happy Canyon facility. On January 5, 1953, the Pendleton Chamber of Commerce approved and transferred its five hundred shares of preferred stock to the Happy Canyon Company.

At this time, the board discussed the possibility of constructing a new show building and arena. By July 1953, the building plans began in earnest as an architect started drawing up plans. Simultaneously, board discussions were held to remove the Old Canyon and sell the land holdings.[281]

For over thirty-eight years, the board had met at the Pendleton Commercial Association in downtown Pendleton, but it now saw the wisdom in joining with the Pendleton Round-Up and moving to this combined venue at the Round-Up grounds. This could not have been an easy transition from the board's own independent business proceedings in the previous years.

Luckily, Mildred Searcy was hired as the Round-Up secretary, and she was a gift to both boards. She managed Happy Canyon's ticket sales and office needs—doing it all for $225 a month. Happy Canyon and Round-Up began a new season of business together.

Highlights Over the Years

Happy Canyon began a souvenir program in 1967 to replace the trifold paper program used in previous years. Robin Fletcher Jr., the show and program director, worked with graphic artists at Klocker Printery in Medford, Oregon, to develop a quality product telling Happy Canyon's story and giving visitors a keepsake from the show.

Bruce Campbell, a longtime show actor, wrote most of the narrative for the 1967 and 1968 programs, devoting the majority to the Indians' story and incorporating the coyote legends passed to him by Emma Farrow. Photographers, including Bus Howdyshell, Bob Grant and Major Lee Moorhouse, captured images of the show in print for the first time.[282]

With the need for sponsorships, Happy Canyon entered joint participation with Round-

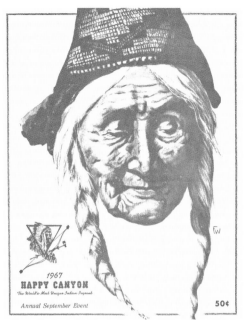
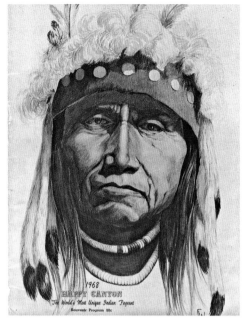

Top: the 1967 and 1968 programs featured Reverend F.W. Wissenbach's paintings of Mrs. Minthorn and Chief Sismakena. *Bottom*: this original artwork by Mary Lou Fletcher was used for thirty years as coyote legend backgrounds. *Author file*.

Up in 1988 to sell advertising to sponsors. The first year brought Happy Canyon $7,500—a much-needed boost with upkeep and costs on the rise.

The Happy Canyon board of 1991 celebrated the seventy-fifth anniversary of this remarkable community event, riding in the Rose Festival parade to kickoff the year. "Our first 75 years have seen change, and it has been a moving and very satisfying experience for my family as well as myself," Jim Duff, 1991 Happy Canyon president and third-generation participant, said.[283]

The Western Art Show also commenced in 1991, bringing in several thousand people and adding another positive element to the week. Director Dennis Hunt worked with art teacher Michael Booth to bring quality western artists to display and sell their work. This art show continued for four years in the Convention Center meeting rooms.

By adding Happy Canyon water bottles in 2001, the show created a new popular showcase; the water is distributed throughout the year and used at most Round-Up and Happy Canyon events. Happy Canyon continues to bottle water yearly to promote the show and events.

Rob Burnside was elected in 2002, making him the first Indian to be a member of the board of directors. "We took Rob because of Rob," Doug Corey said, "and he happens to be a Native American, which will add a whole new dimension to the Board, a new dimension to Round-Up and Happy Canyon."[284]

The *Confederated Umatilla Journal* (*CUJ*) noted, "Known far and wide was a Native American pageant, Happy Canyon has until now never had an Indian as a director."[285]

The 2006 show brought a double anniversary. It was the ninetieth anniversary of Happy Canyon and also the fiftieth-anniversary celebration at its present location. A limited edition Pendleton wool blanket was commissioned as a souvenir. It was designed by the board of directors and featured the Happy Canyon Indian head logo used since the 1930s.

With a group spanning more than two city blocks, the cast, directors, wagons and outriders participated in the Pendleton Rose Festival. More than forty volunteers, horses, oxen and wagons depicted scenes from Happy Canyon.

With the board's backing in 2011, Jason Hill spearheaded an effort to designate Happy Canyon as Oregon's official State Outdoor Pageant and Wild West Show. Jason said in testimony to the senate subcommittee:

> *The Happy Canyon Show is the core event for the evening activities during Round-Up week, with its historically based story line for the first half of the show…to the slap stick second half of the show…With heavy tribal involvement, this show has gone on every year since 1914, except during two years during World War II. This show goes on without fail, rain or shine. Period. This makes it a true Oregon icon. By any standard, this is unheard of for any event, anywhere in the United States.*

After Senator David Nelson, Representative Bob Jenson and Representative Greg Smith sponsored the proposed resolution, it passed through subcommittee and officially became Oregon State Senate Concurrent Resolution 2.

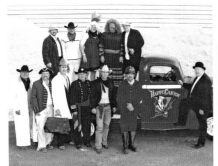

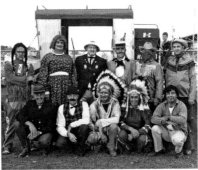

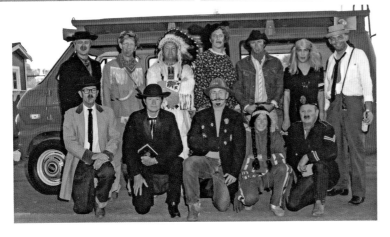

Top: Happy Canyon softball team. *Happy Canyon Collection.*

This page: Don Hawkins said, "When I was president, I had the idea to have all the directors in the parade to wear a costume from the show." *Happy Canyon Collection.*

313

76th OREGON LEGISLATIVE ASSEMBLY--2011 Regular Session

Enrolled

Senate Concurrent Resolution 2

Sponsored by Senator NELSON; Representatives JENSON, G SMITH (Presession filed.)

Whereas the Happy Canyon Indian Pageant and Wild West Show is the longest running outdoor pageant and wild west show in the United States; and

Whereas the Happy Canyon Indian Pageant and Wild West Show will be celebrating its 95th anniversary in 2011; and

Whereas the Happy Canyon Indian Pageant and Wild West Show is well known for its distinctive quality and portrayal of both historic and cultural events during the era of Lewis and Clark and the Oregon Trail; and

Whereas the Happy Canyon Indian Pageant and Wild West Show has been annually presented since 1916 by a cast of both Native Americans from many different area tribes and local community volunteer actors, who participate as a long-standing family tradition; and

Whereas the Happy Canyon Indian Pageant and Wild West Show enlists more than 500 people and more than 50 animals for the production of each year's show; and

Whereas the Happy Canyon Indian Pageant and Wild West Show takes place each year in Pendleton, Oregon, for four nights during the Pendleton Round-Up; and

Whereas Roy Raley conceived the idea for both the Happy Canyon Indian Pageant and Wild West Show and the Pendleton Round-Up and is often called the "father" of both events; and

Whereas Roy Raley wrote a show in 1914, now known as the wild west portion of the Happy Canyon Indian Pageant and Wild West Show, using stories from his father, Colonel Raley, who came to Oregon on the Oregon Trail; and

Whereas Roy Raley designed the scenery and directed the first pageants and later in 1916, with the help of local tribal members, worked up a sequence of Indian village life seen now in the present-day script; and

Whereas the Happy Canyon Indian Pageant and Wild West Show depicts the settling of the American West, beginning with a portrayal of the Native American way of life prior to the arrival of Europeans, continuing with the arrival of Lewis and Clark, followed by the prairie schooners of the pioneers of the Oregon Trail and concluding with a reenactment of a frontier town's rollicking main street mishaps; and

Whereas the Happy Canyon Indian Pageant and Wild West Show is accompanied by a live orchestra of outstanding professional musicians from Oregon, Washington and California; and

Whereas the Happy Canyon Indian Pageant and Wild West Show is known as the "world's most unique Indian pageant"; and

Whereas the Happy Canyon Indian Pageant and Wild West Show contributes to the state's economy by attracting residents and travelers to Oregon to attend, resulting in economic benefit to the local community and businesses; now, therefore,

Be It Resolved by the Legislative Assembly of the State of Oregon:

That we, the members of the Seventy-sixth Legislative Assembly, designate the Happy Canyon Indian Pageant and Wild West Show as Oregon's official state outdoor pageant and wild west show.

Adopted by Senate March 8, 2011

Robert Taylor, Secretary of Senate

Peter Courtney, President of Senate

Adopted by House June 10, 2011

Bruce Hanna, Speaker of House

Arnie Roblan, Speaker of House

Oregon State Senate Concurrent Resolution 2, sponsored by Senator Nelson and Representatives Bob Jenson and Greg Smith. *Happy Canyon Collection.*

Promoting Happy Canyon Across the Northwest

From the beginning, the Happy Canyon directors promoted the Happy Canyon pageant in parades throughout the Northwest. One hundred years have brought the board diverse transportation options.

For several years, in an era when most society used horses, they rode horseback in the parades. They have used wagons, including a 1955 "hayride," for the Dress-Up Parade, as well as a covered wagon in the 1960s.

In 1953, the board voted for the stagecoach as the Westward Ho! Parade's mode of transportation. It has remained the traditional end of their summer parade schedule. The stagecoach ride has not been without incident, though.

Once during a too-sharp turn into the Round-Up arena, the directors riding on the top felt the stagecoach begin to topple.

Wray Hawkins remembered it well. "It had come through the parade and into the Round-

Happy Canyon directors in local parades. *Howdyshell Collection.*

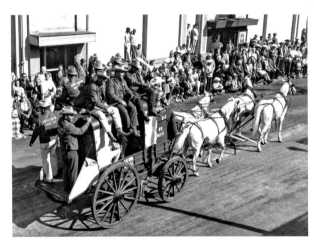

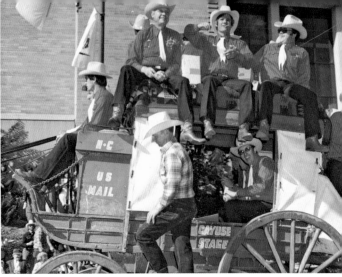

Up Grounds," he said. "It was making a big circle in front of the Indian Village a little too fast, and then it all of a sudden turned over. I ran to get out of the way, as I was right by it."[286]

No one was seriously injured, except one director who broke his ankle. Several, including Emile Holeman, "rode it to the ground and stepped off," according to Holeman.[287]

This page: Happy Canyon boards using the stagecoach for parades. *Happy Canyon Collection.*

Opposite: "Men on a van"—the board's main form for parade transportation and candy throwing. *Happy Canyon Collection.*

The 2014 board heading off for official business. *Eye of Rie.*

MULTIGENERATIONAL DIRECTORS

Several families have had multigenerational director involvement, which speaks to their commitment and community involvement. For example, three generations of of the Jack Duff and George Corey families have now served as Happy Canyon directors.

Similarly, the Hawkins family service on the board began with Don Hawkins and continued with his only son, Tim. Now a third-generation member, Tanner, currently serves. "Happy Canyon was the best board I served on," Don said. "The other men were so dedicated to put

Unfortunately, in 1986, the Happy Canyon directors riding the stagecoach did not fare as well. Something—no one knows to this day what it was exactly—spooked the four-horse team. A block later, as the horses ran full bore, one of them finally went down, and the horse team was stopped at that point. Several directors were injured, landing on the pavement by the courthouse. Several past directors filled in for these injured directors during Happy Canyon's last two performances.[288]

A bright red van became the main form of transportation for the board in the 1960s. The directors are famous for throwing candy from this vantage point, and they claim to be quite good at it. Ask any child who has been pelted with thirty-five Tootsie Rolls.

Happy Canyon's Candy Committee has a busy job in the summer months. In fact, in 2015 alone, the Happy Canyon board purchased and threw 224,640 Tootsie Rolls in parades all over the Northwest.

This page, top: Left, from left to right: Hawkins family board members Kelly, Wray, Bob, Don and Tim; *right*: Tim, Don and Tanner. Three generations of the Hawkins family have now served the board. *Happy Canyon Collection.*

This page, bottom: The Hawkins family, with Deacon (being held, far right), now has a fourth-generation actor. *Eye of Rie.*

Opposite: Jason Hill (left) and Fritz Hill have both directed the show. In 2013, Fritz assisted Jason in the director's booth. *Eye of Rie.*

Three generations of the Sturgis/Kilkenny family have served as directors. *Left to right*: James Sturgis, Mike Kilkenny and Judge John Kilkenny. *Howdyshell Collection.*

HAPPY CANYON SYNONYMOUS WITH HOSPITALITY

The Happy Canyon directors are considered the hospitality wing of the Round-Up umbrella, taking care of the thirsty at almost every Round-Up and Happy Canyon event, usually serving from the famed red Happy Canyon van.

The Happy Canyon directors also host a hospitality room after the show, where good cheer is in abundance. It is not unusual to see a congressman, the president of the Cheyenne Frontier Days or various visiting dignitaries hosted by the board.

the show on. We were a close-knit bunch and really supported each other."[289]

Another generational family was the Sturgis/Kilkenny family. "It is with a sinking feeling of distinct loss and sincere regret that I tender herewith my resignation as President," John F. Kilkenny expressed upon resigning from the board.

"I cannot find words to express my deep appreciation for the whole-hearted cooperation of the directors during my term as President, but want you boys of the Board to know that you are the most conscientious, the most loyal, the most resourceful group of men with whom I have ever had the pleasure of serving."[290]

Dr. Richard Koch with wife Mary McBee Koch. Notice the beaded "badges" made for many years by director Bruce Boylen's wife, Karen Boylen. *Mary Koch.*

Opposite: Past directors, *from left to right:* Bill Morrison, Emile Holeman, Whitey Breaid, Jim Sturgis, Don Hawkins, Jack Luck, Bob Fletcher and Bill Duff. *Howdyshell Collection.*

The current directors find this room a welcome respite away from duties. The show cast also gathers here to recount unexpected moments and to tease one another after the evening's performance.

Current Board of Directors

Each of the directors began by volunteering—whether they were "volunteered" at an early age in the show or moved to Pendleton and intentionally invested in the event.

As newly elected directors step onto the Happy Canyon board, they are continuing history and tradition. Currently, the twelve-member board conducts the general company business on a month-to-month basis. The fixed assets of the company, including the grandstand, the land and the accompanying show property, are retained by the Happy Canyon Foundation Inc., which is made up of the retired board members.

Only elected board members can become stockholders in Happy Canyon. They are chosen by the current board and approved by the Happy Canyon Foundation. The Happy Canyon Company Inc. is the operational arm of Happy Canyon, funding the Happy Canyon Foundation, which owns all the assets and provides generous contributions to the community, high school seniors and Happy Canyon princesses.

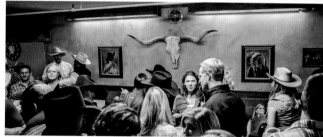

The directors choose their positions based on seniority, and a board member typically serves for eight years. They continue to promote the show and accompanying events by traveling to several parades and related events throughout the Northwest.

Don Hawkins remembered how hard it was to juggle being on the board with a family in tow. "It is hard doing the night show with families; it is tough," he said. This is all without compensation. In fact, most member expenses are out of pocket, adding up throughout the year. Don mentioned how, during his years on the board, they even brought their own sack lunches for Round-Up when funds were short.[291]

When a newly elected director steps onto the board, his spouse and children are in for the ride. Most wives and children find themselves involved with volunteering in various capacities throughout the board tenure. It becomes a family affair and a special community.

Many directors continue to be active in Happy Canyon after resigning from the board. For example, Fred Carmichael played in the orchestra for several years after directing the show from 1954 to 1957.

Currently, around twelve past directors volunteer in the show, dance hall activities

The Director's Room is famed for its hospitality. *Eye of Rie.*

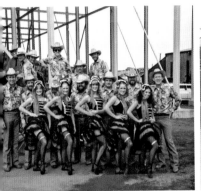

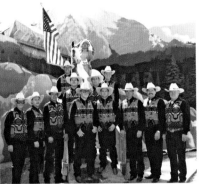

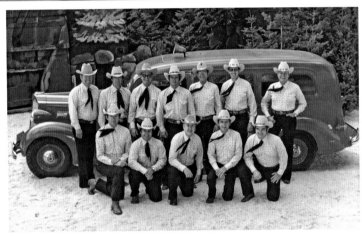

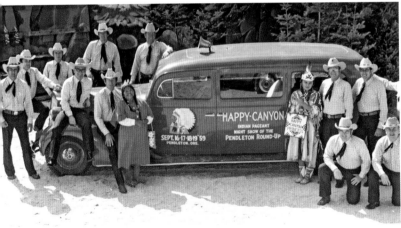

Happy Canyon boards over the years. *Happy Canyon.*

or scenery and arena teams. Each demonstrates his true love of Happy Canyon.

Those who have served as a director will tell you what an honor it is and that it was one of the most fulfilling tasks of his life. But most are quick to say that the volunteers are the backbone year to year. After a director learns what area he is overseeing, the volunteers are the "key help" without which the show and accompanying events could never happen.

Over the last century, the board and its foundation have demonstrated the camaraderie and willingness to perpetuate Happy Canyon. The sacrifice of time and service to the future of the show and its accompanying entertainments has always been the board's priority. Many of the directors willingly go without sleep during the week of Happy Canyon, putting in long hours and taking time off work. But many would agree with past director Raley Peterson, who said, "Some of the happiest associations of my life have occurred during my work with the organization."[292]

Each director steps into a long line of men with vision and with a true appreciation for all things Pendleton. Round-Up has a world-famous slogan we all know: "Let 'Er Buck." But those who love the evening show all say with pride, "Happy Canyon!"

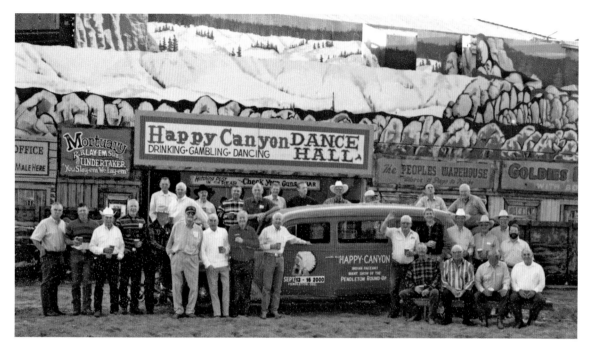

Above: Yearly past director dinner held the week before Happy Canyon. *Happy Canyon Collection*.

Below: The 2014 past director photo. *Harper Jones II*.

15

MULTIPURPOSE ARENA

I am sure someday Pendleton will be proud of Happy Canyon's contribution to a Community Center Building that can be used 12 months out of the year.[293]

With the move to the second location in 1916, the Happy Canyon directors envisioned a much-needed gathering place for eastern Oregon. Even after its hasty construction, the facility proved to serve this purpose.

After the 1916 show closed, the new venue was used almost instantly by a broad scope of groups through the year leading up to the 1917 Happy Canyon. The Umatilla County Auto Club was formed and held their first "convention" at the new Happy Canyon facility, displaying thirty-nine pleasure cars and five trucks. In fact, in 1916, Umatilla County had 1,346 automobiles, placing it second in the state.[294]

The winter of 1916 to 1917 also saw several Pendleton churches combine for revival meetings in the newly built Happy Canyon pavilion. Even the July 4, 1917 Pendleton celebration was held in Happy Canyon.

As World War I raged across the sea, Happy Canyon offered the arena for the local boys' drills. In fact, Troop D drilled there before deployment and, surprisingly, used the dance hall as a dormitory with cots as well as for jitney dances benefiting the Pendleton Reserves (home guard unit) and the Red Cross.

Even some of the military equipment for the Pendleton Reserves was stored in the facility during the early years. The *East Oregonian* summed it up, stating, "Harrly [*sic*] a month has passed that there has not been a demand made for the use of the building erected primarily to entertain the Round-Up crowd."[295]

For thirty-eight years, the Old Canyon continued to be the place for conventions and gatherings of all kinds. For instance, the June 2, 1934 Pendleton Airport dedication was a huge affair. It ended properly in the Happy Canyon dance hall with the Official Airport Dedication Ball under the direction of Ed "Ole" Olson.

Interestingly, the last convention held in the Old Happy Canyon Dance Hall in 1954 was the OLCC, which somehow seems appropriate, as Happy Canyon works closely year to year with that group.

With its move to the armory (later called the convention center), Happy Canyon can also boast several VIPs throughout the last century. For instance, when President Ford visited Pendleton in 1976, the Happy Canyon arena became the perfect venue for this event, offering a place for Pendleton residents to see and greet the president and hear him speak.

Right: An *East Oregonian* newspaper ad for Ford. *From the* East Oregonian.

Below: Vice President Cheney's secret service following him into Goldies before he spoke. *Author file*.

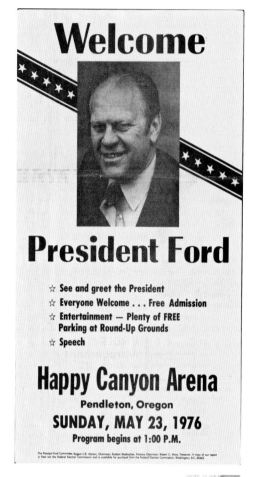

Welcome

President Ford

☆ See and greet the President
☆ Everyone Welcome . . . Free Admission
☆ Entertainment — Plenty of FREE Parking at Round-Up Grounds
☆ Speech

Happy Canyon Arena
Pendleton, Oregon
SUNDAY, MAY 23, 1976
Program begins at 1:00 P.M.

The President Ford Committee, Rogers C.B. Morton, Chairman, Robert Mosbacher, Finance Chairman, Robert C. Moot, Treasurer. A copy of our report is filed with the Federal Election Commission and is available for purchase from the Federal Election Commission, Washington, D.C. 20463.

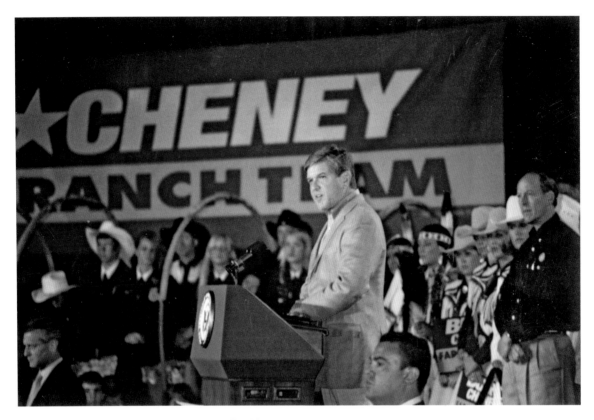

Pendletonian Gordon Smith introduced Vice President
Cheney. *Howdyshell Collection.*

Happy Canyon Linked to the Military

From its beginning, Happy Canyon has also
honored and celebrated men and women in
service.

During World War I, several Happy
Canyon performances showcased the military.
The September 19, 1918 show featured Major
Thornton Mills, an officer in the air service
who was then stationed in Portland. He was

given the opportunity to address the crowd
that evening.

The Camp Lewis Military Band opened the
show's last 1918 performance, entitled "The
Red Cross Show." Not only was the show
dedicated to the Red Cross, but it also gave
proceeds above expenses to the Red Cross.

The five thousand attendees enjoyed this
concert to the utmost. In the grand finale,
stagehands lit the light in Miss Liberty's hand
and released miniature airplanes as a simulated
mountain eruption was observed from the wooden
scenery. The gate swung open and the Camp
Lewis Military Band came marching in, playing
war songs like "Over There." Representing the

League of Nations, Pendleton girls dressed in correlating costumes or Red Cross uniforms and carried the flag of each Allied nation.

The show was talked about for years. It was even one of Roy Raley's favorites. He remembered one of the army musicians, who happened to be a former circus magician, volunteered to lead the music.[296]

World War II

As the board decided to forgo the 1942 Happy Canyon, their business agenda instantly went to the United States military request to use the Happy Canyon property. Happy Canyon did not sit vacant during the canceled years of 1942 and 1943.

In fact, the USO leased the lot owned by Happy Canyon across Third Street and built the USO Building. The American Legion also leased the grounds periodically through the World War II years, enabling them to use the dance hall and Happy Canyon arena to benefit the soldiers stationed in Pendleton, especially those training at the Pendleton Field.

The government leased the arena for military practice and other various uses, and the Oregon Women's Ambulance Corps received assistance from Happy Canyon to purchase a county ambulance. Happy Canyon, out of small funds, willingly donated to the Umatilla County War Fund for several years as well. Several servicemen from the county were directly affiliated with Happy Canyon, including Charles Erwin, a board member who served overseas during the war.

In 1943, Happy Canyon hosted several dances to entertain the boys at the base, making those events as special as they could with proper patriotism. The Mothers and Wives Service Club of Pendleton, with military authority backing, presented a proposal to the board in 1943, asking to use the dance hall as a skating rink for the servicemen. The Happy Canyon board approved this fun use of their dance pavilion to serve all the servicemen stationed in Pendleton, as long as the U.S. government covered the expenses.[297]

In fact, when Happy Canyon Company Inc. incorporated in 1952 as a nonprofit, its fourth key main objective was to "preserve, protect and honor the memory of veterans of any and all wars or military conflicts in which the United States of America has been, or shall be, engaged, and particularly the memory of such residents of Umatilla County, Oregon, as shall have lost their lives in, or been engaged in, such wars and conflicts."[298]

Thus, as Happy Canyon planned on relocating and rebuilding the arena, it partnered with the State of Oregon Military Department to build the multipurpose event center, locating Happy Canyon in the back. Happy Canyon and the State of Oregon Military Department entered a lease for specific areas within the Pendleton National Guard Memorial Armory. Happy Canyon would use these areas during Round-Up week and for specific times throughout the year. The grandstand, when not used for the show, would provide added storage and cover for the National Guard vehicles.

With the tragedy of September 11, 2001, fresh in the board members' minds, the 2002 Happy Canyon pageant featured a grand

The National Guard stored its military cannons under the Happy Canyon grandstands for many years. *Happy Canyon Collection.*

finale with a salute to all veterans and active-duty servicemen, spotlighting local active National Guard. During this performance, which was reminiscent of the 1918 grand finale, the board was underscoring the key objective they had upheld for so many years: honoring the military.

Pendleton Convention Center

In the early 1990s, the city of Pendleton purchased the armory and entered into a new agreement with Happy Canyon. After the transaction was complete, a renovation project transformed the old armory into the Pendleton Convention Center, benefiting both the city and Happy Canyon. With this addition and remodel, many new and exciting opportunities opened for Happy Canyon and the city of Pendleton.

Currently, Happy Canyon willingly donates its parking lot (surrounding the convention center) to the City of Pendleton. This joint-venture facility and the generosity of Happy Canyon have given the Pendleton and surrounding communities the opportunity to host a variety of conventions and activities.

From the State 2A basketball tournament to the Circus, Riverdance, Eastern Star Conventions and, recently, the Rotarians Convention, Happy

Canyon has provided a place for community opportunity. Roy Raley would smile to think Happy Canyon helped the Rotarian gathering, which he founded in Pendleton.

Since its inception, Happy Canyon's goal has been to give back to the community. For instance, the 1940s shows reported doing business for production with over sixty local businesses. The only expense not paid locally was the dance orchestra. In the 1940s, many of the thirty past directors in Pendleton were still helping with the show as well. In 1945 alone, Happy Canyon recorded how seventy-one Pendleton firms and individuals were paid over $15,000 in purchases—an incredible postwar amount.

Right after the current Happy Canyon was built, Pendleton High School held their 1956 graduation ceremonies in the new arena and grandstands. Since many graduations take place in the evening, many families huddled under blankets.

Show livestock volunteer Rusty Black graduated in the Happy Canyon Arena in 1959. She became one of the key people in the last sixty years, providing, owning and training the iconic trail horse for the lone chief to ride.

Steve Corey fondly remembers the commencement program in the Happy Canyon Arena, which seemed large to him at the time.

I remember assembling with my class in the back of what then was the National Guard Armory and marching into the dirt arena of Happy Canyon where our chairs were located. The audience seemed awesome—it was a very large arena filled with excited parents and families. I spoke

as a graduation speaker and Student Body President, about the lives together that we as high school classmates had shared, and to commit ourselves to our futures, to follow our dreams in earnest and constructive ways, and march forward proudly into life.[299]

The Happy Canyon Arena continues offering its venue to the local community in creative ways, such as for the Pendleton High School Mud Wars. The Happy Canyon board hosts a dinner for the Buck Boosters and creates a large mud pit in the center of the arena for girls' teams to battle in.

ROUND-UP AND HAPPY CANYON WEEK: MAXIMUM USAGE OF THE ARENA

For those who work on the grounds, Happy Canyon week is a never-ending "quick change" in the arena, beginning with the set up for the Saturday night concert. This four-day undertaking is impossible without dedicated volunteers. A spectator has no idea how the small stadium changes during the weeklong period to put on a concert, two nights of bull riding and four nights of pageant performances.

Currently, during the week of Round-Up, the Happy Canyon Arena holds three large events, including a Saturday night concert, which kicks off Round-Up, the Professional Bull Riders Only on Monday and Tuesday and, finally, the four nights of the show itself.

The arena changes are a huge undertaking from event to event. After the dress rehearsal

Above: In the beauty of an eastern Oregon fall sunset, the arena is shown in its glory before 2014's PBR. *Eye of Rie.*

Below: Sawdust is a Happy Canyon tradition, used as early as 1917. *Eye of Rie.*

ends, the equipment and stage crew immediately move to construct the stage for the concert and to install sound and lights.

Early Sunday morning brings the stage teardown. This is accomplished by Happy Canyon and Round-Up directors and their key help as they ready the arena for the Professional Bull Riders. They install bucking chutes and runways and hang sponsor signs. They also work up the dirt to provide a "soft landing" for the cowboys.

A rapid transformation also occurs behind the scenes. After the last bull bucks out and the PBR festivities have ended, it takes nine contiguous hours for the Happy Canyon grounds director to make the transformation from the PBR setup to the stage and arena for the show on Wednesday night.

Volunteers work hard to remove the PBR chutes and accompanying items, applying the famous two full semi loads of sawdust for the floor of the show. Only after they finish setting up for Happy Canyon and all the props are in place can the grounds director finally breathe a sigh of relief.

KICKOFF CONCERT

The list of performers who have arrived in Pendleton over the years to kick off the Round-Up and Happy Canyon reads like a country music hall of fame roster. The last thirty years not only have provided a distinct rodeo and night show but have also given Pendleton the reputation for an exceptional community concert the weekend before the festivities begin.

In 1985, to help celebrate Round-Up's seventy-fifth anniversary, Round-Up and Happy Canyon brought forth the idea to use the Happy Canyon arena for a concert benefiting the community and kicking off Round-Up week.

The first concert on Tuesday evening of Round-Up week featured Reba McEntire. Reba was a perfect choice, since her dad had competed at Round-Up and Reba herself had performed several years before at the Happy Canyon dance. Also, in 1985, she had just been dubbed the female vocalist of the year.

Even though the sky drizzled on the crowd, the rain held off until the first true Round-Up concert was in the books. It was a huge success and began the Round-Up tradition of Round-Up/Happy Canyon concerts, providing a much-needed revenue stream for both organizations as well.

In 1986, George Strait was scheduled to be the kickoff concert, but due to a personal tragedy, he had to cancel just days before the concert. Thankfully, Ricky Skaggs took his place before an enthusiastic crowd, which loved his performance.

The backstory of how Happy Canyon's Board of Directors pulled this off is a perfect example of the volunteer spirit. After Ricky Skaggs agreed to come to Pendleton, the board had to arrange a way to transport the performer's key equipment from the Pasco, Washington airport to Pendleton.

According to Scott Sager, several directors—in true Happy Canyon fashion—took their horse trailers to the airport and carefully loaded the band's touring equipment, storing it in Doug and Heather Corey's barn until setup. Ricky's

Reba McEntire with the 1985 Happy Canyon Board in the first kickoff concert. *Hall of Fame Collection.*

concert was described as one of the best ever held, as he gave an extra-long performance and enthusiastically greeted the crowd afterward.[300]

The 1988 Round-Up/Happy Canyon concert featured the Oak Ridge Boys, and the Tuesday evening concert contained two full performances for the first time. That night, crowds nearly filled the Happy Canyon grandstands to full capacity.

For several years, the schedule included two nights of the concert, sometimes involving several groups. This proved to be extra work, and so the concert was moved to the Round-Up grounds to stage a country music festival with several artists. The Round-Up and Happy Canyon boards tried to appeal to a wider audience with this expanded "music festival" format.

Since 2002, the concert has taken place in the Happy Canyon arena for one Saturday evening kickoff concert. This one night and one performance in the more personal Happy Canyon arena is an exciting start to Round-Up week.

The Round-Up/Happy Canyon concert has featured key names from the world of country music. Among these names are Reba McEntire (who came for a second performance), George Strait, Lee Greenwood, Nitty Gritty Dirt Band, Brooks and Dunn, Kenny Chesney, the Steve Miller Band, the Beach Boys, Rascal Flatts, Phil Vassar, Leann Rimes, Willie Nelson, Randy Travis, Charlie Daniel's Band, Alabama, Jo Dee Messina, John Michael Montgomery, Sawyer Brown, Chris LeDoux, Collin Raye, Shenandoah, Tracy Byrd, Brad Paisley and Josh Turner. Kenny Rogers, along with the returning Oak Ridge Boys, played in Happy Canyon's arena in 2010 for the Round-Up centennial celebration.

Over the last thirty years, the Round-Up and Happy Canyon concert has provided a perfect start for events, offering Pendleton and the surrounding communities an opportunity to see well-known entertainers in an intimate setting.

PROFESSIONAL BULL RIDERS ONLY

In an effort to diversify entertainment at Pendleton Round-Up and Happy Canyon, as well as to generate income for both organizations, the Professional Bull Riders Only began in the Happy Canyon Arena in 1999 with a total purse set at $40,000.

After taking a field trip to see a PBR, Doug Corey and Jack Shaw had felt it could be a good addition to the festivities. The top bulls and cowboys in Happy Canyon's arena met with enthusiastic crowds, becoming a successful attraction at Round-Up week.

Randy Bernard, the PBR coordinator in 1999, helped the committee of Round-Up and Happy Canyon directors set a budget and start the tradition. He had the idea to host a sponsor dinner, and his wise suggestions for announcers and clowns were met with hearty approval.

Opposite, top: The 1988 Happy Canyon princesses Rita Allman (second from left) and Ethel Jackson (second from right) with Oak Ridge Boys. *Happy Canyon Collection.*

Opposite, bottom: *From left to right*: Bonnie Sager, Charlie Daniels and Scott Sager. *Happy Canyon Collection.*

Below: The arena is ready for the first PBR bull to buck out. *Eye of Rie.*

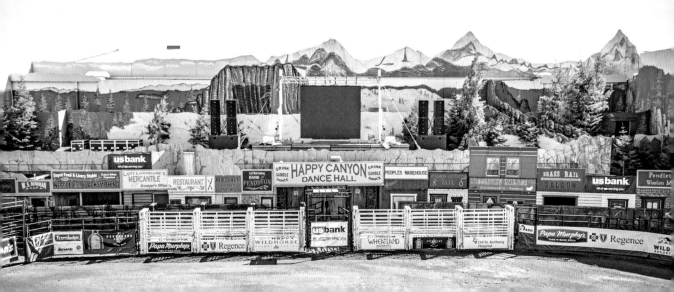

As the committee lined up stock contractors, one contractor, John Growney, felt that running the bulls back through the center of the bucking chutes and inside the convention center would create the best flow. The directors considered this option, but the idea of having the bulls run through the convention center seemed fraught with problems. Imagine the floor damage! Thus, the directors chose the current route through the Happy Canyon East Gate.

The first PBR was a rousing success, and the event quickly became one of the most popular new features in Happy Canyon week, though it took around one hundred volunteers to pull it off. As Round-Up and Happy Canyon coproduced this standalone event, splitting the net proceeds fifty-fifty, they knew it was a keeper.

More than three hundred PBR competitions exist nationwide, but Pendleton's Touring Pro Division PBR has one of the largest cash prizes, which is now around $50,000. Around fifty cowboys compete on two evenings, though the events are just one stop for the bull riders headed to the finals in Las Vegas.

Unlike most PBR venues, the Happy Canyon Arena is only forty feet wide, forcing bulls to buck immediately out of the chute. The small arena allows every seat a close view, drawing a sell-out crowd to the event each year.

"Pendleton is not just a normal, run-of-the-mill PBR event," Jay Daugherty, 2011 senior vice-president of competition, stated. "It's one of our largest purse events and it comes at the right time of the year for contestants to qualify for the World Finals. Pendleton is up there with the oldest and greatest rodeos out there, and it's an honor for us to be involved with them."[301]

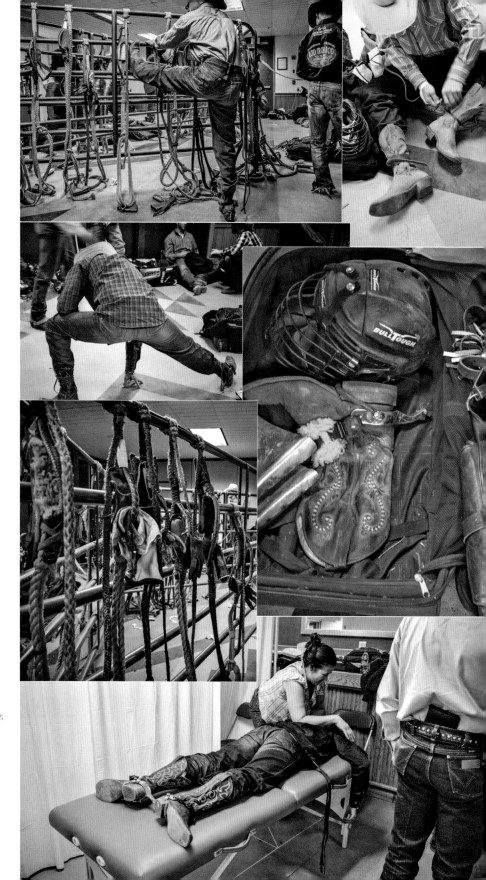

Opposite, top: The sold-out house greets Happy Canyon's intimate PBR venue. *Eye of Rie.*

Opposite: Flint Rasmussen preparing for his PBR performance, 2014. *Eye of Rie.*

This page: Behind the scenes in 2014 at the Round-Up/Happy Canyon PBR. *Eye of Rie.*

Twice, the U.S. Bank/Pendleton PBR Classic has won the PBR's Challenger Series "Venue of the Year" Award. The Pendleton event features the world's top bull riders and the sport's toughest, meanest bulls in a grueling two-day event.

The event has its own surprises. One year, one of the large bulls found himself completely submerged in the Happy Canyon pond. To the production crew's relief, he walked right up the ramp, and no one in the crowd even knew a bucking bull had just taken a swim. You never know what might happen at Happy Canyon!

Rising from the needs of a local Wild West show, a versatile venue came to Pendleton and the surrounding eastern Oregon communities, remaining an important facility in its current location. What once began as just four days of Happy Canyon is now for many of the volunteers, including the Happy Canyon Board of Directors, a weeklong festivity and the best holiday of the year.

Opposite, top: Cowboy Mike Lee from Decatur, Texas, stretches beside wife Dana and son Peter. *Eye of Rie.*

Opposite, bottom: The power of a cowboy prayer moment. *Eye of Rie.*

16
PRESERVING TRADITION AND
CHANGING THROUGH THE YEARS

Officials from other rodeos have come to Pendleton with a notion of copying our idea. But they are immediately discouraged. They can see how difficult it would be without resources we have in Pendleton. No other pageant has the natural setting the Happy Canyon arena has. And other shows don't have the cooperation of local Indians. The Indians from the Umatilla Reservation and from other reservations nearby, are just as proud of the pageant as the white people.

This is a tradition, and many people come back year after year to see the same pageant, exactly as it has always been presented. They'd resent any major changes.
—Russ McKennon, former Happy Canyon president[302]

If Roy Raley, George Hartman and Lee Drake could see Happy Canyon today, would they recognize the show they envisioned?

When Roy Raley penned the first pageant in 1914, he could not have imagined the revered tradition it would become. The strength of the legacy Roy and Anna Minthorn Wannassay started is evident in how the story has matured while maintaining the heart of the creative team's vision. Actors' faces have changed, though they remain mostly local, but at least six generations of volunteers have participated since the pageant's beginning.

This is Happy Canyon's story: springing into life almost overnight and continuing strong one hundred years later. Happy Canyon has seen changes in the last century. Growing from a "Wild West show" where crowds participated in dancing and gaming, it has become—among many things—an unequaled Indian pageant. Current show directors endeavor to maintain the script's integrity and the tradition that is its

strength while also adding innovative changes to enhance entertainment value.

In his later years, Roy penned an undated diary entry, detailing his heart, motivation and key elements as he and Anna wrote the Happy Canyon script.

Roy Raley's undated diary entry on Happy Canyon:

There are certain fundamentals on the production of a pageant that should always be kept in mind. They apply with particular force to Happy Canyon:

Keep it in the picture. Happy Canyon portrays the settlement of the country roughly from the frontier of 1850 to 1880. To keep it accurate all costumes, scenery, equipment and action should be confined to such as might have *been used or* might have *happened during this period.*

This is the time of:

1. The Indian

2. The Emigrants

3. The Frontier town

Which are the features used in Happy Canyon.

Things to do:

Always keep it in the picture,

Keep it symbolical,

Tie it together,

Make it march,

Make it snappy,

Play it straight,

Make each episode a production number,

Be faithful to detail,

"Nothing is too much trouble", and

Don't try to run around the bases twice.[303]

Even when he wrote the diary, Roy felt the show would survive. Though it is undated, we know it was written in his later years, as it mentions people and events in the 1940s.

WHY SHOULD YOU SEE THE SHOW?

Happy Canyon is full of local history and the truth is you never know what will happen at Happy Canyon!

Just recently, after the pheasants were released, one haphazard rooster decided to land on a patron's lap—right in the middle of the show.

The Chinamen once mixed up their buckets of water and confetti, giving the front row of patrons an actual and unexpected bath. These surprises directly contradict the fallacy sometimes heard regarding Happy Canyon, "If you have seen it once, you don't need to see it again."

As volunteer Patti Baker said, "It is not the same show every night. You have all these individuals with minimal rehearsals. There is livestock involved. It all adds up to not the same show."[304]

A collection of show photos from over the years. *Howdyshell Collection.*

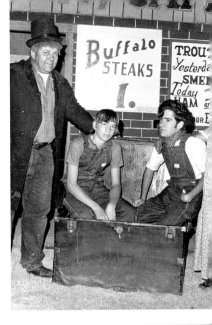
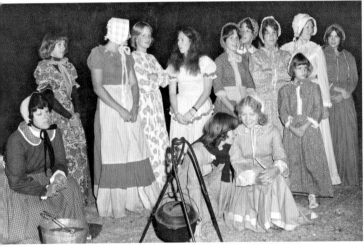
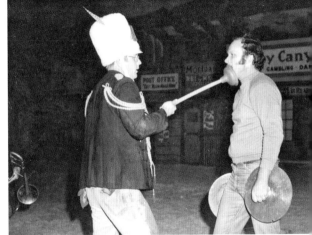
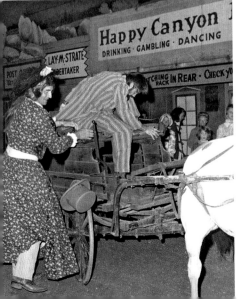
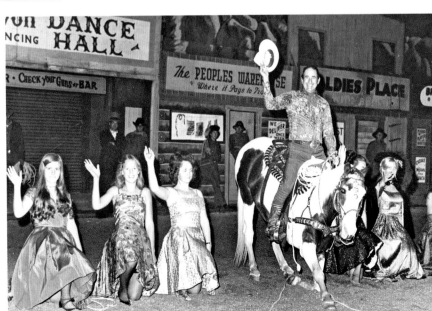

CHALLENGES AND CHANGES

The cue cards from the past one hundred years provide an overview of the changes, obsolete acts and newer improvements. They are a study in an evolving script.

The show no longer features the horse jumping into the pool, the Spanish dancer, the dance of the fairies and the steer bulldogging. It also uses fewer horse parts since fewer people learn to ride and currently does not have a deer or elk.

One of the biggest challenges the Happy Canyon faces, however, is the lack of practice time.

With the kickoff concert and two full PBR performances, the only available time for a full cast, animal and crew rehearsal is Friday evening, before the Dress-Up Parade on Saturday. Although the added events to Happy Canyon week are well attended, they add a significant challenge to the Happy Canyon pageant, especially when some of the key cast are not in town until later in Round-Up week.

Apparently, the lack of practice has been a century-old issue. When the *East Oregonian* described the first performance in 1915, it said: "The show last night was little more than a rehearsal for the next three nights, *for all the stunts were put on without any practice.* Everything ran smoothly, however, and went merry as a marriage bell."[305]

Interestingly, the first performances in the 1955 show location used "slides" on the side of the scenery to further explain the pageant. However, since they were hard to see, they were not successful.

In 2000, the Happy Canyon board aimed to revitalize the show. During their changes, they removed the "Indian Love Call," which was not historically accurate in eastern Oregon. The board also sought outside advice from other show producers.

The same year, after studying the show in Pendleton for a week, Linda Stein, a director and producer from Florida, decided the show was good but very dated. She suggested adding narration and rewriting some of the music.

As a result, the 2001 Board of Directors hired Katharine (Kate) S. Brighton, a writer and theatrical director, to revise the eighty-seven-year-old pageant. Kate had worked locally with Pendleton's Salvation Army and always loved Happy Canyon.

Kate rewrote the script, significantly changing the sequences created by Roy Raley and Anna Minthorn Wannassay. She added more speaking parts and political correctness.

Kate told the *East Oregonian*, "[I] worked desperately to keep all of the traditional roles, but I have tied them together with a real, thematic plot line, creating a scripted story with real dialogue."

Elaine Miles, a *Northern Exposure* star, participated in this new script along with Native American flutist Tdom Bah Toden Kenee, alias Gio DeCarlo.

"It is no longer a pageant," Kate said. "It is now a scripted story with real dialogue."[306]

The new show received mixed reviews. Its biggest challenges were logistics, sound and length, but it was also not the Happy Canyon the community knew.

The 2002 show director looked afresh at the script, evaluating what was working and what needed updating, as well as reviewing the original scripts written by Roy and Anna,

Left: A 1932 Happy Canyon cue card, front and back. *Author file.*

Right: A 1939 Happy Canyon cue card, front and back. *Author file.*

dating back to 1922. Also, Roberta Conner, Marjorie Waheneka and Steve Corey expanded the narration during the Indian and pioneer portions, which helped add depth and clarity to the show action—an important element for first-time viewers.

Before the narration was added, the silhouette provided the storyline, interpreting the pageant for the viewer by symbolically displaying Indian life, the coming of the white man and laying the war bonnet to rest. Today's electronic age requires more explanation.

SPECIALTY ACTS

Since the show's establishment, specialty acts have helped keep the performances fresh.

In 1916, professional pool divers were a huge show draw, coming from Portland to perform in the newly dug "pool" on the set. The next year, the show featured trained live bears.

By the 1920s and 1930s, show directors commonly received several inquiries a year from acts offering their "specialties"—from trick ropers and riders to vocalists and trained animals.

As a result, in its one hundred years, Happy Canyon can boast of a variety of specialty acts. From the world-renowned Montie Montana to the recent Bobby Kerr Mustang acts, these acts have added variety and attraction to the show.

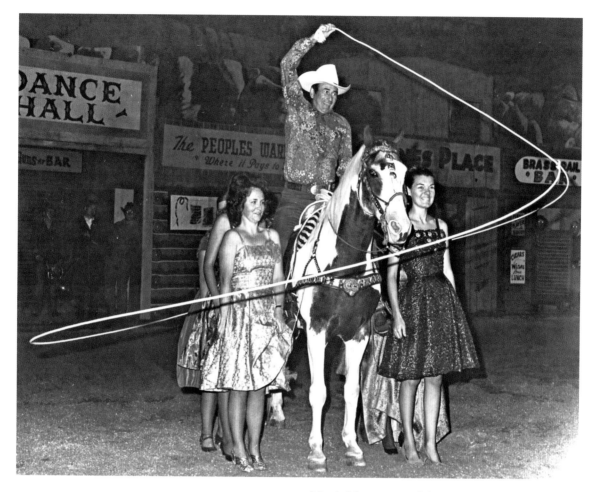

Montie Montana, a well-loved Happy Canyon specialty act. *Howdyshell Collection.*

Montie Montana: these two words describe a beloved specialty act. Montie loved Happy Canyon and performed numerous times in the show, beginning in 1927 at the age of seventeen.

The last time he roped in the Happy Canyon Arena in 1997, he was eighty-seven years old and received a standing ovation. He said he never tired of coming to Pendleton.

"Horses are my work, and horses are my hobby," Montie said. "It's my life and it sure beats working for a living."[307]

Montie served as grand marshal of the Westward Ho! Parade in 1975 and was inducted into the Round-Up and Happy Canyon Hall of Fame in 1980, receiving honor for his dedication and entertainment in both organizations.[308]

Through the years, several other standout acts happily performed in Happy Canyon.

One of the crowd favorites in the 1960s was C.D. Ferguson and his cowboy monkeys, who rode sheep dogs. This type of act actually started in Pendleton with Ferguson's troupe, Calamity Joe and Jane, who rode real western saddles astride the border collie duo of Trail Master and San Sam.

In 1964, Jimmy Murphy of Wisner, Nebraska, performed a Roman ride (racing with one foot on each horse's back) through fire with two white stallions. He also premiered his dog act at Happy Canyon with six white Dalmatians. Jimmy had performed for several television shows, including the Roy Rogers series, and was hired for several movies.

George Taylor, a trained trick roper, arrived to perform from 1963 through 1965. As a specialty act, he brought a coyote and deer that he had trained especially for Happy Canyon. During the bank robbery act, Taylor roped one of the bandits and dragged him out.

Taylor told the *East Oregonian* that Happy Canyon was "his favorite of all the shows he has appeared in," though he toured from Canada to Mexico. He even had shirts made for himself that said, "Happy Canyon—Pendleton Round-Up."[309]

The Budweiser Clydesdales appeared in the show as early as 1965 and have made numerous appearances over the years. Their performance in the forty-foot-wide intimate arena is a crowd pleaser, but it is also tricky. One year, the team's handlers misjudged the turn and ran the heavy wagon up on the boardwalk—much to the show director's surprise.

The show's ninetieth anniversary featured the Kiesner family's trick roping and riding. Their son Rider jumped through his twirling rope and his only brother, Roper, performed

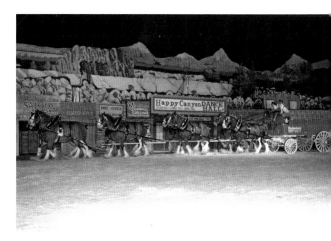

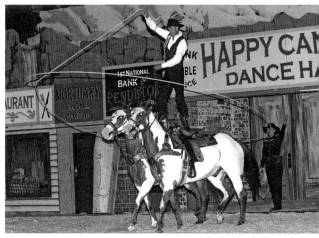

Top: The Budweiser Clydesdales have appeared in the show several times. *Don Cresswell.*

Above: Vince Bruce, trick roper and Roman rider. *Don Cresswell.*

single and double jumps over barriers while Roman riding. The family, including parents Phillip and Julie, have performed all over the nation.

In the 2005 show, eight Samurai warriors from Haramachi City, Japan, appeared in the

opening performance. The warriors entered the arena in traditional Japanese dress on borrowed horses, playing traditional shell instruments, which produced a haunting sound once used to signal other warriors.

Unfortunately, when one of the horses spooked, a warrior fell and broke his one-hundred-year-old shell beyond repair.

The 2007 through 2008 shows featured the Riata Ranch Cowboy Girls Western Performance Team, led by Jennifer Welch Nicholson and joined by Niki Flundra Cammaert of the Calgary Stampede. Together, the girls performed trick roping and riding. They were a Happy Canyon crowd favorite.

THE CAST ADDS SPONTANEITY

The cast itself is full of surprises. On Saturday evenings, acts often change as practical jokes occur all over the set. These pranks have caused lasting changes in the script, and some have entertained the audience even as they surprised cast members.

For years, the Henry act featured a poor pregnant woman finding her husband leaving

Opposite: Bobby Kerr and his rescued and trained mustang in the 2015 show. *Eye of Rie.*

Below: Stuntman Eric Michael Johnson added an unexpected fire act to the 2013 show. *Harper Jones II.*

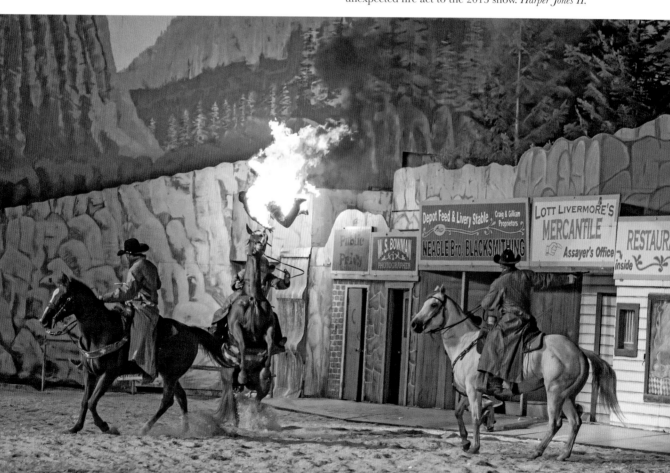

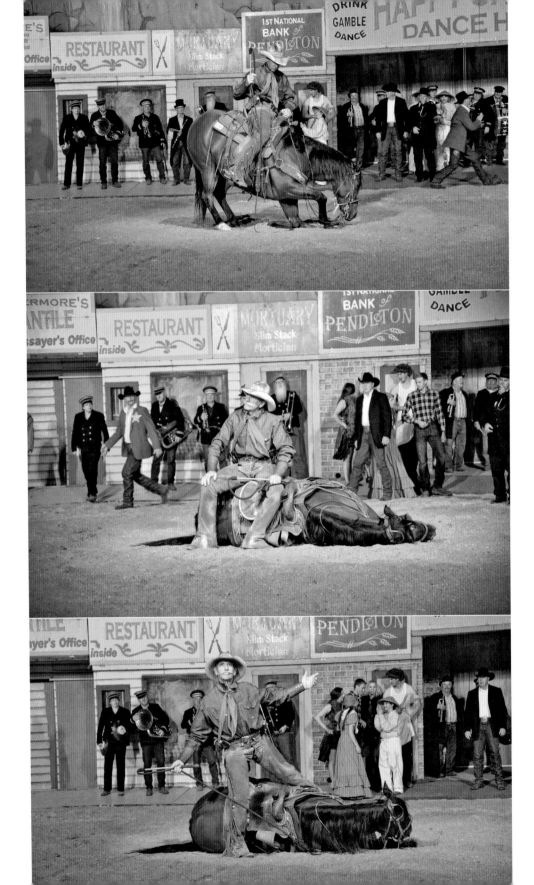

Goldies in his long red underwear. After his wife beats him across the arena with her broom, Henry dives into the pond—never to be seen again.

One Saturday evening performance, Mellissa Joseph and Trudy Bigsby concocted a plan to have another pregnant woman appear, making two pregnant wives beat Henry into the pond. They thought this would be a great trick and the "change" has continued ever since.

This prank is a perfect example of how the cast's amusing Saturday-night additions often stick.

"There are always surprises whether it's new acts or whether it's goof ups," said Bob Critchlow, show director.[310]

STEREOTYPES AND CLICHÉS

Over the years, reporters have at times described the show as full of stereotypes and clichés. Richard Cockle for the *Oregonian* said, "The Pendleton Round-Up's Happy Canyon Indian Pageant fairly drips with clichés and racial and cultural stereotypes—and it's likely to stay that way, even with an attempt to modernize it."[311]

"The history is real," former show director Fritz Hill said. "We have a great Native American culture, a cowboy culture, the livestock and the descendants of this area. The urban population is hungry to reach out and touch the Old West and we have it all. We are unique."[312]

As J.J. Spriet, 2015 Happy Canyon board director, said:

Happy Canyon is important for the future because it maintains a link to our past in so many ways. The time we live in now is so busy and fast paced, it's easy to forget where we came from. Happy Canyon is so rare and special that it should be treasured for years to come. Future generations need to have a place to connect with one another that isn't over a screen and a Wi-Fi connection.[313]

How do you "modernize" history? The uniqueness of this show belongs to the local facts Roy, Anna and the early directors drew from, which were lived out right before their eyes. Instead of stereotypes and clichés, Roy and Anna sketched the beauty of history into a century-old show. Thus, Pendleton has a national treasure in its backyard.

"Altering the pageant—a sometimes tragic, often comedic depiction of frontier Northwest life—isn't about political correctness," tribal member Thomas Morning Owl said. "Tribal life was not PC. This ain't California; we are the West. We have our differences, and we take pride in them, at times. You can leave your PC at home."[314]

Joseph Frazier of the Associated Press said the show "includes some turn-of-the-century stereotypes. Yet hundreds of tribal volunteers participate in roles that are handed down from one generation to the next, and a narrative has been added that outlines the disease, injustices and land-grab treaties that ended the tribal ways of life."[315]

As former director Doug Corey said, "The show depicts history. It has nothing to do with the present day and age."[316]

The Golden Thread: The Volunteers

Happy Canyon's one-hundred-year success comes from its volunteers. The men who bravely dove into a new Pendleton community venture in 1914 would look at this one-hundred-year-old show with pride, knowing the volunteers have continued the tradition and festivities in strength.

From the first Indians who envisioned retelling their important story to the first actors, carpenters and card dealers, volunteers crafted a gem called Happy Canyon.

The show features an average of around five hundred volunteers—many of whom have family ties or roles their grandparents or great-grandparents once played.

Year after year, the volunteer cards (or now e-mails) are sent back in by people willing to donate most of their Round-Up week evenings to produce the show and the following entertainment, ensuring the Pendleton Round-Up night crowd has a wonderful experience.

Families continue this golden thread of volunteering as they pass down parts and the love of show to the next generation. Several families consider their involvement in Happy Canyon as part of their family's own legacy.

Fourth-generation actors Kate and Grace Hill are descendants of both the Hill and Sturgis families. *Eye of Rie.*

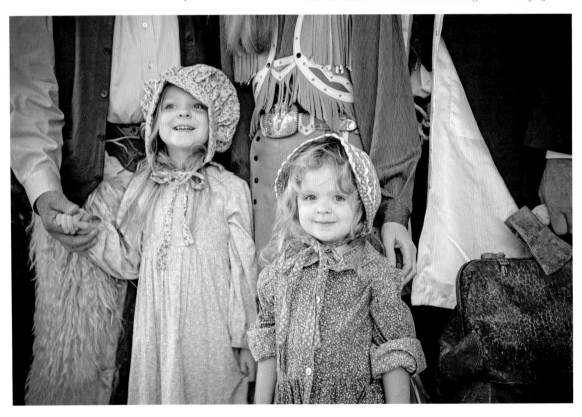

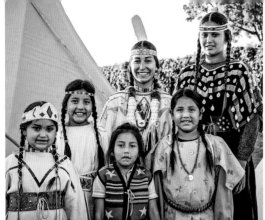

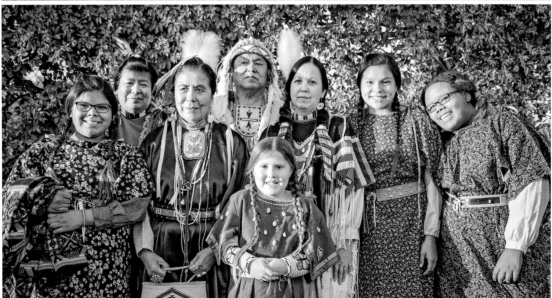

Also, Pendleton is known throughout Oregon as a place where volunteerism is celebrated.

Generation to generation, the parts continue. Today's warriors once took part in the show as toddlers or babies on boards. Where you once watched a swim kid, in just a few years, a cavalry officer or fireman appears.

In fact, many of today's Happy Canyon participants share how they were "volunteered" as a child to make an acting "debut" as the one-month-old baby in the trunk scene or a similar role. The "passing of the acting part" is a century-old gift to the show.

"The strength of Happy Canyon is the longevity of volunteers and the traditional commitment of generations," stated Allen Waggoner, past show director and president.[317]

The list is long and the names are many of those who have dedicated themselves to the one-hundred-year Happy Canyon legacy. Several families, both Indian and non-Indian, have continued the deep tradition of role-passing and volunteer pride through generations.

The relationships among the cast weave this golden thread together. With one hundred years of history in the books, several longtime cast members grew up together in the show. Robin Fletcher Jr. and Jesse Jones Jr. remember playing together as children in the old Happy Canyon set. Later, they acted in the Peace Pipe and Lewis and Clark scenes. Always looking forward to catching up from the year before, these old friends shared the love of Happy Canyon as their fathers did before them.[318]

The outstanding performers through the years are too numerous to mention, but each family can sense the ancestry as they reenact life as it existed for hundreds of years. For most, the show is a gathering or a "family homecoming." The entire cast—Indian and non-Indian—comes together year after year to form the Happy Canyon family. Ultimately, Happy Canyon is a story of people, hard work, tradition and pride—a formula that makes the show go on.

Jason Hill, 2015 Happy Canyon president, said:

Happy Canyon has always meant family to me, but really it also means history. We have been around for one hundred years, and whether or not you agree with how accurate our storyline is, our show has become history

Above: Cydney Corey Curtis holds two-day-old Collins, premiering in her first show in 2014. Collins is a fourth-generation "volunteer." *Cydney Curtis.*

Opposite: Multigenerational Happy Canyon families. *Top, left*: Dicks; *right*: Hodgen/Duffs; *middle*: Olsen/Corey; *bottom*: Burke family. *Eye of Rie.*

because of its longevity. No other outdoor show in the United States has reached this milestone. This is important for the show but also for Pendleton, the state of Oregon and all of the cast members who have made this possible with their dedication and support. To me, this is why everyone comes back to do it "one more year." It has become a piece of significant Pendleton history. It is something that should be preserved for future generations to be able to see.[319]

Bill Shaw and many other pageant actors have stated that if the entire show moved to New York City, it would sell out Madison Square Garden every night. It is the only show of its kind in America—started by local people, run by volunteers and continued in strength for over one hundred years. Whatever their reason for writing the Happy Canyon pageant, Roy Raley and Anna Wannassay Minthorn helped create a way of life.

Happy Canyon is "organized chaos" for those who step into the backstage area and watch the cast, wagons and livestock awaiting their cues. For cast members, though, it is a fluid dance of pieces and parts coming together, reenacting the eastern Oregon heritage after only a few yearly rehearsals.

New performers, new horses and new babies continue to join the show, and to date, six generations have grown (and continue to grow) up in it. Nevertheless, the atmosphere is the same as when the first group of actors performed on Main Street in downtown Pendleton over a century ago, celebrating the real West.

Despite new interpretations of the script, new acts and dropped scenes, Roy and Anna would probably still recognize much of Happy

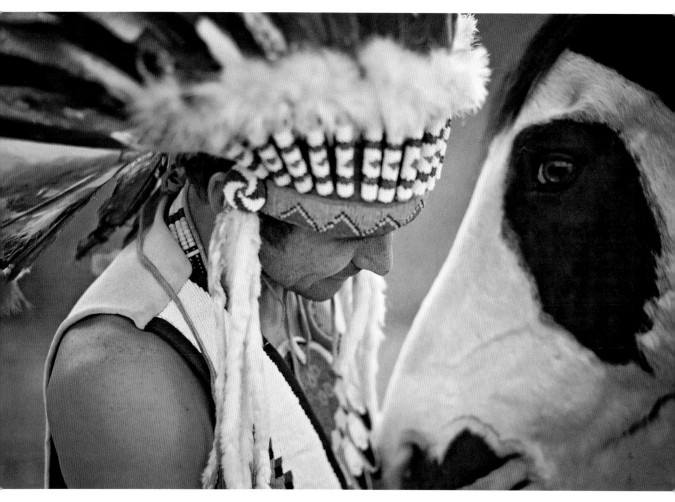

Canyon and the script they wrote one hundred years ago. The cast continues to add spontaneity, special acts appear for the show and true history is told in a western Brigadoon—a yearly wonder that the Pendleton Commercial Club in 1914 named Happy Canyon—what better title to describe a century-old community event?

The Old West is gone but with historic pageantry displayed once a year in a dedicated arena, it is easy to return to the frontier for a little while at least. Roy and Anna would smile to hear that the tradition of family involvement still exists. The scenery change is still in

Above: Bryson Bronson and Chinook, 2015. *Shana Bailey.*

Opposite, top: Jenny and Michael Corey with fifth-generation actor Ellie Corey between them. *Eye of Rie.*

Opposite, bottom: Kamia Dick is the sixth generation of her family to grow up acting in the show. *Eye of Rie.*

operation, the pool is still a fixture for a diving girl and an Indian brave, the pine trees are still faithfully cut in their beloved Blue Mountains and the orchestra is still playing.

And now, on with the show!

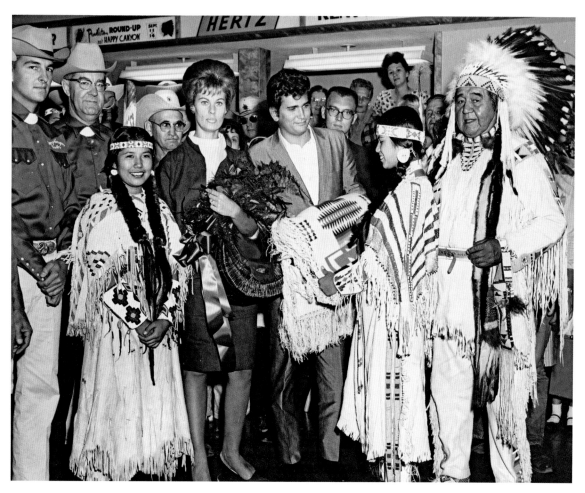

Hall of Fame recipient Chief Clarence Burke (far right), Happy Canyon princesses and board greeting Michael Landon (third from right). *Umatilla County Historical Society.*

APPENDIX A

HALL OF FAME PAST INDUCTEES

Clarence Burke	1969		E.N. "Pink" Boylen	1972
Lee Caldwell	1969		Jackson Sundown	1972
Yakima Canutt	1969			
Henry Collins	1969		Tim Bernhard	1973
George Fletcher	1969		John Hales	1973
Roy Raley	1969		Melissa Parr	1973
Gene Rambo	1969			
George Strand	1969		Bob Crosby	1974
Til Taylor	1969		Bill Switzler	1974
Herb Thompson	1969			
			Elsie Fitzmaurice Dickson	1975
Carl Arnold	1970		Shoat Webster	1975
Faye LeGrow	1970			
			Dr. Joseph Brennan	1976
Philip Bill	1971		Berkley Davis	1976
Allen Drumheller	1971			
Pete Knight	1971		Eliza Bill	1977
Lawrence Lieuallen	1971		Marion Hansell	1977
Hugo Strickland	1971		Lew W. Minor	1977
Mabel Strickland	1971			
			Monk Carden	1978
			George Moens	1978

Finis Kirkpatrick	1979	J. David Hamley	1992
		J.J. Hamley	1992
Montie Montana	1980	Lester H. Hamley	1992
		Don McLaughlin	1992
Ike Rude	1981	William Minthorn	1992
Harley Tucker	1981	Bill Severe	1992
		Duff Severe	1992
Chauncey Bishop	1982		
Clarence Bishop	1982	Floyd "Bus" Howdyshell	1993
Roy Bishop	1982	Leonard King	1993
Dan Bell	1983	John Dalton	1994
George Doak	1983	Herman Rosenberg	1994
Karl Doering	1983		
		Bertha Kapernik Blancett	1995
Clark McEntire	1984	Bob Hawkins	1995
Art Motanic	1984	Don Hawkins	1995
		Wray Hawkins	1995
Everett Bowman	1985	Everett Shaw	1995
Bob Fletcher	1985		
		Jennifer Currin	1996
Pat Folsom	1986	Judy Currin	1996
Sid Seale	1986	Mike Currin	1996
		Ron Jr. Currin	1996
Ella Lazinka Ganger	1987	Ron Sr. Currin	1996
Bob Hales	1987	Steve Currin	1996
		Tony Currin	1996
Bob Christensen	1988	Dean Oliver	1996
Mildred Searcy	1988	Tom Simonton	1996
Bob Chambers	1989	Lawrence G. Frazier	1997
Jack Duff	1989	Billie Hindman	
		(Elgin Stagecoach Team)	1997
Doris Swayze Bounds	1990	Odie Payne	
Verne Terjeson	1990	(Elgin Stagecoach Team)	1997
		Jim Rosenberg	1997
Gerald Swaggart	1991	Dick Truitt	1997
Tessie Williams	1991	Sonny Weatherspoon	
		(Elgin Stagecoach Team)	1997

Bob and Betty Byer	1998		C.W. "Mort" Bishop	2007
Larry Mahan	1998		Jiggs Fisk	2007
Harry Vold	1998		Philip Lyne	2007
Main Street Cowboys	1999		Christian "Sonny" Davis	2008
Beryl Grilley	1999		Fred W. Hill	2008
Jim Shoulders	1999		Bonnie Tucker	2008
Beauregard (the elk)	2000		Deb Copenhaver	2009
Paul Cimmiyotti	2000		Ollie Osborn	2009
Bill McMacken	2000		Willie Wocatsie	2009
McKinley and Susie Williams	2000			
			Roy Cooper	2010
Robin Wesley (R.W.) Fletcher	2001		Tom Currin	2010
Bonnie McCarroll	2001		Mac McCormack	2010
Esther Motanic	2001		King Merritt	2010
Jack Sweek	2001			
			Wes Grilley	2011
Guy Allen	2002		Flint Rasmussen	2011
Frank Tubbs	2002		John Spain	2011
			Kenny Stanton	2011
Raymond "Popcorn" Burke	2003			
Pat Gugin	2003		Frank Leo McCarroll	2012
Wallace Smith	2003		Gilbert Minthorn,	
			(First Round-Up Chiefs)	2012
Jesse Jones Jr	2004		Caroline Motanic	2012
Dr. Richard Koch	2004		No Shirt	
Casey Tibbs	2004		(First Round-Up Chiefs)	2012
			Poker Jim	
Walt Arnold	2005		(First Round-Up Chiefs)	2012
Cataldo	2005		Amos Pond	
Ron J. Hudson	2005		(First Round-Up Chiefs)	2012
William G. "Wilbur" Shaw	2005		George Richmond	2012
Harry Charters	2006		Mike Beers	2013
Marie and Louie Dick	2006		Betty Branstetter	2013
Jack Hodgen	2006		Echo "Magic"	2013
Slim Pickens	2006			

Clint Corey	2014
Robin A. Fletcher Jr.	2014
Fritz Hill	2014
Gary Rempel	2014
Cecelia Charley Bearchum	2015
Lewis Feild	2015
Leo Moomaw	2015

APPENDIX B
ROUND-UP CHIEFS AND
PROMINENT TRIBAL HEADMEN

1910–43 Gilbert Minthorn, Cayuse, Indian organizer at 1910 Round-Up; participated until his death.

1911–36 Poker Jim, Walla Walla; Round-Up chief until his death.

1911–26 Cap Sumkin, Cayuse; led Westward Ho! Parade every year.

1911–60s Tribal headmen participating in Round-Up: Jim Badroads, Cayuse; Amos Pond, Umatilla; Jim Kanine, Walla Walla; Allen Patawa, Cayuse; Paul Showaway, Umatilla; George Red Hawk, Cayuse; Sam Morris, Nez Perce; Johnson Chapman, Cayuse; Uma Sumkin, Cayuse; John Abraham, Walla Walla; Fred Dixon, Cayuse; Leo Sampson, Walla Walla; Tom and Phillip Shillal, Umatilla; Charlie Whirlwind, Cayuse; George Spino, Umatilla; Tom Johnson, Cayuse; Harry Dick, Cayuse; Mitchell Lloyd, Umatilla; Henry White, Umatilla; Anthony Red Hawk, Cayuse; Andrew Barnhart, Umatilla; John Moses, Nez Perce; Tom Joe, Umatilla.

1936–87 Clarence Burke, Walla Walla; became Round-Up cochief, succeeding his father, Poker Jim.

1936–50 Willie Wocatsie, Walla Walla; became Round-Up cochief with Clarence Burke.

1952–54	Luke Cowapoo succeeded Willie Wocatsie as cochief.
1954–58	William Oregon Jones succeeded Luke Cowapoo as Round-Up cochief.
1958–65	Jesse Jones Sr. succeeded William O. Jones as Round-Up cochief.
1978–84	William Minthorn, a.k.a. Cayuse chief Blackhawk, joined Clarence Burke as co-chief.
1983–2006	Raymond Burke named a Round-Up cochief.
1988–present	William Burke and Jesse Jones Jr. named Round-Up cochiefs.
1990	Carl Sampson named chief of the Walla Walla.
2007	Gary Burke, son of Raymond, assumed his father's role as Round-Up cochief.

APPENDIX C
HAPPY CANYON
APPRECIATION AWARDS

The volunteers of Happy Canyon are the backbone of this one-hundred-year-old production. Since 1982, the Happy Canyon Board of Directors has chosen and recognized individuals who have provided outstanding service to the success of Happy Canyon. The creation of this award was the idea of Robert Schuening.

1982

Clarence Burke
Ted Johnson
Bill Minthorn
Tom Simonton
Bud Wishart

1983

Mrs. Doris Bounds
Mrs. Ruth Fletcher

1984

Art Motanic
Dr. Manny Silk

1985

Bill Fletcher
Joanne Pedro

1986

Jack Brown
Mrs. Beryl Grilley

1987

Mike Cappiello
Tessie Williams

1988

Mel Peterson
Elmer "Peanuts" Pozegar

1989

Monk Carden
John Nooy

1990

Ellen Cowapoo
Dave Hamley

1991

Dr. Jules Bittner
Jessie Jones Jr.

1992

Rusty Black
Raymond T. Burke

1993

Emma Farrow
Jim Hill

1994

Leah Conner
Billie Hindman
Odie Payne

1995

Fermore Craig
Tom Hayward

1996

Betty Branstetter
Sheila Pond

1997

Marie Dick
George McClendon

1998

Velma Burke
Verneda Wagner

1999

Bob Forth
Gale Wagner

2000

Viva Bill

2001

Bill Birdsell
Louie Dick

2002

Cecelia Bearchum
Fred Licurse

2003

Caroline Motanic Davis
Tommie Ruth Temple

2004

Calvin Ashbeck
Janie Pond

2005

Jim Loiland
Manny Williams

2006

Ken Long
Elwood Patawa

2007

Brad Stevens
Sharon Weathers

2008

Mary Lou Fletcher
Dr. Ronald Pond

2009

Lance Dick
Dennis Zimmerman
Gary Zimmerman
Jeff Zimmerman
Wally Zimmerman

2010

Greg Duchek
Marjorie Waheneka

2011

Mike Herbes
Toni Minthorn

2012

Dallas Dick
Pat Smalling

2013

Chief Gary Burke
Mary Finney

2014

Tom Baker
Roberta Conner

2015

T.C. Conner
Bruce Reynolds

APPENDIX D
CURRENT HAPPY CANYON BOARD OF DIRECTORS AND ORCHESTRA MEMBERS

Board of Directors

President: Jerrod Spriet
Harper Jones II
Ryan DeGrofft
Corey Neistadt
Kelsy Garton
Tanner Hawkins
Rick Baltzor
Cory Williams
Clay Briscoe
Kenzie Hansell
Johnny Pimentel
Kipp Curtis

ORCHESTRA MEMBERS

Conductor: Andy Cary

Woodwinds

Flute	Miquel Gomez
Oboe	Andrew Carder
Clarinet	Jim Straughan
	Elburn Cooper
	David Christensen
	John Weddle
Alto Sax	Paul Dunsmoor
Tenor Sax	Keith VanVickle

Brass

Trumpet	James Smock
	Garen Horgen
	Trevor Wilson
	Bill Shank
Horn	Jon Owen
	Rebekah Schaub
Trombone	Brian Addison
	Daren Dutto
Euphonium	Eric Cutright
Tuba	Mervin Cutright
	Bob Swoboda

Percussion

Jerry Thompson
Nicole Wilson

APPENDIX E
PAST HAPPY CANYON DIRECTORS

Beginning with Roy Raley through the most recent board member, various community members have carried on the tradition and heritage of Happy Canyon by volunteering as director.

Roy Raley
George Hartman
Lee Drake
J.V. Tallman
Jim Sturgis
C.K. Cranston
W.E. Brock
C.O. Rinehart
M.R. Chessman
Ray Crystal
W.E. Brock
L.S. Bentley
Dr. M.S. Kern
Wes Matlock
W.L. Thompson
James Welch
Ed Schiller

L.C. Scharpf
Edgar Averill
Philo Rounds
Ryman Rice
John Murray
Tom Murphy
Finis Kirkpatrick
James Johns
R.H. Horne
Ray Hester
Lester Hamley
H.M. Hanavan
George C. Baer
Sprague H. Carter
Fred Donert
James Bowler
Glen Storie

Elmer Storie
E.C. Olson
Rudy Mcelner
Ralph Hassel
Will Glass
Art Anderson
J.J. Bauer
C.C. Clarkson
Bert Jerard
Dan Hobart
Fay Hodges
R.E. Chloupek
Leroy Davis
H.W. Dickerson
Ralph Schwalbe
Roy Pitner
Raley Peterson

Nat Kimball
John F. Kilkenny
Bill Freitag
Larry Jensen
Dave Jackson
Walt Holt
Gordon Hertz
Leo Goar
Homer Beale
R.L. Cresswell
Syd Laing
Jens Terjeson
Everett Stroble
Dr. William O. Stram
Bob Riddle
Raphael Raymond
Elmer Pahl
George Moens
Whitey Breaid
Ray Meyersick
Jack Luck
Jack Duff
Fred Carmical
Gail Fouts
Bob Cook
Don Buchanan
Mike Boylen
Bud Hall
Lester King
Lou Levy
Bill Wallen
Bob Rothrock
Gene Pierce
Bill Stickney
U.S. Peter Miller
Jay Graybeal
Bill Duff
George Corey

Emile Holeman
Russ McKennon
Mike Kilkenny
Tuk Hodgen
Bob Hawkins
Don Hawkins
Bob Fletcher Jr.
Bruce Boylen
Bill Morrison
Fred Witherell
Don Webb
Rich Terjeson
Jim Rosenberg
Gene Roden
Howard Phelps
Bob Fletcher Sr.
Roy Schuening
Bob Hawes
Rich Koch
Wray Hawkins
Joe Temple
Wes Grilley
Ron Terjeson
Ken Jackson
Ed Meyersick
Bob Mautz
Stan Timmermann
Bob Scheuning
Dennis Moffit
Bob Hale
Mark Rosenberg
Steve Corey
Brent Fife
Tim Hawkins
Fritz Hill
Bob Critchlow
Dave Schnebly
Robin Severe

Ron Stroble
Dick Huston
Jim Duff
Dennis Hunt
Bob Fetsch
Scott Sager
Bob Brown
Kelly Hawkins
Duane DeGrofft
Kirk Tullis
Larry Lorenzen
Chuck Jenson
Bob Blanc
Rod Pahl
Bob Burns
Cliff Bracher
Wayne Low
Terry McArtor
Matt Duchek
David Stuvland
Jack Matlock
Dave Blanc
Berk Davis
Doug Corey
Jim Naughton
Kevin Hale
Dave Gallaher
Andy VanderPlaat
Rob Burnside
Allen Waggoner
Chris Cockburn
Kevin Porter
Bob Rosselle
Michael Corey
Randy Perkins
Jason Hill

APPENDIX F

PAST HAPPY CANYON PRESIDENTS

Beginning with Joe Tallman, many men have led the Happy Canyon board over the last one hundred years. Though a volunteer position, this job entails running the meetings, giving guidance and setting the vision for that year.

Joe Tallman	Bill Duff	Jim Duff
James Sturgis	Don Buchanan	Dennis Hunt
James Johns	R.A. "Bob" Fletcher	Kelly Hawkins
L.C. Scharpf	Don Hawkins	Bob Blanc
Les Hamley	Russ McKennon	Wayne Low
Philo Rounds	Emile Holeman	Terry McArtor
Elmer Storie	Bill Morrison	Matt Duchek
John Murray	Mike Kilkenny	David Stuvland
John Kilkenny	Bob Hawes	Jack Matlock
Fay Hodges	Rich Koch	Doug Corey
Raley Peterson	Wes Grilley	Kevin Hale
Homer Beale	Stan Timmermann	Allen Waggoner
Syd Laing	Steve Corey	Chris Cockburn
Jack Duff	Mark Rosenberg	Bob Rosselle
Whitey Breaid	Tim Hawkins	Jason Hill

APPENDIX G

HAPPY CANYON PRINCESSES

Page 374: The 1955–72 Happy Canyon princesses. *Happy Canyon Collection.*

Page 375: The 1973–92 Happy Canyon princesses. *Happy Canyon Collection.*

Page 376: The 1992–2007 Happy Canyon princesses. *Happy Canyon Collection.*

Page 377: The 2008–16 Happy Canyon princesses. *Happy Canyon Collection.*

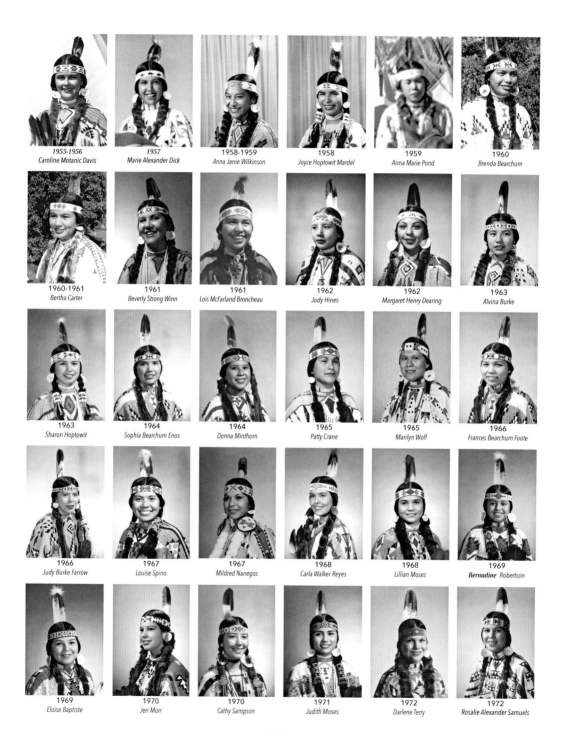

1955-1956
Caroline Motanic Davis

1957
Marie Alexander Dick

1958-1959
Anna Janie Wilkinson

1958
Joyce Hoptowit Mardel

1959
Anna Marie Pond

1960
Brenda Bearchum

1960-1961
Bertha Carter

1961
Beverly Strong Winn

1961
Lois McFarland Broncheau

1962
Judy Hines

1962
Margaret Henry Dearing

1963
Alvina Burke

1963
Sharon Hoptowit

1964
Sophia Bearchum Enos

1964
Donna Minthorn

1965
Patty Crane

1965
Marilyn Wolf

1966
Frances Bearchum Foote

1966
Judy Burke Farrow

1967
Louise Spino

1967
Mildred Nanegos

1968
Carla Walker Reyes

1968
Lillian Moses

1969
Bernadine Robertson

1969
Eloise Baptiste

1970
Jeri Murr

1970
Cathy Sampson

1971
Judith Moses

1972
Darlene Terry

1972
Rosalie Alexander Samuels

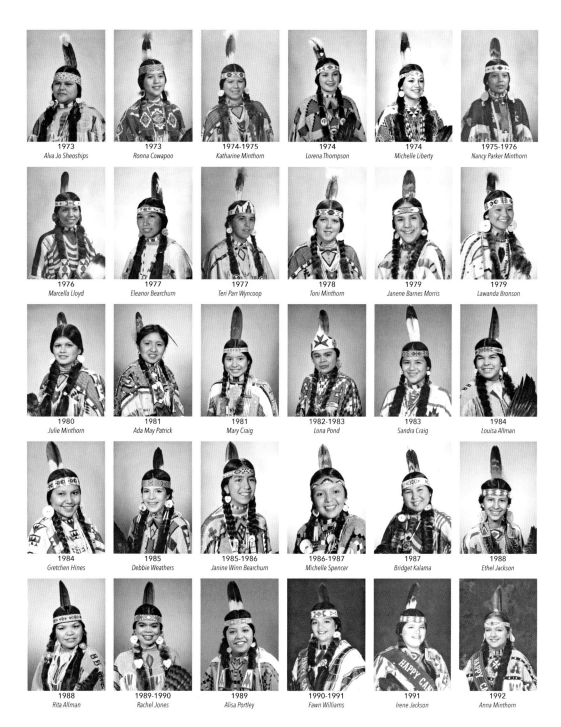

1973
Alva Jo Sheoships

1973
Ronna Cowapoo

1974-1975
Katharine Minthorn

1974
Lorena Thompson

1974
Michelle Liberty

1975-1976
Nancy Parker Minthorn

1976
Marcella Lloyd

1977
Eleanor Bearchum

1977
Teri Parr Wyncoop

1978
Toni Minthorn

1979
Janene Barnes Morris

1979
Lawanda Bronson

1980
Julie Minthorn

1981
Ada May Patrick

1981
Mary Craig

1982-1983
Lona Pond

1983
Sandra Craig

1984
Louisa Allman

1984
Gretchen Hines

1985
Debbie Weathers

1985-1986
Janine Winn Bearchum

1986-1987
Michelle Spencer

1987
Bridget Kalama

1988
Ethel Jackson

1988
Rita Allman

1989-1990
Rachel Jones

1989
Alisa Portley

1990-1991
Fawn Williams

1991
Irene Jackson

1992
Anna Minthorn

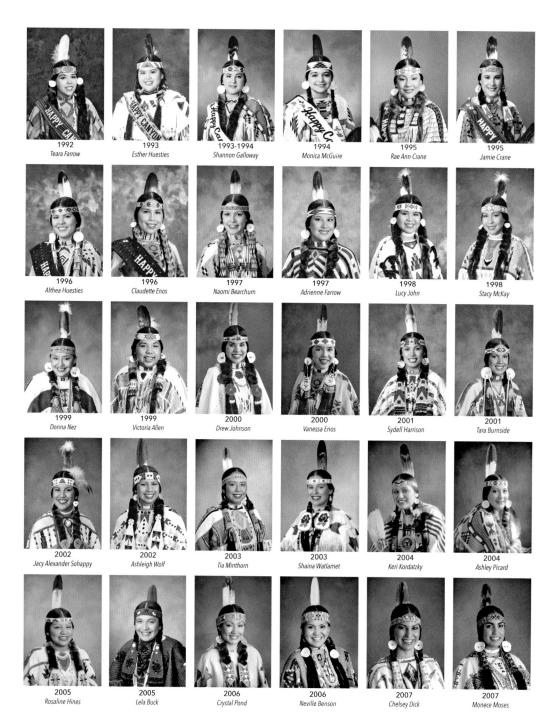

1992 Teara Farrow	1993 Esther Huesties	1993-1994 Shannon Galloway	1994 Monica McGuire	1995 Rae Ann Crane	1995 Jamie Crane
1996 Althea Huesties	1996 Claudette Enos	1997 Naomi Bearchum	1997 Adrienne Farrow	1998 Lucy John	1998 Stacy McKay
1999 Donna Nez	1999 Victoria Allen	2000 Drew Johnson	2000 Vanessa Enos	2001 Sydell Harrison	2001 Tara Burnside
2002 Jacy Alexander Sohappy	2002 Ashleigh Wolf	2003 Tia Minthorn	2003 Shaina Watlamet	2004 Keri Kordatzky	2004 Ashley Picard
2005 Rosaline Hines	2005 Lela Buck	2006 Crystal Pond	2006 Neville Benson	2007 Chelsey Dick	2007 Monece Moses

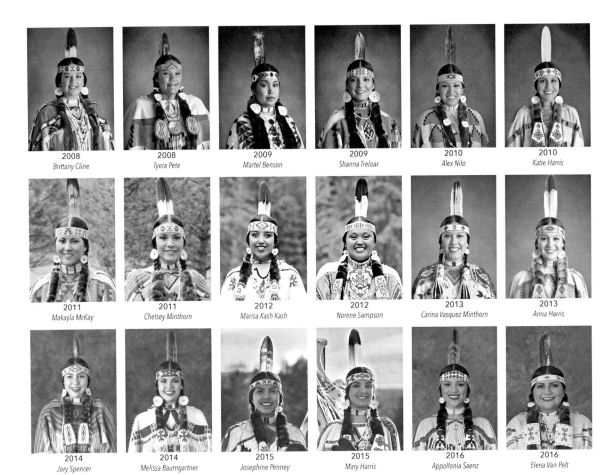

2008
Brittany Cline

2008
Tyera Pete

2009
Martel Benson

2009
Shanna Treloar

2010
Alex Nilo

2010
Katie Harris

2011
Makayla McKay

2011
Chelsey Minthorn

2012
Marisa Kash Kash

2012
Norene Sampson

2013
Carina Vasquez Minthorn

2013
Anna Harris

2014
Jory Spencer

2014
Melissa Baumgartner

2015
Josephine Penney

2015
Mary Harris

2016
Appollonia Saenz

2016
Elena Van Pelt

NOTES

Acknowledgements

1. Raley, letter to the Happy Canyon board, December 7, 1940.

Chapter 1

2. Furlong, *Let 'Er Buck*, 103.
3. Holaday, Hall of Fame article.
4. *East Oregonian*, September 9 1913, 1, 5.
5. Ibid., September 8, 1913, 1.
6. Ibid., September 11, 1954, 9.
7. Ibid., September 24, 1915, 19.
8. Ibid., September 2, 1914, 5.
9. Furlong, *Let 'Er Buck*, 103–04.
10. *Happy Canyon Program*, 2013, 13.
11. *East Oregonian*, August 28, 1931, 1.
12. Ibid., September 14, 1914.
13. The board of directors was called the Happy Canyon committee for the first two years, from 1914 to 1915. After incorporation in 1916, the organizers elected eleven board members, thus forming the first board.
14. *East Oregonian*, September 11, 1914, 1.
15. Ibid.
16. *East Oregonian*, November 19, 1954, 9.

17. Ibid., September 11, 1914, 5.
18. Ibid., September 18, 1914, 2.
19. Ibid., September 22, 1914, 1.
20. Ibid., September 23, 1914, 1.
21. Ibid., November 19, 1954, 9.
22. Ibid., September 24, 1914, 12.
23. Ibid., 1.
24. Ibid., 12.
25. Ibid.
26. *East Oregonian*, September 22, 1915, 1.
27. Ibid., September 23, 1915, 1.
28. Virginia Roberts, interview by the author, May 2015.
29. *East Oregonian*, September 23, 1915, 5.
30. Ibid., September 24, 1915, 1.
31. Ibid., September 23, 1915, 5.
32. Ibid., September 24, 1915, 5.
33. Ibid., September 22, 1915, 1.
34. Ibid.
35. Ibid., September 27, 1915, 1, 5.
36. Ibid.
37. Ibid.

Chapter 2

38. Ibid., February 24, 1956, 1.
39. Ibid., January 24, 1956, 1.
40. Scott Sager, interview by the author, July 2015.
41. Raley, Harlow Kellogg paper, 1.
42. Searcey, Happy Canyon paper, Hall of Fame Collection.
43. *East Oregonian*, September 16, 1926, 1.
44. Roy Raley, letter to Pendleton Commercial Association, December 6, 1928, author file.
45. Raley, Happy Canyon Agreement, December 7, 1940.
46. *East Oregonian*, June 29, 1951.
47. Ibid., September 7, 1956.
48. Ibid., February 24, 1956.
49. Ibid., September 20, 1917, 1, 4.

Chapter 3

50. Wes Grilley, letter to Happy Canyon cast, July 10, 1978, author file.

51. *East Oregonian*, August 2, 1916, 1.

52. Ibid., April 17, 1975, 5C.

53. Ibid., September 21, 1916, 1.

54. Ibid.

55. Ibid., September 20, 1916, 1.

56. Ibid.

57. Raley, undated diary.

58. *East Oregonian*, September 25, 1916, 1.

59. Ibid., September 19, 1917, 1.

60. Ibid., September 12, 1969, 3.

61. *Pendleton Evening Tribune*, September 19, 1918, 1.

62. *East Oregonian*, September 16, 1919, 1.

63. Ibid., September 21, 1921, 1.

64. *Happy Canyon Program*, 1996, 21.

65. *East Oregonian, Round-Up Edition*, September 12, 2001, 22.

66. Robin Fletcher Jr., interview with Chief Raymond Burke, April 1992, author file.

67. Walter Holt, letter to Happy Canyon board, July 31, 1944, author file.

68. *East Oregonian*, September 13, 1941, 1.

69. Macnab, *Century of News and People in the* East Oregonian, 267.

70. *East Oregonian*, August 24, 1950, 2.

71. Ibid., April 17, 1975, 5C.

72. Ibid., September 15, 1955, 1.

73. Ibid.

74. Ibid., November 19, 1954, 9.

Chapter 4

75. *East Oregonian, Round-Up Edition*, September 12, 1941, 1.

76. Happy Canyon Board of Directors Minutes, December 26, 1928.

77. *East Oregonian*, September 13, 1983, B2.

78. Price, *Nun-Mip-Ni-Sheek*, 42.

79. *Confederated Umatilla Journal*, September, 2009, 14.

80. The word *draw* refers to the low ground between two parallel ridges.

81. Furlong, *Let 'Er Buck*, 10.

82. Ibid.

83. *Confederated Umatilla Journal*, May, 2010, 35.

84. Marjorie Waheneka, interview by the author, May 2015.

85. *East Oregonian*, September 20, 1919, 9.

86. Ibid., September 9, 2006, 17–18.

87. "Nixyaawii Story."

88. *East Oregonian*, September 9, 2006, 17–18.

89. "Nixyaawii Story," 16.

90. *East Oregonian*, September 14, 1988, 10A.

91. *Confederated Umatilla Journal*, September, 2009, 14.

Chapter 5

92. *East Oregonian*, September 12, 1941, 1.

93. The Silhouette set comprises a backlit recess with a screen where an actor or pair of actors pose while the narration describes the next section of the pageant.

94. Cayuse is one of the three Indian languages of the local tribes and was mainly lost around 1940, as have most of the pure Cayuse people.

95. Official show welcome, as translated from Cayuse into English, author file.

96. Gary Burke, interview by the author, August 2015.

97. Conner, Waheneka and Corey, *Happy Canyon Pageant Narration*, 2002.

98. *Pioneer Trails* 6, no. 3 (Spring 1982): 5.

99. Fritz Hill, interview by the author, June 2015.

100. Conner, Waheneka and Corey, *Happy Canyon Pageant Narration*, 2002.

101. Ibid.

102. Ibid.

103. Conner, Waheneka and Corey, *Happy Canyon Pageant Narration*, 2002.

104. *Happy Canyon Program*, 1994, 20.

105. Bales and Hill, *Round-Up at 100*, 65.

106. Fermore Craig, interview by the author, September 2015.

107. *East Oregonian*, September 12, 1968, 1.

108. Ibid.

109. Ibid.

110. T.C. Conner, interview by Jason Hill, April 2015, author file.

111. Dorys Grover, interview by the author, September 2015.

112. Steve Corey, interview by the author, July 2015.

113. *Emigrant Routes Through Umatilla County*.

114. *East Oregonian*, November 19, 1954, 9.

115. Robin Fletcher Jr., interview by the author, December 2012.

116. *East Oregonian*, September 19, 1970, 4.

117. *East Oregonian*, September 12, 1978, C7.

118. Ibid.

119. Fritz Hill, interview.

120. Raley, undated diary.

121. T.C. Conner, interview by Jason Hill, April 2015, author file.

122. Conner, Waheneka and Corey, *Happy Canyon Pageant Narration*, 2002.

123. *East Oregonian*, September 18, 1965, 1.

124. Conner, Waheneka and Corey, *Happy Canyon Pageant Narration*, 2002.

125. *East Oregonian*, September 14, 1994, 14A.

126. Ibid., September 14, 1988, 10A.

127. Former Oregon senator Mark Hatfield, letter to Happy Canyon board, September 16, 1957, author file.

Chapter 6

128. *East Oregonian*, September 22, 1915, 1.

129. Ibid., September 9, 1980, C9.

130. Macnab, *Century of News and People in the* East Oregonian, 152.

131. Mildred Searcey, "The Pendleton Round-Up," Hall of Fame Collection.

132. Shelby McQuinn, e-mail interview by the author, June 2015.

133. *East Oregonian*, September 23, 1915, 5.

134. Jackie Culham, interview by the author, September 2015.

135. *East Oregonian*, December 24, 1968, 10.

136. Culham, interview.

137. R.A. Fletcher, interview by the author, September 1985.

138. *East Oregonian*, September 11, 1975, 1.

139. Bales and Hill, *Round-Up at 100*, 255.

140. Ann Terry Hill, contributing writer, April 2015.

Chapter 7

141. *East Oregonian*, September 9, 1975, p. E2.

142. Ibid., September 22, 1914, p. 8.

143. Happy Canyon papers, author file.

144. *East Oregonian*, September 25, 1914, 3.

145. Dorys Grover, letter to Robin Fletcher Jr., September 25, 1967, author file.

146. *East Oregonian*, September 12, 1969 p. 3.

147. Tom and Patti Baker, interview by the author, August 2015.

148. Dix Holoday, letter to show director Elmer Storie, 1930, author file.

149. *East Oregonian*, April 4, 1983.

150. Ingrid Thamert, interview by the author, September 2015.

151. Happy Canyon papers, author file.

152. *East Oregonian*, September 21, 1915, 1; November 19, 1954, 9.

153. Ken Long, interview by the author, June 2015.

154. R.A. Fletcher, interview.

155. Bob Forth, interview by the author, August 2015.

156. Danny Houle, e-mail interview by the author, December 2015.

157. *Happy Canyon Program*, 1997, 20.

Chapter 8

158. Furlong, *Let 'Er Buck*, 81.

159. Salt Lake City Costume Company's slogan was "We dress the big productions!" Established in 1889, the company recently closed in 2005.

160. Salt Lake City Costume Company, Costume Order from Happy Canyon, 1926, author file.

161. Contract with Salt Lake City Costume Company, August 6, 1930, and Happy Canyon Board of Directors notes, August 15, 1956.

162. *(Sunday) Oregonian*, August 22, 1937, 1.

163. *East Oregonian*, September 19, 1970, 4.

164. Kathy Burke, interview by the author, August 2015.

165. Richards, "Out where the Old West Lives On."

Chapter 9

166. Furlong, *Let 'Er Buck*, 105.

167. Raley, undated diary.

168. *East Oregonian*, September 11, 1914, 1.

169. May, *Pendleton*, 14–15.

170. *East Oregonian*, September 21, 1914, 1.

171. Ibid., 1.

172. Ibid., September 24, 1914, 12.

173. Ibid., August 27, 1915, 1.

174. Ibid., August 16, 1916, p. 1.

175. Traveling shows and local assemblies flourished in the United States in the late nineteenth and early twentieth centuries, providing popular education combined with entertainment in the form of lectures, concerts and plays. They were modeled after activities at the Chautauqua Institution in western New York.

176. *East Oregonian*, August 23, 1916, p.1.

177. Ibid., August 28, 1916, 8.

178. Emile Holeman, interview by the author, June 2015. Emile grew up across the street from the Old Canyon.

179. Ibid., September 21, 1916, 1.

180. Ibid., September 19, 1917, 1.

181. *East Oregonian, Round-Up Edition*, September 12, 1941, 1.

182. Holeman, interview.

183. *East Oregonian*, September 14, 1970, 6.

184. Bruce Boylen, interview by the author, August 2015.

185. Roy Raley to J.S. Laing, May 18, 1950, author file.

186. Roy Raley memo to Happy Canyon board on "Carroll Tract," September 8, 1952, author file.

187. *East Oregonian*, November 19, 1954, 9.

188. Ibid., September 12, 2000, 7B.

189. Ibid.

190. Ibid., September 12, 2000, 7B.

191. Ibid., September 18, 1965, 1.

192. Ibid., September 22, 1914, 8.

Chapter 10

193. Ibid., September 10, 1952, 2.

194. Boylen, interview.

195. *East Oregonian*, September 12, 1938.

196. Ibid., September 11, 2002, 23.

197. *East Oregonian, Souvenir Edition*, September, 1938.

198. *East Oregonian*, September 10, 1952, 2.

199. Sherrill McKee Byers, interview by the author, June 2015.
200. *East Oregonian*, September 17, 1966.
201. Ibid., September 9, 1975, E3.
202. Bill Ryder, interview by the author, September 2015.

Chapter 11

203 *East Oregonian*, September 14, 1939, 1.
204. Ibid., September 19, 1917, 1.
205. Ibid., November 19, 1954, 9.
206. Ibid., September 12, 1916, 1.
207. Ibid., September 21, 1916, 1.
208. Grilley, letter to Happy Canyon board.
209. Ben Jory, letter to Happy Canyon board, August 29, 1929, author file.
210. Boylen, interview.
211. Berk Davis, interview by the author, September 2015.
212. Grover, interview.
213. R.A. Fletcher, interview.
214. *East Oregonian*, May 8, 1953, 1.
215. Ibid., September 19, 1970, 4.
216. Ibid., September 14, 1971, F2.
217. Ibid., September 18, 1965, 1.

Chapter 12

218. *East Oregonian, Souvenir Edition*, 1938, 54.
219. After purchasing Happy Canyon bucks, gentlemen would pay for each dance (the lady's dance was free). Between numbers, rope boys cleared the dance floor and collected Happy Canyon bucks for the next number.
220. *East Oregonian*, November, 19, 1954, 9.
221. Ibid., September 9, 1980, C9.
222. Holaday, paper on Happy Canyon, Hall of Fame Collection.
223. *East Oregonian*, September 21, 1914, 1.
224. Ibid., August 19, 1914, 8; September 18, 1914, 8.
225. Ibid., September 24, 1914, 12.
226. *East Oregonian, Souvenir Edition*, September 24, 1915, 19.

227. *East Oregonian*, September 23, 1915, 1.

228. Ibid., 5.

229. Ibid., August 16, 1916, 1.

230. Macnab, *Century of News and People in the* East Oregonian, 161.

231. *East Oregonian*, September 20, 1917, 8.

232. R.A. Fletcher, interview.

233. Happy Canyon Board of Directors Minutes, 1944.

234. *Pendleton Tribune (Sunday Morning Edition)*, September 22 1918, 1.

235. *East Oregonian*, September 19, 1919, 1.

236. Ibid., September 18, 1919, 29.

237. Ibid., September 23, 1920, 1, 6.

238. Ibid., September 14, 1970, 1.

239. Ibid., September 8, 1970, 1.

240. Holeman, interview.

241. *East Oregonian*, September 14, 1971, 2.

242. *Pilot Rock News*, September 30, 1971, 1.

243. *East Oregonian*, March 19, 2015, 1.

244. Bruce Reynolds, interview by Jason Hill, April 2015, author file.

245. *East Oregonian*, November 19, 1954, 9.

246. Ibid., September 23, 1915, 1.

247. Ibid., September 18, 1916, 1.

248. Ibid., September 15, 1916, 1.

249. Chief Raymond Burke, interview by Robin Fletcher, March 1992, author file.

250. *Pioneer Trails* 34, nos. 1 and 2 (September 2010): 7.

251. Mary Ann Stangier, interview by the author, April 2009.

252. *East Oregonian (Souvenir Edition)*, September, 1939, 51.

253. E.O. Thompson, letter to Happy Canyon board, September 6, 1950, author file.

Chapter 13

254. *East Oregonian*, September 15, 2006, 11A.

255. Happy Canyon Board of Directors Minutes, March 18, 1955.

256. *Oregonian/Oregon Live*, September 11, 2010.

257. Ibid.

258. Marie Dick, interview by the author, June 2015.

259. *East Oregonian*, September 15, 2006, 11A.

260. Ibid.

261. Ibid., September 11, 1965, 7.

262. Ibid.

263. Ibid., September 12, 1972, F10.
264. Judy Farrow, interview by the author, August 2015.
265. Tessie Williams, interview by the author, April–May 2012.
266. Sophia Enos, interview by the author, February 2016.
267. Toni Minthorn, interview by the author, April 2011.
268. *Confederated Tribal Journal*, September 2014, 11.

Chapter 14

269. *East Oregonian*, September 24, 1915 19.
270. "What's a Happy Canyon director?" Author file.
271. *East Oregonian*, September 22, 1914, 8.
272. Ibid., September 18, 1914, 2.
273. J.F. Robinson was the "director" of the Red Dog Saloon in 1914. During the show's festivities, his 1914 Hudson five-passenger car was stolen, as the *East Oregonian* later reported on September 24, 1914, 5.
274. *East Oregonian*, September 2, 1914, 1.
275. *Polk's Umatilla County Directory*, 1914, 13.
276. *Polk's Umatilla County Directory*, 1912, 10.
277. Happy Canyon Board of Directors Minutes, 1916.
278. *East Oregonian*, August 16, 1916, 1.
279. Macnab, *Century of News and People in the* East Oregonian, 208–09.
280. Happy Canyon Board of Directors Minutes, July 14, 1942.
281. Happy Canyon Company Resolutions (Special Meeting of Stockholders), January 4, 1953, 1–4.
282. Bruce Campbell, interview by the author, January 2016.
283. Happy Canyon president Jim Duff's summary letter for 1991 Happy Canyon Company Inc. Financial Statements, author file.
284. *Confederated Umatilla Journal*, November 2002, 1.
285. Ibid.
286. Wray Hawkins, interview by the author, September 2014.
287. Holeman, interview.
288. Sager, interview.
289. Don Hawkins, interview by the author, April 2012.
290. Mike Kilkenny, letter to Happy Canyon board, October 23, 1941, author file.
291. Hawkins, interview.
292. Raley, letter to Happy Canyon board, November 5, 1948.

Chapter 15

293. Ray Meyersick, letter to Happy Canyon board, April 10, 1953, author file.

294. Macnab, *Century of News and People in the* East Oregonian, 169.

295. *East Oregonian*, September 21, 1917, 27.

296. Ibid., November 19, 1954, 9.

297. Happy Canyon Board of Directors Minutes, March 1954.

298. Happy Canyon Company Inc., Articles of Incorporation, 1952.

299. Steve Corey, e-mail interview by the author, November 2015.

300. Sager, interview.

301. *East Oregonian, Pendleton Round-Up*, "Into the Next Century," September 2011, 24–25.

Chapter 16

302. *East Oregonian*, September 9, 1969, F4.

303. Raley, undated diary.

304. Patti Baker, interview by the author, August 2015.

305. *East Oregonian*, September 23, 1915, 1.

306. Ibid., January 1, 2002, 3A.

307. Ibid., September 9, 1980, B10–11.

308. Ibid., September 13, 1968.

309. Ibid., September 14, 1965, 13.

310. Ibid., September 14, 1988, 4A.

311. *Oregonian*, September 16, 2000, 1.

312. Fritz Hill, interview.

313. Jerrod Spriet, e-mail interview by the author, June 2015.

314. *Oregonian*, September 16, 2000, 1.

315. *Orange County Register*, August 10, 2005.

316. Doug Corey, interview by the author, July 2015.

317. Allen Waggoner, interview by the author, June 2015.

318. Robin Fletcher Jr. and Chief Jesse Jones, interview by the author, September 2012.

319. Jason Hill, e-mail interview by the author, August 2015.

BIBLIOGRAPHY

Books

Bales, Michael, and Ann Terry Hill. *Pendleton Round-Up at 100*. Norman: University of Oklahoma Press, 2009.

Furlong, Charles Wellington. *Let 'Er Buck: A Story of the Passing of the Old West*. New York: G.P. Putnam's Sons, 1921.

Macnab, Gordon. *A Century of News and People in the* East Oregonian, *1875–1973*. Pendleton: East Oregonian Publishing Co., 1975.

May, Keith F. *Pendleton: A Short History of a Real Western Town*. Kearney, NE: Morris Publishing, 2005.

Polk's Umatilla County Directory. Pendleton, OR: R.L. Polk, 1914.

Polk's Umatilla County Directory. Pendleton, OR: R.L. Polk, 1912.

Papers

Assorted Happy Canyon papers and documents, author file.

Assorted papers from Robin A. Fletcher Jr. file.

Happy Canyon Company Inc. Articles of Incorporation, 1952. Happy Canyon Collection.

Happy Canyon Company Resolutions (Special Meeting of Stockholders), January 4, 1953. Happy Canyon Collection.

Happy Canyon contract with Salt Lake City Costume Company, August 6, 1930. Happy Canyon Collection.

Holaday, Joseph. Paper on Happy Canyon. Hall of Fame Collection.

Raley, Adna. Harlow Kellogg paper, 1941. Raphael Hoffman personal collection.

Raley, Roy. Happy Canyon Agreement, December 7, 1940. Happy Canyon Collection.

———. Letter to Happy Canyon board, November 5, 1948. Happy Canyon Collection.

———. Letter to the Happy Canyon board, December 7, 1940. Happy Canyon Collection.

Searcy, Mildred. Various papers on Happy Canyon. Hall of Fame Collection.

Magazine Articles

Pioneer Trails. Various volumes. Pendleton, OR.

Richards, Leverett G. "Out Where the Old West Lives On." Reprint, *Reader's Digest,* September 1957.

Newspapers

East Oregonian (Pendleton)

East Oregonian (Pendleton) Round-Up Edition

Orange County Register (Santa Ana, CA)

(Pendleton, OR) Confederated Umatilla Journal

Pendleton (OR) Evening Tribune

Pilot Rock (OR) News

(Portland) Oregonian

Other

Conner, Roberta, Marjorie Waheneka and Steve Corey. *Happy Canyon Pageant Narration,* 2002.

Emigrant Routes Through Umatilla County. Pendleton, OR: Umatilla County Historical Society, 1993.

Happy Canyon Program. Pendleton, OR: Happy Canyon Company Inc., 1923–present.

"The Nixyaawii Story." *Confederated Tribal Journal.* September, 2010.

Price, Gladys Bibee. *Nun-Mip-Ni-Sheek "We Remember."* Booklet, 1959.

Raley, Roy. Undated diary. Raley family collection.

INDEX

Author Becky Fletcher Waggoner welcomes you to the Canyon. *Eye of Rie.*

ABOUT THE AUTHOR

Becky Fletcher Waggoner is a fourth-generation Happy Canyon participant and fifth-generation resident of Pendleton, Oregon. When she was three years old, she was "volunteered" to act in Happy Canyon. She fell in love with the show, the smell of sawdust and the orchestra playing live music under the stars.

With a passion to see Happy Canyon's history preserved and to honor a century of people who have volunteered, Becky began a quest to collect and research historical documents, conduct interviews with key Happy Canyon volunteers and collect rare, never-before-published photos. Becky describes it as "an archaeological dig" into an important piece of Pendleton and a unique American treasure.

She and her husband, Allen, former Happy Canyon show director and president, have three children: Kyle, Kaleigh and Riley—all fifth-generation Happy Canyon volunteers and actors. On with the show!